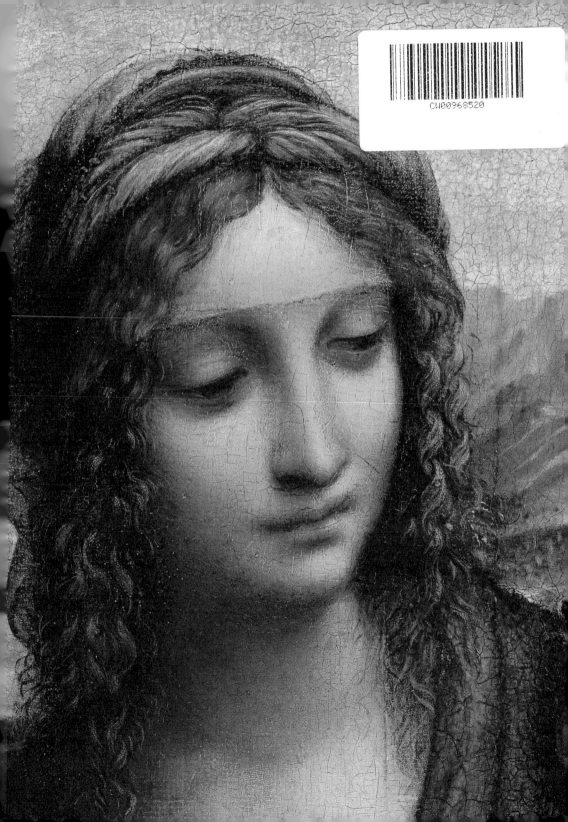

Leonardo da Vinci

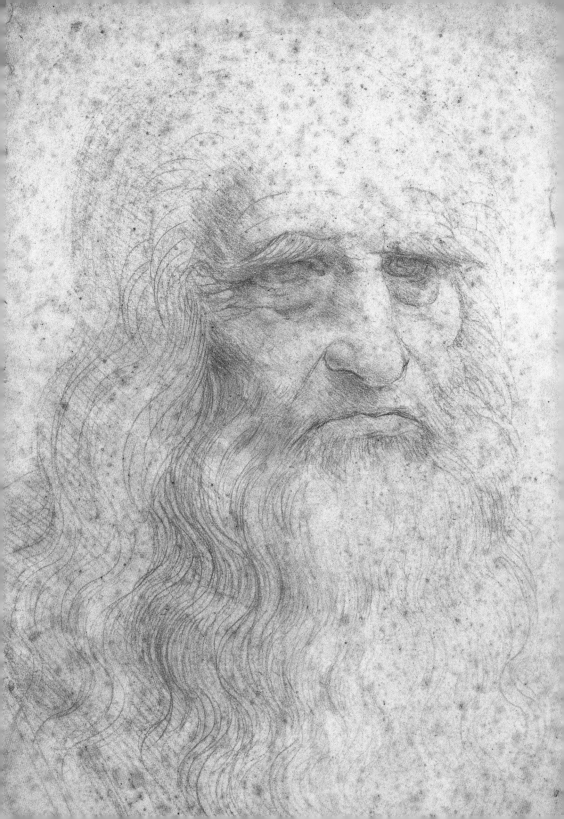

Frank Zöllner

Leonardo da Vinci

1452–1519

The Complete Paintings

TASCHEN

Contents

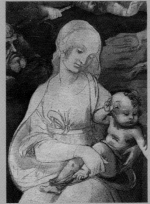
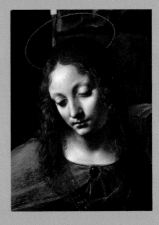
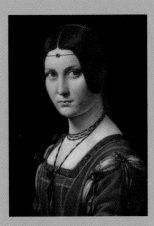

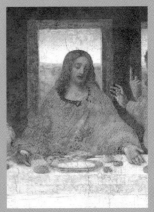

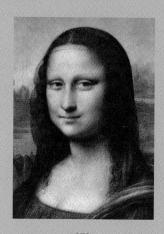

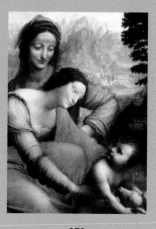

Preface

The focus of this book, whose 2019 expanded edition marks the 500th anniversary of the artist's death, are the works of Leonardo as well as a wealth of original sources, which are discussed in depth in the ten chapters of the main text. The accompanying references and further reading can be found in the Bibliography (pp. 412–423) and in the catalogue section, which also offers a critical appraisal of Leonardo scholarship to date. The analyses in the main text approach Leonardo's works from the perspective of their socio-cultural context and the history of their respective genres. They concentrate upon a "historical explanation of pictures" (Baxandall 1985) and interpret the content of Leonardo's paintings against the backdrop of context and pictorial tradition. In the main text I have furthermore sought to show that Leonardo's theoretical and scientific ideas can likewise only be understood in full against the backdrop of their historical contingency.

For publications within the field of Leonardo scholarship in recent years, the reader is directed here to the specialist bibliographies (Bibliography, Section 4). In the following pages there is only room to pay tribute to the most important discoveries. These include the painting of Christ as *Mundi* presented to the public in 2011 and sold on 15 November 2017 at auction in New York, whose design undoubtedly goes back to Leonardo (fig. 1; see Cat. XXXII). This is evidenced by two autograph studies by Leonardo for Christ's draperies (Cat. D40–41) and by other versions of the subject that were produced in his workshop or within his circle. A *Salvator Mundi* formerly in the collection of the Marquis de Ganay, a second in San Domenico Maggiore in Naples, and a third in the Detroit Institute of Arts are all variants from Leonardo's circle (figs. 3, 7 and 11). Two *Salvator Mundi* paintings from the former Stark and Worsley collections are only documented by old photographs (figs. 9-10). Like the New York *Salvator Mundi*, they depict Christ as Saviour making the

Fig. 1
Workshop of Leonardo, after a design by Leonardo with participation of Leonardo
Christ as Salvator Mundi, from 1507 (?) *Oil on walnut, 65.5 x 45.1–45.6 cm*
Private collection, planned for Louvre Abu Dhabi (2017 state)

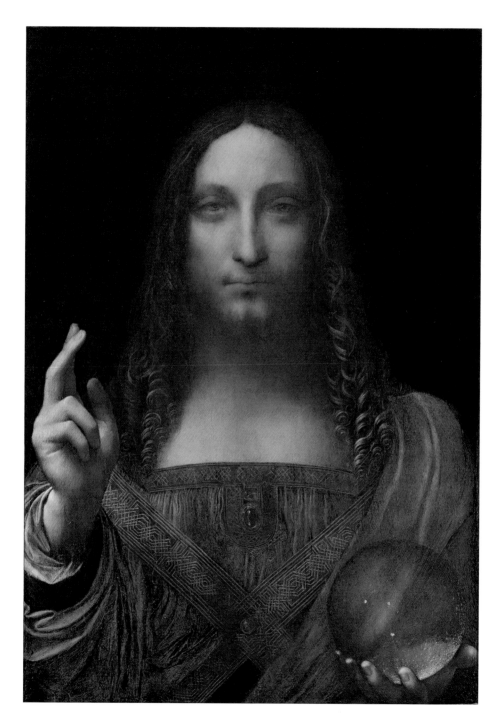

sign of blessing with his right hand and holding a crystal orb in his left. Other variants, which were probably also executed on the basis of Leonardo's *Salvator Mundi* design, show a portrait of Christ without crystal orb or gesture of blessing (fig. 8).

The New York *Salvator Mundi* is a high-quality, albeit heavily restored Old Master painting (see below), on whose completion it is likely that Leonardo was directly involved. But the viewpoint, regularly expressed since 2011, that the New York *Salvator Mundi* represents a wholly autograph work by Leonardo himself, remains particularly problematic. Doubts over such an attribution arise out of three circumstances. Firstly, in contrast to other original paintings by Leonardo, the New York *Salvator Mundi* is not mentioned in early sources. Secondly, the painting's provenance can only be traced back securely to the start of the 20th century. Thirdly, following its rediscovery in 2005, the evidently badly damaged painting has undergone radical restoration, the start of which in 2005 does not appear to be documented at all (Modestini 2014, p. 142). A documentation of all the restoration works carried out, announced several times since 2011, has still not been published, which casts the previous process of authentication into a bad light and makes it impossible to pass final judgement on the New York *Salvator Mundi*.

We need only look at certain details of the painting for the problematic nature of the recent restoration to become apparent. An example is an omega-shaped fold in Christ's draperies, which is located to the left of the intersecting ornamental bands of his outer garment. This detail is already present in one of the two drapery studies by Leonardo (Cat. D41) and is also found in the Salvator Mundi paintings from the Ganay Collection (fig. 3), San Domenico Maggiore (fig. 7) and the Worsley Collection (fig. 10). It is least stylized and comes closest to Leonardo's original drawing in the Ganay *Salvator Mundi*. In the New York *Salvator Mundi,* by contrast, the omega motif has shrunk to a barely legible cipher. This reduction of a detail that is also of iconographical interest (Snow-Smith 1982, pp. 58–61) allows two conclusions: either the execution of the omega motif in the New York *Salvator Mundi* is not by Leonardo himself, or it testifies to the scale of the painting's damaged state of preservation. The problematic nature of the restoration is highlighted, too, when we compare the photographs of the New York *Salvator Mundi* published since 2011. From an examination of these widely disseminated images, it is plain that the painting has been altered since its first public presentation in 2011. Thus the photographs published between 2011 and c. 2014 show, in the right half of the picture (i.e. on Christ's left shoulder), a whole series of drapery folds of differentiated shape (fig. 2). The exact course of these folds and their shadows can be made out without difficulty even behind the crystal globe which Christ is holding in his left hand. By contrast, the photographs taken in 2017 (fig. 1) reveal a simplification of the drapery folds in this area, as well as a reduction in their number. Their course beneath the orb has likewise been simplified and is less clearly visible. An impression of the nature of this alteration is also conveyed by a comparison with a

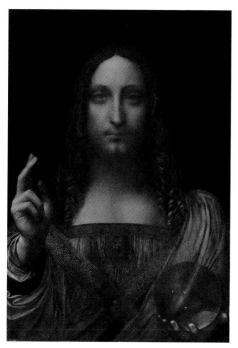

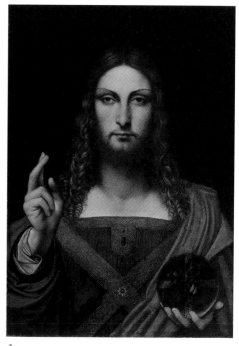

2

3

photograph taken around 1904, which shows the painting in a state prior to the restorations carried out as from 2005 (fig. 4). Here the drapery folds behind the crystal orb run visibly further, as is the case in the new photographs of the New York *Salvator Mundi* published between 2011 and 2014. In the upper area of Christ's left shoulder, however, the 1904 photograph corresponds to the state of the New York *Salvator Mundi* at the time of its auction in November 2017 (fig. 1). A look at a version of the Salvator Mundi formerly in the collection of the Marquis de Ganay is equally illuminating (fig. 3): here, the drapery folds above the crystal orb come closest to the 2011 state of the New York *Salvator Mundi* (fig. 2). The same detail in the variant in Detroit (fig. 11), by contrast, corresponds more closely to the New

Fig. 2
Workshop of Leonardo, after a design by Leonardo with participation of Leonardo
Christ as Salvator Mundi, from 1507(?), *Oil on walnut, 65.5 x 45.1–45.6 cm*
Private collection, planned for Louvre Abu Dhabi (2011–2014 state)

Fig. 3
Circle of Leonardo da Vinci, **Christ as Salvator Mundi**, *Oil on walnut, 68,6 x 48,9 cm*
Privatse collection, formerly Marquis de Ganay Collection, Paris, auctioned at Sotheby's,
28 May 1999, lot 00020, Important Old Master Paintings, sold for US$332,500

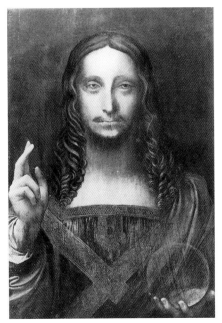
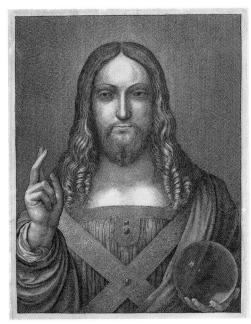

4 5

York *Salvator Mundi* in its current state. These comparisons prove, in other words, that even after its exhibition in 2011, and during the period in which it was being marketed in the years up to 2017, the New York *Salvator Mundi* was altered through its restoration in a questionable manner. The special characteristics of the New York *Salvator Mundi* include its iconic presence, its sfumato effects and hence its extraordinarily atmospheric impact. These effects are already partially present in a Salvator Mundi painting from Forlì, which served Leonardo as a visual source (fig. 6).

In view of the currently insufficient documentation of the restoration campaign, however, it remains unclear to what extent this sense of aura goes back to interventions by the restorer. At all events, photographs taken immediately after the painting's rediscovery in 2005 show a *Salvator Mundi* that is somewhat less atmospheric in its effect (Modestini 2014, p. 141f; 2018, p. 412).

Fig. 4
Leonardo da Vinci and Workshop (?) **Christ as Salvator Mundi**
Photograph of 1904

Fig. 5
Wenzel Hollar, **Christ as Salvator Mundi**, 1650
Etching, 24.6 x 19 cm, Royal Library, Windsor Castle

The heated debates over the condition and attribution of the New York picture have thrust questions of content into the background. One possible historical frame of reference is suggested by the painting's references to devotional portraits of Christ. Of particular interest in this regard are the prayers to St Veronica popular in Leonardo's day, which in 15th and 16th-century book illumination were often accompanied by pictures of Christ as Salvator Mundi. The text of the prayer was thereby introduced or accompanied by miniatures either of St Veronica's veil, a portrait of Christ in the Ecce Homo tradition, or half-length representations of Christ as Salvator Mundi. Highly significant in this context is the prayer spoken in front of the picture of the Saviour, which opens with the words "Salve

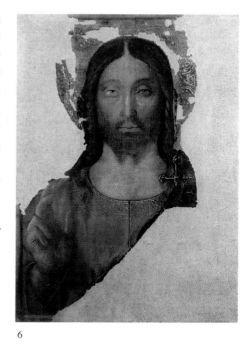

6

sancta facies". The person praying thus addresses the Holy Face directly before their eyes. The "Salve sancta facies" prayer is bound up with the hope that devotions performed before the eyes of the Redeemer will help reduce a person's punishments in Hell and ensure that they pass directly into the realm of the blessed, where in the last days they will stand before the divine countenance itself (Zöllner 2021).

Miniatures taking up the theme of praying directly before the Holy Face can be found in many of the illuminated manuscripts of this period, for example in a book of hours illustrated around 1515 by Simon Bening and today housed in the Pierpont Morgan Library in New York (Ms M399, fol. 194v; fig. 14). Here a gold-framed representation of Christ as Salvator Mundi is surrounded by the faithful in prayer and a number of angels. The people praying thus seem to have already reached Heaven through their devotion. What is also striking is that the faithful are arranged as if they were gathered around a panel painting of

Fig. 6
Melozzo da Forlì, **Salvator Mundi**, 1480–1482
Oil on panel, 54 x 40.5 cm
Urbino, Galleria Nazionale delle Marche, Palazzo Ducale

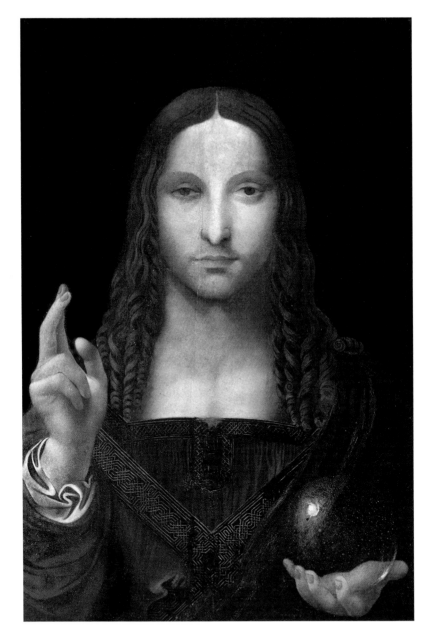

Fig. 7
Girolamo Alibrandi, **Christ as Salvator Mundi**
Tempera on panel, 66.5 x 46.5 cm
Naples, San Domenico Maggiore

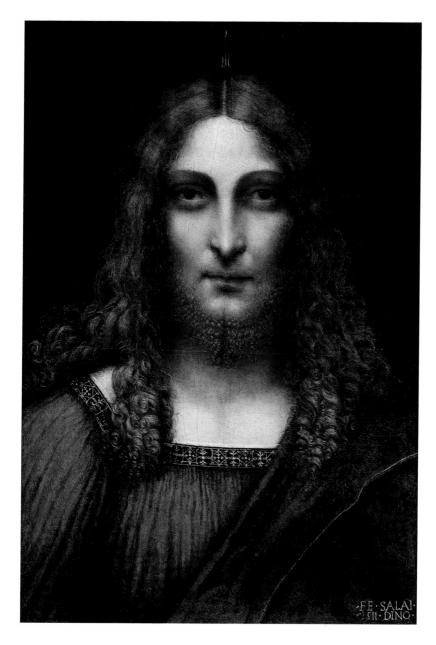

Fig. 8
Giacomo Salaì, **Head of Christ**, 1511,
Oil on panel, 57.5 x 37.5 cm
Milan, Pinacoteca Ambrosiana

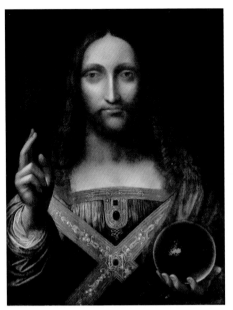
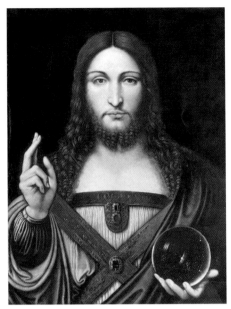

9 10

the Salvator Mundi. A Flemish prayer book dating from the same period, today in the collection of the Fitzwilliam Museum in Cambridge, also shows the Salvator Mundi as a panel painting, whereby here the act of worshipping the image of Christ is relocated to a small predella painting (the skilful representation across the base; Ms 1058-1975, fol. 13v; fig. 13).

A portrait produced around 1460 by the Netherlandish artist Petrus Christus (fig. 12) allows us to picture how a *Salvator Mundi* might appear in the context of private devotion. Seated in the centre of the painting is an elegantly dressed young man with a small book in his right hand. Pinned up on the wall in the background is a somewhat tattered sheet from an illuminated prayer book or a single woodcut print bearing a portrait of the Saviour and,

Fig. 9
Artist unknown, **Christ as Salvator Mundi**, c. 1560 (?),*Oil (?) on panel, 63.5 x 49.5 cm*
Formerly Viktor Stark Collection, Zurich, current whereabouts unknown

Fig. 10
Artist unknown, **Salvator Mundi**, *Oil (?) on panel, 62.5 x 48.8 cm*
Formerly Worsley Collection (prior to that Yarborough Collection) current whereabouts unknown

Fig. 11
Artist unknown, **Salvator Mundi**, *Oil (?) on panel, 65 x 47.5 cm*
Detroit Institute of Arts

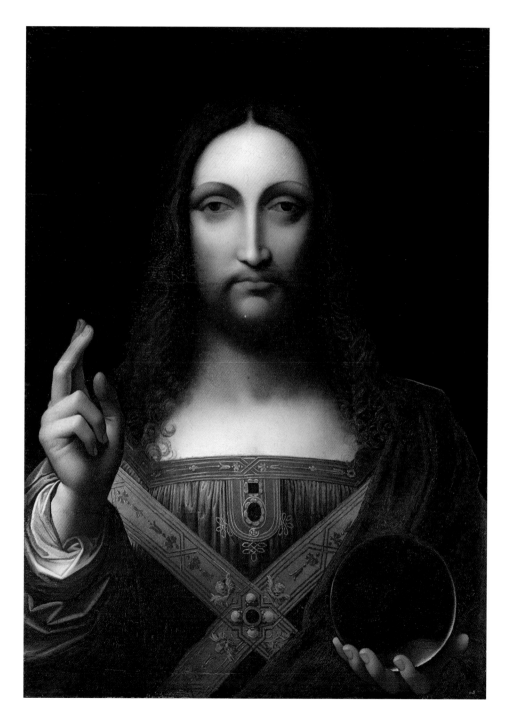

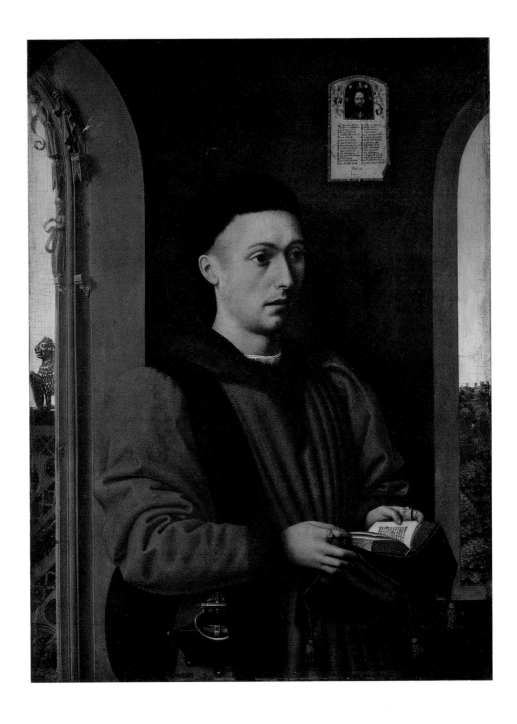

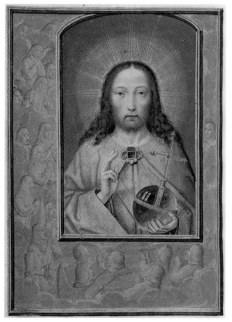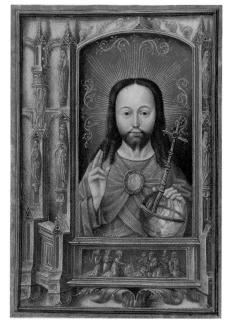

13 14

below it, the prayer of St Veronica laid out in two columns. In terms of its function, the New York *Salvator Mundi* thus probably belongs to the private devotional practice of the early 16th century associated with the prayer "Salve sancta facies".

Frank Zöllner, 2019

Fig. 12
Petrus Christus, **Portrait of a Young Man**, 1450-1460
Oil on oak, 35.4 x 25 cm London, The National Gallery

Fig. 13
Artist unknown, Miniature from a Flemish book of hours (Bruges), **Salve Sancta Facies,
Christ as Salvator Mundi**, c. 1510, *Parchment and gold, book page 19.6 x 13.2 cm
Cambridge (US), The Fitzwilliam Museum, (Ms 15677) fol. 13v*

Fig. 14
Simon Bening and Workshop, Miniature from the Da Costa hours, **Salve Sancta Facies,
Christ as Salvator Mundi**, c. 1515, *Parchment, book page 17.2 x 12.5 cm
New York, Pierpont Morgan Library (Ms M399), fol. 194v*

I
The young artist in Florence

1469–1480

Indeed, the great Leonardo remained like a child for the whole of his life in more than one way; it is said that all great men are bound to retain some infantile part. Even as an adult he continued to play, and this was another reason why he often appeared uncanny and incomprehensible to his contemporaries.

SIGMUND FREUD, 1910

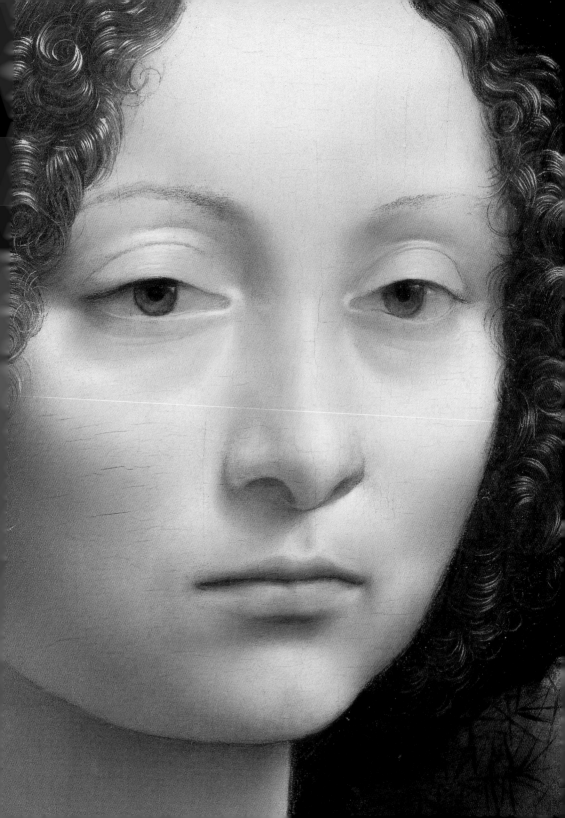

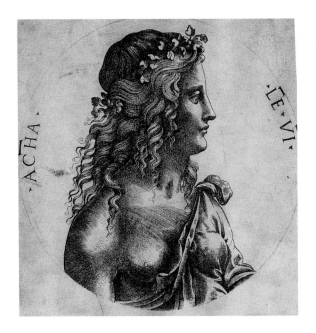

Amongst the great figures of the Italian Renaissance, Leonardo da Vinci remains one of the most enigmatic of them all. Although he has bequeathed to us the most extensive body of writings of any artist of his generation, rarely amongst these thousands of pages of manuscript do we find references to his personal opinions and feelings. We do not even have a very clear idea of what he looked like, and tend to picture him in two ways. On the one hand, we imagine Leonardo as a bearded old man – as he has come down to us in the so-called Turin *Self-portrait* (ill. p. 24) and in a drawing by his pupil, Francesco Melzi (1493–1570; ill. p. 21). On the other hand, we see him as a handsome youth, the embodiment of the Florentine Early Renaissance ideal of beauty, of the type that Leonardo himself drew many times (Nathan/Zöllner 2014, Cat. 184–185, 198, 203, 205) and which adorns, in an androgynous variation, the signet of an "Achademia Leonardi Vinci" which he founded (ill. p. 20). Rarely, in visualizing Leonardo's appearance, do we imagine a man in his prime, an artist between the ages of 30 and 60, the period of his career during which he produced most of his works. The reasons for this are essentially twofold: in the figure of the old man with the flowing beard, Leonardo appears to us as the wise inquirer and thinker, as someone who, through long years of study, has acquired a wealth of "scientific" knowledge and reached a venerable old age in the meantime.

Page 19
Detail of **Portrait of Ginevra de' Benci**, c. 1478–1480
(ill. pp. 58/59)

Unknown artist
Emblem of the "Achademia Leonardi Vinci" with Female Bust in Profile
Copperplate engraving, dia. 130 mm. London, The British Museum, Inv. B.M.5.–P.v.180.2

Francesco Melzi (?), **Portrait of Leonardo**, c. 1515 (?)
Red chalk, 274 x 190 mm. Windsor Castle, Royal Library (RL 12726)

In the handsome youth, on the other hand, we see the untutored genius who has outstripped his old teacher even before completing his apprenticeship (see below).

The wisdom associated with old age is thus just as much a characteristic of Leonardo and his art as the precocious talent that was with him from his earliest youth and would remain with him to his life's end. In his *Lives of the Artists*, first published in 1550, the biographer Giorgio Vasari (1511–1574) takes up the story of the talented young Leonardo, who was born on 15 April 1452 in Vinci, not far from Florence. In his typically anecdotal fashion, Vasari describes how Leonardo's artistic career began as follows: Ser Piero, Leonardo's father, "one day took some of Leonardo's drawings along to Andrea del Verrocchio

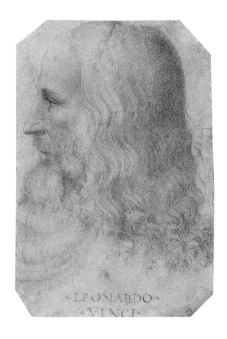

(who was a close friend of his) and earnestly begged him to say whether it would be profitable for the boy to study design. Andrea was amazed to see what extraordinary beginnings Leonardo had made and he urged Piero to make him study the subject. So Piero arranged for Leonardo to enter Andrea's workshop. The boy was delighted with this decision, and he began to practise not only one branch of the arts but all the branches in which design plays a part."

While the tale of the young genius who had already mastered the fundamentals of his future métier even before commencing his apprenticeship may be a commonplace of art history, it undoubtedly contains a grain of truth. For the young Leonardo must have demonstrated an extraordinary aptitude for drawing at a very early age. No other artist of his generation left behind such an extensive, authentic and at the same time innovative graphic œuvre. Leonardo's earliest surviving drawings from the 1470s already display the talented handling of metalpoint and pen to which Vasari pays enthusiastic tribute. Typical of Leonardo's sheer pleasure in drawing are the small, often playful sketches of figures in motion, executed with short, energetic strokes of the pen (Nathan/Zöllner 2014, Cat. 1, 7–8, 110–111, 113, 115; ill. p. 229). Exercises in rendering three-dimensional objects are thereby joined by excursions into pure imagination. At the same time, other drawings from Leonardo's early years demonstrate the scrupulous accuracy and graphic precision that all artists had to learn during their training.

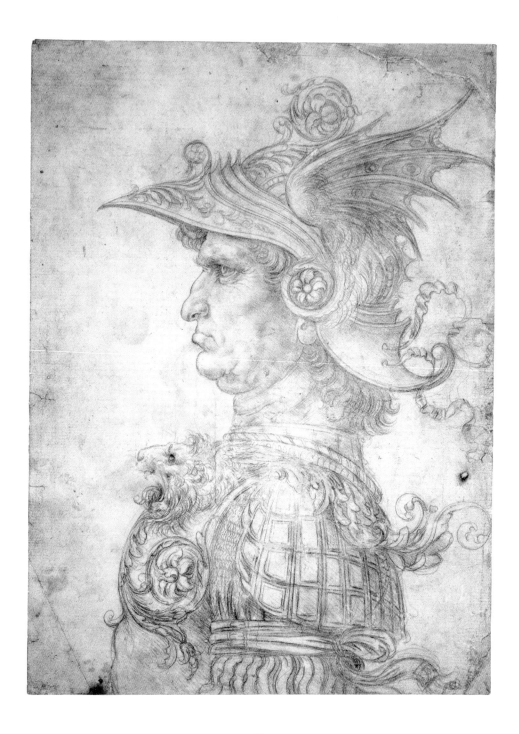

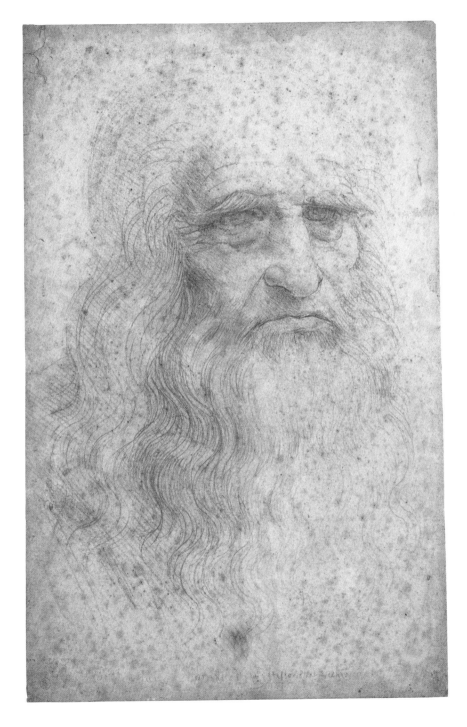

One such is his silverpoint drawing of an older man, the so-called *Antique Warrior* (ill. p. 23), probably executed *c.* 1472 or shortly afterwards, in which Leonardo takes up a figural type employed in his master Verrocchio's (1435–1488) workshop and derived from the works of classical antiquity. It is possible that young artists such as Leonardo honed their draughtsman's skills by making studies of works of this kind. Indeed, at one point in his posthumously compiled *Trattato di pittura* (*Treatise on Painting*), Leonardo advises artists to copy the works of "good masters" in order to learn how to "represent objects well in relief" (McM 63). Whatever the case, we may assume that the young Leonardo, like other artists at the start of their career, trained his hand and eye by making studies of older works of art, and in particular, too, of nature.

Typical of such studies of nature are the sketches that Leonardo produced during his apprenticeship, including his earliest dated drawing, today housed in the Uffizi in Florence (ill. p. 27). In the top left-hand corner, in his own characteristic mirror-writing, are the words "on the day of St Mary of the Snow Miracle 5 August 1473". Executed in pen and ink over a barely visible preparatory sketch, the study shows a view of a valley bordered by hills, leading away towards a distant horizon. The drawing is thought to portray a real landscape, but opinions vary widely as to the identity of the fortified hilltop village on the left. Leonardo's drawing not only bears witness to the increasing importance of studies from nature in the 15th century, but also demonstrates the efforts artists were making to subordinate the features of the visible world to their own creative will. Thus, for instance, the crowns of the individual trees on the hill on the right are simply sketched in with rapid hatching. In places these hatchings combine to form oscillating patterns that go well beyond the immediate imitation of nature. It is also possible, however, that this same sketch – generally considered one of the earliest autonomous landscape studies in art history – takes up elements used by Leonardo's teacher, Verrocchio. Patterns and sections of landscape similar to those in Leonardo's drawing can in fact be found in the backgrounds of several of Verrocchio's Madonna paintings, as can the motif of vegetation growing over the edge of a cliff. The younger artist perhaps oriented himself in his drawings – as later in his smaller paintings (see below) – towards the style of his teacher.

A typical product of Verrocchio's workshop is the small *Dreyfus Madonna*, which is occasionally attributed to Leonardo himself (Cat. II/ill. p. 30) and which reveals some parallels with Leonardo's *Madonna of the Carnation* (Cat. III/ill. p. 31). This little panel, which is also known as the *Madonna of the Pomegranate*, derives from a compositional type found chiefly in Venice. Verrocchio probably encountered this type during a trip to Venice in 1469 and subsequently introduced it to Florence. In her left hand, the very youthful-looking Virgin

Head of a Bearded Man (so-called Self-portrait), *c.* 1510–1515 (?)
Red chalk, 333 x 215 mm. Turin, Biblioteca Reale, Inv. 15571

holds a split, ripe pomegranate, a symbol of Christ's Passion. The infant Jesus has taken a seed of the pomegranate with his right hand and holds it up to his mother with an inquiring gaze. This symbolic reference to Christ's future Passion is reinforced by the stone parapet running across the foreground, which can be interpreted as a reference to the altar and thus to the Eucharistic Sacrifice of Christ. This symbolism is even clearer in other variations on the same compositional theme issuing from the workshops of Verrocchio and Giovanni Bellini (*c.* 1433–*c.* 1516), in which roses and cherries rest on top of the parapet as symbols of the Eucharist. In the context of such contemplative paintings, the parapet thus links the elements making up the intimate devotional scene with a reminder of Christ's Passion.

That the *Dreyfus Madonna* was intended as the object of quiet prayer in a private home is further underlined by the striking contrast within the picture between interior and exterior. The Virgin and Child are seated in a positively gloomy room. A short stretch of wall behind the Virgin's head gives way to two windows, one on either side, which are bounded in turn by grey pilasters and further sections of wall. This narrow interior is contrasted with the view, through the windows behind, out onto a bright and expansive landscape, which the artist has portrayed with some care. This landscape reveals parallels with Flemish and Umbrian works from the years around 1470, for example in the highlights placed on the trees in the middle ground and in the overall layout of the scenery. The Virgin's blue mantle, on the other hand, is more typical of Tuscan – and specifically Florentine – painting: its folds spill over the parapet like an altar cloth and recall similar draperies in the paintings of Lorenzo di Credi (*c.* 1458–1537).

The *Dreyfus Madonna* is in many respects characteristic of small-format devotional panels of the second half of the 15th century. Behind the tiny piece of pomegranate, barely visible in the Infant's right hand, lies the artistic assumption that the viewer is standing very close to the painting and thus that the panel itself is hanging in a domestic setting. Indeed, Verrocchio's *Dreyfus Madonna* seems to echo the recommendations of Fra Giovanni Dominici (*c.* 1356–1419), a Dominican preacher who in his *Regola del governo di cura famigliare* of 1403 set out, in great detail, the beneficial effects of having small devotional paintings in the family home. Pictures of holy infants should be hung in the house, he advised, since these would appeal to children from a very tender age. Children would be drawn to such pictures, would see themselves in the infants portrayed and model themselves upon them. Pictures of the Virgin Mary with the infant Jesus in her arms were also to be recommended, with Jesus holding a bird or a pomegranate in his little hands; equally praiseworthy were portrayals of the infant Jesus asleep or standing in front of his mother. Dominici thus assigned a specific didactic function to such devotional panels, with whose subjects younger viewers, in particular, could identify.

Leonardo's *Madonna of the Carnation* (Cat. III/ill. p. 31) was probably conceived with a similar function in mind. This is possibly the painting to which Vasari is referring when

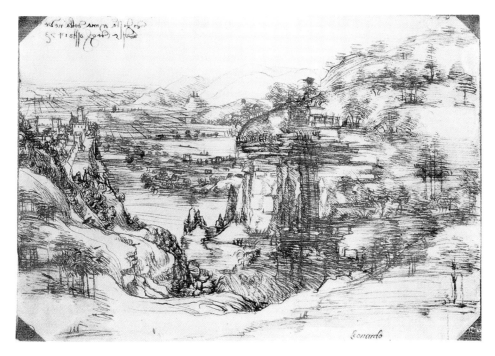

Arno Landscape, 5 August 1473
Pen and ink, 190 x 285 mm. Florence, Galleria degli Uffizi,
Gabinetto dei Disegni e delle Stampe, Inv. 436E

he describes, in his *Life of Leonardo*, "a Madonna, a very fine work which came into the possession of Pope Clement VII (r. 1523–1534); one of the details in this picture was a vase of water containing some flowers, painted with wonderful realism, which had on them dewdrops that looked more convincing than the real thing." Probably executed while Leonardo was still with Verrocchio, the panel takes up elements of Early Netherlandish painting in its slender pillars in the middle ground and its background landscape. The figures of the Virgin and the infant Jesus, on the other hand, clearly draw on the pictorial forms employed in Verrocchio's workshop. As was the convention in devotional panels of this kind, Leonardo's portrayal of the loving relationship between Mary and the infant Jesus is complemented with a number of familiar Christian symbols. The Holy Child is reaching out, in the still clumsy manner of a young infant, for a red carnation, a symbol of the Passion of Christ, which thus introduces into this scene of childlike innocence a reference to the later Crucifixion awaiting the Saviour. Equally symbolic in its intention is the crystal vase filled with flowers in the bottom right-hand corner, a clear reference to the purity and virginity of Mary. On another level, meanwhile, motifs such as the

carnation and the crystal vase, which demand great skill on the part of the artist, allowed Leonardo to give an impressive demonstration of his talent – a talent also exhibited in the masterly swathe of drapery bunched in the Virgin's lap, whose intense hue gives life to the dark foreground and corresponds in compositional terms with the brightness of the Virgin's face and neck. In contrast to comparable works by Verrocchio, Leonardo also brings mother and child closer together and thereby arrives, albeit still imperfectly, at the pyramidal composition that would later become the hallmark of High Renaissance painting. The *Madonna of the Carnation* also differs from the majority of the paintings issuing from Verrocchio's workshop in its painting technique. By using oil as his binding medium, Leonardo was able to achieve softer transitions between the individual areas of colour. It is this, for example, that lends the background the evocative atmosphere lacking in Verrocchio's landscapes, for all their profusion of vegetation, and which would characterize later paintings such as the *Mona Lisa* and the *Virgin and Child with St Anne*.

A difference in technique between master and pupil also emerges in *The Baptism of Christ* (Cat. IV/ill. p. 32). This large altarpiece, which was probably originally destined for the Vallombrose church of San Salvi just outside Florence, was begun by Verrocchio some time around 1470–1472. Parts of the background landscape, however, were completed by Leonardo around 1475 or soon afterwards. The angel kneeling on the far left, his face turned towards the central scene, is also the work of the young Leonardo. As Vasari tells us, "at that time Verrocchio was working on a panel picture showing the Baptism of Christ by St John, for which Leonardo painted an angel who was holding some garments; and despite his youth, he executed it in such a manner that his angel was far better than the figures painted by Andrea. This was the reason why Andrea would never touch colours again, he was so ashamed that a boy understood their use better than he did." Vasari, who was born as late as 1511, is known for supplementing the gaps in his knowledge about earlier art history with entertaining anecdotes, and the tale about Leonardo working on Andrea del Verrocchio's *Baptism of Christ* sounds like a prime example. However, modern-day technical analysis of the panel has fully confirmed the information provided by the biographer from Aretino. Even his bold assertion that Verrocchio abandoned painting after seeing what his extraordinarily gifted pupil could do may not be a piece of pure fiction. It is a fact that scarcely any paintings can be attributed to Verrocchio after the completion of the *Baptism of Christ* – a point that may also have struck Vasari.

Already employing a distinct and innovative technique, Leonardo's angel in Verrocchio's painting also adopts a pose infused with a typically Leonardesque sense of movement. Thus his upper body faces one way while his head turns to look in the other direction, and the movement of his left elbow is taken up again in the position of his right upper arm. The angel is distinguished, too, by the softness of his face, its gentle modelling distinctly different from the harder skin tones usually found in Verrocchio's work (ill.

pp. 34/35). The same applies to the figure of Christ in the centre of the painting, which – close inspections have revealed – was reworked in oils at a later stage. Here, too, the flesh of Christ's body appears softer than that of John the Baptist, painted by Verrocchio in the original tempera. In another significant contribution to Verrocchio's panel, and one that looks forward to his own later works, Leonardo also repainted the left-hand background in oils. What had started out as a view of shrubs and trees now became a very different landscape of water and rocky cliffs. In executing this new background, Leonardo created a sense of depth typical of his art: the landscape stretches away in a seemingly natural manner right into the far distance. Limpid waters play around precipitous cliffs; a warm light falls more or less evenly from the left across the group of figures in the foreground; dramatically cleft mountains

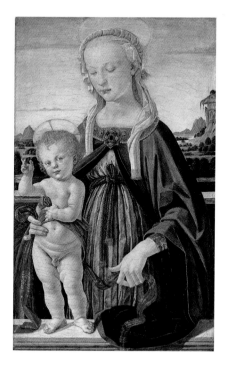

contrast with the smooth, horizontal expanse of water and fade in the distance into a soft blur; directly above the horizon, the blue of the sky lightens until it becomes a gleaming white. Similar horizons, and a certain predilection for rocky landscapes, can be found in Leonardo's later works, where their atmospheric effects are exploited even more fully.

The overall composition and iconographical details of Verrocchio and Leonardo's panel are based both on the descriptions of the Baptism of Christ in the Gospels (Matthew 3:3–17; Mark 1:9–11; John 1:26–36) and on earlier pictorial conventions: Christ, who has removed most of his clothes, is standing on the rocky bed of the river Jordan and is being baptized by John, stepping forwards from the right. Above him hovers the dove of the Holy Spirit, above which in turn we can see the hands of God the Father. The presence of the dove has caused the bird of prey on the right to take flight: a symbolic adversary of the Holy Spirit, it is here fleeing the Holy Spirit's greater power. On the left-hand side of the picture, the angel painted by Leonardo is holding Christ's robe, its original colour now somewhat faded. Some have sought to identify this figure with Archangel Michael,

Andrea del Verrocchio (?) and Workshop, **Virgin and Child**, c. 1475 (?)
Tempera on wood, 74 x 46 cm
Staatliche Museen zu Berlin, Gemäldegalerie

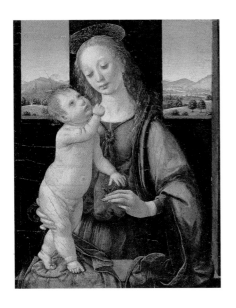

Lorenzo di Credi
Madonna of the Pomegranate (Dreyfus Madonna), c. 1470–1472 (?) or later
Tempera and oil (?) on oak, 15.7 x 12.8 cm
Washington, DC, National Gallery of Art, Samuel H. Kress Collection, Inv. 1144 (K1850)

Madonna of the Carnation (Madonna with a Vase of Flowers), c. 1472–1478 (?)
Tempera (?) and oil on poplar (?), 62.3 x 48.5 cm
Munich, Bayerische Staatsgemäldesammlungen, Alte Pinakothek, Inv. 7779 (1493)

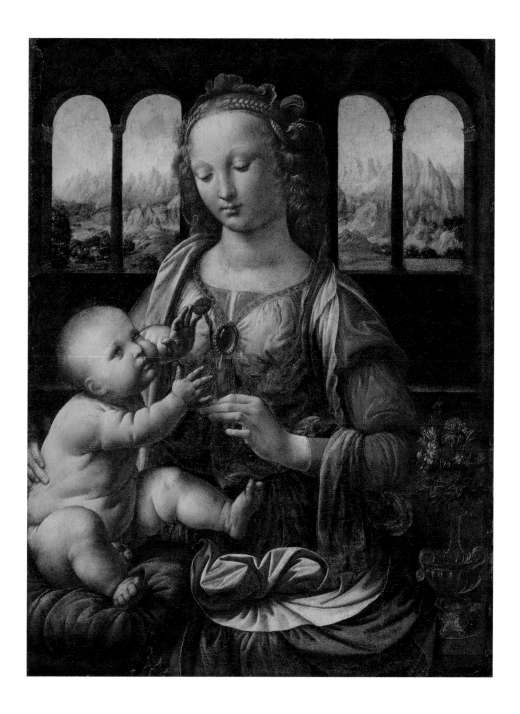

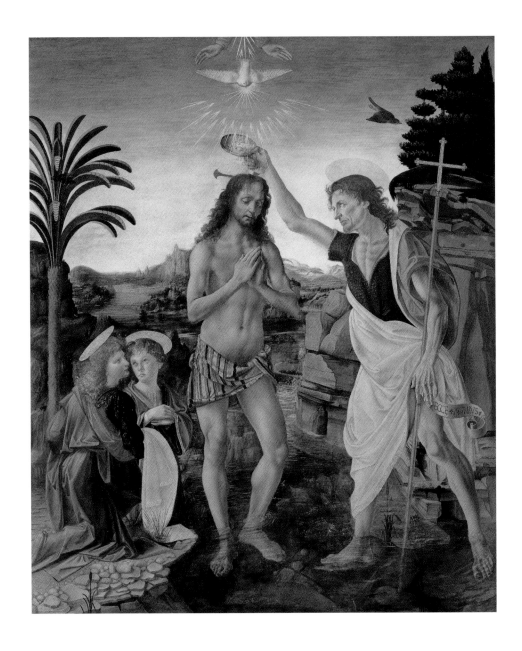

who was particularly venerated by the Vallombrose monks of San Salvi, for whom the altarpiece was probably painted. Behind the angel, a palm tree provides a formal conclusion to the foreground scene. This palm tree – lent a somewhat archaic character by its schematic portrayal – represents the Tree of Paradise, symbolizing salvation and life, and also pointing to Christ's future triumph over death. A similar iconography underlies the staff in John's left hand, too, whose banderole bears the words ecce agnivs d[ei, ecce qui tollit peccatum mundi] (John 1:29; "Behold the Lamb of God, who takes away the sin of the world"). These words are a reference both to Christ's sacrifice on the cross and to the panel's intended function as an altarpiece: they are reminder of the Sacrifice of Christ being re-enacted in the celebration of Mass at the altar, directly in front of the altarpiece portraying the Baptism of Christ.

Although, in his use of oils in the *Baptism of Christ*, Leonardo demonstrates a certain degree of technical independence, he was still working in Verrocchio's workshop during this period. It is not surprising, therefore, that almost all of Leonardo's early paintings reveal formal parallels with the works of his master and start from the same compositional premises. One such is the *Annunciation*, which was largely executed by Leonardo and today hangs in the Uffizi in Florence (Cat. V/ill. pp. 36/37). The decorative sarcophagus placed before Mary, for instance, corresponds closely, in its rich ornamentation, with a similar sarcophagus that Andrea del Verrocchio sculpted in 1472 for the Old Sacristy in San Lorenzo in Florence. This also provides us with a provisional point of reference for the dating of the *Annunciation*, which remains the subject of much debate.

The attribution of the painting is similarly a matter of some controversy, although a study by Leonardo for the right sleeve of the Archangel Gabriel (Nathan/Zöllner 2014, Cat. 3) is considered an indication that he was responsible for a considerable part of the composition. The painting, it may also be said, does not give the impression of being the work of a fully independent and mature artist such as Verrocchio. In comparison to the *Baptism of Christ*, for example, the *Annunciation* reveals a greater number of *pentimenti* – places where the overall composition and individual details differ in the final version from the original design. These suggest that the painting was executed by an artist still lacking in compositional experience, like Leonardo. Fingerprints on the panel are a further indication that the young Leonardo was here at work: dabbing his freshly applied oil paints with his fingers and the ball of his right hand was one of Leonardo's particular trademarks in Florence.

Andrea del Verrocchio and Leonardo
The Baptism of Christ, c. 1470–1472 and c. 1475
Oil and tempera on poplar, 180 x 151.3 cm. Florence, Galleria degli Uffizi, Inv. 8358

Pages 34/35
Detail of **The Baptism of Christ**, c. 1470–1472 and c. 1475

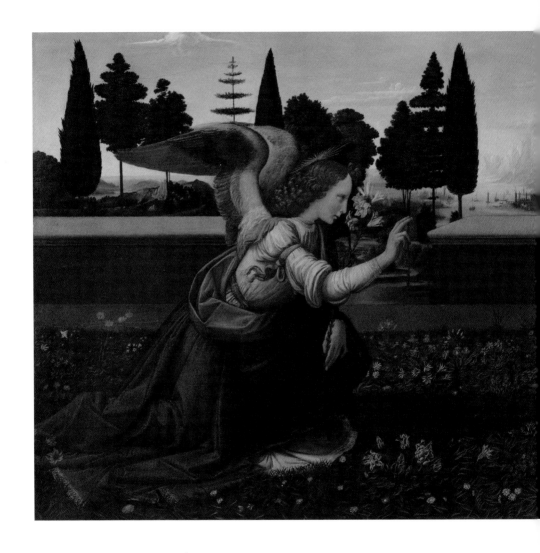

*It is true that decorum should be observed, that is, movements should
announce the motion of the mind of the one who is moving.
Accordingly, if the painter has to represent someone who must show fearful
reverence, the figure should not be done with such audacity and
presumption that the effect seems to be despair, or the uttering of a command.*

LEONARDO DA VINCI, TPL 58

Pages 36–47
Annunciation, c. 1473–1475 (?)
Oil and tempera on poplar, 100 x 221.5 cm. Florence, Galleria degli Uffizi, Inv. 1618

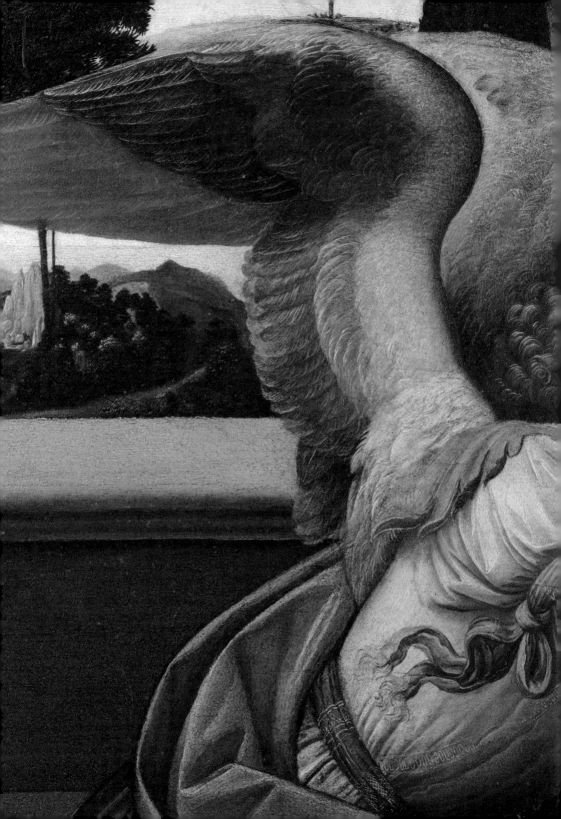

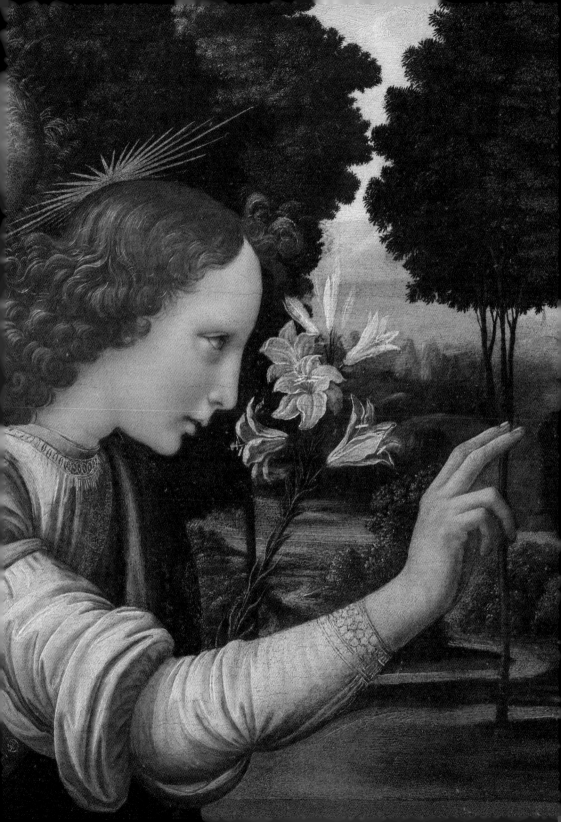

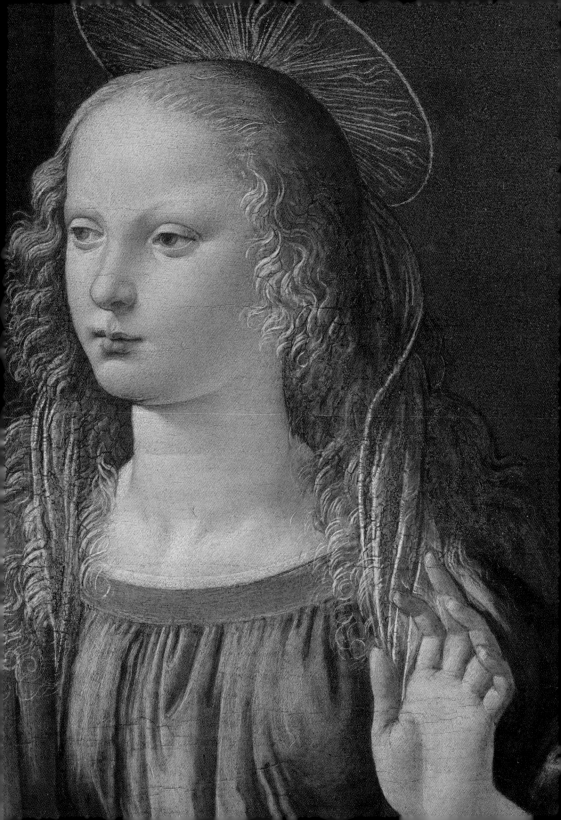

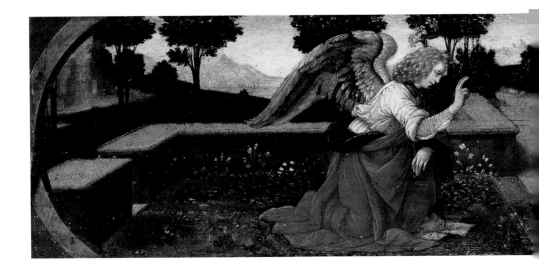

The time and place of the Annunciation are clearly laid down: we are in Nazareth, where on 25 March the Archangel Gabriel appears to Mary in the garden, interrupts her reading the Bible (Isaiah 7:14), and informs her that she has been chosen to bear the Son of God (Protevangelium of James II; Luke 1:26–38). The present scene, which largely follows 15th-century conventions, is flanked to the right by relatively contemporary architecture. The middle ground is concluded by a low wall rising to about knee-height and interrupted half way along by a small gap. Through this gap – which also serves to frame the gesture of greeting by Gabriel and the lily in his left hand – we can see a path leading away into the distance. Concluding the composition are a number of trees, sharply silhouetted against the bright sky, and beyond them mountains. A number of details within the painting carry a deeper meaning. Thus the white lily in Gabriel's hand is a symbol of Mary's purity, and the meadow in the foreground, with its many flowers, a reference to Nazareth, since according to *The Golden Legend* (1263/73) by Jacobus de Voragine (*c.* 1230–1298), Nazareth denotes "flower". There is significance, too, contained within the distant background, where in addition to the sea and the mountains we are also shown a port. This town by the sea is perhaps a reference to Marian symbolism: Mary was referred to in 15th-century liturgical books as *stella maris* (star of the sea) and as the sheltering harbour for all who had been shipwrecked on the sea of life (cf. Ch. III, IX). The maritime panorama in the background of the *Annunciation* may be inspired by just such ideas.

Annunciations, finally, fell into a number of subtly different categories. In the present painting, Gabriel's right hand forms what can be clearly identified as the traditional gesture of Annunciation, while Mary's left hand is raised in what at first sight appears a conven-

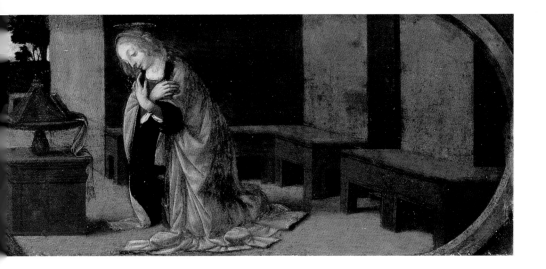

tional gesture of greeting. Mary's particular gesture, however, may also signify that we are looking at a specific, *conturbatio* type of Annunciation. The *conturbatio* interpretation of the Annunciation focuses on Mary's disquiet at being suddenly confronted by an angel in her garden and being given the unusual news that she is to bear God's son. Leonardo's Mary, on the other hand, maintains considerably more composure than her terrified counterparts in other *conturbatio* Annunciations, such as those by Sandro Botticelli (1445–1510). To all appearances, in Leonardo's modification of the *conturbatio* motif we are already seeing the innovative treatment of a pictorial type. This is further confirmed by a look back at Verrocchio's *Baptism of Christ*, whose overall design remains much more heavily indebted to earlier treatments of the same subject than does Leonardo's *Annunciation*. A similar conclusion emerges from a comparison of Leonardo's painting and a small *Annunciation* in the Louvre (Cat. VIII/ill. pp. 48/49), probably executed by Lorenzo di Credi, a fellow pupil in Verrocchio's workshop. Credi's composition adheres significantly more closely to established convention. The gestures made by his two figures, for example, are closely based on older paintings: while Gabriel raises his right hand, Mary folds her hands against her breast in the gesture of *humiliatio* (submission).

As already glimpsed in the *Baptism of Christ*, the background landscape in the Uffizi *Annunciation* looks forward to later paintings by Leonardo. It also demonstrates his masterly handling of the elements of water, air and light, which here bathe the steep foothills of the almost alpine ridges and peaks in the distance in an atmosphere of increasing density

Lorenzo di Credi, after a design by Leonardo (?), **Annunciation**, c. 1478 or 1485
Tempera on poplar, 16 x 60 cm. Paris, Musée du Louvre, Inv. 1602A (1265)

**Studies of a Virgin and Child (right, a study
for the *Benois Madonna*)**, c. 1478–1480
Pen and ink, 198 x 150 mm. London, The British Museum, Inv. 1860-6-16-100r

Benois Madonna, c. 1478–1480
Oil on wood, transferred to canvas, 49.5 x 31 cm. St Petersburg, Hermitag

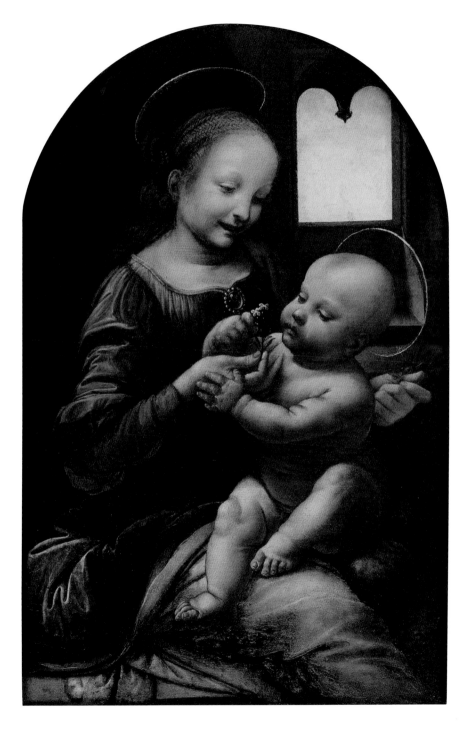

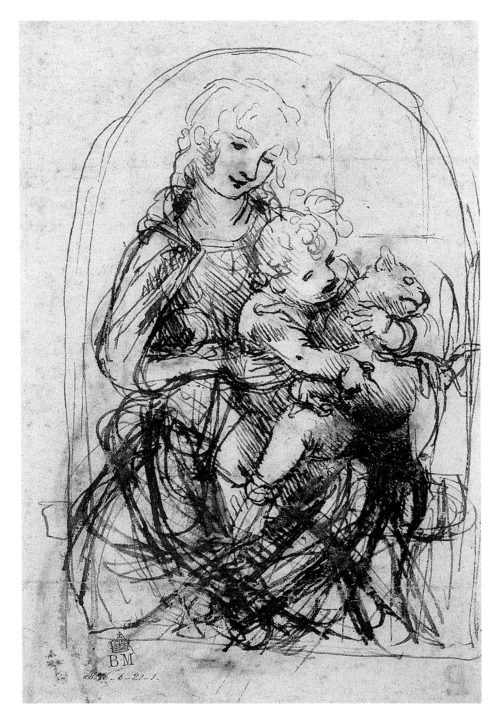

(ill. pp. 46/47). Leonardo would later describe similar phenomena in several places in his treatise on painting, for example when writing about the particular charm of horizons combining the elements of mountains and sea: "These horizons make a very fine sight in painting. It is true that there should be some mountains, behind one another, at the sides, with colour diminishing by degrees, as is required by the rule for the diminution of colours seen at great distances" (TPL 936). The atmospheric phenomena not described until 1508 in Leonardo's *Treatise on Painting* thus make their appearance considerably earlier in painting than in his theoretical writings. His artistic practice thus preceded his artistic theory.

Having worked and collaborated on larger paintings such as the *Annunciation* and the *Baptism of Christ*, Leonardo also continued, in the late 1470s, to paint small-format Madonnas. This emerges from a note of December 1478, in which Leonardo mentions that he is "starting the two Virgin Marys" ("incomincai le due Vergini Marie"; Nathan/Zöllner 2014, Cat. 192), but is evidenced, too, by the numerous studies of the Virgin and the infant Jesus that he produced during this period (Nathan/Zöllner 2014, Cat. 4 and 110–121; ills. pp. 50, 52, 229). These sketches manifest the young artist's urge to test out – within the bounds of pictorial convention – the possibilities of movement and expression in a variety of subjects. At the same time, however, they also include experiments in pure flights of fancy, exercises in free artistic expression which are permissible in drawing but would be out of place in painting. Not all of Leonardo's extant drawings can therefore be taken as preliminary studies for actual paintings. A number of these drawings nevertheless lead at least indirectly to the so-called *Benois Madonna*, which may be seen as the finest of Leonardo's early interpretations of the Virgin and Child theme (Cat. VI/ill. p. 51).

The *Benois Madonna*, named after one of its former owners, stands out from similar works by other artists by virtue of its darker palette, its more pronounced contrasts of light and shade and its greater dynamism. Leonardo's preliminary studies for the composition themselves reveal a remarkable animation, but only in the final painting do the ideas spontaneously developed in the drawings fuse into a harmonious whole. The emotional bond between mother and child is given formal expression not just in their physical proximity, but even in their poses. Thus both figures adopt the same sitting position, with one leg bent and other extended, whereby the legs of the infant Jesus are a smaller, mirror-image version of those of his mother. In this the *Benois Madonna* anticipates Leonardo's *Virgin and Child with St Anne* (Cat. XXVII/ill. p. 281), executed a few years later, in which the artist establishes a similar physical and at the same time genealogical relationship between the Virgin and her mother, St Anne. The fall of the draperies across the Virgin's right

Study for a Madonna with a Cat, c. 1478–1480
Pen and ink over preliminary stylus drawing, 132 x 95 mm
London, The British Museum, Inv. 1856-6-21-1

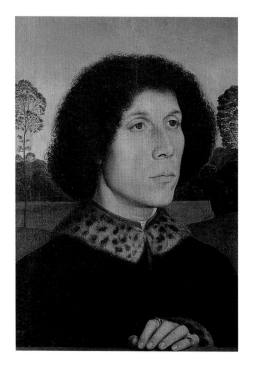

thigh in the *Benois Madonna* also appears to anticipate the later painting, and is even found in a related study from the period after 1510 (ill. p. 278).

In the *Benois Madonna*, which is dated on stylistic grounds to the years between 1475 and 1480, Leonardo makes his first appearance as an independent artist who has arrived at his own formal style. For in terms of its composition, technique and palette, the *Benois Madonna* differs profoundly from comparable products issuing from Verrocchio's workshop, and also from Leonardo's own earlier *Madonna of the Carnation*. Leonardo's growing independence is also evidenced by two documents dating from early 1478. In January of that year Leonardo was asked to paint a large altarpiece for the chapel of St Bernard in the Palazzo Vecchio, the Florentine seat of government. Leonardo's father, a successful notary who had built up a considerable reputation in Florence and had already done work for the Signoria (the city council), may have had a hand in securing this commission. But although Leonardo received a generous advance of 25 gold ducats in March, three months after the contract was signed, he probably never even started the painting. With the contract for the St Bernard chapel, nevertheless, Leonardo is legally documented for the first time as an independent artist.

A certain degree of independence is also demonstrated by Leonardo's *Portrait of Ginevra de' Benci* (Cat. VII/ill. pp. 58/59) as regards its technique and its interpretation of the genre. This small portrait represents a first truly fixed point of reference in Leonardo's painted œuvre, since it is the earliest extant work that can be linked with two well-documented individuals: the sitter, Ginevra de' Benci (1457–*c.* 1520), a young woman very well known in Florence, and Bernardo Bembo (1433–1519), who probably commissioned the picture. The *Portrait of Ginevra de' Benci* is Leonardo's first secular painting. Much more than his religious paintings, it succeeds in breaking away from the pictorial conventions of Verrocchio's

Hans Memling, **Portrait of a Young Man**, c. 1478–80 (?)
Oil and tempera (?) on wood, 38 x 27 cm. Florence, Galleria degli Uffizi

workshop. The most striking feature of the portrait is the immediate proximity of the sitter both to the viewer and to the vegetation behind her; together they share virtually the entire pictorial plane. The young woman, Ginevra de' Benci, is brought right to the front of the picture. She is seated in front of a juniper bush, which seems to surround her head like a wreath and fills a large part of the background. Comparable "close-ups" were already to be found in Flemish portraits of the type introduced by Jan van Eyck (c. 1390–1441) a generation earlier, and subsequently popularized by Hans Memling (1435–1494; ill. p. 54) and Petrus Christus (c. 1410–1472/73). There are echoes of Flemish portraiture, too, in the format (the panel was originally longer, but was at some point trimmed along the bottom), in the naturalistic rendition of the juniper bush and in the sitter's pose. In contrast to her head, which faces almost frontally towards the viewer, Ginevra's upper body is angled almost diagonal to the pictorial plane, lending her – despite her rather listless expression – a certain dynamism. It is perhaps worth noting that Ginevra's genteel pallor was determined not by artistic considerations but by her sickly constitution, something expressly mentioned in a number of sources. The same sources also document Ginevra's aspirations as a poet and her admiration for Petrarch, interests which she shared with her platonic lover, Bernardo Bembo.

The juniper bush that, in conjunction with Ginevra's luminous face, dominates the portrait is more than a mere decorative accessory. Like a number of other plants, it was also a symbol of female virtue. Furthermore, the Italian word for juniper, *ginepro*, makes a play on the name of the sitter, Ginevra. More such allusions are explored on the reverse of the panel (Cat. VIIb/ill. p. 57), where a number of different plants are portrayed in meaningful combination: against a background painted to look like red porphyry marble, we see a branch of laurel, juniper and palm, connected to each other by a scrolling banderole bearing, in capital letters, the words "VIRTVTEM FORMA DECORAT" – "Beauty Adorns Virtue". The inscription and the plant attributes thus underline the connection between virtue and beauty. In its imitation of red, durable and very rare porphyry marble, the reverse of the portrait speaks of the resilience of Ginevra's virtue. The laurel and palm branches that frame the scroll are associated with Bernardo Bembo, who commissioned the painting. His personal arms consisted of a laurel branch and a palm branch and, between them, the inscription "VIRTVS ET HONOR". The emblem on the reverse of the portrait, with its laurel, juniper and palm branches, therefore represents a cleverly adapted modification of Bembo's own motto: in exactly the same spot as the inscription that originally filled the space between the branches of laurel and palm, we now see a branch of juniper in allusion to Ginevra's name and virtue. The laurel and the palm also make reference to Ginevra's literary leanings, since in poetry inspired by Petrarch, their evergreen branches represented the ultimate expression of poetic aspiration. The palm frond is likewise another traditional symbol of virtue.

Lastly, the inscription "VIRTVTEM FORMA DECORAT", which is so closely intertwined with the plants symbolic of virtue, establishes a connection between beauty and virtue which, as well as being a theme of contemporary literature, is also found on the front of the panel, where Ginevra's physical beauty is to be understood as an expression of her virtue. The front and back of this portrait could thus hardly be connected more closely. On the front, the juniper bush frames Ginevra's beauty, while on the back the laurel, palm branch and inscription surround the juniper which represents the young woman portrayed on the front.

The importance of the *Portrait of Ginevra de' Benci* lies above all in the fact that Leonardo here broke away from the profile view traditionally employed in Florence for portraits of women. Such portraits often served as wedding gifts or as part of a bride's dowry and had to reflect a relatively rigid ideal of female behaviour, leaving virtually no room for dynamism in their composition. Ginevra de' Benci, by contrast, is portrayed by Leonardo not as a bride, but as the partner and literary equal of Bernardo Bembo. For this reason the artist portrays her in three-quarter view, something previously reserved primarily for portraits of men and granting the sitter greater personal presence in the picture. Not least as a result of this innovation, Leonardo succeeds in lending a psychological dimension to his sitter – something that would become the hallmark of Renaissance portraiture.

Undoubtedly crucial to this new development was Leonardo's interest in the possibilities of oil painting and his preference for dynamic figural composition, already apparent in his angel in *The Baptism of Christ* and in his drawings. The man who commissioned the portrait, Bernardo Bembo, may well also have had a part to play in the proceedings, however. He had earlier spent time as a Venetian envoy at the court of Charles the Bold in Burgundy, from where he returned with new expectations of portraiture, expectations that, in Florence, it required Leonardo to fulfil. The contact between Bembo and Leonardo, which was to prove decisive in the evolution of portraiture, may have been initiated via the Benci family. Ginevra's brother Giovanni (1456–1523) was a friend of Leonardo's, and when Giorgio Vasari came to write his *Lives*, Leonardo's unfinished *Adoration of the Magi* (ill. pp. 74/75) was still to be found in the house of Giovanni's son, Amerigo Benci. The importance of personal contacts of this kind for the genesis of works of art would be demonstrated by the commission for this same *Adoration* (cf. Ch. II).

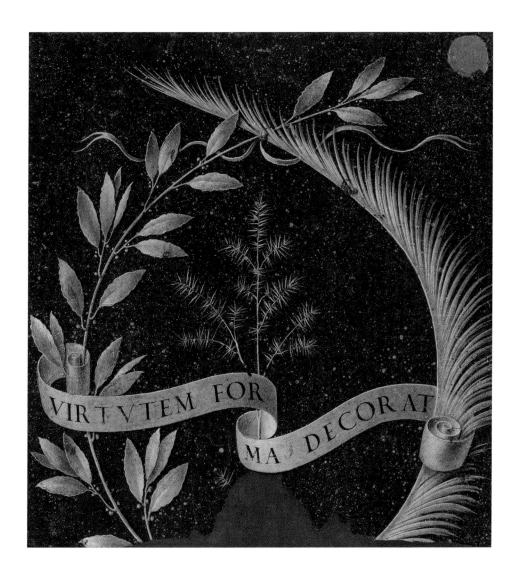

Leonardo (?)
Portrait of Ginevra de' Benci (reverse), c. 1478–1480
Tempera (and oil?) on poplar, 38.8 x 36.7 cm
Washington, DC, National Gallery of Art, Ailsa Mellon Bruce Fund, 1967, Inv. 2326

It was one of those faces that seem to belong more
to the imaginary realm of poetry than to the raw reality of life:
contours that recall da Vinci, the noble oval with naïve
dimples and sentimentally pointed chin of the Lombard School.

HEINRICH HEINE, 1837

Pages 58–65
Portrait of Ginevra de' Benci, c. 1478–1480
Oil and tempera on poplar, 38.8 x 36.7 cm
Washington, DC, National Gallery of Art, Ailsa Mellon Bruce Fund, 1967, Inv. 2326

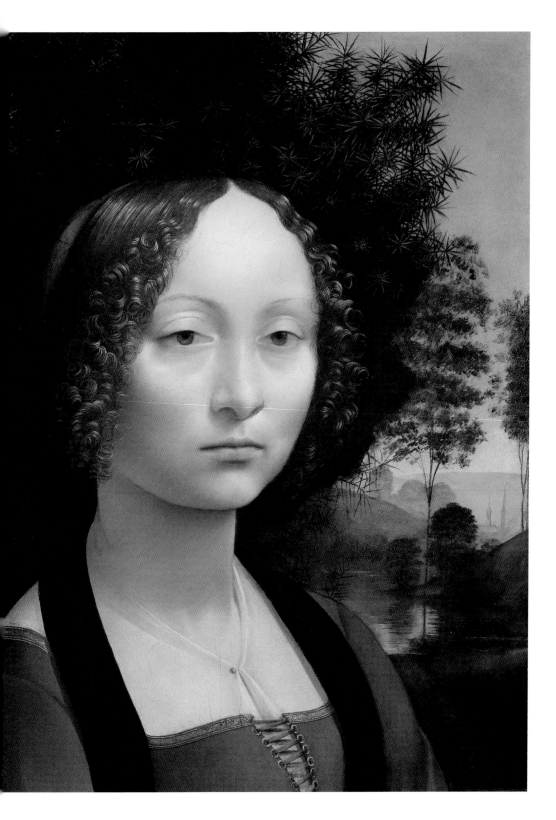

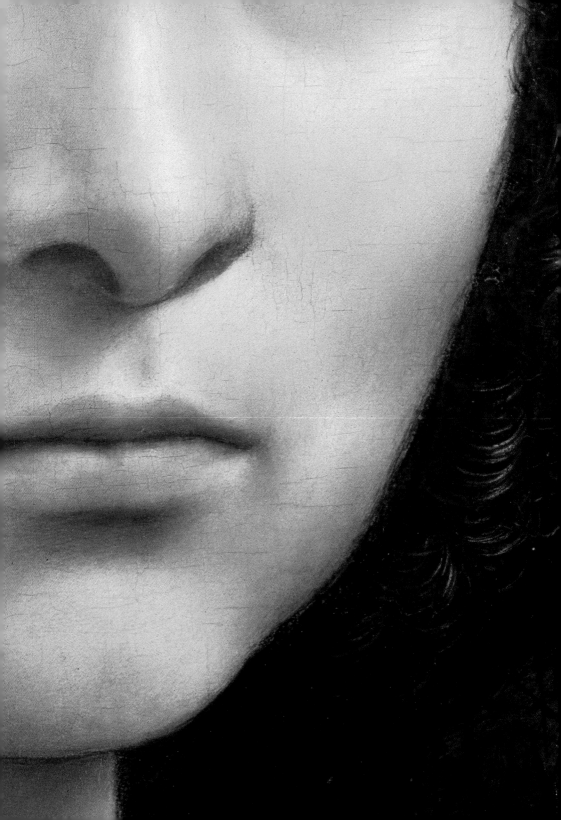

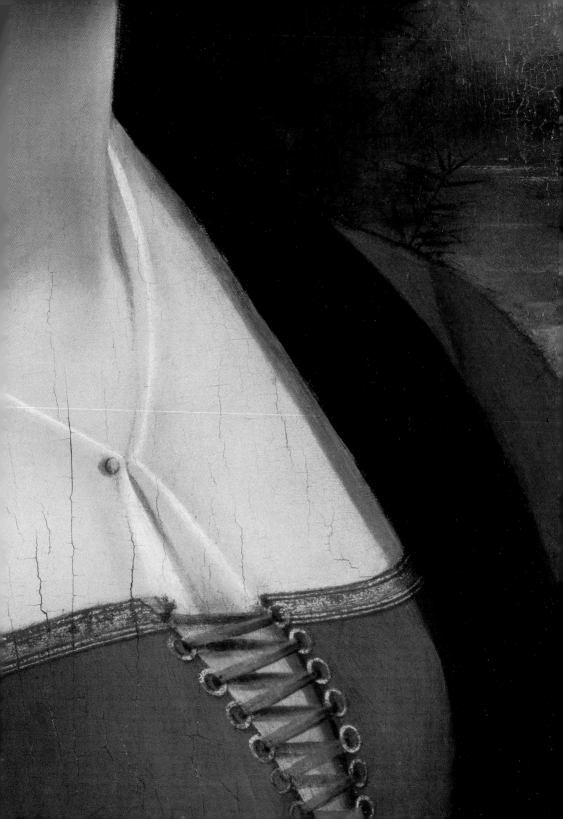

II

Professional breakthrough in Florence

1480–1482

Leonardo knows only the one, vast, eternal space, in which his figures float, so to speak. The one offers, within the pictorial framework, an ensemble of individual, contiguous objects, the other an extract from infinity.

OSWALD SPENGLER, 1917

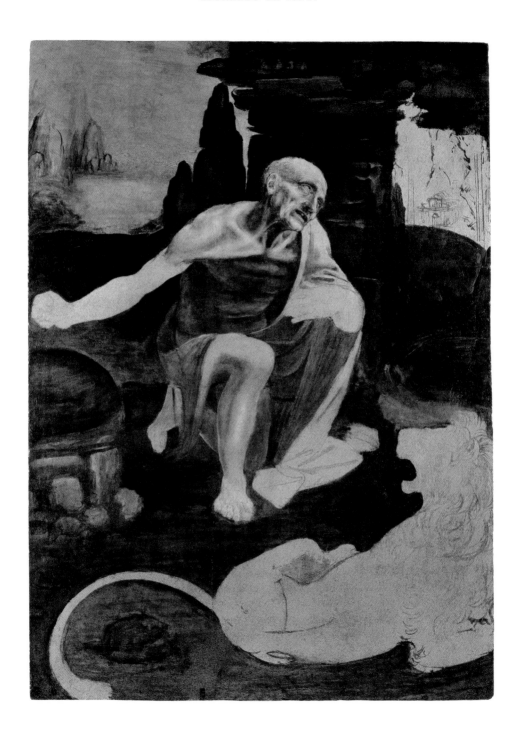

With the commission for the chapel of St Bernard in the Palazzo Vecchio and through the *Portrait of Ginevra de' Benci*, Leonardo had for the first time had dealings with important patrons – on the one hand, with senior representatives of the Florentine government and, on the other, with the Benci family, who maintained commercial and social links with the most powerful family in the city, the Medici. Corresponding to his increased importance as an artist is the fact that Leonardo proceeded to execute his next two paintings, both of them large, outside Andrea del Verrocchio's workshop.

After completing the *Portrait of Ginevra de' Benci*, he embarked on a painting of *St Jerome*, today housed in the Vatican Museums (Cat. IX/ill. p. 68). This picture, which suffered extensive damage in later years, remained unfinished, but still conveys an approximate idea of Leonardo's original intention. The saint is portrayed as a penitent in the wilderness, here indicated as a barren landscape dotted with small rocky outcrops. Wearing an expression of suffering, St Jerome is kneeling in almost the exact centre of the composition. His left hand touches the seam of his open robe while his right hand grasps a stone and is drawn back in preparation for a blow. On his emaciated, bony chest there is a dark patch in the region of his heart – in all likelihood a blood-soaked wound that the saint has inflicted on himself during his penance. At the lower edge of the painting lies a lion, Jerome's pet and attribute, whom the saint once helped by pulling a thorn out of his paw. Lying directly in front of St Jerome, the lion is watching the proceedings and, with his mouth wide open, seems to want to fuel the fervour with which Jerome is performing his penitential exercises (see below).

The saint himself is in fact – although this can be made out only with difficulty – looking towards a small crucifix rising parallel to the right-hand edge of the picture. He thereby establishes a link between his own suffering as a penitent and the Passion of Christ. In the right-hand background, in the saint's line of vision, is the façade of a Renaissance-style church – possibly a reference to the church of the Nativity in Bethlehem, as mentioned in *The Golden Legend*, where Jerome would spend his latter years and be buried.

In portraying St Jerome as an ascetic penitent, Leonardo follows a pictorial convention established earlier in the 15th century. He deviates from this tradition, however, in one important point: his Jerome has no beard. Furthermore, in comparison with other paintings of the same subject, Leonardo places much greater emphasis upon the barrenness of the rocky setting. His dramatic vision of St Jerome's penance and its location within

Page 67
Detail of **Adoration of the Magi**, 1481/82
(ill. pp. 74/75)

St Jerome, c. 1480–1482
Oil and tempera on walnut, 102.8 x 73.5 cm. Rome, Pinacoteca Vaticana, Inv. 40337

a landscape devoid of vegetation were probably inspired directly or indirectly by a letter that Jerome wrote to Eustochium in the year 384, passages from which are cited in the entry on St Jerome in *The Golden Legend* and which were made the subject of other depictions of the saint (cf. Bellini, ill. p. 71). In this moving letter – effectively an essay on the preservation of virginity formulated from the saint's ascetic viewpoint – Jerome argues for the renunciation of the pleasures of the flesh while at the same time describing the very real temptations to which, even in his capacity as a man of God, he too finds himself constantly exposed. There is nothing abstract about his appeals for virtue and his exhortations to asceticism, for in his letter Jerome also describes being tormented by the feeling of lust, a human failing that may have been equally familiar to the viewer. The corresponding passage of the letter runs as follows: "All the company I had was scorpions and wild beasts, yet at times I felt myself surrounded by clusters of pretty girls, and the fires of lust were lighted in my frozen body and moribund flesh. So it was that I wept continually and starved the rebellious flesh for weeks at a time. Often I joined day to night and did not stop beating my chest until the Lord restored my peace of mind."

Even if Leonardo's painting is unable to incorporate every last dramatic detail of Jerome's description, in its portrayal of the penitent saint it clearly conveys an emotional agony with which viewers wracked by a similar inner conflict could identify. In a later passage of his letter, Jerome describes in more detail the solitary wilderness to which he banished himself, and how he deliberately increased his isolation by wandering ever further into its depths. "Angry and stern with myself, I plunged alone, deeper and deeper, into the wasteland. Wherever I saw a ravine, a rugged mountain or a jagged cliff, I knelt down to pray, I used them as a scourge for my sinful flesh." These rocks and cliffs are more than simply the characteristic features of a wilderness landscape, however. They also carry a symbolic meaning, one that Jerome reveals elsewhere in his letter: "It is impossible that man's innate ardour, arising from his depths, should leave his senses untouched. To him be praise and recognition, therefore, who kills sordid thoughts dead even as they are born and dashes them against the rocks. The rock, however, is Christ."

With its highly realistic portrayal of St Jerome in the act of penitence, the painting issues a strong statement to the viewer, who could meditate on the saint's ascetic and penitent pose in his prayers. The rocky landscape little more than outlined in the unfinished picture thereby becomes a metaphor for the faithful individual's constant battle against the temptations of the flesh, against "sordid" thoughts, as Jerome calls them. Lastly, the barrenness of the rocks – which is intended more than just metaphorically – is taken up in the ascetic, emaciated body of the saint.

Since Leonardo did not finish the painting, *St Jerome* probably never served its intended purpose as an altarpiece. The artist himself may have held on to it for a while, possibly right up to his death, after which it may have been sold to a collector. From the start of the

16th century, namely, and above all in the wake of Michelangelo (1475–1564), unfinished works of art began to be appreciated in their own right. Pictures were valued not simply for their religious content, but increasingly for such criteria as their inventiveness and artistic innovations. Here, from an early stage, lay one of Leonardo's strengths, for his art was based from the very beginning on "scientific" studies and ideas. In the suffering expression on the face of St Jerome, for example, he illustrates both his own and contemporary notions of physiognomy and physiology. The muscles and sinews of the saint's shoulder and neck may also be taken as an early indication of Leonardo's interest in the surface anatomy of the human body. His most detailed anatomical studies,

which have come down to us in the so-called anatomical Manuscript A in Windsor Castle (Nathan/Zöllner 2014, Cat. 291–293, 298–301; ill. p. 307), were not conducted until some time between c. 1508 and 1510, however. Leonardo's artistic interest in anatomy thus preceded his "scientific" exploration of the same field by many years.

What caused Leonardo to abandon work on *St Jerome* was probably the commission for an *Adoration of the Magi* (Cat. X/ill. pp. 74/75) for the high altar of the Augustinian church of San Donato a Scopeto, just outside Florence. Leonardo's father, who administered the monastery's business affairs, may have been instrumental in setting up the commission in March 1481. The fact that a year later Leonardo left this painting unfinished, too, was probably due to his move to Milan. The commission was subsequently taken over by Filippino Lippi (1457–1504), whose own *Adoration of the Magi* was completed in 1496 (ill. p. 86). Another reason why Leonardo stopped work on the project may also have been the complex provisions of the contract, which contain a number of anomalies.

Dated July 1481, the corresponding document runs as follows: "Leonardo di Ser Piero da Vinci has undertaken as of March 1480 [i.e., 1481] to paint a panel for our main altar-

Giovanni Bellini, **St Jerome in the Dessert**, c. 1479
Tempera on wood, 151 x 113 cm. Florence, Galleria degli Uffizi

piece which he is obliged to have completed in 24 or at the most 30 months. And in the event of his not bringing it to completion he will forfeit that part of it which he has done, and we shall be at liberty to do as we please with it. For painting this altarpiece he is to have one third of a holding in Valdelsa which was formerly the property of Simone, father of Brother Francesco, who bequeathed it with the following injunction, that when three years have elapsed from the time of its completion we may buy it back for 300 *fiorini di sugello*, and within this stipulated time he may not enter into any other undertaking about it. And he must supply his own colours, [and] gold, and meet any other expenses he might incur. And moreover he must pay from his own pocket the appropriate deposit into the Monte [delle Doti = a dowry fund] to provide a dowry to the value of 150 *fiorini di sugello*, for the daughter of Salvestro di Giovanni." In the original document, this is then followed by two further entries that relate to Leonardo's financial situation: "He has had 28 *fiorini larghi* in order to arrange the above-mentioned dowry on our behalf, because he says he does not have the means to pay, and time was elapsing and it was prejudicial to us. In addition he must pay for the colours obtained for him from the Ingesuati which amounts to one and a half *fio[rini] larghi*: 4 L[ire] 2 sol[di] 4 din[ari]" (MK § 666).

This lengthy document is probably not the actual contract for the commission, but rather an additional business agreement intended to clarify the unusual terms of payment. Other contracts for altarpieces from this same period, such as the contract drawn up with Domenico Ghirlandaio (1449–1494) for an *Adoration of the Magi* (completed in 1487) for the Ospedale degli Innocenti in Florence, are much more straightforward.

The unusual document relating to Leonardo's *Adoration*, on the other hand, details complicated arrangements relating to extra administrative and financial obligations that the artist had to fulfil if he was to receive the agreed sum of 300 *fiorini* once the painting was complete. The financial basis for this payment was one third of the total value of a land

Study of a Kneeling Angel, c. 1480–1483
Pen and ink, 125 x 60 mm. London, The British Museum, Inv. 1913-6-17-1

holding that the monastery had inherited. This third was valued at 300 *fiorini*, which the monks were to dispose of as follows: 150 *fiorini* were to be used to finance the altarpiece, and the other 150 *fiorini* were to furnish a dowry for a certain Elisabetta, a relative of the donor, within a year. By signing the contract, Leonardo accepted not just the title to one third of the holding and the income this brought with it, but also the not insignificant obligation to put up the dowry for the above-mentioned Elisabetta. As was standard at that time for large-scale altarpieces, Leonardo was also required to bear the costs of his artist's materials himself. Leonardo's fee was thus not paid in the frequently employed manner of periodic instalments, from which he could have defrayed his living expenses and material costs, but was tied up in a legal arrangement that required him to lay out a considerable amount of money in advance.

Just four months after signing the first agreement, it emerged that he had insufficient funds at his disposal either to pay for his materials or to make the deposit on the dowry he had contractually agreed to provide. As the two addenda to the above document make painfully clear, the artist was obliged to go back to the monks to borrow money in order to buy paints and put down a first payment towards the dowry.

In the end, even the monks of San Donato a Scopeto themselves realized that the contract they had drawn up with Leonardo did not favour the rapid execution of a large altarpiece. In the agreement they later concluded with Filippino Lippi, they abandoned the complex arrangements of 1481. Instead, the monks sold off the corresponding portion of the property and were consequently in a position to pay the artist the sum of 300 *fiorini* in cash. In retrospect, their revised agreement with Filippino Lippi also helped to exonerate Leonardo; it effectively acknowledged that the stipulations of the 1481 contract had ruled out any possibility of completing the altarpiece. The artist, in other words, was not to blame for the unsatisfactory way in which the commission ended.

Despite its unfinished state, the main features of the composition of the almost square *Adoration*, which today hangs in the Uffizi, are clearly identifiable. Mary and the infant Jesus are seated in the central foreground in front of a small rocky outcrop, out of which two trees are growing. The three kings who followed the Star of Bethlehem on their journey from the East worship before the Child sitting on his mother's lap. In the right-hand foreground, one of the kings has sunk to his knees in reverence; the Child is blessing him as he offers his gift. On the left, a second king is bowing low before the Virgin and Child. The figure kneeling in front of him to the left, looking up with his head raised, is probably that of the third and youngest king. Grouped in a semicircle around the Virgin are also numerous other individuals, including Joseph, who is probably the bearded old man behind the Virgin and who has just removed the lid from the precious vessel presented by the first king. Others belong to the kings' large retinue or are perhaps to be identified as angels.

*Whenever he began to paint, it seemed
that Leonardo trembled, and he never finished any of
the works he commenced because, so sublime
was his idea of art, he saw faults even in the things
that to others seemed miracles.*

GIAN PAOLO LOMAZZO, 1590

Pages 74–77
Adoration of the Magi, 1481/82
*Oil on wood, 243 x 246 cm
Florence, Galleria degli Uffizi, Inv. 1594*

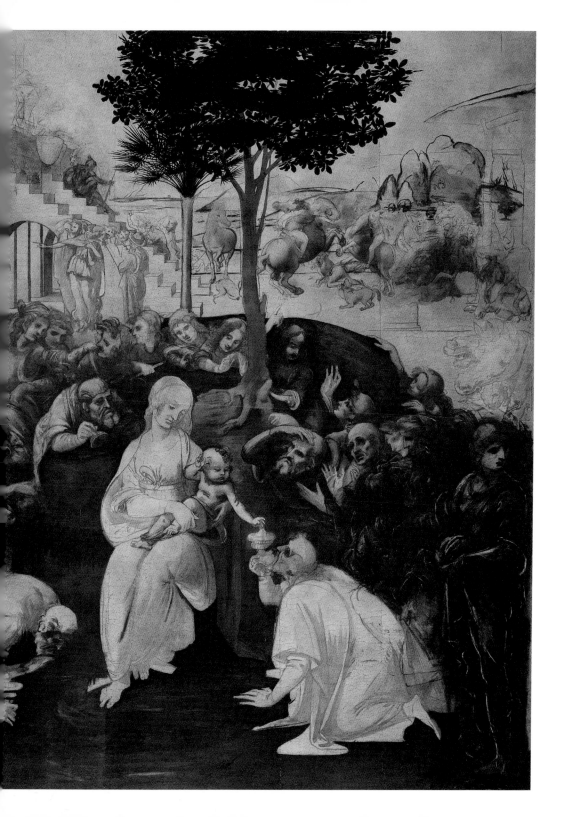

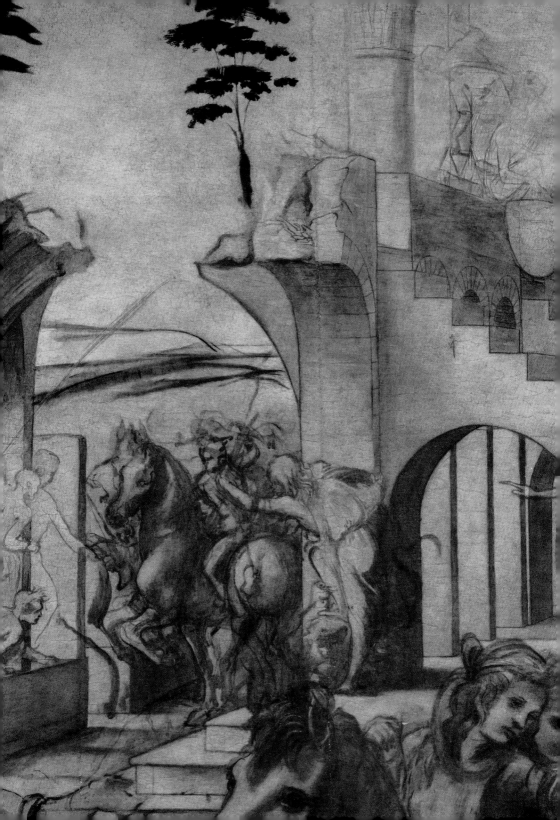

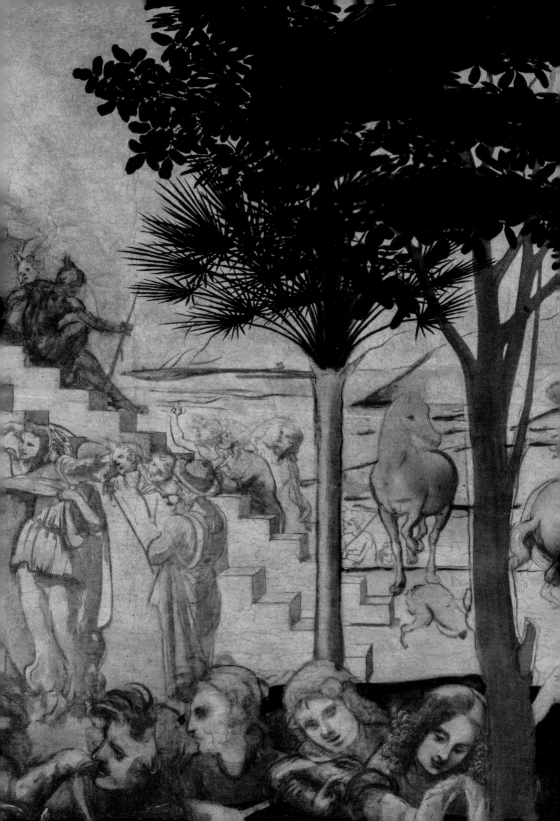

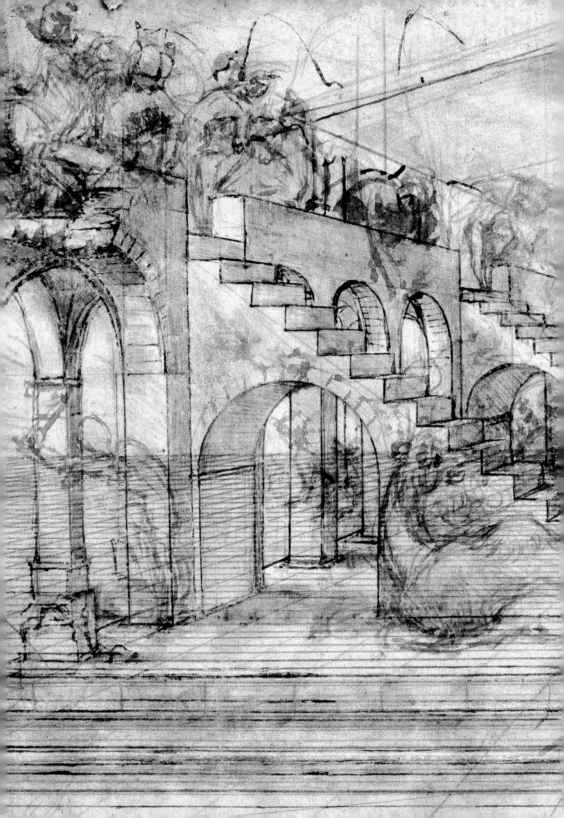

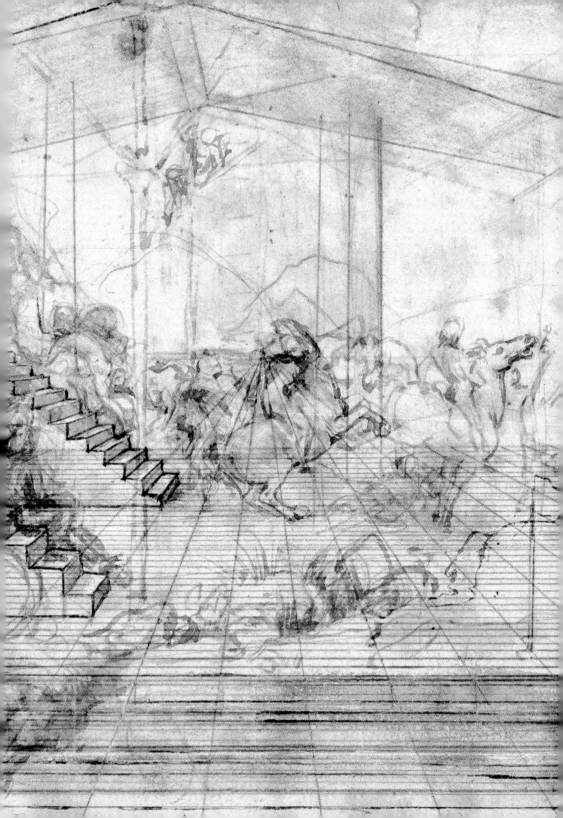

The figures within the composition thereby display a striking variety of movements and gestures. While the majority of those present devote their undivided attention to the central group of Virgin and Child, some are looking at an apparition in the top part of the picture, probably the Star of Bethlehem, as seen, for example, in Sandro Botticelli's *Adoration of the Magi* (ill. p. 84) painted only shortly before. We are directed towards this imaginary star, or at least towards its light, by a number of gestures in the crowd. Thus two young men – one in the left-hand middle ground and the other on the right of the foot of the nearest tree – are each pointing with the index finger of one hand up to the sky, in order to draw attention to the divine light. This same gesture was regularly performed in 15th-century mystery plays based on the story of the Magi and is found in an earlier *Adoration of the Magi* executed by an artist from the workshop of Fra Angelico for the "silver cabinet" in SS Annunziata in Florence. However, Leonardo infuses this gesturing towards the divine light with greater dynamism than the older artist.

A comparison with similar "pointing gestures", of the kind employed in Florence a few years earlier by artists in the circle of Domenico Veneziano (*c.* 1410–1461) and Filippo Lippi (*c.* 1406–1469) in portrayals of St John the Baptist, again makes clear the increased dramatic intensity of Leonardo's gestures. On the other hand, the gesture of the hand raised above the head, made by the figure in the right-hand foreground in an attempt to shield himself from the strength of the divine light, appears relatively conventional. This *aposkopein* hand gesture, as it was known, can be found in numerous earlier versions of the Adoration.

Within the group of figures clustered around the central foreground, particular attention should also be paid to Joseph – a character who in many Adorations plays something of a subsidiary role. In Leonardo's composition he is holding the lid of a precious vessel in his right hand. Leonardo thereby indicates that the first king has already presented his gift, gold. According to one legend, the Holy Family accepted the gold, but then gave it to the poor on account of its primarily worldly value. Since the gold, the first gift, has thus evidently already been received, Leonardo's painting must be portraying the moment when the second king presents the Child with his gift of frankincense. Since frankincense was a symbol of Christ's sacrificial death on the cross, its presentation within the *Adoration* may

Pages 78/79
**Detail of Perspective Study for the Background
of the *Adoration of the Magi*, 1481**
*Pen, ink, traces of metalpoint and white, 165 x 290 mm
Florence, Galleria degli Uffizi, Gabinetto dei Disegni e delle Stampe, Inv. 436E recto*

Study of a Horse and Rider, c. 1481
Metalpoint on pale pink prepared paper, 120 x 78 mm. Private Collection

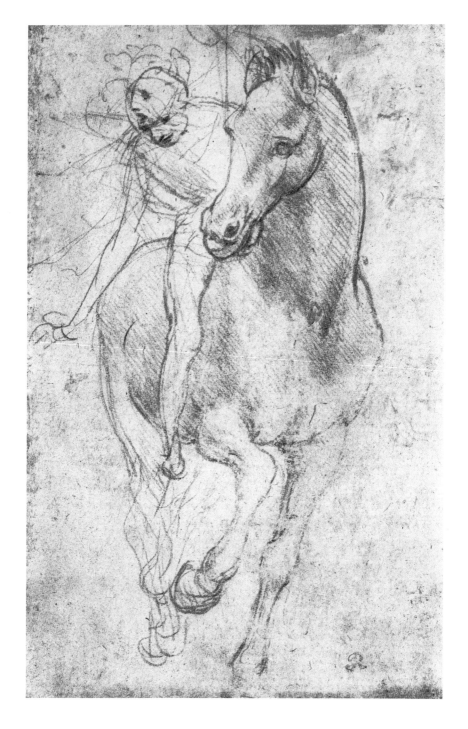

*I was at pains to look out for persons, philosophies,
help from the past and from the present, in order to establish particular
rules, axiomatic pointers towards a new, expanded
understanding of art. For this reason I am profoundly impressed
by Leonardo da Vinci and Caspar David Friedrich.*
JOSEPH BEUYS, 1974

Composition Sketch for the *Adoration of the Magi*, 1481
*Pen and ink over metalpoint, 285 x 215 mm
Paris, Musée du Louvre, Cabinet des Dessins, R.F.1978*

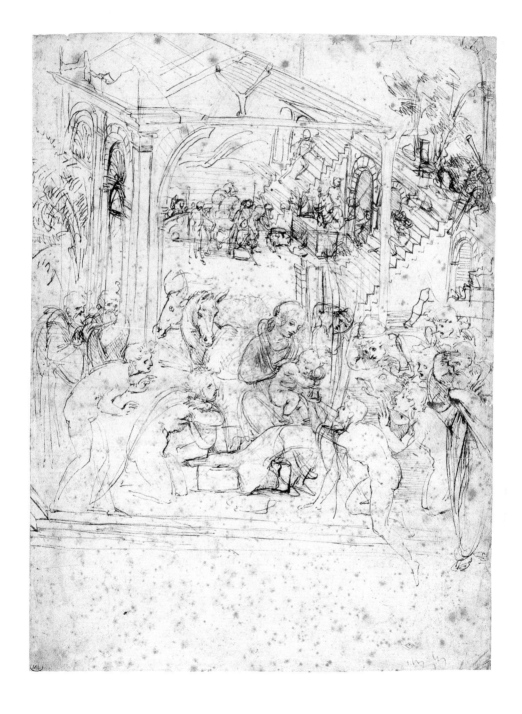

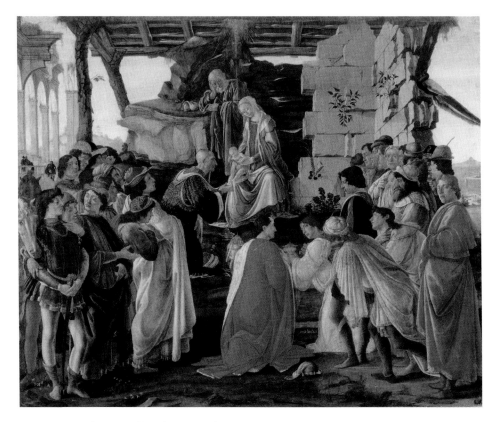

Sandro Botticelli, **Adoration of the Magi for Gaspare del Lama**, c. 1472–1475
Tempera on wood, 111 x 134 cm. Florence, Galleria degli Uffizi

be understood as a reference to the liturgical re-enactment of the Sacrifice taking place
in front of the altar during mass. As such, it would have established a direct connection
between the subject of the altarpiece and the Eucharist being celebrated beneath it – a
connection typically offered by all altarpieces.

In comparison with the figures in the front section of the painting, who are gathered
closely around the Virgin and Child and the symbolically charged foreground scene, the
people and animals from the kings' entourage in the rear of the composition enjoy consid-
erably more space. As in many paintings of the *Adoration of the Magi*, the ruins of the palace
of King David, the Old Testament ancestor of Christ, can be seen in the background (ill.
pp. 78/79). A striking detail here is a number of people busying themselves in front of and
on top of the ruins. They have prompted some to conclude that the figures in the left half
of background are engaged in rebuilding David's semi-derelict palace. Whatever the case,

the two saplings growing on top of the ruins correspond to the two trees behind the Virgin and Child. They may be read – like the rebuilding of David's palace, if this is indeed what is happening – as symbols of the age of peace and grace that was ushered in with the birth of Christ. The larger of the two trees in the middle ground is clinging by its roots to the bare rock, whereby one of these roots seems to establish a link between the tree itself and the head of the Christ Child.

Leonardo may here be drawing upon the story of the Magi as narrated in the popular *Golden Legend* by Jacobus da Voragine, and in particular its discussion of the nature of the star followed by the Wise Men. "Note that the star the Magi saw was a five-fold star", we are told, whereby the fifth of these stars represented Christ himself, interpreted as the "root and stock of David, the bright and morning star". Lastly, the two horses rearing up in the background, whose riders appear at first sight to be engaged in combat, may also be a reference to another medieval legend, according to which the three kings had at one time been bitter enemies. It was only after their miraculous journey and after witnessing the nativity of Christ, the Saviour, that they made peace with each other, like the rest of the world. The violent confrontation of the two horses in the background is thus an allusion to their former enmity, and offers a stark contrast to the era of peace proclaimed by the Adoration scene in the foreground. In his clear compositional division of foreground and background, Leonardo draws a line between the era before Christ and the age of grace, which began with the birth of Christ and His adoration by all peoples.

In formal terms, Leonardo drew inspiration for his altarpiece from two different but very prominent *Adoration* panels. He took the semicircular arrangement of the foreground figures from Sandro Botticelli's *Adoration of the Magi for Gaspare del Lama* (ill. p. 84), which originally adorned a side altar in Santa Maria Novella in Florence. Leonardo's *Adoration of the Magi* was destined for a high altar, however, and demanded an emphatically more hierarchical composition in line with its more elevated status. Leonardo may have found such monumentality in Fra Angelico's (*c.* 1395–1455) high altarpiece for San Marco in Florence (ill. p. 87), which in the second half of the 15th century was still considered the paradigm of its genre. Unlike the older work by Fra Angelico, however, Leonardo's altarpiece does not portray a *sacra conversazione*, a relatively static group of saints gathered around the Virgin and Child, but a scene from life: the Adoration of the Child and the presentation of the second gift. Leonardo's *Adoration* thus shows the beginnings of a narrative structure. Narrative themes such as the Adoration and the Annunciation were already finding their way into altarpieces for side chapels from this same period; with Leonardo's *Adoration of the Magi*, they were about to burst onto the stage of the high altar. It was now possible for a *storia*, a narrative in the sense used by Leon Battista Alberti in his treatise on painting, to occupy the supreme position within the hierarchy of religious art – the high altar.

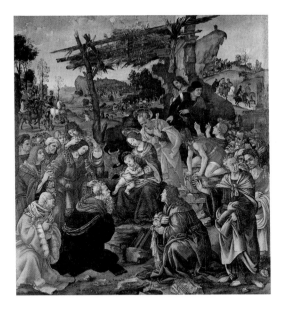

Even more than the unfinished *St Jerome*, the *Adoration* offers us a profound insight into Leonardo's creative process. In several places the painting resembles an enormous sketch. Particularly in the background, where the individual figures are for the most part set down in the barest of detail, the artist reveals the spontaneity of his method, which in many places sees him altering the composition even as he paints. Leonardo's inventive process – evidently not entirely planned in advance – can be followed in numerous studies from the period around 1480 (Nathan/ Zöllner 2014, Cat. 1, 2, 5–14; ills. pp. 78/79, 81, 83), although only very few of these drawings can be related with absolute certainty to the *Adoration of the Magi* begun in 1481. Just one sketch of the overall composition, the so-called Gallichon drawing, and a perspective study for the background executed probably a little later, can be firmly accepted as preliminary studies for the altarpiece (ills. pp. 78/79, 83).

The other drawings from this period contain motifs that are no more than similar to those in the *Adoration of the Magi*, and which possibly relate to an *Adoration of the Shepherds* that Leonardo was also planning. The Gallichon drawing is particularly informative. It includes in the background the flights of steps belonging to the former palace of King David, albeit on the right-hand side. The composition as a whole, however, remains far more indebted to earlier 15th-century conventions. Thus the Bethlehem stable is granted a prominent position and is directly linked with the ruins of David's palace. In the second surviving drawing, the roof of the stable is shifted further into the background and only vaguely indicated, while at the same time the rather slapdash perspective of the first drawing is worked out with almost pedantic precision. In the actual painting, the Bethlehem stable is moved to the extreme right-hand edge of the picture (where it is barely recognizable) and its place in the composition is taken by the two trees in the middle ground. Leonardo thereby places the emphasis firmly on the centre of the picture, in the typ-

Filippino Lippi, **Adoration of the Magi**, 1496
Tempera on wood, 258 x 243 cm. Florence, Galleria degli Uffizi

ical fashion of important altar-pieces, and imposes a formal hierarchy on the composition as a whole.

Another feature of the *Adoration*, up till now rather ignored, is the striking pre-dominance of certain figural types. Thus the foreground, in particular, is dominated by five bearded old men: two of the three kings, Joseph, an onlooker to the right of the Virgin and the figure on the left-hand edge of the panel. The figural type of the beautiful youth appears even more

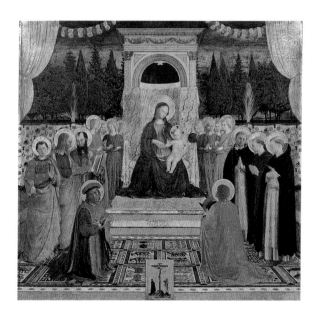

frequently, above all in the group behind the Virgin, in the right-hand middle ground and amongst the figures to the left of Joseph. Middle-aged men are almost entirely absent, an omission all the more surprising in view of the fact that the three kings were usually portrayed at three different stages of life. These three kings of three different ages can be seen in numerous works of Florentine painting, from that of Gentile da Fabriano (*c.* 1370–1427), Lorenzo Monaco (*c.* 1370–*c.* 1425) and Masaccio (1401–1428) to Botticelli's *Adoration for Gaspare del Lama*. Leonardo's unusual and one-sided concentration upon two types cannot be adequately explained by the unfinished state of his painting. Rather, Leonardo is continuing the practice – also employed in Verrocchio's workshop – of using certain figural types. Personal preference may also have played a part, for Leonardo took a life-long pleasure in drawing finely proportioned faces of youths and furrowed countenances of old men, and in contrasting the two types (Nathan/Zöllner 2014, Cat. 184–185, 189–198, 200–206, 210, 214; ill. p. 23).

The predominance of old men and youths in the *Adoration of the Magi* may also have a third, socio-historical explanation, arising out of the Florentine cult of the Magi. From the 12th century onwards, the Feast of Epiphany, on 6 January, had been marked throughout Europe with a Procession of the Magi, conducted with as much pomp and ceremony as possible. So too in Florence, where the lay confraternity of the "Compagnia de' Magi" was

Fra Angelico, **Altarpiece for San Marco**, c. 1438–1440
Tempera on wood, 220 x 227 cm. Florence, Museo di San Marco

*It may be true that one must be more than the work in order
to create it, and that greatness has its origins is
something greater. Certain figures at least, such as Leonardo,
Goethe and also Tolstoy, seem to suggest as much.*

THOMAS MANN, 1928

responsible for organizing the Epiphany celebrations. Up to 700 riders took part, parading through the city to commemorate the Adoration of the Christ Child. With the particularly spectacular pageant of 1468, in which the city itself became one enormous stage set, veneration of the Magi reached a peak. During the celebrations, the young members of the fraternity wore masks carved with the faces of their fathers and imitated their actions and habits. The roles of the middle and eldest king were also taken by young men in similar disguises. In their theatrical imitation of the older men, the members of the younger generation demonstrated their aspiration to the social positions still held and fiercely defended by their fathers. In the festive Procession of the Magi and in the re-enactment of the Adoration of the Christ Child, the age dualism in Florentine society was thus made manifest – a dualism with which the polarity between young and old figural types in Leonardo's *Adoration of the Magi* directly corresponds.

It is possible there was even a personal issue at play here. For Leonardo, in 1481 not yet fully established in Florence, had been awarded his largest commission to date probably through the offices of his father. The young artist's struggle to make his professional breakthrough in Florence was thus directly linked to the social position and business contacts of his father, against which Leonardo had little to set. The age dualism of the city of Florence was thus matched by a similar dualism between the artist and his father. Was it to escape this very age dualism, one can't help wondering, that Leonardo had to abandon the *Adoration* unfinished and turn his back on Florence?

Detail of **St Jerome**, c. 1480–1482
(ill. p. 68)

III

A fresh start in Milan

1483–1484

In the whole world there is perhaps no other example of
a genius so universal, so inventive, so incapable of contenting
himself, so eager for infinity, so naturally intelligent, so far
ahead of his century and the centuries which followed.
His figures express an incredible sensibility and spirit; they
overflow with unexpressed ideas and sensations.

HIPPOLYTE TAINE, 1866

Why, towards the end of 1482 or in early 1483, at the age of about 30, Leonardo should have decided to turn his back on Florence and make a new start in Milan has never been fully explained. Probably the most important factor behind his move were the better career prospects offered by the Lombard capital, which with its population of 125,000 was considerably larger than Florence, which numbered around 41,000 inhabitants. Its greater economic importance alone was enough to make the Milanese court of the ruling Sforza family look a more promising place to find work than the city of Florence.

In Milan, Leonardo applied speculatively for well-paid work in not one, but two areas. Not only did he offer to execute an equestrian monument of Francesco Sforza (1401–1466; cf. Ch. IV), but he also tendered his services as an engineer and military architect. Milan was at that time (1483–1484) at war with Venice, and its military ambitions offered attractive scope for a technically gifted artist such as Leonardo. With military expenditure accounting for over 70 per cent of the entire Sforza budget, the prospects of finding employment as an engineer must have struck Leonardo as good. This would explain the memorable letter that he wrote to Ludovico Sforza (1452–1508), in which he applied for the position of court artist (RLW § 1340/MK § 612; Nathan/Zöllner 2014, Ch. 14). Leonardo devotes the main part of the letter, however, to detailing his abilities as a military engineer; only right at the end does he mention his artistic achievements and offer to undertake the equestrian monument mentioned above. It is a striking fact that, amongst his early drawings of military architecture and equipment, those offering a potential application in a battle with Milan's maritime neighbour, Venice, stand out in particular. They include various sketches of fortifications and of machines suitable for use in naval warfare. During this same period Leonardo also made numerous studies relating to surveying equipment for military applications.

Leonardo's first commission in Milan was of an entirely peaceful nature, however. Possibly following a recommendation by Ludovico Sforza, the Franciscan lay confraternity attached to the church of San Francesco Grande asked the Florentine artist, together with two local artists, the brothers Ambrogio and Evangelista de Predis, to paint a large altarpiece for their recently completed chapel, dedicated to the Feast of the Immaculate Conception. A detailed contract of 25 April 1483 stipulates that the artists were to paint and gild a large retable which joiners and woodcarvers had already completed in 1482 (cf. reconstruction, ill. p. 110), and whose central panel Leonardo was also to paint. Today known as the *Virgin of the Rocks*, this middle panel exists in two versions. The older of the two, executed by Leonardo largely between 1483 and 1484, today hangs in the Louvre in Paris (Cat. XI/ill. p. 95). The second version, which was painted at a later date, partly by Ambrogio de Predis, is housed in the National Gallery in London (Cat. XVI/ill. p. 101). Also in the National Gallery are the two side panels executed by Ambrogio de Predis and portraying two angels making music (ill. p. 114).

Study of a Hand, c. 1483
Black chalk heightened with white on dark grey prepared paper, 153 x 220 mm
Windsor Castle, Royal Library (RL 12520r)

Page 91
Detail of **The Virgin of the Rocks**, c. 1495–1499 and 1506–1508
(ill. p. 101)

Several reliefs depicting scenes from the Life of Mary completed the front of this monumental retable, which concluded at the top with a number of prophets and God the Father. A niche in the centre of the altarpiece probably housed what was the true object of devotion within the artistic programme as a whole: a wooden statue of the Virgin and Child – the *Immacolata* – as the symbol of the Immaculate Conception. Leonardo's *Virgin of the Rocks* stood in front of this niche and for 364 days of the year concealed the sculpture of the Virgin behind it. Only on 8 December, the Feast of the Immaculate Conception, was Leonardo's painting lowered by means of a sliding mechanism, bringing the *Immacolata* into view and allowing it be worshipped directly. Thus it seems that Leonardo's *Virgin of the Rocks* in fact served as a sort of screen, behind which was concealed the true object of devotion – the statue of the Virgin, which is mentioned several times in records but

*[...] so that he seemed to his contemporaries
to be the possessor of some unsanctified and secret wisdom.*
WALTER PATER, 1869

**The Virgin of the Rocks
(Virgin and Child with the Infant St John and an Angel)**, 1483–1484/85
Oil on wood, transferred to canvas, 197.3 x 120 cm. Paris, Musée du Louvre, Inv. 777 (MR 320)

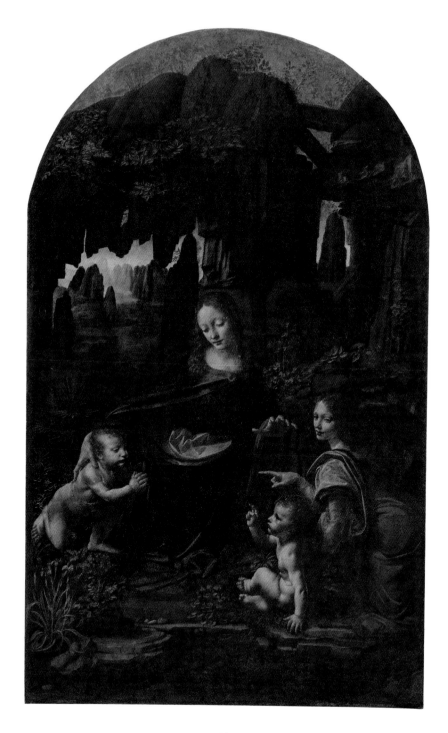

which has since vanished. The possibility may not be excluded, however, that the wooden statue and Leonardo's *Virgin of the Rocks* were both visible at once: the panel at the lower level of the altarpiece, and the statue one "storey" above it.

Leonardo's middle panel portrays a very youthful Virgin Mary together with the infant St John, the infant Christ and an angel in front of a rocky grotto. Mary is seated in almost the exact centre of the composition and gazes gently down towards the infant St John, her right hand resting on his shoulder as he kneels in prayer. Her left hand seems to hover protectively above the seated infant Jesus. The scene is flanked on the right by an angel, probably Uriel, who is pointing with his right hand towards the infant John. In formal terms, this composition continues to reveal parallels with Florentine art, for example with the very similar arrangement of Christ and John in the marble retable by Mino da Fiesole (1429–1484) in Fiesole cathedral (ill. p. 113). Leonardo's *Study of a Virgin worshipping the Child* (ill. p. 96), which anticipates the composition of *The Virgin of the Rocks* in the disposition of the figures, was probably also executed in Florence.

Despite its references to Florentine forms, the constellation of the figures in the *Virgin of the Rocks* deserves closer examination, since a meeting between John and Christ as infants is rarely depicted in art. Such a meeting is recorded not in the Bible itself, but in pseudepigraphical writings (Protevangelium of James, 17–22). Here it is described how, on the flight into Egypt, Mary and Jesus met Elizabeth and John in the wilderness. The unusual combination of figures in Leonardo's painting and its rugged setting within a rocky landscape, a place of seclusion and refuge, draw upon this encounter during the flight into Egypt and probably also upon medieval accounts of the life of St John.

Seclusion is in fact a central theme of the *Virgin of the Rocks*. Thus the stony ground, consisting in places of thin strata of rock, seems to fall away suddenly and steeply at the

Studies of a Virgin worshipping the Child, c. 1482–1485
Silverpoint, partly reworked by the artist with pen and dark brown ink on pink prepared paper;
lines ruled with metalpoint (recto), 195 x 162 mm
New York, The Metropolitan Museum of Art, Rogers Fund, 1917 (17.142.1)

front edge of the picture, almost as if the Virgin were sitting on the edge of a chasm that opens up between the viewer and the painting. In this way, too, Leonardo establishes the remote nature of the location, something reinforced by the rugged rock formations in the middle ground and background. The grotto is thereby divided into two passages of different widths, through which can be seen a distant mountain landscape bathed in light and mist, together with an area of water whose presence at such an altitude comes as something of a surprise – one would not necessarily expect to see a relatively large body of water amidst such rocky heights. A number of these elements may carry a very broad symbolism: the passage on the left, for example, leading through the rocks towards the water, might be intended to represent the *vena di aqua bellissima* (vein of most beautiful water), a metaphorical image through which, in the 14th century, the Dominican Domenico Cavalca sought to convey the purity of the Virgin. Indeed, water in general stood for the purity of Mary. In the second version of the *Virgin of the Rocks*, in particular, the body of water in the background has grown to a considerable size, to the extent that – even at this altitude – it can be called a sea (ill. pp. 106/107). This, too, may be intended as a reference to Marian symbolism: earlier exegetists derived the name "Mary" from the Latin word for sea, *mare*, and just as all rivers flow into the sea, so divine Grace flows into Mary. The divide opening up in front of Mary may be similarly interpreted with reference to patristic sources and contemporary Franciscan literature: this abyss was seen as the impenetrable depths of the great ocean of prehistory, from which all water comes and to which all water returns.

Marian symbolism may also underlie the unusual rock formations of the background, cleft into two passages. It is possible that they refer to similar topoi (stock themes) in the liturgy and to metaphors used to describe Mary in the Bible. In the Song of Songs (1:14), for example, Mary is described as a "dove ... in the clefts of the rock" (*columba in foraminibus petrae*) and "in the cavities of walls" (*in caverna maceriae*). The Mother of God was also considered to be a "rock cleft not by human hand" (*lapis sine manu caesus*; *lapis abscissus de monte*) and "the exalted, untouched, crystalline mountain and the cave in the mountain" (*montagna eccelsa, intatta, cristallina, cavità nella montagna*). The barren rock, eroded by the forces of nature, might in this context be interpreted as a metaphor for Mary and a reference to her unexpected fertility. Marian epithets of this kind were also transferred to Christ, who was considered the Son of God born out of rock, as the "mountain hewn out of the mountain not by human hand" (*mons de monte sine manu hominis excisus*). Thus the mountains, rocks and cave were all able to symbolize not only Mary, her virginity and thus the Christian paradox of the virgin birth, but also Christ as the incarnation of God born out of the rock.

It should be pointed out, of course, that interpretations of this kind are not to be taken in their most literal sense. The rocky grotto is no more a literal representation of Mary or her womb than the single pillar of rock in the right-hand background is a concrete

image of Christ. Rather, such rock formations are a potential reminder of certain familiar epithets, phrases associated with Mary and Christ that – like the altarpiece of the *Virgin of the Rocks* by Leonardo – provided a backdrop to Christian worship. That the Confraternity who commissioned the *Virgin of the Rocks* considered it important for their altarpiece to invoke just such associations emerges, moreover, from the detailed instructions that they laid down in the contract, where specific reference is made to "the mountains and rocks to be worked in oil" (see below).

The mountain hewn not by human hand also held a specific meaning for the Franciscan Confraternity of the Immaculate Conception who commissioned the painting. Alongside Christ and St Francis, the founder of the Franciscan order, the Confraternity also venerated the figure of St John the Baptist. John was not only a namesake of Francis, whose civilian name was Giovanni Bernardone; according to Franciscan thought, John – the last forerunner of Christ – was also the *alter Franciscus*, the "other" Francis, and thus someone directly related to the founder of their order. The Confraternity was thus able to identify itself directly with the infant St John in the painting, who is praying to Christ and at the same time receiving Christ's blessing. The Confraternity was thereby present in two ways – in front of the altarpiece during prayer, and within the panel itself in the figure of St John. By extending her right arm and part of her cloak around John's shoulders, more-over, the Virgin places the infant, and with him the members of the Confraternity, under her protection. This motif of protection is not only expressed through Mary's cloak shield-ing the infant St John, but is also take up in the rocks and caves of the background, which represent literal as well as metaphorical places of refuge. This may be another reason why Leonardo devoted such painstaking attention to the execution of the rocky background.

Other specific elements of Franciscan thinking may also have played a role in the composition of the *Virgin of the Rocks*. The mountain as a place of closer proximity to the divine and as a religious symbol held a number of important associations for the Order of St Francis. Barren, rocky mountains and rocky landscapes appear with marked frequency in paintings of John the Baptist and St Francis, for the lives and works of both saints are traditionally closely bound up with certain types of natural environment. Thus artists in the Middle Ages were already employing an arid, rocky type of landscape to describe the wilderness to which John withdrew while still a young man. The setting within which the saint pursued his mission thus came to be characterized as a mountainous and remote type of region. This same setting of a barren wilderness amidst rocky mountains was associated by many artists with St Francis, too. In Franciscan thinking, moreover, a bare-sided, fis-sured mountain was directly associated with Monte La Verna (also written Alverna and La Vernia), the most important station in the life of the popular saint. In the year 1222 Francis had withdrawn to the mountainous seclusion of La Verna (in central Italy), where in 1224 he received the famous impression of the stigmata, the crucifixion wounds of Christ.

Study for the Head of a Girl, 1483
Silverpoint on brownish prepared paper, 182 x 159 mm
Turin, Biblioteca Reale, Inv. 15572r

99

Leonardo da Vinci, mirror deep and sombre,
Where charming angels, with a sweet smilecharged
with mystery, appear in the shadeof the
glaciers and pines which bound their country.
CHARLES BAUDELAIRE, 1857

Pages 101–109
The Virgin of the Rocks (Virgin and Child with the Infant St John and an Angel),
c. 1495–1499 and 1506–1508
Oil on poplar (parqueted), 189.5 x 120 cm. London, The National Gallery, Inv. 1093

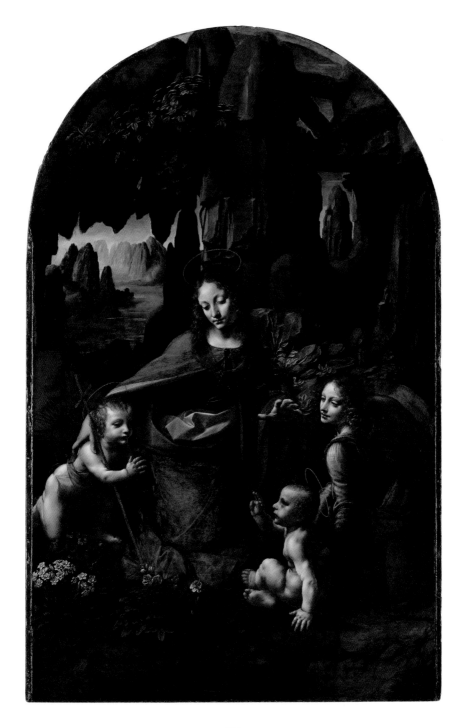

Hundreds of paintings from the 13th to the 15th century record this miraculous event against a backdrop of precipitous cliffs. Since the imprinting of the stigmata onto the saint's hands, feet and side took place in the midst of the craggy slopes of Monte La Verna, the cracks in the rock were identified with the wounds themselves. Thus the fissures in the rock corresponded to the wounds that had opened up in the saint's flesh. This is precisely the interpretation offered in the so-called "Little Flowers of St Francis" (*Fioretti di san Francesco*), where, in an appendix, a direct link is established between the Passion of Christ, the rocks of Mount La Verna and the stigmatization of St Francis: "... St Francis was standing beside that cell, gazing at the form of the mountain and marvelling at the great chasms and openings in the massive rocks. And he began to pray, and then it was revealed to him by God that those striking chasms had been made in a miraculous way at the hour of Christ's Passion when, as the Gospel says, 'the rocks split' [Matthew 27:51]. And God wanted this to be manifested in a special way here on Mount Alverna in order to show that the Passion of Christ was to be renewed on that mountain in the soul of St Francis by love and compassion and in his body through the imprinting of the stigmata."

The cleft mountain in the *Virgin of the Rocks* could thus be interpreted as a specifically Franciscan topography and hence as a religious motif combining Franciscan (in the shape of the rock) and Marian (in the shape of the rock and the body of water) symbolism. It served to remind contemporary 15th-century viewers, and in particular the Franciscans, of the stigmatization of their saint (his *christoformitas*) and hence of the most important episode in his life.

Leaving aside such Marian and Franciscan interpretations of the *Virgin of the Rocks*, the painting can also be understood in purely artistic terms as a statement of Leonardo's "scientific" studies. The grotto split into two passages in Leonardo's altarpiece, with its view of an alpine body of water, indeed appears to illustrate the notion of the body of the earth and of the earth as a living being, ideas that Leonardo would take up regularly in his own writings and that had been formulated many times in antiquity and the Middle Ages. Seen from this angle, the *Virgin of the Rocks* would appear to anticipate the geological and hydrological ideas that the artist would later express in the context of his "scientific" reflections upon "the body of the earth". Leonardo discusses the flow of water in particular in the Codex Leicester, that is, between 1506 and 1508 (ills. pp. 274, 275), although he touches upon it in earlier manuscripts, too. He describes how water is carried beneath

Detail of
**The Virgin of the Rocks (Virgin and Child with the Infant St John
and an Angel),** c. 1495–1499 and 1506–1508
(ill. p. 101)

the ground to all parts of the earth, just as blood is transported in veins throughout the body. One such fascinating passage, which might explain the presence of a large body of water at alpine altitudes, runs as follows: "By the ancients man has been called the world in miniature; and certainly this name is well bestowed, because, inasmuch as man is composed of earth, water, air and fire, his body resembles that of the earth; and as man has in him bones the supports and framework of his flesh, the world has its rocks the supports of the earth; as man has in him a pool of blood in which the lungs rise and fall in breathing, so the body of the earth has its ocean tide which likewise rises and falls every six hours, as if the world breathed; as in that pool of blood veins have their origin, which ramify all over the human body, so likewise the ocean sea fills the body of the earth with infinite springs of water" (RLW § 929).

A few years later, in the Codex Leicester, Leonardo returned to the subject of the earth as a living being: "The waters circulate with constant motion from the utmost depths of the sea to the highest summits of the mountains, not obeying the nature of heavy matter; and in this case it acts as does the blood of animals which is always moving from the sea of the heart and flows to the top of their heads; and here it is that veins burst – as one may see when a vein bursts in the nose, that all the blood from below rises to the level of the burst vein. […] These waters traverse the body of the earth with infinite ramifications" (RLW § 963). In another part of the same manuscript, the artist continues: "The body of the earth, like the bodies of animals, is intersected with ramifications of waters which are all in connection and are constituted to give nutriment and life to the earth and to its creatures. These come from the depth of the sea and, after many revolutions, have to return to it by the rivers created by the bursting of these springs" (RLW § 970).

These passages from Leonardo's writings may give us a better understanding of the presence in the *Virgin of the Rocks* of the striking rock formations and the body of water. As an artist, he uses fissures in the rock to allow us a profound insight, so to speak, into the

Diagrammatic reconstruction of the altar retable incorporating the *Virgin of the Rocks*

Detailed reconstruction of the altar retable incorporating the *Virgin of the Rocks*, after Malaguzzi-Valeri

anatomy of the earth. It should also be noted that in this case, too, the painting precedes the theory. The *Virgin of the Rocks* was executed many years before Leonardo first put down on paper his ideas concerning the body of the earth, a subject to which he frequently returned. As so often the case with Leonardo, the art precedes the theoretical and "scientific" reflections.

The complex, deliberately multi-layered nature of the *Virgin of the Rocks*, and its harmonious composition and masterly layout, give no hint of the unpleasant legal wranglings into which Leonardo and his two colleagues were drawn shortly after the work was completed. A bitter dispute erupted over payment, and the artists threatened to sell the work to an art lover who had apparently offered them more than the Confraternity was prepared to pay. It was probably this dispute which prompted the painting of the second version of the *Virgin of the Rocks*. In the end it would be this second version, finished as late as 1508, that indeed graced the Confraternity's chapel in San Francesco Grande in Milan for the rest of the 16th century (Cat. XVI). The earlier version, on the other hand, seems to have been sold early on to a collector, possibly Ludovico Sforza, who probably purchased it initially for himself.

The extensive documentation relating to the two versions of the *Virgin of the Rocks*, most of which is written in Latin, allows us a profound insight into the business practices of patrons and artists in the 15th century. The contract of 25 April 1483 makes it clear that Leonardo and his colleagues were embarking on a very wide-ranging and complex venture. They agreed not only to paint the middle panel and the wings of the altarpiece, but also to gild the woodcarvings already completed by other artists. It was thereby stipulated that the artists were to carry out the gilding not in their own workshop, but in the monastery of San Francesco Grande, and were to purchase the gold from the Confraternity at a named price – a not unusual condition of contracts from this era. Even more revealing are the instructions relating to the painting of the individual components of the altarpiece, which are described in detail in an appendix written in Italian:

"List of the decorations to be applied to the altarpiece of the Conception of the Glorious Virgin Mary placed in the Church of S. Francesco in Milan.

First, we desire that [on] the whole altarpiece, namely the carved compartments together with the figures, but excepting their faces, everything is to be done in fine gold to the value of 3 libre 10 s[oldi] per leaf.

Also, that the cloak of Our Lady in the middle be of gold brocade and ultramarine blue.

Also, that the gown be of gold brocade and crimson lake, in oil.

Also, the lining of the cloak to be gold brocade and green, in oil. Also, the seraphim done in sgraffito work.

Also, God the Father, to have a cloak of gold brocade and ultramarine blue.

Also, the angels above them to be decorated and their garments fashioned after the Greek style, in oil.

Also, the mountains and rocks to be worked in oil and differentiated with several colours.

Also, in the empty panels there are to be four angels, each differing from one picture to the other, namely one picture where they sing, another where they play an instrument.

Also, in all the other sections where Our Lady may be, she shall be decorated like the one in the middle and the other figures are to be in the Greek style, decorated with various colours, in the Greek or modern style, all of which shall be done to perfection; similarly the buildings, mountains, soffits, flat surfaces of the said compartments – and everything done in oil. And any defective carving to be rectified.

Also, the sybils to be decorated. The background to be made into a vault in the form of a housing [for the sybils] and the figures in garments differentiated from each other, all done in oil.

Also, the cornices, pilasters, capitals and all their carving done in gold, as specified above, with no colour thereon.

Also, on the middle panel is to be painted on the flat surface Our Lady with her son and the angels all done in oil to perfection with the two prophets painted on the flat surfaces in colours of fine quality as specified above.

Also, the plinth, decorated like the other internal compartments.

Also, all the faces, hands, legs, which are uncovered shall be painted in oil to perfection.

Also, in the place where the infant is, let there be put gold worked to look like *spinn-christi* [?]" (MK § 667).

This list describes the individual components of the retable not in an ordered sequence but in a somewhat unsystematic fashion. Although the middle panel, the largest painted component, is mentioned several times, there is a striking absence of any reference to

the precise arrangement of the figures. Nor does the list mention St John the Baptist, who played an important role for the Confraternity as their representative within the picture (see above). These issues were probably agreed verbally. All the more attention could thus be devoted to the painting and gilding of the architectural details and the numerous small subsidiary figures in the reliefs. The angels in the side panels were clearly of particular importance to the members of the Confraternity, since they set out in comparative detail how they were to be differentiated. The patrons similarly insist repeatedly on the use of expensive materials such as gold and ultramarine, and on the fact that the figures are to be

painted in oil. These stipulations were a standard feature of contracts relating to altarpieces. More unusual, however, is the attempt to direct the artists to adopt a more or less precisely defined style for the smaller relief figures. Mention is made twice of the "Greek style" (*figure grege*) and once of a "Greek or modern style" (*fogia grega o moderna*), whereby *grega* is clearly intended to mean a Greco-Byzantine and hence old-fashioned style of painting, and *fogia moderna* a more contemporary, modern style. The patrons had clearly yet to come across the term *maniera*, which would later be so widely used. First coined in Cennino Cennini's (*c.* 1370–1440) *Libro dell' Arte* (*c.* 1400, Ch. 27) to describe the style of an artist or a workshop, it would later, in the writings of Giorgio Vasari, be applied to the style of an entire epoch. Instead, the Confraternity used the word *fogia*, which was employed chiefly in the context of clothing and fashion. In trying to describe a specific style, the patrons thereby made reference to a sphere of everyday life that was subject to more rapid changes than painting.

Consideration should lastly also be given to the ways in which the finished painting differs from the instructions laid down in the contract. Thus Mary's cloak does not reveal the gold brocade stipulated by the Confraternity, nor does it employ quite the

Mino da Fiesole, **Virgin and SS Laurence (?) and
Remigius with the Christ Child and Infant St John**, c. 1464–1466
Marble. Fiesole, Cathedral, Salutati Chapel

Ambrogio de Predis (?), **Angel playing the Violin** and **Angel playing the Lute**
(right- and left-hand wings of the *Virgin of the Rocks* altarpiece)
Oil on wood, each 116.8 x 61 cm. London, The National Gallery

same colours. Furthermore, in place of the four angels envisaged in the contract, only two were painted. Such deviations nevertheless still fell well within the usual bounds. Hence it should not be considered strange that, in the protracted legal battle between the two parties that followed (see below), the patrons made not a single mention of the finished painting's departure from the stipulations of the original contract and never cited this as an argument against the artists. They were more concerned with the size of the additional fee

being demanded by the artists, and in this matter the Confraternity were determined to stick to the terms set out in the original contract. The painters had indeed been promised a bonus, upon completion of the painting, over and above their agreed fee of 800 lire (200 ducats). In an arrangement that would ultimately prove disadvantageous for the artists, however, it was laid down that the amount of the bonus was to be decided by a commission consisting of just three members of the Confraternity. Just how widely opinions as to the size of the bonus could diverge emerged a few years after the completion of the first version of the painting. If we are to believe the assurances of the artists, their work fully deserved an additional payment amounting to the not inconsiderable sum of 100 ducats. When the Confraternity offered them a bonus of only 25 ducats, the artists declared that its members were not expert in such matters, and that "the blind cannot judge colours". They called for an independent commission of experts to value the painting anew, and at the same time hinted that they had found people who wanted to buy the painting and who had already offered them a bonus of 100 ducats. The implied threat that they were going to sell the painting to a third party, and its actual sale to a private collector not long afterwards, were both highly unusual. The artists evidently succeeded in overturning a legally incontestable agreement with their economic and aesthetic arguments and in sending the first version of the *Virgin of the Rocks* away from its original destination.

The *Virgin of the Rocks* thereby became one of the first major paintings in post-medieval art history to leave its religious context soon after its completion and on the initiative of its artist. The painting thus stood at the start of a lengthy historical process, over the course of which the work of art would gradually lose its value as an object of religious veneration and assume a new value as an object of aesthetic appreciation.

There are some who make excessive use to gold,
because they think it lends a certain majesty to painting. I would
not praise them at all. […] I would try to represent
with colours rather than with gold this wealth of rays of gold that
almost blinds the eyes of the spectators from all angles.
LEON BATTISTA ALBERTI, 1435

IV

Beginnings as court artist in Milan

1485–1494

But before we go any further, we must say a little more about
Leonardo's personality and talents. The many gifts that Nature
bestowed upon him concentrated themselves primarily in
his eye. Hence, although capable of all things, he appeared great
above all as a painter. He did not rely simply upon the inner
impulses of his innate, inestimable talent; he permitted no arbitrary,
random stroke of the brush; everything had to be deliberate
and considered. From the pure proportions to which he devoted
so much research, to the strangest monsters that he compiled
out of contradictory figures, everything had to be both natural
and rational.

JOHANN WOLFGANG VON GOETHE, 1787

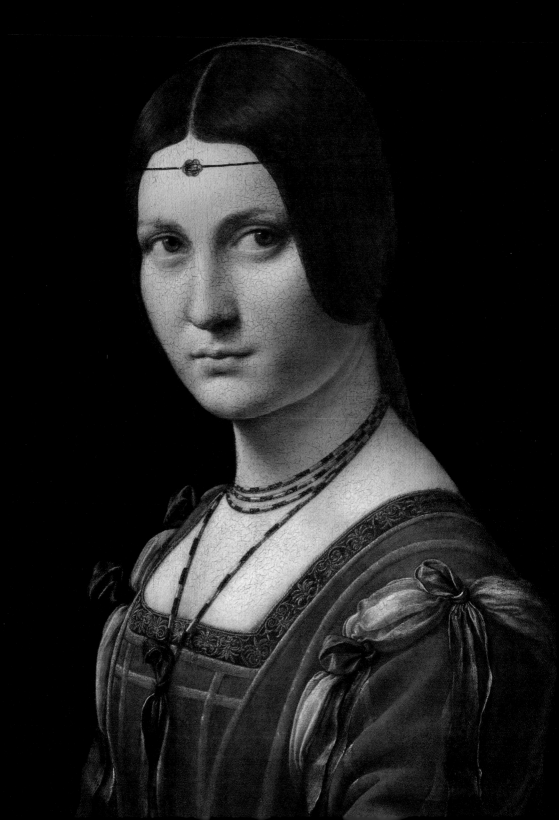

On the basis of payment receipts, we know that Leonardo finished the *Virgin of the Rocks* in late 1484 or early 1485. Even though he had thus completed his first larger-scale painting in Milan admirably on schedule, the artist appears to have received no other commissions for paintings at this stage. Even his hopes of a position as court artist, conveyed in his letter to Ludovico Sforza, would be fulfilled only some years later. Precisely what professional activities Leonardo pursued in the mid to late 1480s in Milan, and how he kept his head financially above water, are questions that remain largely unexplained to this day. All we know for certain about this period is that it saw him designing war machines, some of them more fantastical than practical. He also drew weapons of all different kinds, fortifications, complex defence systems, siege equipment and more besides (Nathan/Zöllner 2014, Cat. 564–589 and Ch. 14).

Amongst the curiosities of this phase are heavily armoured vehicles, whose immense weight would have all but prevented them from moving. Other ideas seem more immediately dangerous, such as his suggestion that the firepower of smaller cannon could be increased by using what was effectively grapeshot and an automated loading system (Nathan/Zöllner 2014, Cat. 566). Positively gruesome are the horse-drawn chariots armoured with scythes, with which the enemy could literally be mown down. Leonardo copied at least one device of this kind from a contemporary military treatise, Roberto Valturio's (c. 1405/15–1475) *De re militari* of 1472, and drew it several times (ill. pp. 120/121). Not without irony, however, did he accompany his drawing with a warning that this kind of equipment could do just as much damage to one's own troops as to those of the enemy (Nathan/Zöllner 2014, Cat. 564–576, 579–580).

Leonardo did not restrict his skills as a draughtsman to war machines alone. During this same period he was also trying his hand at architecture, producing designs for churches (ill. p. 123) and endeavouring to impress the authorities in charge of the construction of Milan Cathedral with his designs (Nathan/Zöllner 2014, Cat. 481–483). There are even records of a number of payments made to the Florentine artist from July 1487 onwards, in connection with the building of a model for the crossing-dome (*tiburio*) of the still unfinished cathedral. Leonardo's proposals drew little response, however; the contracts went to local Lombard architects who were either better qualified or better connected. More important, in terms of architectural history, are Leonardo's numerous designs for centrally planned buildings – even if none of them, it seems, got further than the drawing-board (Nathan/Zöllner 2014, Cat. 484–491, 495). They nevertheless reflect the architectural debate surrounding churches on centralized plans, which was current in the late 15th century and which would culminate, just a few years later, in the proposed new designs for St Peter's in Rome (Nathan/Zöllner 2014, Ch. 12).

Only towards the end of the 1480s does Leonardo seem to have returned more productively to the visual arts. The *Litta Madonna*, a small-format representation of the Virgin

and Child, may have been executed at this time or a little later, although its attribution to Leonardo, always contentious, can no longer be upheld (Cat. XIV/ill. p. 127). The overall hardness of the contours of the Virgin and Child, and the comparatively mundane atmosphere of the background, point instead to one of Leonardo's pupils, Giovanni Antonio Boltraffio (1467–1516), to whom the master entrusted either the entire execution of the painting, or at least its completion. Two drawings from Boltraffio's hand serve to confirm this suspicion. Leonardo was nevertheless directly involved in the original design of the *Litta Madonna*, as evidenced by two authenticated preparatory studies (Nathan/Zöllner 2014, Cat. 17–18; ill. p. 126).

That Leonardo should supply the designs for smaller Madonna paintings without always executing them entirely himself was probably bound up with the fact that, around 1490, he was preoccupied with more important things. Over a period of time somewhere between 1484 and 1494 – it is not possible to be more precise – the artist was engaged upon his important and most difficult project to date, the Sforza monument – the largest equestrian statue in the modern age. The monument, which was to be much bigger than life size and cast in bronze, was intended by Ludovico Sforza to commemorate the military successes of his father, Francesco Sforza, and of course to cast his own achievements in an equally impressive light. Francesco had distinguished himself as a general in the 1430s and lent his military support to the then Duke of Milan, Filippo Maria Visconti (1392–1447). In 1441 Francesco Sforza allied himself with Milan's ruling Visconti dynasty yet more closely by marrying Bianca Maria Visconti (*c.* 1424–1468), the duke's daughter. When Filippo Maria Visconti died a few years later, in 1447, Francesco Sforza used the resulting power vacuum to set himself up as ruler of Milan. As the son-in-law of the deceased Filippo Maria Visconti, who had left no legitimate male heirs, Francesco was officially proclaimed Duke of Milan in 1450 and went on to found a new dynasty to succeed the Visconti.

Following Francesco's own death, the title passed to his first-born son, Galeazzo Maria (1444–1476), and when he was murdered in 1476, he was succeeded in turn by his son Gian Galeazzo Sforza (1469–1494), who was still a minor. Since Gian Galeazzo was not yet in a position to govern in his own name, the reins of power were seized by his uncle, Ludovico Sforza. When, in 1494, Gian Galeazzo mysteriously departed

Page 117
Detail of **Portrait of an Unknown Woman (La Belle Ferronière)**, c. 1490–1495
(ill. p. 153)

Pages 120/121
Scythed Chariot, c. 1483–1485
Pen and ink, 210 x 290 mm. Turin, Biblioteca Reale, Inv. 15583r

this life, Ludovico was officially able to declare himself sole ruler of Milan. Prior to 1494, therefore, Ludovico il Moro, Leonardo's patron and employer, was not the rightful Duke of Milan, since this title belonged to his nephew Gian Galeazzo, who stood in the direct line of male succession. Ludovico was thus faced with the problem of legitimizing his claim to power, which was flawed in two genealogical respects: firstly, his father Francesco did not stand in direct line of male succession from the Visconti dukes; and secondly, he himself, Ludovico, was not the first-born son of the Sforza family, but merely the uncle of the true Duke of Milan, who died young in circumstances never fully explained. These genealogical weaknesses led him to focus his cultural policy largely upon demonstrating the magnificence of the still young Sforza dynasty. The products of this policy included such vainglorious literary monuments as Giovanni Simonetta's (c. 1410/20–1491) De gestis Francisci Sphortiae (cf. Ch. V), an extensive building programme in Milan and Pavia, the commissioning of the Last Supper and above all the equestrian monument to Francesco Sforza, which was intended to do no less than redefine its genre.

Plans for an equestrian monument were first mooted in the early 1470s, and by November 1473 they were already taking concrete shape. In a letter from Galeazzo Maria Sforza to Bartolomeo da Cremona dating from this same year, we find the first mention of a life-size equestrian statue to be sited in front of the Castello Sforzesco, the Sforza's castle in Milan: "For we would like to have an image [imagine] of our Most Illustrious Lord and father made in his good memory, of bronze and mounted on horseback, and we want to erect it in some part of our Milan castle, either on the entrenchment facing the piazza or somewhere else where it will be seen to advantage. We wish and enjoin you to search in our city for a master who can execute this work and cast it in metal, and if no such master is to be found in our city, we wish you to investigate and find out whether in another city or elsewhere there is a master who knows how to do it. And he must make the image and the horse as well as can possibly be imagined. The image must be as big as His Lordship and the horse of a goodly size. And if such a master is to be found, send us news, and let us know how much the costs, including the metal, the work and all other things, will amount to. And we wish you to search in Rome, Florence and all other cities where the master might be found who could carry out this work successfully."

<div align="center">

Studies of a Centrally planned Building, c. 1487–1490
Pen and ink, 233 x 162 mm,
Paris, Bibliothèque de l'Institute de France, Codex Ashburnham 1875/1 (Ms. B 2184), fol. 5v

Pages 124/125
Allegory of Statecraft (Justice and Prudence), c. 1490–1494
Pen and ink, 205 x 285 mm. Oxford, The Governing Body, Christ Church, Inv. JBS 18r

</div>

In painting he brought to the technique of colouring in
oils a way of darkening the shadows which has enabled modern
painters to give great vigour and relief to their figures.
GIORGIO VASARI, 1568

Study of the Head of a Woman, c. 1490
Silverpoint on greenish prepared paper, 180 x 168 mm
Paris, Musée du Louvre, Cabinet des Dessins

Pages 127–131
Giovanni Antonio Boltraffio (?), after a design by Leonardo
Litta Madonna, c. 1490
Tempera (and oil?) on wood, transferred to canvas, 42 x 33 cm
St Petersburg, Hermitage, Inv. 249

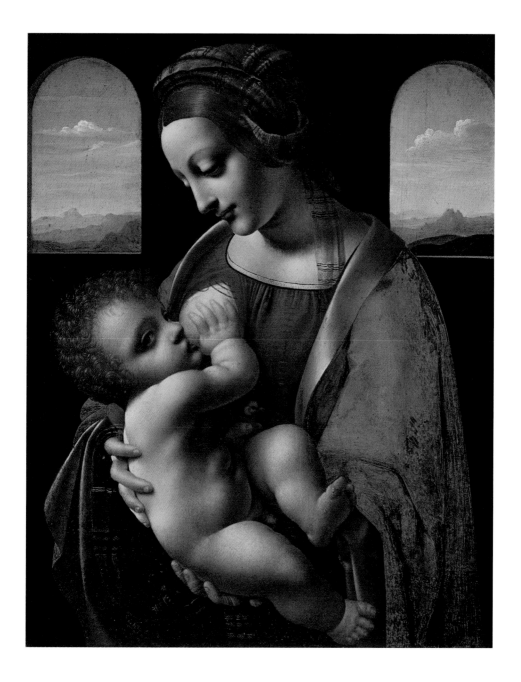

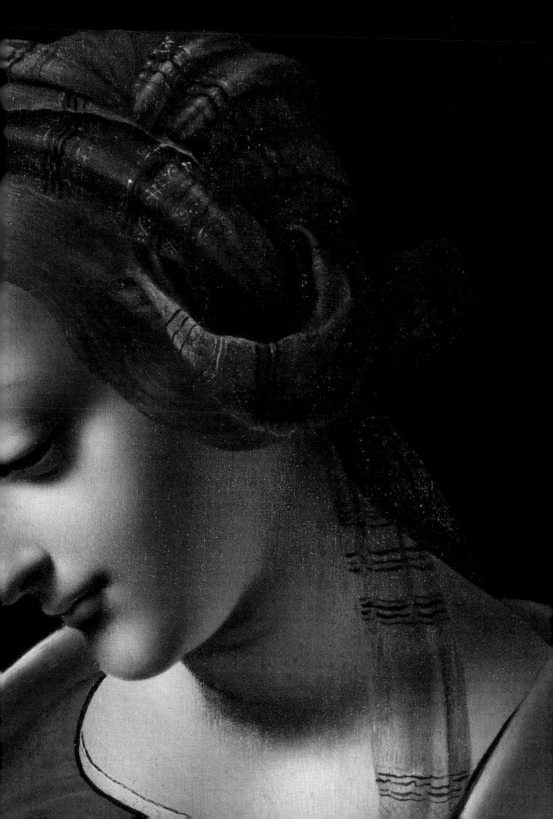

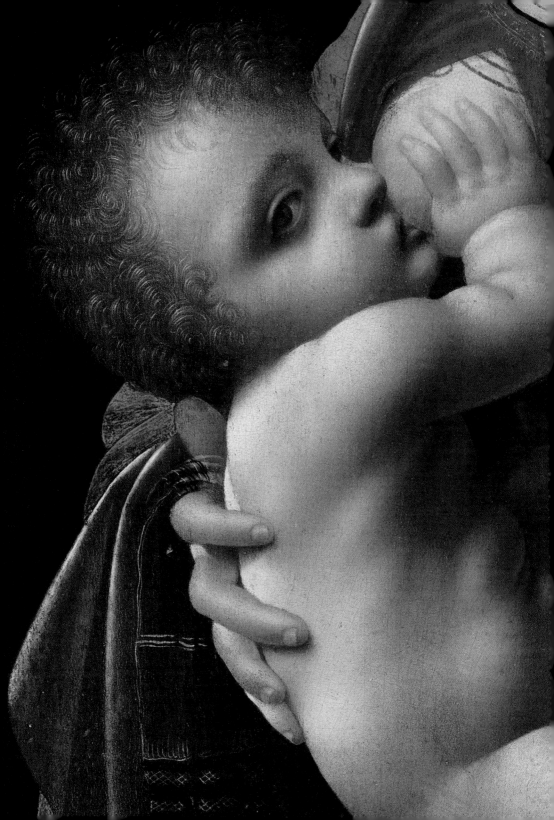

Actual work on the monument, at first planned only in life size ("as big as His Lordship") and hence on a modest scale, was repeatedly postponed, however, since there were no competent artists to be found either in Upper Italy or elsewhere. Following the murder of Galeazzo Maria in 1476 and the temporary exiling of Ludovico Sforza from 1477 to 1479, the project came to a complete standstill.

As the Sforza family consolidated its power in the 1480s, however, the idea of an equestrian monument must have acquired a new relevance, to the point that Leonardo could refer to it in the speculative letter of application that he addressed to Ludovico (cf. Ch. IV): "Moreover, work could be undertaken on the bronze horse which will be to the immortal glory and eternal honour of the auspicious memory of His Lordship your father, and of the illustrious house of Sforza" (MK § 612). A good ten years later, around 1495, Leonardo would even claim that Ludovico had invited him to come to Milan to execute the monument (RLW § 1347).

There is no reliable evidence, however, to prove that Leonardo was indeed appointed specifically to build the monument, or even that he started working on the project soon after his arrival in Milan, namely in 1483 or 1484. The first authentic document relating to Leonardo's work on the monument dates from as late as 22 July 1489 and only suggests that all is not well. The Florentine envoy in Milan, Piero Alamanno, inquired in a letter to Lorenzo de' Medici whether there were artists in Florence who would be able to see the colossal monument through to completion, since Leonardo does not seem to be capable of it: "It is the intention of His Lordship Ludovico to erect a worthy monument to his father, and he has already instructed Leonardo da Vinci to produce the model for a very large bronze horse and on it the figure of Duke Francesco in full armour. Since His Excellency would like to make something truly outstanding [*in superlativo grado*], I was advised by him to write to you and to ask you to send him one or two artists from Florence who are accomplished in this field. For although the Duke has commissioned Leonardo da Vinci to do the work, it seems to me that he is not confident that he knows how to do it."

It is possible that Leonardo was to lose responsibility for the project or – if we interpret the letter a little more optimistically – was to be assigned some experienced assistants. Whatever the case, he must have broken off work on the monument, because on 23 April 1490 he wrote in a notebook that he had "recommenced the horse" (RLW § 720). And indeed, over the next two years the artist worked intensively on designs for the monumental work, and above all on the technical aspects of casting it in bronze (Nathan/Zöllner 2014, Cat. 65–73; ills. pp. 136/137, 138).

Finally, in 1493 he completed an enormous clay model of the horse, over seven metres (!) in height, which was exhibited that same year during the festivities to mark the marriage of Bianca Maria Sforza, Ludovico's niece, to Emperor Maximilian I (r. 1468–1519), when it

formed part of the decorations in the Corte Vecchio in Milan. An ode composed by the court poet Baldassare Taccone in 1493 describes the work thus:

"See in the Corte the colossal horse,
To be cast in bronze in memory of the father:
I firmly believe that Greece and Rome
Never saw a greater work of art.
Just see how beautiful this horse is;
Leonardo made it single-handedly,
A fine sculptor, painter, geometer:
His rare genius sent from Heaven.
It was always the wish of His Lordship [Ludovico],
But it was not begun earlier
For a Leonardo had not yet been found,
He who now shapes it so well
That everyone who sees it is amazed.
And if one compares him with Phidias,
With Myron, Scopas and Praxiteles,
One can but say: Never on earth was a work more beautiful."

Alongside the usual panegyric, Taccone's poem contains a number of interesting references. It speaks of a "colossal" horse (*gran colosso*) and thus indirectly of the revision the project has undergone – in Galeazzo Maria Sforza's letter of 1473 it was envisaged as only life-sized (see above). The significant increase in the size of the monument can thus be attributed to Ludovico, whose craving for public admiration clearly surpassed even that of his deceased brother. Revealing, too, is Taccone's description of Leonardo as a geometer (*geometra*), clearly a reference to the artist's "scientific" studies (cf. Ch. V). Lastly, the poem also offers us a guide to the dating of the monument, for Taccone speaks in the present tense of the sculpting of the monument. The clay model had evidently only just been finished or was not far off completion.

On 20 December 1493 Leonardo made another important note in the manuscript later known as the Codex Madrid II, indicating some of the serious technical difficulties into which the project had run. The pit in which the horse was to be cast, and which thus had to be at least as deep as the horse was tall, had hit the water table (CM II, fol. 151v). Shortly after this, therefore, Leonardo must have decided to cast the horse lying horizontally in the pit, not standing upright. In view of this and other problems, the ambitious project got little further than the clay model, and in 1494 the bronze earmarked for the monument was appropriated to make cannon instead. The need to fight the French, who had

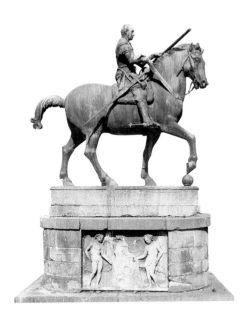

marched into Italy as Ludovico's allies and had subsequently become his enemies, meant that there were now more urgent uses for the metal. The largest monument ever designed to honour the memory of a soldier and general fell victim, characteristically, to the demands of another war.

For some years the clay model for the Sforza monument aroused the curiosity and admiration of guests and others passing through Milan, but after the arrival of the French troops in 1499 it fell into the hands of mercenaries who had little interest in art. It was used, so the story goes, for target practice by the archers, whereby it was largely ruined and eventually destroyed altogether. Like the final execution of the bronze equestrian monument, its clay model thus also fell victim to the consequences of war. Still surviving, however, are numerous sketches and preparatory studies from Leonardo's hand, which convey a lively impression of the different stages and the technical challenges of the project (Nathan/Zöllner 2014, Cat. 63–73; ills. pp. 136/137, 138, 141). Thus, besides a drawing for a – strangely surrealist – ironwork mould for casting the head, there are also numerous studies relating to the final appearance, movements and proportions of the horse. The most impressive of these studies shows a rider on a horse rearing up on its hind legs. Lying beneath it is an opponent who has clearly fallen to the ground and is holding up his shield in his right hand in an attempt to ward off further attack (ill. p. 141). The motif of the rearing horse and a slain enemy lying on the ground beneath it derives from antiquity: Xenophon (4th century BC), in his writings on horsemanship and cavalry, describes it as a compositional formula of particular dignity (*dexileos*). The same motif also appeared on antique coins, where it carried imperial and military connotations (ill. p. 302); such coins were widely available in the 15th century, and we know that Leonardo was familiar

Donatello, **Equestrian Monument of the Condottiere Erasmo da Narni (so-called Gattamelata)**, 1444–1453
Bronze, 340 x 390 cm. Padua, Piazza del Santo

After Leonardo, **Designs for the Sforza Monument**
Copperplate engraving, 217 x 159 mm. London, The British Museum, Inv. B.M.5–P.v.181.3

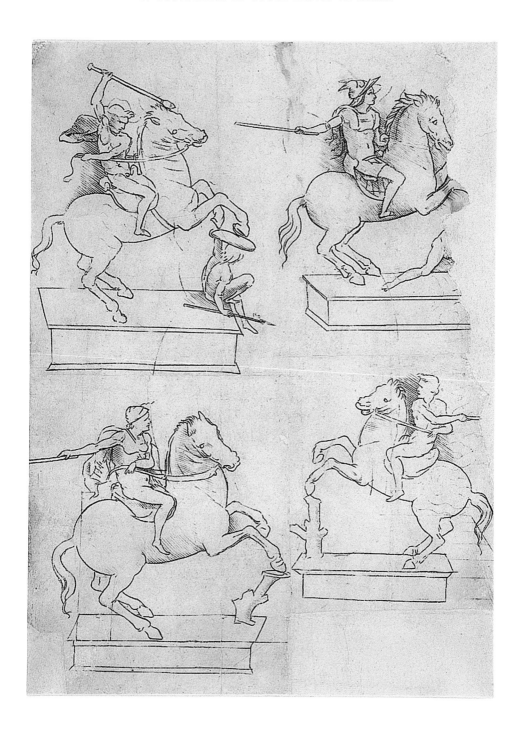

with them. Through the *dexileos* motif familiar from Greek literature and numismatics, it was attempted to position the political and military ambitions of 15th-century patrons within the grand tradition of antiquity, whose rulers and generals were seen as outstanding individuals worthy of emulation. This reference to an antique tradition must have been especially attractive to Galeazzo Maria Sforza, and later to his brother Ludovico, since the dynasty founded by their father was still young and thus relatively lacking in tradition. An equestrian monument aligning them with classical antiquity would help make up for this genealogical deficiency.

The construction of a horse rearing up on two legs – especially in view of the enormous scale of the project – would have posed considerable problems with regard to the stability of the statue. In a second planning phase, therefore, Leonardo decided to use the less dramatic option of a horse striding forwards. The more animated and artistically more interesting *dexileos* motif thus remained simply an ideal, one that Leonardo would take up once more in his Trivulzio monument (cf. Ch. IX), but which would only finally be translated into sculpture by the artists of the 17th and 18th century. By adopting a walking horse, the project now resembled such monuments as the so-called *Regisole* in Pavia, an antique equestrian statue that Leonardo went to look at in person around 1490. The artist thus made a return, in this second phase, to a more traditional formal solution.

Equestrian monuments derive their significance not only from their size, the rank of the person being venerated and the artistry of their design, but also from the site on which they are erected. The most famous and largest equestrian statues of Leonardo's day – the *Gattamelata* by Donatello (1386–1466; ill. p. 134) in Padua, and the still unfinished *Colleoni* by Andrea del Verrocchio in Venice – were firmly embedded within a religious context by their function and location. As cenotaphs, respectively commemorating the deaths of the distinguished generals Gattamelata and Colleoni, both were sited directly outside churches, the *Gattamelata* beside St Anthony's basilica in Padua and the *Colleoni* in front of the Dominican church of SS Giovanni e Paolo in Venice. From Piero Alamanno's letter of 22 July 1489, cited earlier, we know that the equestrian monument for Francesco Sforza was also intended as a *sepultura* (sepulchral monument). But in contrast to the two equestrian statues in Padua and Venice, this *sepultura* was never intended for an ecclesias-

Pages 136/137
Casting Mould for the Head of the Sforza Horse, c. 1491–1493
Red chalk, 210 x 290 mm. Madrid, Biblioteca Nacional, Codex Madrid II (Ms. 8936), ff. 156v–157r

**Study of the Wooden Framework with Casting Mould
for the Sforza Horse**, c. 1491–1493
Red chalk, 210 x 146 mm. Madrid, Biblioteca Nacional, Codex Madrid II (MS 8936), fol. 155v

tical setting; rather, it was to be sited either inside the grounds of the Castello Sforzesco, seat of power of the Sforza dukes, or on top of the outer fortification wall, on the side facing the city. The decision to erect the Sforza monument in front of the ducal palace and directly facing the city of Milan was clearly a deliberate break with post-antique tradition. Far more than simply a memorial to the dead, the monument was to be a grandiose display of Sforza grandeur. The choice of location for the Sforza monument was, in itself, a supreme demonstration of power.

This desire to reinforce the legitimacy of the young Sforza dynasty and cast it in a glittering light expressed itself not just in plans for spectacular monuments, which offered a welcome challenge for an ambitious artist, but also extended to smaller-scale and today less well-known areas of activity. As court artist from 1487 to 1490, Leonardo was also in charge of the design and often, too, the organization of theatrical productions (Nathan/ Zöllner 2014, Cat. 496) and court festivities. In January 1490, for example, he designed the artistic decorations and necessary technical equipment for the "Festa del Paradiso" staged on the occasion of the marriage of Isabella of Aragon (1470–1524) to Gian Galeazzo Sforza. This pageant was written by the court poet Bernardo Bellincioni (1452–1492), who like Leonardo had also come to Milan from Florence.

A description of the "Festa del Paradiso" can be found in a collection of Bernardo Bellincioni's poetry, published in book form in 1493. This description, which together with Bellincioni's ode to the *Portrait of Cecilia Gallerani* (see below) marks the first time that Leonardo's name is mentioned in print, sheds light on the activities on which the artist was engaged at the Milanese court: "The following small work, composed by Mr Bernardo Bellincioni for a pageant or rather a performance entitled 'Paradise', was commissioned by Ludovico in praise of the Duchess of Milan. It is called 'Paradise' because, with the assistance of the great talent and skill of Leonardo da Vinci of Florence, it presented Paradise with all the seven planets orbiting around it. And the planets were portrayed by men in the manner described by the poets. And these planets all spoke in praise of the aforementioned Duchess [...]". The primary task of the court artist was thus to cast the virtues of the members of the ruling dynasty in a favourable light and make them the subject of a piece of theatrical entertainment. The artist was thereby expected to include impressive artistic and technical effects. Anyone hoping for a successful and lasting engagement as court artist in Milan, therefore, had to bring with them a certain degree of technical expertise.

It was probably within the context of such pageants and performances that Leonardo also devised a number of allegories, in which, for example, Ludovico il Moro plays the role of protector of the official but still underage ruler of Milan, his nephew Gian Galeazzo Sforza. Leonardo thereby provided the artistic backdrop to Ludovico's political ambitions, inventing complex allegories that managed to captivate the young Gian Galeazzo even

Study for the Sforza Monument, c. 1488/89
Metalpoint on blue prepared paper, 148 x 185 mm. Windsor Castle, Royal Library (RL 12358)

as they illustrated his calculating uncle's thirst for power. In one of these allegories (ill. pp. 124/125), Gian Galeazzo appears in the centre of the picture as a cockerel sitting on a cage (the cockerel, *galetto* in Italian, is a play upon his name, Galeazzo). Lunging towards him from the right is a mob made up of foxes, a bird of prey and a horned satyr-like creature. To the left of centre, Ludovico is represented by the figures of not just one, but two Virtues. Thus he is both Justice (*giustizia*, with the attribute of the sword) and Prudence (*prudenza*, with a mirror). Prudence is swinging above her head a snake (the traditional *biscia viscontea*) and a sort of broom or brush, both heraldic symbols of the Sforza family. Prudence is holding her left hand protectively over the cockerel, which is behind her back. Ludovico in allegorical form is thus protecting the *galetto* Gian Galeazzo from the mob approaching from the right.

[…] and for years he seemed to those about him
as one listening to a voice silent for other men.
WALTER PATER, 1869

The Ermine as a Symbol of Purity, c. 1490
Pen and ink, dia. 91 mm. Cambridge, The Fitzwilliam Museum

Pages 143–145
Portrait of Cecilia Gallerani (Lady with an Ermine), 1489/90
Oil on walnut, 55 x 40.5 cm. Cracow, Muzeum Narodowe, Czartoryski Collection, Inv. 134

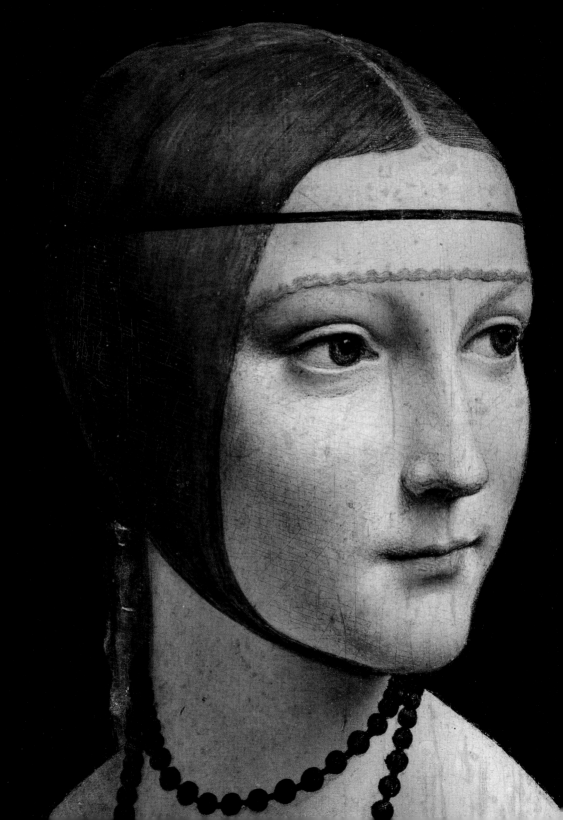

As artist to the Sforza court and its festivities, Leonardo was once again in demand as a painter. The creative talents that he had previously brought to pageants and allegories found their most impressive expression in his *Portrait of Cecilia Gallerani* (Cat. XIII/ill. p. 143), in which Leonardo broke away from the compositional format prevailing in Upper Italian portraiture of his day (cf. portrait by de Predis, ill. p. 146). Thus he did not adopt the profile view typically employed in nuptial portraits, since he did not have to portray Cecilia as a bride, but as the mistress of Ludovico Sforza (see below). Leonardo also distanced himself from the traditional, rather static pose in which head and upper body face the same way. In the *Portrait of Cecilia Gallerani*, the two are angled in different directions: the upper body is turned to the left, the head to the right. The painting thereby corresponds to the dynamic style of portraiture that Leonardo was already working towards in his *Portrait of Ginevra de' Benci* (Cat. VII/ill. pp. 58/59) and which is explicitly formulated in his treatise on painting (TPL 357). This desire to infuse the portrait with a sense of movement emerges not only in the positioning of Cecilia's head and body, but also in the dynamic pose of the ermine, which echoes that of the young woman. Cecilia's elegantly curved but at the same time somewhat overly large hand in turn corresponds with the figure of the ermine.

The presence of the ermine within the composition is on the one hand an allusion to Cecilia's surname, since the sound of Gallerani is reminiscent of the Greek word for ermine, *galée*. On the other hand, the ermine was also a symbol of purity and moderation, for according to legend it abhorred dirt and ate only once a day. Leonardo refers specifically to these qualities of the ermine in his writings, where he makes notes on the allegorical significance of other animals, too (RLW § 1234). The legendary purity of the ermine is also the starting-point for a pen drawing probably dating from around 1490 (ill. p. 142).

Ambrogio de Predis (?), **Portrait of a Young Woman in Profile**, c. 1490 (?)
Oil on wood, 51 x 34 cm. Milan, Pinacoteca Ambrosiana

Antonello da Messina, **Portrait of a Young Man**, 1474
Oil on poplar, 32 x 26 cm. Staatliche Museen zu Berlin, Gemäldegalerie

In this allegory, Leonardo illustrates the traditional belief that an ermine would rather be killed than sully its white fur in dirty water as it flees. From the late 1480s onwards, moreover, the ermine could also be read as an allusion to Ludovico Sforza, who used it as one of his emblems. In the figurative sense, therefore, this portrait shows Ludovico, in the shape of his symbolic animal, being tenderly stroked in the sitter's arms. The comparatively complex symbolism of this portrait, and the delicate situation it portrays, have their explanation in the fact that the young woman was Ludovico Sforza's favourite mistress.

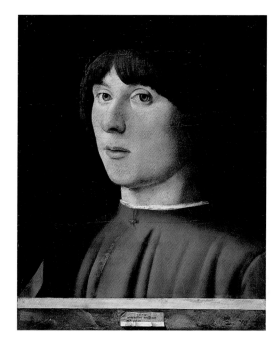

Born Cecilia Bergamini in 1473, at the age of ten she was betrothed (*pro verba*) to Giovanni Stefano Visconti. This betrothal was dissolved in 1487. Not long afterwards, probably in 1489, Cecilia became the mistress of Ludovico Sforza, who for his part had been betrothed to Beatrice d'Este (1475–1497) since 1480. The official solemnization of Ludovico's marriage to Beatrice d'Este seems to have been delayed from 1490, as originally planned, to 1491 as a consequence of Ludovico's affair with Cecilia. Thus the Ferrarese envoy in Milan, Giacomo Trotti, wrote in November 1490 that Ludovico was not at all looking forward to the arrival of his lawful bride Beatrice, for his mistress Cecilia was as lovely as a flower and, moreover, pregnant. In order to avoid angering his future wife Beatrice, in February 1491 Cecilia was removed from the ducal place as a precaution and taken to a new location, where on 3 May she gave birth to a son, Cesare. There is documentary evidence that the present portrait, which was probably finished quite some time earlier, remained in her possession and perhaps served to remind her of the premarital and extramarital pleasures she and Ludovico shared. Perhaps it was also intended to make up, in some small way, for the inconveniences that Cecilia had to suffer in view of the impending marriage between Ludovico and Beatrice.

Of the nuptial and prenuptial conflicts and pleasures that possibly find expression in Leonardo's *Portrait of Cecilia Gallerani* there is naturally no mention in the panegyrical poetry written for the court. Before his death in 1492, for example, court poet Bernardo Bellincioni composed the following effusive ode to Cecilia and her portrait:

"The poet: 'Nature, who stirs your wrath, who arouses your envy?'
Nature: 'It is Vinci, who has painted one of your stars!
Cecilia, today so very beautiful, is the one
Beside whose beautiful eyes the sun appears as a dark shadow.'

The poet: 'All honour to you [Nature], even if in his picture
She seems to listen and not talk.
Think only, the more alive and more beautiful she is,
The greater will be your glory in future times.

Be grateful therefore to Ludovico, or rather
To the talent [*ingegno*] and hand of Leonardo
Which allows you to be part of posterity.

Everyone who sees her – even if too late
To see her alive – will say: that suffices for us
To understand what is nature and what art.'"

In his fictitious dialogue, Bellincioni takes up the popular theme of the rivalry between nature and the artist, who tries to compete with nature in his works. To this he adds the usual references to the beauty of the lady in the portrait and the generosity of the patron, and in this case also implies that only in the painting are we seeing the sitter behave in the appropriate manner for young women. Only in her portrait, in other words, is she no longer talking (*favella*) but listening! Apart from this joking allusion to ideal female behaviour, which apparently consists of polite silence, Bellincioni's poem also sheds light on contemporary attitudes towards the function of the portrait: it was to hand down a likeness of the young woman for posterity.

Alongside the *Portrait of Cecilia Gallerani*, Leonardo's early works as court painter also include the so-called *Belle Ferronière* (Cat. XV/ill. p. 153), whose attribution to Leonardo is today rarely doubted. In compositional terms, the painting is closely related to a portrait type found across northern Italy, in which a stone parapet separates the viewer from the pictorial space. This same type surfaces in the works of Antonello da Messina (*c.* 1430–1479; ill. p. 147) and Giorgione (1477–1510), for example, and is ultimately indebted to earlier Flemish models. Uncertainty continues to reign, however, over the dating of the portrait and the identity of the sitter. The portrait may show Lucrezia Crivelli, another of Ludovico Sforza's mistresses. If this is indeed the case, then the following lines by another contemporary poet (probably Antonio Tebaldeo) can be related to the painting:

"How well high Art here corresponds to Nature!
Da Vinci could, as so often, have depicted the soul.
But he did not, so that the painting might be a good likeness.
For the Moor alone possessed her soul in his love.
She who is meant is called Lucretia, and to her the gods
Gave everything with a lavish hand.
How rare her form! Leonardo painted her, the Moor loved her:
The one, first among painters, the other, first among princes.
Surely the painter has offended Nature and the high goddesses
With his picture. It galls her the latter that the human hand is
capable of so much,
The former that a figure that should quickly perish
Has been granted immortality.
He did it for the love of the Moor, for which the Moor protects him.
Both gods and men fear to upset the Moor."

The poet here reflects upon the rivalry between art and nature even more clearly than Bellincioni. He also stresses the gracious patronage bestowed by Ludovico Sforza (also known as Ludovico il Moro, "the Moor"), who alone is able to protect the painter from Nature, whose jealously has been aroused by his art. The poet also raises the issue of the portrayal of the soul, a central aspect of the individual portrait of the modern age. While affirming that Leonardo could easily have portrayed the sitter's soul, the poet emphasizes that it belongs to the patron and ruler, in this case Ludovico il Moro, who as absolute ruler and as a man was accustomed to commanding the bodies and souls of his mistresses.

Amongst the portraits associated with Leonardo's first period in Milan is lastly the *Portrait of a Musician* (Cat. XII/ill. p. 150), whose attribution to Leonardo is the subject of controversy, however. Compared with the more elegant portraits of the *Belle Ferronière* and *Cecilia Gallerani*, the painting of the young man looking out of the picture towards the right seems rather wooden, partly owing to the fact that the musician's upper body is facing in the same direction as his gaze. But despite the rather less dynamic pose of the *Musician*, both it and the two other portraits from the Milan period convey a certain atmosphere, one that arises out of their subtle shading and that would shortly be encapsulated in the term *sfumato* (cf. Ch. VII and IX). Contours and outlines hereby begin to dissolve as objects no longer rely on crystalline focus and sharp-edged definition to convey themselves to the viewer. The portrait now takes its meaning less from the realism with which it portrays its sitter than from its constitution of atmosphere, a shift in emphasis that was in turn accompanied by increasing autonomy on the part of the painting.

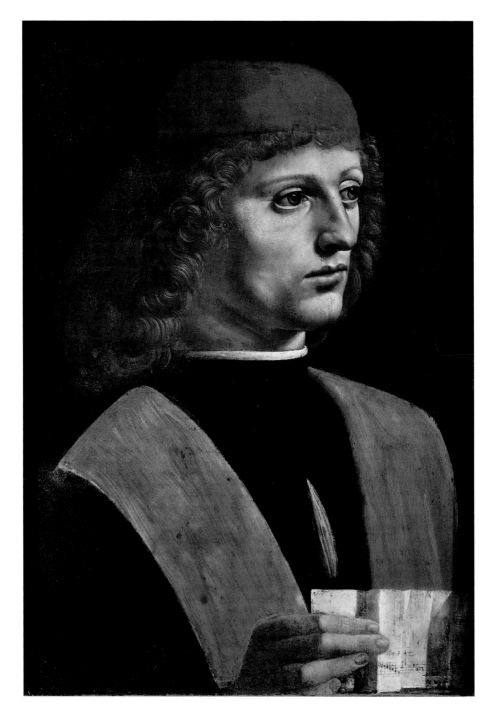

*There have even been some to say […] that Leonardo had
no intention of finishing it when he started. This was
because it was so large that it proved an insoluble problem to cast
it in one piece; and one can realize why, the outcome
being what it was, many came to the conclusion they did, seeing
that so many of his works remained unfinished.*

GIORGIO VASARI, 1568

Giovanni Antonio Boltraffio (?) and Leonardo (?)
Portrait of a Musician, c. 1485
Tempera and oil on wood (walnut?), 44.7 x 32 cm. Milan, Pinacoteca Ambrosiana, Inv. 99

Painting is the finest of all the mechanical arts, and the noblest.
It creates more wondrous things than poetry or sculpture.
The painter deploys shading and colour and marries them with the gift
of precise observation. He must be a master of everything, for
everything interests him. The painter is a philosopher of natural science,
an architect and a skilful dissector. In this is rooted the excellence
of his portrayal of every part of the human body. This skill was some time
ago developed and brought to near perfection by Leonardo da Vinci.
GERONIMO CARDANO, 1551

Portrait of an Unknown Woman (La Belle Ferronière), c. 1490–1495
Oil on walnut, 63 x 45 cm. Paris, Musée du Louvre, Inv. 778

V
The artist and "science"

I expected to see little more than such designs in anatomy as might be useful to a painter in his own profession. But I saw, and indeed with astonishment, that Leonardo had been a general and a deep student. When I consider what pains he has taken upon every part of the body, the superiority of his universal genius, his particular excellence in mechanics and hydraulics, and the attention with which such a man would examine and see objects which he was to draw, I am fully persuaded that Leonardo was the best anatomist at that time in the world.

WILLIAM HUNTER, 1784

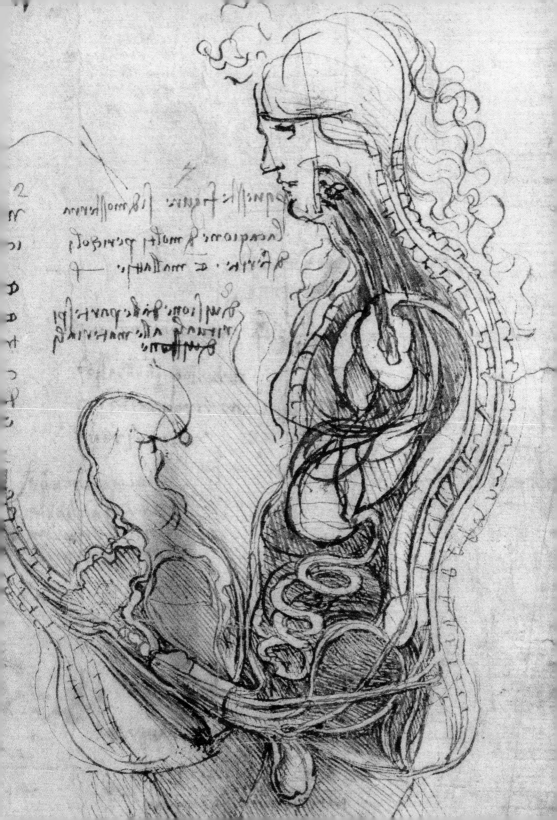

Aristotle (384–322 BC) opens his *Metaphysics* with the observation that all men by nature desire to have knowledge, and hereby stresses the importance of empirical observation. Leonardo da Vinci may be seen as the prototype of such a man, thirsty for knowledge and understanding gained through sensory experience. Leonardo adopts the same dictum in his own writings at the latest around 1490, having assimilated Aristotle's thought via his reading of Dante's (1265–1321) *Convivio* (1306/08; RLW § 10). In a poetic vision that comes closer to Plato's (427–347 BC) cave allegory (*Politeia*, 7.1–3) than to Aristotle, the artist describes his yearning for knowledge thus: "Unable to resist my eager desire and wanting to see the great [wealth] of the various and strange shapes made by formative nature, and having wandered some distance among gloomy rocks, I came to the entrance of a great cavern, in front of which I stood some time, astonished and unaware of such a thing. Bending my back into an arch I rested my left hand on my knee and held my right hand over my downcast and contracted eyebrows: often bending first one way and then the other, to see whether I could discover anything inside, and this being forbidden by the deep darkness within, and after having remained there some time, two contrary emotions arose in me, fear and desire – fear of the threatening dark cavern, desire to see whether there were any marvellous things within it…" (RLW § 1339).

If Leonardo's thirst for knowledge and discovery was still held in check in this vision by his fear of the threatening unknown, by the end of the 1480s at the latest he had thrown himself with unbridled enthusiasm into the study of a wide range of fields. While working on the preparations for the Sforza monument, he also embarked on more in-depth studies into the proportions of the human body, anatomy and physiology. These studies, which Leonardo's contemporaries frequently dismissed as the artistically unproductive whims of a restless mind, have been acknowledged since the 19th century as the forerunners of an empirical science based on the accurate observation of natural phenomena. In his studies of the human body, for example, and above all in his direct visual translation of his findings and insights, the artist was undoubtedly many generations ahead of his contemporaries. This is true not only of the anatomical studies, which he commenced largely around 1489 and which he intensified at the start of the 1500s, but also of Leonardo's study of the proportions of the human body. In a note made in one of his manuscripts, the artist dates the start of these studies to April 1489 (RLW § 1370).

That same year, or not long afterwards, he began compiling a systematic record of the measurements of a number of young men, two of whom are even identified by name as

Trezzo and Caravaggio. He proceeded to record their measurements – from the tips of the toes to the top of their heads – in notes and sketches (Nathan/Zöllner 2014, Cat. 226–247; ills. pp. 160, 168/169). During virtually exactly the same period he was also taking measurements of the horses owned by his patron Ludovico il Moro (Nathan/Zöllner 2014, Cat. 248–254). After what must have been months of taking measurements, therefore, Leonardo arrived at an almost complete overview of human proportions, at which point he then started to look at the proportions of sitting and kneeling figures. Finally, he compared the results of his anthropometric studies – i.e. studies involving the systematic measuring of the proportions of the human body – with the only investigation of human proportions to survive from antiquity, namely the *Vitruvian Man*.

Vitruvius (*c.* 80–*c.* 20 BC), an only moderately successful architect and engineer during the days of the Roman Empire, wrote a treatise on architecture that included in its third volume a description of the complete measurements of the human body. These led him to conclude that a man with legs and arms outstretched could be inscribed within the perfect geometric figures of the circle and the square alike. These two figures are usually referred to as the *homo ad circulum* and the *homo ad quadratum*, and also as the *Vitruvian Man*. According to Vitruvius's theory, the centre of the human body as inscribed within the square and circle coincided with the navel. Vitruvius's findings were taken up again during the Renaissance and in subsequent epochs and illustrated with widely differing results. Best known is the drawing by Leonardo (ill. p. 159); rather more notorious is the later woodcut by the Milanese surveyor Cesare Cesariano (1483–1543), showing a figure who not only has a noteworthy erection but also enormous hands and strikingly long feet (ill. p. 158).

Like several authors before and after him, Cesariano interpreted Vitruvius's description from the point of view of the geometry of medieval architecture and related the two figures, circle and square, directly to each other, i.e. the square is exactly contained within the circle. In order for the figure to fit inside this geometric construction, however, it has to stretch out considerably – hence the huge hands and elongated feet. Leonardo, by contrast, did not orient himself towards the geometric relationship between the circle and the square, and in his drawing these two geometric figures are not forcibly related. Rather, he corrected inconsistencies in Vitruvius's proportions on the basis of his own measurements, drawing on the proportions of the human body that he had established by first-hand, empirical observation. Thus the hands and feet in Leonardo's diagram revert to their appropriate size. Only the centre of the *homo ad circulum* now coincides with the navel, whereas the centre of the *homo ad quadratum* is located just above the genitals. By measuring man accurately anew, Leonardo succeeded in moving past the canon of human proportions established in antiquity. His drawing thereby marks a triumph of empiricism over the widely held faith in the authority of classical authors. Furthermore, in his famous, revised

drawing of the *Vitruvian Man*, Leonardo created what remains even today the definitive visual statement of the proportions of the human figure.

The theory of proportion was naturally no invention of Leonardo's. The sculptors of antiquity and the artist workshops of the Middle Ages had all employed certain systems of measurement that, if adhered to more or less accurately, would guarantee a satisfactory rendition of the human figure in sculpture and painting (Nathan/Zöllner 2014, Ch. 6). By the second half of the 15th century, a detailed knowledge of human proportions had already become standard amongst the leading artists of the day, as seen in the case of Antonio (1431/32–1498) and Piero del Pollaiuolo (1443–1496), whose works are clearly based on an intensive study of the measurements of the human body. On the theoretical front, the humanist Leon Battista Alberti (1404–1472) had already developed a canon of proportion in his *De statua*, written before the middle of the century. These earlier efforts by artists and theoreticians, however, fell far short of the standard and accuracy of Leonardo's own studies. Leonardo's anthropometry in turn went far beyond the requirements of normal artistic practice.

Leonardo's interest in an anthropometry of mathematical precision was in part connected with the high regard in which the exact sciences, and with them measurement and geometry, were at that time held. Comparable efforts to establish a "scientific" basis for the fine arts could be found as far back as antiquity: through the rationality of measurement, art too could approach the *logos* and thus a more highly regarded sphere of human activity (Philostratus the Lemnian, *Eikones*, 1.1). The artists and theoreticians of the Quattrocento formed part of the same tradition when they tried to confer the higher status of exact

Cesare Cesariano, **Vitruvian Man**, 1521
From Commentary on Vitruvius, fol. 50r

The Proportions of the Human Figure (after Vitruvius), c. 1490
Pen, ink and watercolour over metalpoint, 344 x 245 mm
Venice, Gallerie dell'Accademia, Inv. 228

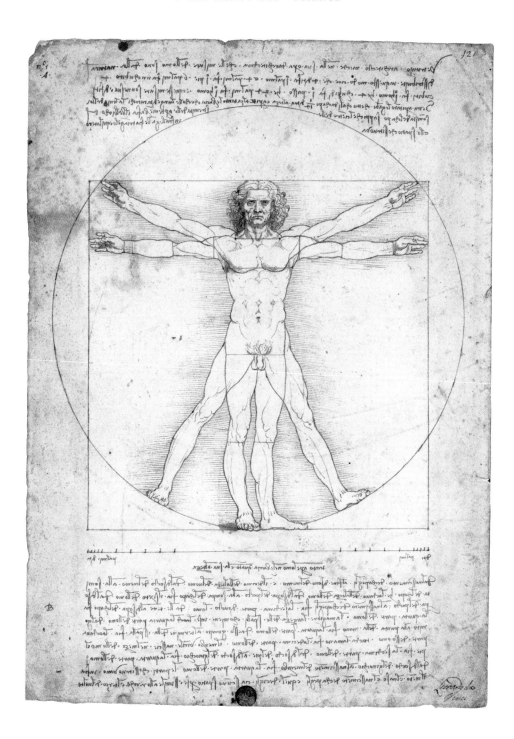

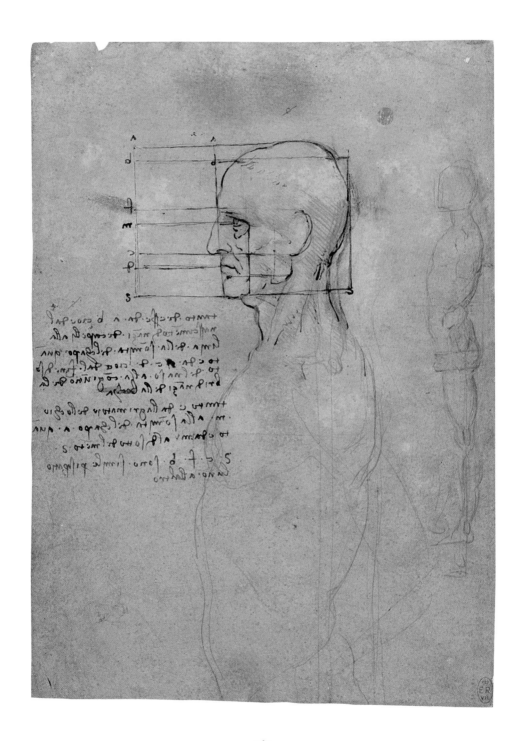

science upon art. Thus Alberti sought to establish a "scientific" foundation for art in the first two books of his treatise *De pictura* of 1435.

Other authors, such as the mathematician Luca Pacioli (*c.* 1445–1514) in the dedication to his *Summa de arithmetica, geometria, proportioni et proportionalita* of 1494, honoured the efforts of artists to attain mathematical exactitude in painting by expressly extolling the merits of painters who used dividers and rulers, geometry, arithmetic and perspective. In his commentary on Vitruvius (fol. 46v) of 1521, Cesare Cesariano also stresses that the study of the exact measurements and symmetries of classical buildings leads to fame and social recognition. Leonardo himself argues for the application of mathematical procedures to painting: number and measurement, synonymous with arithmetic and geometry, guarantee a greater degree of certainty and provide the true basis of painting (McM 33). The ennoblement of painting through arithmetic and geometry was still being recommended even in the 16th century. When Leonardo started taking accurate measurements of the human body in 1489, he was driven by the same idea that artistic activities could be elevated to a new status by their marriage with the exact sciences. It would appear that Leonardo's anthropometry was not without effect, for in his ode on the Sforza monument, the poet Baldassare Taccone expressly lauds his artist colleague as a "geometer" (cf. Ch. IV), a term that in 15th-century usage also implied someone with expertise in the field of surveying.

Leonardo's anthropometry and other efforts to provide art with a "scientific" grounding began in earnest only after his arrival in Milan, and in particular towards the end of the 1480s. Leonardo's own career had started in Andrea del Verrocchio's workshop not with a "scientific" training, however, but with a practical apprenticeship. Leonardo acknowledged this practical background when he described himself as "not a man of letters" (*uomo senza lettere*; RLW § 10), in other words as an uneducated man who had not been schooled in the liberal arts. The altogether seven liberal arts had formed the basis of higher education since late antiquity, and were divided into the *trivium* (grammar, logic and rhetoric) and *quadrivium* (geometry, astronomy, arithmetic and music). Not until the late 1480s in Milan did Leonardo begin devoting a significant proportion of his time to studying the traditional branches of science, for example geometry and Latin grammar, in which he was largely self-taught.

In order to understand why Leonardo should want to further his education, it is necessary to be clear about the social status of fine art in the 15th century. Amongst the literati of the Quattrocento, fine art was seen almost without exception not as a liberal art but as an

Study of the Proportions of the Head and Face, c. 1489/90
Pen and dark brown ink over metalpoint on blue prepared paper, 213 x 153 mm
Windsor Castle, Royal Library (RL 12601)

ars mechanica, an art that was tied to handicraft. Even by the start of the 16th century painting was still not considered a liberal art and was frequently ranked lower than poetry. In view of this situation, it is no surprise that Leonardo should have been anxious to establish his reputation in Milan with the help of theoretical and "scientific" studies. At a more personal level, of course, he thereby sought to compete with the men of letters held in higher esteem than himself at the Sforza court.

Indicative of this rivalry were the problems and polemics that arose out of the unrealized project for the equestrian monument to Francesco Sforza. The earliest documented reference to Leonardo's work on the monument is found in a letter of 22 July 1489, which reveals that the important commission was in immediate danger of being given to another sculptor, since Ludovico Sforza had apparently come to the conclusion that Leonardo wasn't up to the job (cf. Ch. IV). When the Milan literati also seized upon the monument as a target for their criticism, Leonardo must have felt his role as a fine artist challenged yet again. July 1489 namely saw the translation into Italian of Giovanni Simonetta's *De gestis Francisci Sphortiae*, a eulogy to Francesco Sforza. The dedication to this Italian edition was written by Francesco Puteolano, who used the occasion to stress the superiority of literary creations over works of fine art. Puteolano expressly pointed out that the memory of great rulers and generals of the past, such as Alexander the Great and Julius Caesar, had been preserved not by monumental works of art but thanks to writers and historians. Small books had guaranteed these men more enduring protection from oblivion than monuments created from the most expensive materials. A ruler was not preserved in the *memoria* of posterity by statues and pictures, which as a rule rapidly deteriorated or were even destroyed and which attracted only criticism – thus Puteolano in his long-winded preface. Possibly as a reaction both to this line of argument and the threat of losing the commission for the equestrian monument to another artist (cf. Ch. IV), in August 1489 Leonardo asked the humanist Piattino Piatti to compose some poems in praise of the work still to be completed. Perhaps he hoped to be able to counter Puteolano's polemics with Piatti's poetry.

Puteolano's remarks unmistakably express an open rivalry between the artists and writers at the Milan court. His comparison, for example, of the eternal *memoria* bequeathed by literary works with the less enduring testament of fragile works of art could not be clearer. Nor is it possible to overlook his allusion to the plans to cast the monumental equestrian statue of Francesco Sforza in costly bronze. In 1489, therefore, both the imminent threat of losing this commission and the doubts cast on the efficacy of fine art

Anatomical Study of the Layers of the Brain and Scalp, c. 1490–1493
Pen, two shades of brown ink and red chalk, 203 x 152 mm
Windsor Castle, Royal Library (RL 12603r)

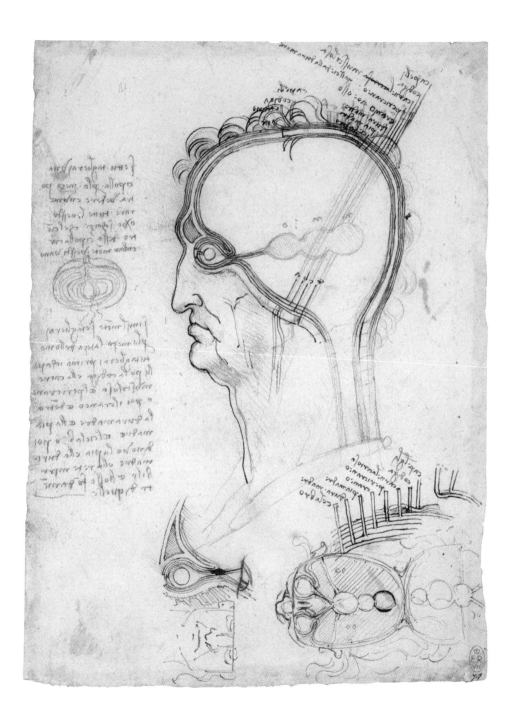

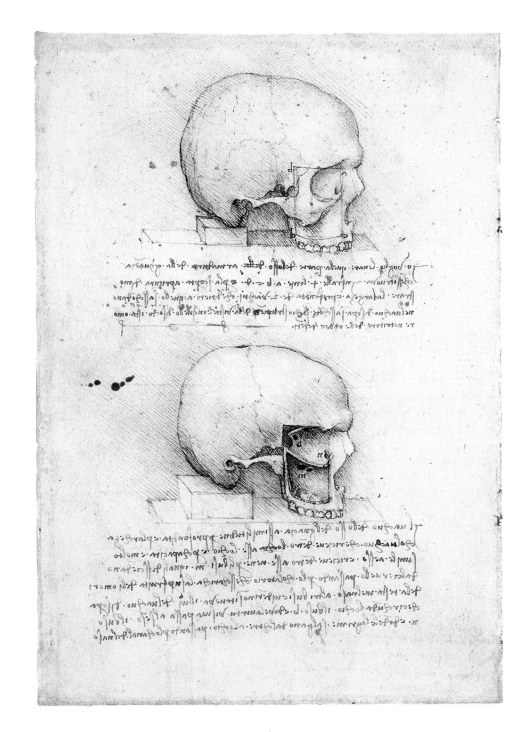

by the writers at the Milanese court cast a radical question mark over Leonardo's social status as an artist. It is probably no coincidence that Leonardo should, at this point in time, intensify his researches into proportion and other spheres of knowledge in which he hoped to make a name for himself both as a scientist and an artist. This same period lastly also provided the stimulus for the *Paragone*, the comparison of the arts conducted by Leonardo at the start of his treatise on painting. The fierce dispute being conducted in polemical form between the writers and the artists attached to the Milan court, in which each sought to prove their métier to be superior to that of their opponents, reached an initial climax around 1492 – precisely the period during which Leonardo composed the introduction to his *Trattato di pittura*, in which he takes issue with the poets and writers who had inveighed against the enduring value of fine art. Writing with extraordinary vehemence, Leonardo compares them with "beasts" (RLW § 11/MK 2) and argues against the classification of fine art as one of the lower "artes mecanicae" (RLW, *Paragone*, 9–12, and TPL 19). It is in the light of all these factors, therefore, that Leonardo's intensive efforts to establish a "scientific" grounding for the fine arts must be understood.

Alongside his investigations into the proportions of the human figure, Leonardo ventured even further into the realms of "science" with the anatomical and physiological studies on which he also embarked in grand style towards the end of the 1480s. These years, for example, saw him studying the dimensions of the human skull as well as the different "ventricles" of the brain (ills. pp. 163, 164, 167), even if he thereby allowed himself to be guided in essence by the incorrect but nevertheless widespread theories propounded in antiquity and the Middle Ages. Thus Leonardo accepted the notion of the so-called *senso comune* – literally "common sense", but in those days thought of as the central switchboard of the brain (see below) – and in line with contemporary thinking assigned it a specific location within the brain. Explanatory notes accompanying one of his drawings (ill. p. 166) make this location clear: "Where the line *a–m* is intersected by the line *c–b*, there will be the confluence of all the senses, and where the line *r–n* is intersected by the line *h–f*, there the fulcrum of the cranium is located at one third up from the base line of the head." Leonardo was thus attempting to apply the principles of anthropometry to the inside of the skull, something yet to be measured with any empirical accuracy. Just as it was possible to determine the measurements of the visible outer parts of the body, so, too, the location inside the body of such an important organ as the *senso comune* was calculated with mathematical precision.

Anatomical Study of the Human Skull in Side View,
showing the Eye Sockets and Maxillary Sinus, 1489
Pen and brown ink over black pencil, 188 x 134 mm
Windsor Castle, Royal Library (RL 19057v)

As well as plotting the exact position of "common sense", Leonardo also identified the location of the other functions of the brain. In a drawing showing vertical and horizontal sections of the human head (ill. p. 163), he takes up traditional medieval notions of the different compartments of the human brain, which he envisages as three chambers the size of nutshells arranged one behind the other. The first of these three chambers contains the *imprensiva*, where sense impressions are received, the second the *senso comune*, and third the *memoria* or memory. An even more striking anatomical misapprehension that Leonardo took over from antiquity and the Middle Ages is evident in his so-called coitus drawings (Nathan/Zöllner 2014, Cat. 364, 366; ill. p. 155). In his representation of sexual intercourse, Leonardo draws upon contemporary thinking and the physiology enshrined in the *Corpus Hippocraticum* in depicting the ways in which the internal organs of the human body interconnect. Thus a tube-like duct leads from the woman's breasts to her womb, while the male organ is directly linked not only to the testicles but also to the lungs and the spinal cord, and hence to the brain. The sketches at the bottom of the sheet, showing a cross section and a longitudinal section of the penis, accordingly portray two channels, the lower for the sperm from the testes and the upper for the spiritual powers transported from the brain along the spinal cord. In his later anatomical drawings, which were based on extensive studies of dissected corpses, Leonardo increasingly questioned these antiquated notions of the human anatomy and how it functions.

Leonardo's conviction that the inner organs of the human being were closely interconnected reflects a highly complex understanding of human nature. The two channels in the penis, for example, illustrate the view that there were two ingredients necessary for procreation: in addition to sperm, a spiritual substance was also required. This spiritual substance, which ultimately came from the very seat of the soul, was thought to carry higher intellectual and spiritual qualities, while the sperm from the testicles, with its own specific make-up, was responsible for baser urges, although also for such properties as courage in battle. Similar notions of the effect and function of bodily substances also informed Leonardo's thinking on tears, which he believed came directly from the heart as the seat of all feeling (RL 19057v).

Anatomical Studies of the Human Skull: Sagittal Section in Side View, 1489
Pen and two shades of brown ink over black chalk, 188 x 134 mm
Windsor Castle, Royal Library (RL 19057r)

Pages 168/169
Detail of **Torso of a Man in Profile, the Head Squared for Proportion,
and Two Horsemen,** c. 1490 and c. 1504
Pen and ink and red chalk over metalpoint, 280 x 222 mm
Venice, Gallerie dell'Accademia, Inv. 236r

LIONARDO DA VINCI.

In order to appreciate the full significance of the physiological notions encountered so far, we must take a closer look at just how Leonardo thought the brain, and in particular the *senso comune*, actually worked. At the heart of this physiology, which presupposes that the processes of the soul exert a direct mechanical influence upon the body and its functions, lie Leonardo's views on the functioning of the brain (ill. p. 163). To Leonardo's understanding, the things perceived by the five senses are sent first to the *imprensiva*, which is no more than a temporary holding centre. The impressions received here are then transferred to the *senso comune* for correlation and evaluation, before finally being stored in the *memoria*, where they "are more or less retained according to the importance or force of the impression" (RLW § 836).

To Leonardo's way of thinking, the "common sense" is also responsible for the physical expression of mental states, for on the one hand it is the seat of the soul, and on the other it holds sway over the body's means of expression, such as gesture and mien, through the influence it is able to exert on muscles, sinews, tendons and nerves (RLW § 838). The commands issuing from the *senso comune* are thereby conveyed to the organs that are to execute them by means of a vehicle termed a "spirit" (*spirito*). The spirit itself is an incorporeal quality that cannot express itself without a body and hence needs nerves and muscles to produce movements in an animate being (RLW § 859, 1212, 1214).

Leonardo's reflections on the direct links between the spirit and the external features of the body also find their way into his studies of human physiognomy, which similarly presuppose an immediate connection between cause and effect. This immediacy was something the artist sought to illustrate in his countless character heads and caricatures. These drawings – often more grotesque than realistic, and frequently juxtaposing a number of different facial types (Nathan/Zöllner 2014, Cat. 192–225; ills. pp. 170, 172/173, 177) – express the idea that the human face is a direct reflection of an individual's underlying character and feelings in that moment. According to this view, a man whose face resembles that of a lion in all probability shares the characteristics of the same animal. Leonardo takes up this physiognomic cliché in one of his studies, in which he portrays a man with leonine features wearing a lion-skin flung across his shoulder, the lion's head clearly visible (ill. p. 177).

Grotesque Portrait Study of a Man, c. 1500–1505
Black chalk, reworked by foreign hand (pricked), 390 x 280 mm
Oxford, Governing Body, Christ Church, Inv. JBS 19

Pages 172/173
Detail of **Five Grotesque Heads**, c. 1490
Pen and ink, 261 x 206 mm
Windsor Castle, Royal Library (RL 12495r)

Jacques Daliwe, **Character Heads (Christ and two Apostles?)**, c. 1400
Silverpoint on brownish prepared paper, 88 x 129 mm
Staatsbibliothek zu Berlin, Handschriftenabteilung, Libr. pict. A 74, fol. Va

The same idea also underlies Leonardo's famous drawing of five grotesque heads (ill.
pp. 172/173): an old man seen in profile is surrounded by four other men, whose power-
fully expressive features reveal widely differing and, by implication, negative characteris-
tics. They seem to be mocking the man in the centre, who stoically endures their jeering
– his own face undistorted but nevertheless deeply lined and etched by the hand of fate.
Such assemblies of different faces and characters were also a feature of pattern drawings of
the type that have come down to us from workshops north of the Alps. Amongst sheets
of character heads by Jacques Daliwe (active *c.* 1380–1416), for example, we find *Susanna and
the Elders* depicted in a similar fashion (ills. pp. 174, 175).

With his studies into the proportions, the anatomy and the physiology of the human
body, Leonardo had far from exhausted the spectrum of his interests. Again probably
from the end of the 1480s onwards, he also devoted himself to other projects, which had
absolutely nothing to do with art. These included not just the war machines encountered
earlier (cf. Ch. IV; Nathan/Zöllner 2014, Ch. 14 and Cat. 562–593; ill. p. 179), but also
designs for flying machines and studies of bird flight (Nathan/Zöllner 2014, Cat. 594–645).

Jacques Daliwe, **Character Heads (Susanna and the Elders)**, c. 1400
Silverpoint (?) on brownish prepared paper, 88 x 129 mm
Staatsbibliothek zu Berlin, Handschriftenabteilung, Libr. pict. A 74, fol. VIb

The question of whether Leonardo could ever have got off the ground in any of these devices is of little interest. The artist was probably fully aware of the problems any such attempt would have entailed, for the material weight of some of his machines was alone sufficient to keep them firmly on the ground. He nevertheless returned repeatedly to studies of bird flight, the aerodynamics of flying and the construction of wings. Curiosity and imagination clearly spurred him to execute studies and designs that went far beyond the technological capabilities of his own day (Nathan/Zöllner 2014, Ch. 15). Such was Leonardo's perseverance that one might speak, in his case, of a triumph of "scientific" curiosity over the prospects of practical success. These studies are also indirect evidence of a certain, albeit still modest, prosperity, since Leonardo clearly had the time and financial means to explore areas of knowledge that were more likely to entail costs than to bring money in.

On the basis of what payments Leonardo accumulated his modest savings in the 1490s is not altogether clear, since surviving records are both incomplete and contradictory. Thus Luca Pacioli claims in his *Divina proportione* that Leonardo received only a regular salary as

court artist as from 1496 (!), although this does not necessarily mean that the artist was better paid from this point onwards than he had been in previous years. Leonardo's income certainly fluctuated widely, ranging – it is estimated – between 50 and over 100 ducats a year. Nor were artists working for a court always paid regularly in cash; they were occasionally presented with gifts instead. The pros and cons of such a system of remuneration, which depended directly upon the humour and goodwill of the prince concerned, were experienced by Leonardo at first hand. In a lengthy draft of a letter written in 1495/96, he complains about the fact that he still has not been paid: for a period of 36 months he has received only 50 ducats (200 lire), with which it has barely been possible to maintain six people. His salary for two years is still outstanding, and he has been forced to pay for expensive assistants out of his own pocket. In another such draft, he again requests the *premio del mio servizio*, the "reward of my service" (RLW § 1344–1345).

From all appearances, it would seem that during this period – roughly the years 1494 to 1496 – neither the annual salary due to the artist and his workshop, nor individual fees relating to particular projects, were paid regularly or in full. This is confirmed by Leonardo's private accounts, as far as they can be reconstructed. By 1492 the artist had accumulated around 200 ducats (811 lire) and by 1493 had boosted his reserves to 300 ducats – an increase of 50 per cent. This percentage growth was not matched over the following years, however. Thus although Leonardo's cash savings totalled 600 ducats (2400 lire) by 1499, this actually translates into a lower annual growth rate and is possibly a clue that Ludovico Sforza had been feeling less generous towards him. In the spring of 1499, in fact, Ludovico expressly remarked that he had not paid Leonardo enough and that he intended to remunerate him better in future. That same spring he made the artist a gift of a vineyard just outside Milan, whose market value a few years later was taxed at 1100 *lire imperiali*, an amount three or four times higher than the annual salary of a senior official or a university professor. If Leonardo complained about being badly paid, he was still better off than most. Without a relatively solid financial basis, he could not have afforded to keep going without payment, nor would he have had time to spare for his "scientific" studies. Even if it was often late in being paid, it was the income he earned from his many activities as court artist that made it possible for Leonardo to strive towards the universal knowledge for which he would subsequently become famous.

Character Head of an Older Man and Sketch of a Lion's Head, c. 1505–1510
Red chalk with white heightening on pink prepared paper, 183 x 136 mm
Windsor Castle, Royal Library (RL 12502)

*To preserve Nature's chiefest boon, that is freedom, I can find
means of offence and defence, when it is assailed
by ambitious tyrants [...] and also I shall show how communities
can maintain their good and just Lords.*

LEONARDO DA VINCI, RLW § 1204

**Study with Hoist for a Cannon in an
Ordnance Foundry**, c. 1487
*Pen and ink on brownish prepared paper, 250 x 183 mm
Windsor Castle, Royal Library (RL 12647r)*

From the *Last Supper* to the fall of Ludovico Sforza

1495–1499

It had a melancholy and delicate palette, rich in shadows, without éclat in the bright colours, and triumphing in the chiaroscuro which, had it not existed, would have had to have been invented for such a subject [the "Last Supper"].

HENRI STENDHAL, 1817

Leonardo's reputation in Milan was firmly cemented by the portraits that he painted for the court and by his work on the equestrian monument to Francesco Sforza. It was in his capacity as court artist that he also created undoubtedly the most famous work of his first Milanese period, the *Last Supper* (Cat. XVII/ill. pp. 186/187). Probably commissioned by Ludovico Sforza, the painting was executed between 1495 and 1497 in the refectory of the monastery Santa Maria delle Grazie. None other of Leonardo's works attracted such immediate and rhapsodic praise from his contemporaries as his *Last Supper*. Amongst the first to comment on it was Leonardo's friend Luca Pacioli, who had followed its progress throughout and who wrote an enthusiastic description of it immediately after its completion. Above all, he praised the painting's fidelity to life: it was "not possible to imagine the apostles more agitated upon hearing the voice of unfailing truth, when Jesus said: 'One of you shall betray me'. In their poses and their expressions, they seem to be speaking one to another and this one to that with vigorous astonishment and dismay, as so worthily composed by the skilful hand of our Leonardo." Antonio de Beatis was no less impressed when he visited the Dominican refectory in December 1517, and described the painting as follows: "It is most excellent, although it is beginning to deteriorate – I don't know whether because of the damp in the wall or because of some other inadvertence. The persons in this Last Supper are portraits painted from life of several people at court and of Milanese citizens of the day, in life size. You can also see a sacristy very rich in brocade paraments, similarly donated by the said Ludovico."

The fascination exerted by the *Last Supper* from a very early stage is also documented some ten years later by Paolo Giovio (1483–1552), who – after complaining about Leonardo's "scientific" studies, which had kept him away from painting – goes on to write: "Greatly admired in Milan, nevertheless, is a wall-painting of Christ dining with his disciples. King Louis of France is said to have been so taken with this work that, contemplating it with profound emotion, he asked those around him whether it was possible to remove it from the wall and take it back to France, even if it meant destroying the famous refectory." These early descriptions of Leonardo's wall-painting raise two of the themes that, over the following centuries, would dominate the discussion of the *Last Supper*, namely the rapid deterioration of the work, which was executed in a not very durable tempera technique, and the remarkably varied and life-like poses and gestures of Christ's disciples.

Known the world over in countless copies, reworkings and reproductions (ill. p. 205), Leonardo's *Last Supper* remains the most famous version of its subject. Like the Florentine artists before him, Leonardo portrays the Last Supper in a stage-like setting constructed according to the rules of centralized perspective. The orthogonal lines thereby converge in Christ's head, emphasizing the Saviour's central position within the scene. Leonardo concentrates his composition upon the moment when Jesus sits down with his disciples and

Unknown artist, **The Last Supper**, 1476
Woodcut, 254 x 352 mm. Milan, Raccolta Vinciana

Page 181
Detail of the **Last Supper**, c. 1495–1497
(ill. pp. 186/187)

declares: "Verily I say unto you, that one of you shall betray me" (*Amen dico vobis, quia unus vestrum me traditurus est;* Matthew 26:21). The shock and horror with which this announcement is greeted by virtually all the disciples are expressed in a wide range of gestures and reactions: at the far left end of the table, Bartholomew rises from his chair in indignation, while beside him James the Younger and Andrew raise their hands in astonishment. Peter has also partly risen from his chair and is looking angrily towards the centre of the picture. In front of him is the traitor Judas, recoiling in shock and with his right hand clutching the pouch containing the money he has been paid to betray Christ. For the first time in the history of post-medieval Last Suppers, Judas is sitting not in front of the table, but behind it. He thereby appears immediately next to John, whose reaction is somewhat muted (he does not yet know he is sitting next to the traitor) and who casts his gaze downwards, almost contemplatively, with folded hands.

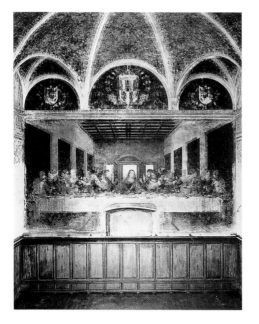

Comparatively motionless in the centre of the composition, framed by the opening behind him, sits Jesus himself. He is flanked on his other side by two more groups of three disciples: Thomas, James the Elder and Philip, followed further right by Matthew, Thaddaeus and Simon. Leonardo's *Last Supper* is exceptional in several respects. It is one of only a handful of paintings executed in Lombardy between 1430 and 1499 that are located in a refectory and that at the same time clearly portray the moment when Jesus announces his impending betrayal.

In contrast to similar works by his immediate contemporaries, Leonardo imbues the scene with life both by clustering the twelve apostles into four distinct groups and by endowing his figures with precisely calculated gestures and expressions. Last Suppers by other artists from the same period reveal none of the dramatic intensity of Leonardo's scene (ill. p. 183). Sketches, studies and preparatory drawings relating directly to the final composition (Nathan/Zöllner 2014, Cat. 19–26; ills. pp. 192, 194, 196, 198), as well as eyewitness reports, all confirm the fact that the artist went to extraordinary lengths to achieve a particularly expressive range of gestures and facial expressions.

Leonardo's efforts were clearly so unusual and so widely reported amongst his contemporaries that Giovanbattista Giraldi (1504–1573) still writes about them decades later: "Whenever Leonardo wanted to paint a figure, he first thought about [that person's] qualities and nature, i.e. about whether they were noble or common, cheerful or stern, troubled or happy, old or young, angry or calm, good or bad. And when he had established their character, he went to where he knew people of this kind would be gathered, and diligently observed their faces, their mannerisms, their dress and the movements of their bodies.

Unknown artist, **Photo of the north wall of the Refectory**
Milan, Santa Maria delle Grazie

Preliminary Sketch for the *Last Supper*, c. 1495
Pen and ink, 266 x 215 mm. Windsor Castle, Royal Library (RL 12542)

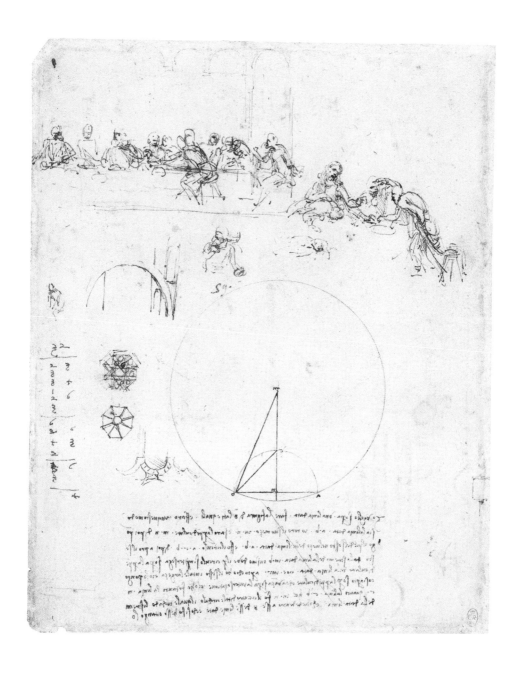

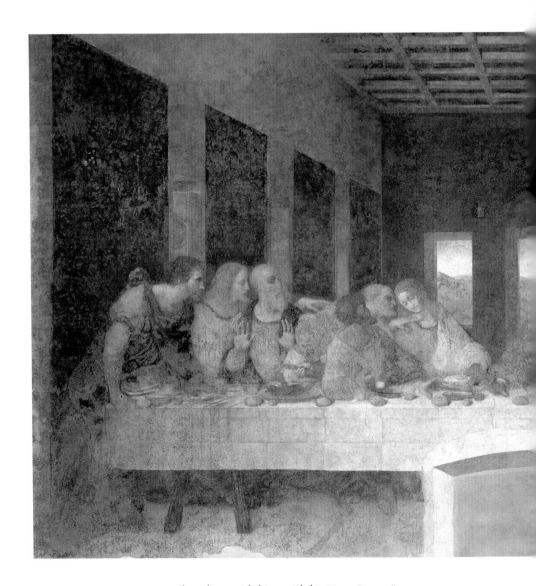

I enjoyed working with him, with his "Last Supper",
but nowadays there are no artists who can be
compared with his genius; the new Leonardos are Armani,
Krizia and the other Italian designers.

ANDY WARHOL, 1987

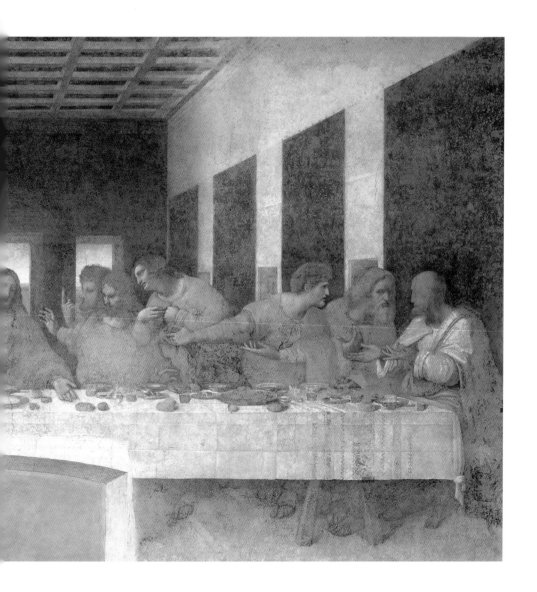

Pages 186–191
The Last Supper, c. 1495–1497
Tempera on plaster, 460 x 880 cm. Milan, Santa Maria delle Grazie, Refectory

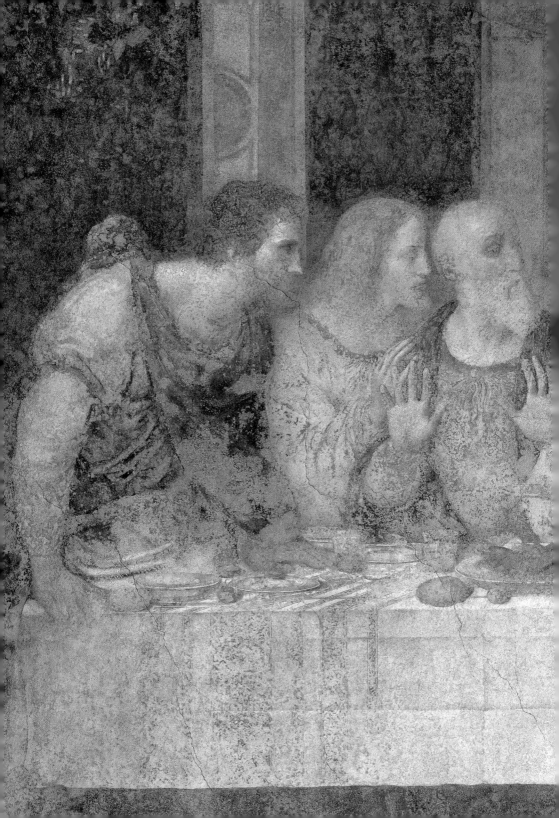

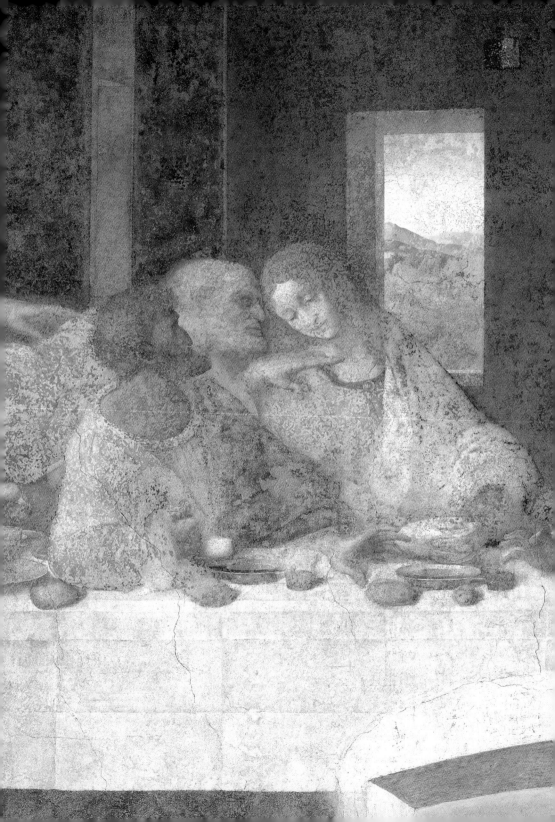

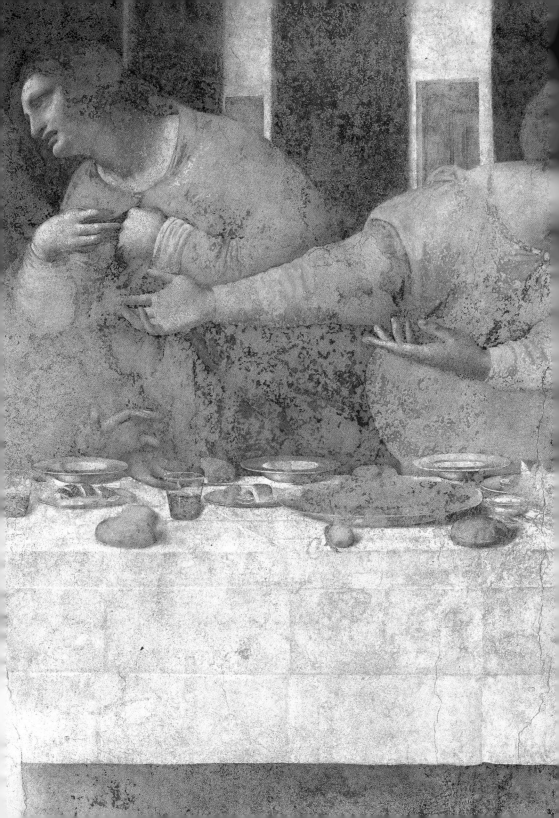

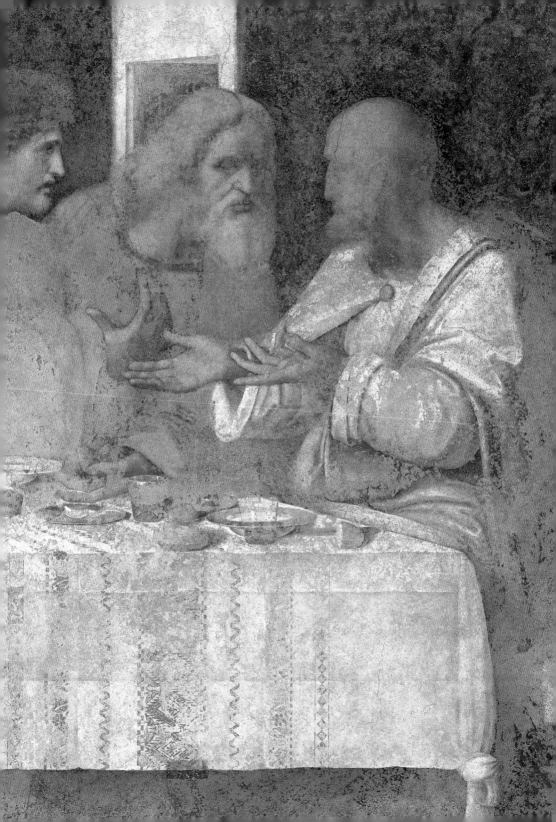

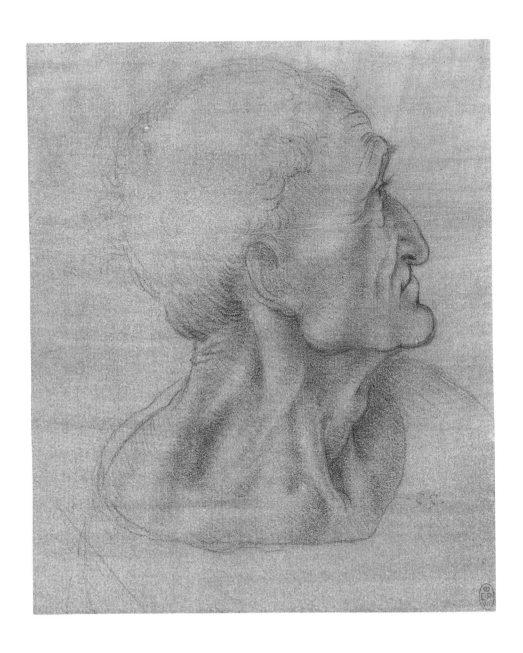

Study for the *Last Supper* (Judas), c. 1495
Red chalk on reddish prepared paper, 180 x 150 mm. Windsor Castle, Royal Library (RL 12547r)

Detail of the
Last Supper: Judas, c. c. 1495-1497

Study for the *Last Supper* (St James the Elder), c. 1495
Red chalk, pen and ink, 250 x 170 mm. Windsor Castle, Royal Library (RL 12552r)

Detail of the
Last Supper: St James the Elder, c. c. 1495-1497

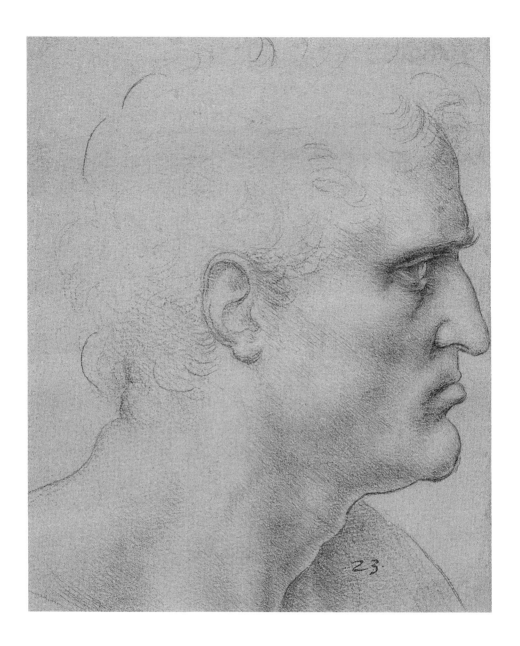

Study for the *Last Supper* (St Bartholomew), c. 1495
Red chalk on reddish prepared paper, 193 x 148 mm. Windsor Castle, Royal Library (RL 12548r)

Detail of the
Last Supper: St Bartholomew, c. c. 1495-1497

Study for the *Last Supper* (St Philip), c. 1495
Black chalk, 190 x 150 mm. Windsor Castle, Royal Library (RL 12551r)

Detail of the
Last Supper: St Philip, c. 1495-1497

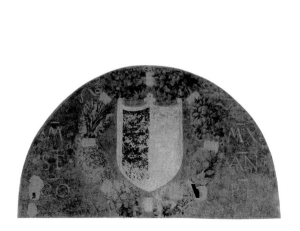

And when he had found something that was suitable for his purposes, he recorded it with a pen in a notebook that he always wore on his belt. And when he had done this many, many times and had gathered what seemed to be enough for his painting, he started to fashion it, and he made it succeed marvellously. Even assuming this is what he did in all his works, he did so with particular diligence in the picture that he painted in Milan in the monastery of the Friars Preacher, in which our Saviour is shown seated at table with his disciples."

Giraldi's detailed description is fully confirmed by Leonardo's writings. In the treatise on painting, which he commenced around 1490, Leonardo wrote that, when out for a walk, a painter should observe the poses and faces of the people around him and jot them down in a notebook. The motifs of movement and expression captured in this way would lead on to rough compositions (*componimento inculto*), which could then be developed and perfected (TPL 290, 173, 179, 189). That these recommendations were rooted in Leonardo's own practice is suggested by notes he made during the early stages of his work on the *Last Supper*. In a notebook today known as the Codex Forster (RLW § 665–667), he wrote down the names of several people whose hands and faces he wanted to use in the *Last Supper*. In the same manuscript he also describes the very wide-ranging reactions of the disciples to Christ's announcement that he is to be betrayed – the scene, in other words, which he would portray in the final composition.

It is interesting in this context to examine to what extent the descriptions in Leonardo's notebook correspond to the reactions displayed by the disciples in the final painting, executed shortly afterwards. In the following passage, for example, Leonardo explores ideas for two of his figures: "One who was drinking has left his glass in its place and turned his head towards the speaker. Another wrings the fingers of his hands and turns with a frown

to his companion" (MK § 579). None of the figures in the final composition in fact appears exactly as described here. Only John, to the left of Christ, has his fingers intertwined and is inclining his head towards the group formed by Judas and Peter, albeit without raising his brows. Further poses outlined in Leonardo's notes similarly bear only a partial resemblance to those adopted by the disciples in the final painting: "Another with hands spread open to show the palms shrugs his shoulders up his ears and mouths astonishment. Another speaks into his neighbour's ear, and the listener twists his body round to him and lends his ear while holding a knife in one hand and in the other some bread half cut through by a knife" (MK § 579). This description applies to a limited extent to Andrew, who is raising his hands, at least, while James the Younger perhaps whispers something in his ear. The knife mentioned in the notebook appears in Peter's left hand, although the cut loaf is not in his other hand. The figure of Peter corresponds to some degree to another note by Leonardo: "Another draws back behind the one who inclines forward [i.e. Judas in the painting] and has sight of the speaker between the wall and the leaning man" (MK § 580).

Some of the other figures whom Leonardo describes in lively terms in his notes must have struck him as unsuitable for inclusion in the final composition. Thus he mentions one disciple who has upset a glass and spilled its contents on the table, another who is staring and a third who is shading his eyes with his hands. This last figure does not appear in the *Last Supper* itself, but can be identified in a preliminary sketch (ill. p. 185). It was evidently dropped from the final composition. In place of the glass described as being knocked over

Three lunettes above the *Last Supper*, c. 1495/96
Tempera and oil on plaster, width at base 335 cm (central lunette) and 225 cm (left and right-hand lunettes)
Milan, Santa Maria delle Grazie, Refectory

by a disciple, we can see in the painting that Judas, in his violent reaction, has upset a small container of salt. The fact that the final composition deviates from the ideas set down in Leonardo's notebook sheds significant light on his working method. This method on the one hand involved painstaking preparations in the shape of numerous notes and drawings, yet on the other hand allowed for spontaneous departures from all his plans. The comparison between Leonardo's notebook entries and his finished wall-painting also testifies to the fact that the artist had already decided at an early stage to portray the moment when Christ announces that he is to be betrayed.

The meticulous care with which Leonardo planned the *Last Supper* is also evidenced by his studies for the faces of James the Elder, Philip, Judas, Bartholomew and Peter (ills. pp. 192, 194, 196, 198). He thereby took up some of the facial types that had already appeared in his earlier *Adoration of the Magi* – an angelic youth in the case of the study for Philip the Apostle, and a bearded old man with a furrowed face for Peter (this study was never used, however). At least in the early stages of the *Last Supper*, therefore, Leonardo was employing a figural repertoire that was not entirely new. The desire to redress this deficit may well have been the reason why he devoted so much time to assembling a wider variety of figural types, especially since he considered it a grave error to repeat the same figures and physiognomies within one and the same composition. As Leonardo argued in his treatise on painting: "It is an extreme defect when painters repeat the same movements, and the same faces and manners of drapery in the same narrative painting and make the greater part of the faces resemble that of their master […]" (McM 86).

Leonardo was not the only one to condemn the repeated use of the same figural types. Between 1497 and 1499, one of his contemporaries, the Milanese court poet Gaspare Visconti, also complained about an unnamed painter who ignored a fundamental rule of artistic decorum. Just as there had once been a painter, as described by the poet Horace, incapable of drawing anything but a cypress, so this artist was only capable of painting himself, even when he was supposed to be portraying something else entirely. He painted not just his handsome face, but even his gestures and movements. He too lacked the discipline necessary to achieve concentrated results. Freely translated, the sonnet runs as follows:

"There was once a painter who knew
only how to paint a cypress,
just as Horace writes in his verses
in order to teach us poetry.
And in our own times there is one
who holds firmly in his mind his own image,
and when he paints others, it often happens
that he paints none other than himself.

And not only his face, however handsome it may be,
does he paint with the greatest skill,
but also his own actions and ways.
In truth, he puts off what is urgent,
for his mind wanders aimlessly around,
whenever the moon commands him.
In order to create poetry
and also to master an entire work,
he lacks the shackles of discipline."

Visconti's lines, with their reference to the involuntary tendency of the painter to portray himself, express in the language of poetry the familiar Tuscan saying *Ogni pittore dipinge sé* – every painter paints himself. It was a tendency that Leonardo – the most prominent Tuscan artist at the Milan court during the period in which this sonnet was written – had been denouncing since *c.* 1492. There can be no doubt, therefore, that Visconti's polemic is aimed directly at Leonardo. Just how emphatically Leonardo sought to caution artists against this tendency towards self-portrayal emerges from passages in his treatise on painting. "A painter who has clumsy hands will paint similar hands in his works, and the same will occur with any limb, unless long study has taught him to avoid it. Therefore, O painter, look carefully what part is most ill-favoured in your own person and take particular pains to correct it in your studies. For if you are coarse, your figures will seem the same and devoid of charm; and it is the same with any part that may be good or poor in yourself; it will be shown in some degree in your figures […]; and if you should be ugly, you would select faces that were not beautiful and you would then make ugly faces, as many painters do. For often a master's work resembles himself" (RLW § 586–587).

This tendency towards involuntary self-portrayal, which is today known under the name of automimesis, can be countered, however, once its cause has been identified. Leonardo wrote on this subject several years later: "Having often considered the cause of this defect, it seems to me one must conclude that the soul which rules and directs each body is really that which forms our judgement before it is our own judgement. Thus it has developed the whole shape of a man, as it has deemed to be best with long, or short, or flat nose, and definitely assigned his height and shape. This judgement is so powerful that it moves the painter's arm and makes him copy himself, since it seems to that soul that this is the true way to construct a man […]" (McM 86).

The soul thus exerts a determining influence both on the outer form of the body and on the way that body performs a task such as painting, for example. The artist, steered by the soul, paints his figures exactly as his soul once shaped his own body. The artist's cre-

ative process has to be expressed using essentially the same physiological vocabulary as his own body, and leads him perforce to reproduce himself involuntarily and unintentionally in his work. Thus every artist always paints the same type, one which resembles his own figure. The painter can successfully counter this tendency, however, by deliberately re-programming the human brain and in particular by manipulating the data perceived with the five senses. Since these data are passed for processing to the *senso comune*, the central agency of the soul (cf. Ch. V), they can be used to implant new ideas, which will check the tendency towards self-portrayal dictated *a priori* by the soul. Should the artist make a particular study of figure drawing, for example, the *senso comune* assimilates what he thereby learns. By deliberately teaching himself to draw figures that look the very oppo-site of himself, therefore, the artist can build up resistance to the compulsion to portray himself. A fat painter thus ought to draw thin figures and vice versa, or better still figures of perfect physical proportions. Leonardo offers the following advice on the matter: "The painter ought to make his [model] figure according to the rule of a natural body, which is commonly thought to be praiseworthy in its proportion. Furthermore, he should measure himself and ascertain in what part his person varies much or little from that already termed praiseworthy, and when he has secured this knowledge, he protects himself through all his study from falling into the same faults in the figures created by him, which are found in his person. You must know that you have to fight to the last against this bad habit, since it is a defect that was born at the same time as your judgement" (McM 87).

Detailed study and use of perfectly proportioned figures are not the only weapons in the fight against automimesis, however. In addition to the intensive education of the brain, Leonardo also names another, less arduous means of manipulating one's inner judgement – by taking short walks in the countryside. These expose the artist's mind to the rich diversity of nature, and his observation of the various objects along the way will enable him to build up a reservoir of valuable and less valuable things (TPL 56). Even Leonardo's seemingly light-hearted recommendation that the artist should give his mind a rest from assiduous study and allow it to wander freely has its roots in the artist's actual practice, as we know from independent sources. It may have been this recommendation that prompted Gaspare Visconti to level at Leonardo his not entirely serious accusation of lack of discipline (see above). That Leonardo had a relaxed rather than disciplined manner of working also emerges from the account by Matteo Bandello (b. 1485), who was attached to the monastery of Santa Maria delle Grazie until 1501 and may be considered an eye-witness. In the preface to the 58th novella in his collection of novellas published in 1554, he writes on Leonardo's *Last Supper* and the Sforza monument as follows: "It might also happen, however, that he did nothing on it for two, three or four days; nevertheless he sometimes spent one or two hours there simply contemplating, considering and carefully assessing his figures. I also saw how, on a sudden urge or whim, at midday and with the

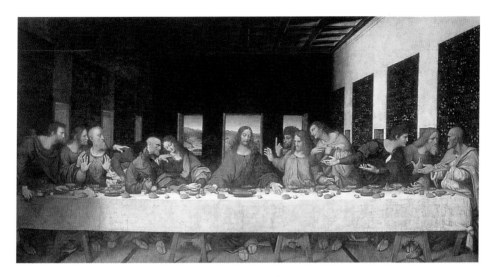

Unknown 16th-century artist, **Copy of Leonardo's *Last Supper***
Oil on canvas, 418 x 794 cm. Tongerlo, Da Vinci Museum

sun at its zenith, he left the Old Court, where he was working on the marvellous horse of clay, and hastened to Santa Maria della Grazie, mounted the scaffolding, took up his brush and added one or two strokes to one of the figures, and suddenly departed and went off somewhere else." As in the case of Giovanbattista Giraldi, here too a contemporary source provides confirmation of the working process described by the artist in his own notebooks.

Ever since Leonardo's contemporaries first set eyes upon the *Last Supper*, attention has repeatedly focused upon Leonardo's masterly portrayal of the reactions of Christ's disciples and the lamentable deterioration of the painting as a whole. Equally interesting, however, is the question of the physical context of the painting, which was part of a large decorative programme. Since Leonardo executed the *Last Supper* on its north wall, the refectory, which measures some 35 metres long and just about 9 metres wide, has altered in shape (ill. p. 184). The windows of the vaulted room were originally much smaller, and the floor level was somewhat lower. The original decoration of the room has also seen changes. Partly lost are ornamental bands along the longer sides of the room containing portraits of saints and beatified individuals connected with the Dominican order, accompanied by inscriptions. These inscriptions, which are largely taken from the Bible, can be read as a sort of continuous text; they are mutually related and emphasize above all the importance of the communal meal. Through their content, the inscriptions on the two longitudinal walls thus establish a connection with the *Last Supper* on the north wall, where the communal meal itself is depicted.

Unknown artist, **Copy of Leonardo's *Last Supper*,** 1498
Copperplate engraving, 322 x 425 mm. Vienna, Graphische Sammlung Albertina, Inv. 1952/366a

There are further connections between the *Last Supper* and the lunettes on the wall above it (Cat. XVIII/ill. pp. 200/201), containing the joint arms of Ludovico Sforza and his wife in the middle and those of his eldest son, Massimiliano, on the left-hand side. The inscription accompanying the lunette on the right refers to the duchy of Bari, which was conferred upon Ludovico's second-born son, Francesco, in 1497. Directly above the *Last Supper*, therefore, are heraldic portraits, so to speak, of the donor's family. The Sforza also appear on the south wall in the *Crucifixion with Donors* (ill. p. 209) completed in 1495 by Giovanni Donato Montorfano (*c.* 1460–1502/03). Kneeling on either side of the fresco in the form of donor portraits are Ludovico Sforza and his eldest son Massimiliano on the left and his wife Beatrice and younger son Francesco on the right (today barely visible). The donor and his family thus inserted themselves into the sacred pictorial programme by means of portraits and coats of arms.

One reason for the massive presence of the Sforza in the refectory of a Dominican monastery emerges from the history of the Santa Maria delle Grazie complex, which was

built after 1460. In 1492 Ludovico had the newly completed choir of the church altered to provide a last resting place for his family. The choir and further parts of the church interior thereby became a mausoleum for the Sforza and their political allies. As the burial place of the ruling family, Santa Maria delle Grazie acquired a dynastic dimension, which, although initially confined primarily to the church itself, also found expression in parts of the decorative programme of the refectory. Thus the coats of arms with their inscriptions in the lunettes above the *Last Supper* are a direct reflection of the power politics of the day and Ludovico's eagerness to establish his dynastic authority. He himself is named in the central lunette as "DVX MEDIOLANI" (Duke of Milan), a rank officially granted to him only in 1495. The coats of arms to the right and left are those of his sons and thus point to the continuation of the still young dynasty. Lastly, the neighbouring lunettes at the end of the two longitudinal walls contain two empty fields, as if the arms of future sons were to be inserted later. Through this decorative programme, Ludovico sought to tie the fortunes of the Sforza into a sacred context. Indeed, the family presented in the heraldic devices in the lunettes and in the donor portraits on the south wall quite literally appear in the company of the saints and blessed venerated by the Dominican order, as portrayed in the bands along the longitudinal walls. The Sforza family thus becomes, as it were, an imaginary part of the Dominican "family", whose communal meal is also the theme of the inscriptions along the same longitudinal walls. The genealogical structure of the refectory's decorative programme even influenced the composition of the *Last Supper*, exerting a direct effect upon its layout. Thus the division of the apostles into groups, which is considered one of Leonardo's revolutionary innovations, actually corresponds to the rhythm established by the lunettes: the disciples at the two ends of the table appear beneath the two smaller arches, while the two inner groups and Christ himself all appear beneath the central arch. Judas falls symbolically outside these compositional groupings; his is the only head that cannot be assigned to a specific lunette. The traitor sits outside the ordering structure.

If we consider the decoration of the refectory as a whole, it becomes clear that Leonardo's *Last Supper* was closely bound up with Ludovico Sforza's efforts to reinforce the genealogical and dynastic legitimacy of his rule. The choice, in the *Last Supper*, to portray the moment at which Christ announces his impending betrayal may also conceal a hidden reference to the political situation in which Ludovico Sforza found himself. It is a fact that Last Suppers focusing specifically upon Christ's announcement are extremely rare in Upper Italian refectories of the 15th century. Just how unusual it was within its genre is demonstrated by the first engravings of Leonardo's wall-painting, in which Christ's announcement is expressly included in a Latin inscription (ill. p. 206). It is possible that the groupings of disciples and the theme of betrayal in Leonardo's *Last Supper* correspond with the latent conflicts of loyalty and problematical alliances, both domestic and foreign, which characterized Ludovico Sforza's rule. Ludovico's power at home resulted, amongst

*I took Andy to see the "Last Supper" in Milan and the painting
had a profound effect on him. He had always had
a deep interest in religious iconography and his "Last Supper"
paintings are a beautiful reflection of that interest.*
FRED HUGHES, 1987

other things, from the murder of Galeazzo Maria Sforza (1476), the mysterious death of Gian Galeazzo Sforza (1494), the removal from power of Bona da Savoia (wife of Galeazzo Maria and mother of Gian Galeazzo) and the liquidation of Cicco Simonetta, the Sforza state secretary. Ludovico himself only narrowly escaped a murder attempt in 1484, probably instigated by the supporters of Bona da Savoia. Domestic politics was frequently characterized by offended loyalties (including within the Sforza family) and hence also by betrayal. Trust was by no means automatic even between family members; as Ludovico wrote with admirable frankness to his brother, Cardinal Ascanio Sforza, in 1499: "Monsignore, no offence, but I don't trust you, even though you are my brother."

Things were no better on the international front. Although Ludovico continued to expand his power right up to his fall by means of strategic coalitions, in the end it was the French whom he had summoned to Italy who would turn against him. In the political shape of constantly shifting loyalties and the termination of alliances, we thus find the same theme of betrayal. The treachery of the fort commander in Milan finally led to the fall of the city. Although we naturally cannot suppose that the choice of theme for Leonardo's *Last Supper* was intentionally related to the political situation, the correspondence between the motif of betrayal in the painting and the culture of betrayal in contemporary life can hardly be overlooked.

Leonardo's last surviving commission for Ludovico Sforza, the decoration of the Sala delle Asse in the Castello Sforzesco, which he carried out between 1496 and 1497 (Cat. XIX/ill. p. 211), can also be related to the political situation and in particular to Milanese political alliances. Here Leonardo decorated an entire room with artfully intertwined boughs of several trees, arranged around a coat of arms in the centre of the ceiling and four tablets with inscriptions. The shield and the inscriptions refer to the most important political and private events in Ludovico's life: his marriage to Beatrice d'Este, the marriage of his niece Bianca Maria to Emperor Maximilian I, his appointment as Duke of Milan and his victory over the French at the battle of Fornovo. But Ludovico was not allowed to savour for very long the political triumph that Leonardo had so subtly recorded in the Sala

Giovanni Donato Montorfano, **Crucifixion with Donors**, 1495
Fresco, approx. 880 x 700 cm. Milan, Santa Maria delle Grazie, Refectory

delle Asse: by 1499 the political situation had already been turned on its head. That sum-
mer, French troops poured into Northern Italy once again and brought Ludovico's rule to
an end. On 6 October Louis XII (r. 1498–1515), who had succeeded Charles VIII as king
of France, made his triumphal entry into Milan. Leonardo remained in the city for a few
more months, perhaps waiting to see whether Milan's new masters might have work for
him. His hopes may even have been fulfilled: Louis XII is thought to have commissioned
a painting from him, the result of which is the so-called *Burlington House Cartoon* (Cat.
XX/ill. p. 217). Whatever the case, this commission can only have delayed Leonardo's
departure by a few months, for on 14 December 1499 he took the precautionary step
of transferring 600 gold ducats to Florence, probably the large part of his cash reserves.
Shortly afterwards he set off for Mantua and Venice in search of new patrons.

Leonardo da Vinci, perhaps alone amongst all artists, had a truly supra-Christian vision. He knows the land of the "Orient", the inner as well as the outer. There is something supra-European and reticent about him, as distinguishes someone who has seen too great a range of good and bad things.
FRIEDRICH NIETZSCHE, 1885

Sala delle Asse, c. 1496–1497
Tempera on plaster. Milan, Castello Sforzesco, Sala delle Asse

VII

From Mantua
to Venice
and back
to Florence

1500–1503

*Those who put the moustache on Mona Lisa are not
attacking it, or art, but Leonardo da Vinci the man.
What irritates them is that this man with half a dozen
pictures has this great name in history, whereas they,
with their large oeuvre, aren't sure.*

BARNETT NEWMAN, 1992

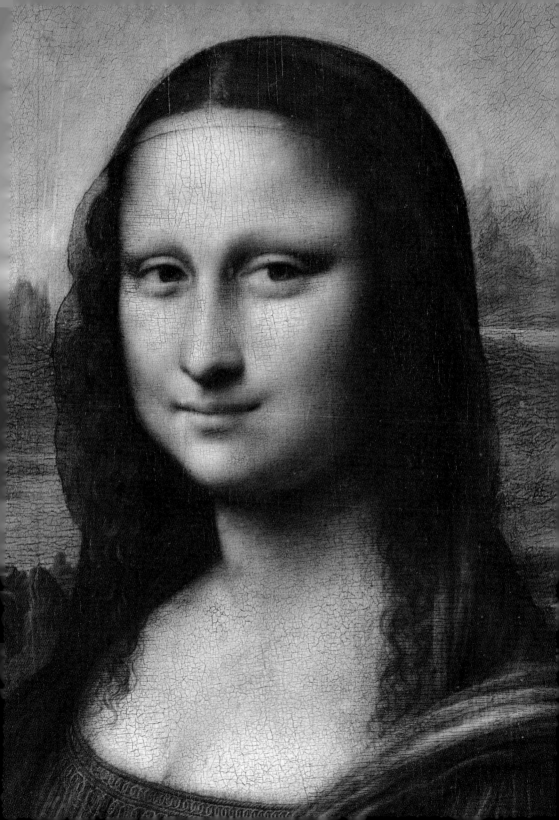

Following the fall of Ludovico Sforza, up till then his most important patron, Leonardo went first to Mantua, where Isabella d' Este had established a reputation for herself as a generous if somewhat capricious patron of the arts. It was probably here, in December 1499 or early the next year, that Leonardo produced a cartoon for a portrait of Isabella, who is seen in profile in the tradition of Mantuan court portraiture (Cat. XXI/ill. p. 214). The genealogical portraits of the d'Este family in Mantua, for example, employ the same profile view. The cartoon, to which Isabella also refers in later letters (see below), did not immediately lead to other commissions in Mantua, however, and so Leonardo travelled on to Venice, where he may have been briefly employed as a military engineer.

Although he does not appear to have produced any paintings in the city of canals, the subtle shading in his pictures is said to have influenced Venetian colleagues such as Giorgione – at least according to Giorgio Vasari in his *Life of Giorgione*. Vasari's claim is partially corroborated by a letter from Lorenzo Gusnasco to Isabella d' Este of 13 March 1500, which makes it clear that Leonardo had taken his pictures with him to Venice and had shown them to other people there: "Leonardo is here in Venice, and he has shown me a portrait of Your Highness, which resembles you very closely, is very well done and could not be bettered."

Leonardo must have left Venice fairly quickly and returned to Florence, for on 24 April 1500 he withdrew 50 gold ducats out of the account to which he had transferred the 600 ducats from Milan the previous December. He probably brought back with him the *Burlington House Cartoon* portraying the Virgin and Child with St Anne and the infant St John (Cat. XX/ill. p. 217). The origins of the cartoon, which today hangs in London, are the subject of some controversy. It possibly represents the preparatory design for a painting of St Anne commissioned by Louis XII as a gift for his wife Anne de Bretagne (1477–1514). The final painting was never executed, however, but at least one surviving preliminary sketch (ill. p. 282) and the cartoon itself convey an accurate impression of the overall composition of the proposed picture.

The figures are placed in front of a rocky landscape, Mary sitting sideways on the lap of her mother Anne. The Christ Child seems to be slipping out of her arms and, with his hand raised in a gesture of blessing, is turned towards the infant St John, who is

Page 213
Detail of **Portrait of Lisa del Giocondo (Mona Lisa)**, 1503–1506 and later (1510?)
(ill. p. 235)

Half-length Portrait of a Young Woman in Profile (Isabella d'Este), c. 1499/1500
Black and red chalk on paper, pricked, 63 x 46 cm
Paris, Musée du Louvre, Inv. M.I. 753

Pages 217–219

Burlington House Cartoon (Virgin and Child with St Anne and the Infant St John),
1499–1500 or c. 1508 (?)
Charcoal, with white chalk heightening, on brownish paper, mounted on canvas,
141.5 x 106.5 cm (max. dimensions). London, The National Gallery, Inv. 6337

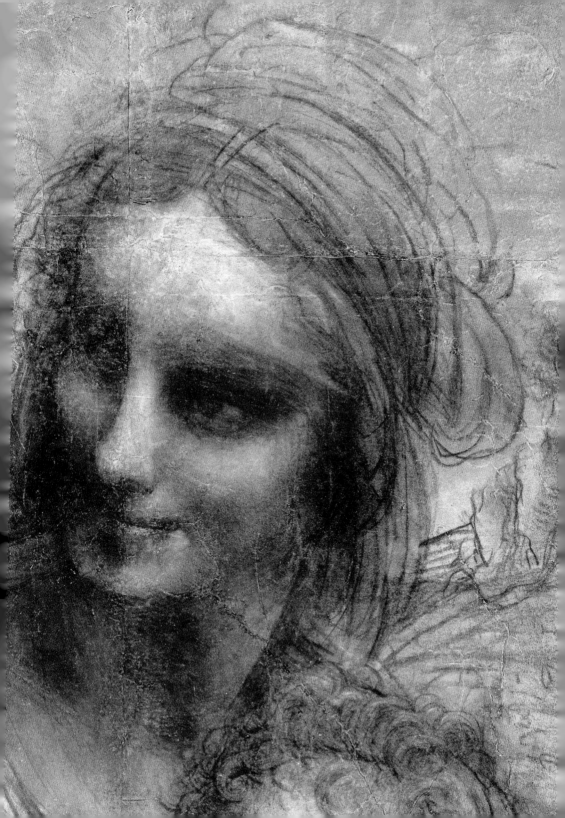

approaching from the right (ill. p. 101). With this gesture of blessing Leonardo establishes an obvious link with the *Virgin of the Rocks*, in which Jesus and John are also portrayed facing each other. In the gesture of St Anne, who is pointing upwards with her index finger, Leonardo takes up a gesture found earlier in his *Adoration of the Magi* (ill. pp. 74/75). Certain parts of the cartoon are considerably more finished than others. While the feet of both women and St Anne's left hand are rendered in little more than outline, the faces are fully modelled and, with their deep shadows and white highlights, already exhibit some of the qualities of a finished oil painting.

In comparison with Leonardo's other compositions, the *Burlington House Cartoon* drew little response from other artists of the day. Of his contemporaries, only Bernardino Luini (*c.* 1480–1532) took over Leonardo's composition in its entirety in his painting of the *Holy Family*, executed in Milan around 1530 (ill. p. 220). He thereby added the figure of Joseph on the right-hand edge of the panel. The possibility cannot be ruled out that Leonardo had also envisaged a Joseph in his painting. Whatever the case, Luini's *Holy Family* provides a general impression of what Leonardo's painting might have looked like had it been finished. It also reveals, even more clearly than the *Burlington House Cartoon* itself, an underlying structure that deviates strongly from Leonardo's previous compositions. Thus the pyramidal, centralized constellation of figures seen in almost all of Leonardo's earlier paintings, such as the *Virgin with the Carnation*, the *Benois Madonna*, the *Portrait of Cecilia Gallerani* and the *Virgin of the Rocks*, is absent from the *Burlington House Cartoon*, whose figures instead betray a lack of overall cohesion. It is not outside the bounds of possibility, in this regard, that Leonardo discarded the *Burlington House Cartoon* precisely because it failed to achieve,

Bernardino Luini
Holy Family with St Anne and the Infant St John, c. 1530
Oil on wood, 118 x 92 cm
Milan, Pinacoteca Ambrosiana

in the grouping of its figures, the compositional tautness that distinguished his known works up till then.

According to Giorgio Vasari, Leonardo had another opportunity to produce a cartoon of St Anne not long after his return to Florence. Vasari's report is unreliable on a number of counts, however. He claims, for example, that Leonardo was commissioned to execute a painting of St Anne for the high altar of SS Annunziata, but we know for a fact that a quite different subject had been chosen for this altarpiece. It is more likely that Leonardo executed his cartoon for the Giacomini-Tebalducci family chapel, which was dedicated to St Anne and was located inside the church of SS Annunziata.

It was probably this cartoon that Vasari, although he had never seen it, describes in such astonishing detail: "… finally he did a cartoon showing Our Lady with St Anne and the Infant Christ. This work not only won the astonished admiration of all the artists but when finished for two days it attracted to the room where it was exhibited a crowd of men and women, young and old, who flocked there, as if they were attending a great festival, to gaze in amazement at the marvels he had created. For in the face of Our Lady are seen all the simplicity and loveliness and grace that can be conferred on the mother of Christ, since Leonardo wanted to show the humility and modesty appropriate to an image of the Virgin who is overflowing with joy at seeing the beauty of her Son. She is holding him tenderly in her lap, and she lets her pure gaze fall on St John, who is depicted as a little boy playing with a lamb; and this is not without a smile from St Anne, who is supremely joyful as she contemplates the divinity of her earthly progeny."

Whether Vasari is here describing a St Anne composition that has since been lost, or whether he has simply muddled up the descriptions of two different designs, is a question that has yet to be fully clarified. Was he perhaps mixing up a composition such as the *Burlington House Cartoon*, portraying a Virgin and Child with St Anne and including an infant St John, with a cartoon featuring a lamb in place of St John? All we know for certain is that by April 1501 Leonardo had completed a cartoon of the Virgin and Child with St Anne and a lamb, but without an infant St John.

This cartoon is mentioned in a letter of 3 April 1501 sent to Isabellad' Este by the Carmelite monk Fra Pietro da Novellara: "Your Most Illustrious, Excellent and Singular Lady, I have just received Your Excellency's letter and will carry out with all speed and diligence that which you instruct me to do. From what I gather, the life that Leonardo leads is haphazard and extremely unpredictable, so that he seems to live only from day to day. Since he came to Florence he has done the drawing of a cartoon. He is portraying a Christ Child of about a year old who is almost slipping out of his Mother's arms to take hold of a lamb, which he then appears to embrace. His Mother, half rising from the lap of St Anne, takes hold of the Child to separate him from the lamb (a sacrificial animal) signifying the Passion. St Anne, rising slightly from her sitting position, appears

to want to restrain her daughter from separating the Child from the lamb. She is perhaps intended to represent the Church, which would not have the Passion of Christ impeded. These figures are life-sized but can fit into a small cartoon because all are either seated or bending over and each one is positioned a little in front of each other and to the left-hand side. This drawing is as yet unfinished. He has done nothing else save for the fact that two of his apprentices are making copies and he puts his hand to one of them from time to time. He is hard at work on geometry and has no time for the brush. I write this only to let Your Excellency know that I have received your letters. I shall carry out Your Excellency's commission and keep Your Excellency informed. I commend myself to Your Excellency and may God keep Her in his grace..." (MK § 669).

Novellara's description may be counted as reliable not just in view of the wealth and accuracy of the details it contains, but also because it tallies with a painting by Brescianino (c. 1487–1525), a Sienese artist active in the early 16th century, which is based on Leonardo's cartoon and portrays the Virgin and Child with St Anne and a lamb in a figural group angled towards the left (Cat. XXIIa and b/ills. pp. 223, 440). The figures in Brescianino's painting are closely interrelated and the Child is playing busily with the lamb in the bottom left-hand corner. A very similar formal sequence can be seen in Raphael's *Holy Family with a Lamb* of 1507 (ill. p. 222). The young artist had clearly seen Leonardo's cartoon, made an immediate copy of it and then used the composition at a later date as the starting-point for his own painting. In particular the relationship between the Virgin, the Child and the lamb in Raphael's painting revealsa close kinship with the lost work by Leonardo, while the figure of Joseph is based on a somewhat earlier model – Filippino Lippi's

Raphael
Holy Family with a Lamb, 1507
Oil on wood, 29 x 21 cm. Madrid, Museo Nacional del Prado

Adoration of the Magi of 1496 (ill. p. 86), the painting that replaced Leonardo's unfinished altarpiece for San Donato a Scopeto (cf. Ch. II). In both Raphael's painting and Filippino's altarpiece, Joseph is leaning over the group of the mother and child from behind with a staff in his hand. Indeed, not only did Filippino's *Adoration* provide Raphael with the model for Joseph in his *Holy Family with a Lamb*, but it was probably also a starting-point for the constellation of the figures in Leonardo's first St Anne cartoon, as we know it from Brescianino's early 16th-century copy.

In both compositions we find the same figural sequence, with the difference that Leonardo has replaced Joseph with the seated St Anne and has added the lamb. If we extend this comparison to include the *Virgin and Child with St Anne* by Benozzo Gozzoli (1420–1492), which today hangs in Pisa, we can clearly see how Leonardo has transcended earlier variations on this compositional type and arrived at a more dynamic figural progression. The rhythmical gradation of the central group in Filippino Lippi's *Adoration* may thereby have provided the most important stimulus for the dynamism of Leonardo's composition.

Unlike most other descriptions of paintings from this period, Pietro da Novellara's letter also ventures a specific interpretation of Leonardo's St Anne cartoon. To Pietro da Novellara, a devout Christian and a member of the clergy, the composition is a reminder that Christ is destined for the Passion. The Virgin may not pull her young son away from his symbolic animal, the lamb, and St Anne, as the personification of the Church, must prevent the Virgin from following her maternal instincts and keeping the infant Christ from fulfilling his destiny. Alongside his very detailed description and interpretation of the cartoon, Novellara also provides information about Leonardo's unconventional way of life.

Unknown artist, after Brescianino
Virgin and Child with St Anne, c. 1501 (?)
Oil (?) on wood, 129 x 94 cm. Madrid, Museo Nacional del Prado, Inv. 505 (899)

*Leonardo begins with the interior, the mental space, and not
with measured outlines, and to finish – if he finishes
at all and does not leave the picture incomplete – lays a
ghostly body of colour over the true, incorporeal
image, quite impossible to describe in material form.*

OSWALD SPENGLER, 1917

Pages 225–227
Giacomo Salaì (?), after a design by Leonardo, **Madonna of the Yarnwinder**, c. 1501–1507 (?)
Oil on wood, 50.2 x 36.4 cm. New York, Private Collection

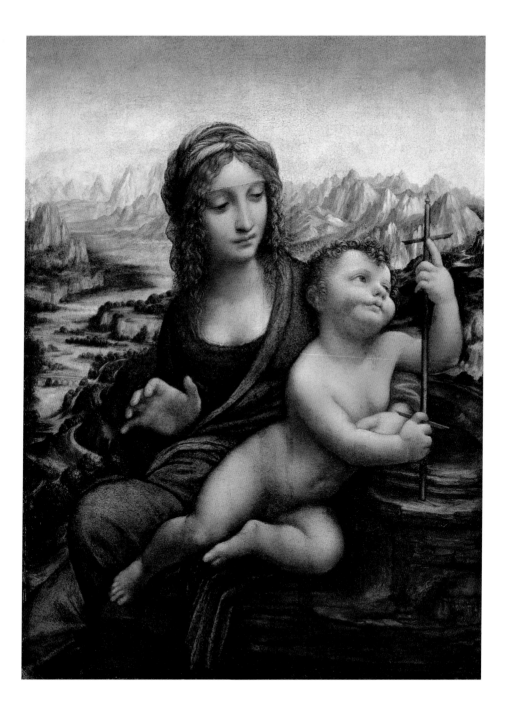

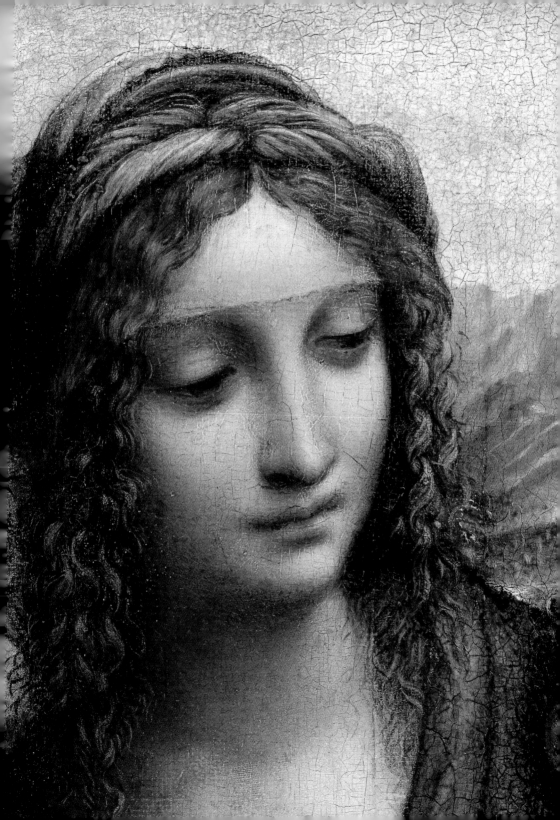

Study of a Bust of a Woman, 1501
Red chalk on pink prepared paper, 221 x 159 mm
Windsor Castle, Royal Library (RL 12514r)

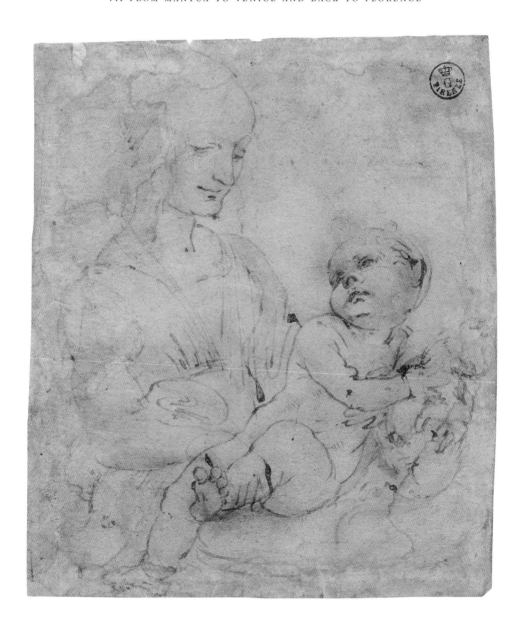

Study for a Madonna with a Cat, c. 1478–1480
Pen and ink, 125 x 105 mm
Florence, Galleria degli Uffizi, Gabinetto dei Disegni e delle Stampe, Inv. 421E recto

The artist evidently lived for the moment, painted only occasionally and even then against his will. This impression is confirmed by a letter that Novellara composed barely two weeks later, on 14 April 1501, which contains another highly informative description of a painting and runs as follows: "Your Most Illustrious, Excellent and Singular Lady, During this Holy Week I have learned the intention of Leonardo the painter through [Giacomo] Salaì his pupil and from some other friends of his who, in order that I might obtain more information, brought him to me on Holy Wednesday. In short, his mathematical experiments have so greatly distracted him from painting that he cannot bear the brush. However, I tactfully made sure he understood Your Excellency's wishes seeing that he was most eagerly inclined to please Your Excellency by reason of the kindness you showed to him at Mantua, I spoke to him freely about everything. The upshot was that if he could discharge himself without dishonour from his obligations to His Majesty the King of France as he hoped to do within a month at the most, then he would rather serve Your Excellency than anyone else in the world. But that in any event, once he has finished a little picture that he is doing for one Robertet, a favourite of the King of France, he will immediately do the portrait and send it to Your Excellency. I leave him well entreated. The little picture that he is doing is of a Madonna seated as if she were about to spin yarn. The Child has placed his foot on the basket of yarns and has grasped the yarn-winder and gazes attentively at the four spokes that are in the form of a cross. As if desirous of the cross he smiles and holds it firm, and is unwilling to yield it to his Mother who seems to want to take it away from him" (MK § 670).

Novellara here supplies a careful description of the so-called *Madonna of the Yarnwinder*, which Leonardo had begun for Florimond Robertet (d. 1524), secretary to the king of France. This small composition, with its very youthful-looking Virgin and the Christ Child, survives in a number of versions, of which two stand out for their superior artistic quality and are therefore considered by some to stem at least partly from the hand of Leonardo (Cat. XXIII–XXIV/ills. pp. 225, 231). These two surviving paintings differ in one vital detail from Novellara's description, however: the infant Christ does not have his foot resting on a "basket of yarns". These works are evidently replicas from Leonardo's workshop that were executed under his supervision. In his earlier letter, indeed, Novellara had mentioned the fact that "two of his apprentices are making copies and he puts his hand to one of them from time to time".

<div style="text-align:center">

Workshop of Leonardo, after a design by Leonardo,
Madonna of the Yarnwinder, 1501–1507 or later (?)
Oil on wood (poplar?), 48.3 x 36.9 cm
Drumlanrig Castle, In the collection of The Duke
of Buccleuch & Queensberry, KT

</div>

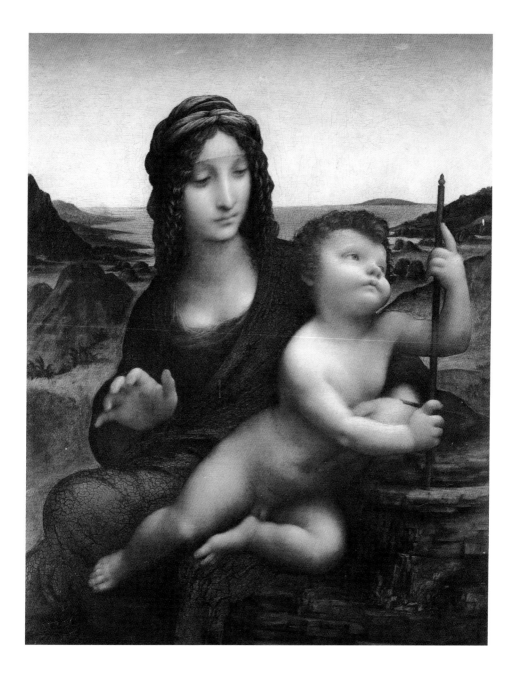

LINFANTE·DAME ISABIEL.

In his letter of 14 April, Novellara again offers a possible interpretation of this latest composition by Leonardo: the small painting takes as its theme both the Virgin's love for her child, on whom her gaze tenderly rests, and the future Passion of Christ. The infant Christ focuses intently on a yarn-winder, which, by virtue of its resemblance to a crucifix, was regarded as a symbol of his later death. Mary seems to want to prevent the Child from moving any closer to the yarn-winder and holds him gently round the upper body with her left arm. But even Mary can do nothing to prevent the Crucifixion, which Christ is destined to suffer: the son turns away from his mother's tender gaze. He has already distanced himself from her right hand, raised as if in protection, and is entirely absorbed in his contemplation of the symbol of his Passion. The religious significance of the painting is thus emphatically conveyed by the symbolism inherent not just in the yarn-winder but even in the movements of the figures. Furthermore, the *Madonna of the Yarnwinder* also fulfils the didactic function that Fra Giovanni Dominici, as we have seen earlier, attributed to devotional paintings for private worship (cf. Ch. I).

Leonardo's first version of the *Virgin and Child with St Anne*, and his *Madonna of the Yarnwinder* for Florimond Robertet, the favourite of the French king, give the impression that at the start of the 16th century he was painting with great enthusiasm. The opposite was true, however; Leonardo was in fact looking for work that had nothing to do with a brush and paint. Thus in July 1502, for example, he offered Sultan Bajezid II (r. 1481–1512) his services as an engineer. In a letter of application that was translated into Turkish, Leonardo emphasized his competence in such areas as the building of windmills and the construction of a bridge over the Bosporus. The corresponding passage from this remarkable letter runs, in translation, as follows: "I, Your slave, have heard that it is Your intention

Unknown 17th-century artist
Copy of the Portrait of Isabella of Portugal by Jan van Eyck
Pen drawing, with wash (?). Location unknown

to build a bridge from Galata to Stambul, but that You have not done so because no expert was to be found. I, Your slave, know how to do it. I will build it as high as a bow, so that no one will agree to walk across it because it will be so high [...]."

The dimensions of the bridge, which Leonardo wrote down on a page of his "L" notebook (RLW §1109), were probably still a little too large, given the technological capacities of his day, to be built. Whatever the case, the project – which attracted the attention of Michelangelo four years later – appears to have come to nothing. Leonardo remained in Florence, where he continued to devote his time primarily to "non-artistic" subjects such as mathematics and geometry. As evidenced by the letters addressed to Isabella d'Este, cited above, Leonardo's unwillingness

to take up a brush was viewed by his contemporaries with both surprise and irritation. Those commissions he did take on, moreover, were plagued by endless delays – perhaps a consequence of the lack of discipline to which Gaspare Visconti jokingly referred in his sonnet (cf. Ch. VI). Angelo Tovaglia seems to have reached a similar conclusion in a letter he wrote to Isabella d' Este, who was still waiting in vain for a portrait by the artist: if there were to be a competition for the slowest painter, Leonardo would win hands down.

In the summer of 1502, however, Leonardo "officially" turned his attention to a completely different sphere when he took up a position as military engineer to General Cesare Borgia (1475–1507). He spent almost a year travelling with this cruel and notorious figure, mainly in Central Italy. He used these journeys to make a whole variety of studies and, amongst other things, provided his master with topographical drawings whose main purpose was no doubt connected with military strategy. Cesare Borgia's military campaigns required precise knowledge of the terrain, which he was able to acquire from Leonardo's vivid and precise bird's-eye views (Nathan/Zöllner 2014, Cat. 464–467).

Unknown artist (Bolognese?)
Virgin and Child
Tempera (?) on wood. Milan, Private Collection, Collezione G. M. N.

Leonardo da Vinci's essay on the reason why distant mountains and objects appear blue once again gave me great pleasure. As an artist who found answers by looking directly at nature, by thinking about and comprehending the phenomenon itself, he arrived straight away at the right answer.

JOHANN WOLFGANG VON GOETHE, 1817

Pages 235–239
Portrait of Lisa del Giocondo (Mona Lisa), 1503–1506 and later (1510?)
Oil on poplar, 77 x 53 cm. Paris, Musée du Louvre, Inv. 779

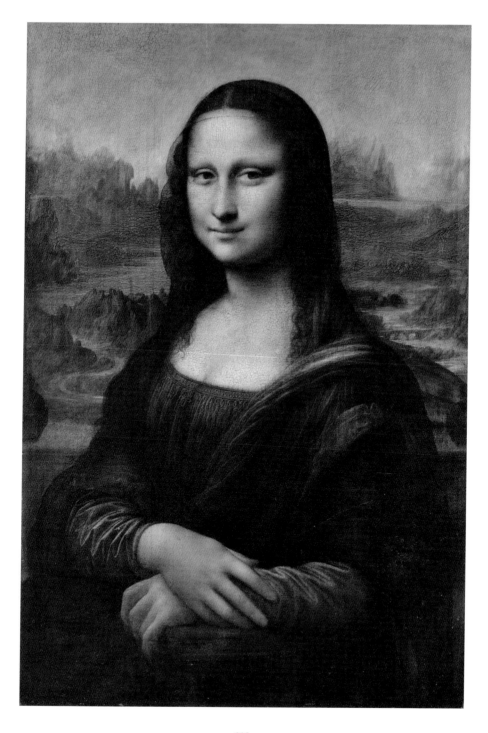

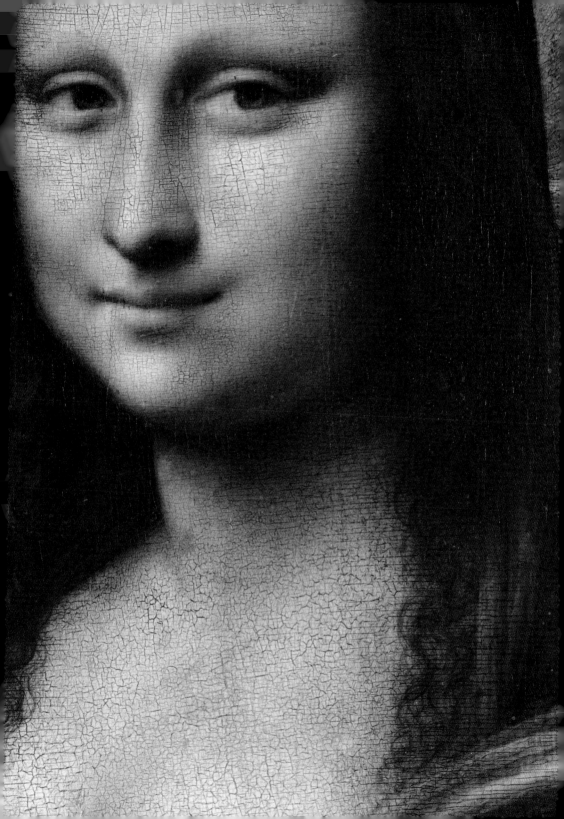

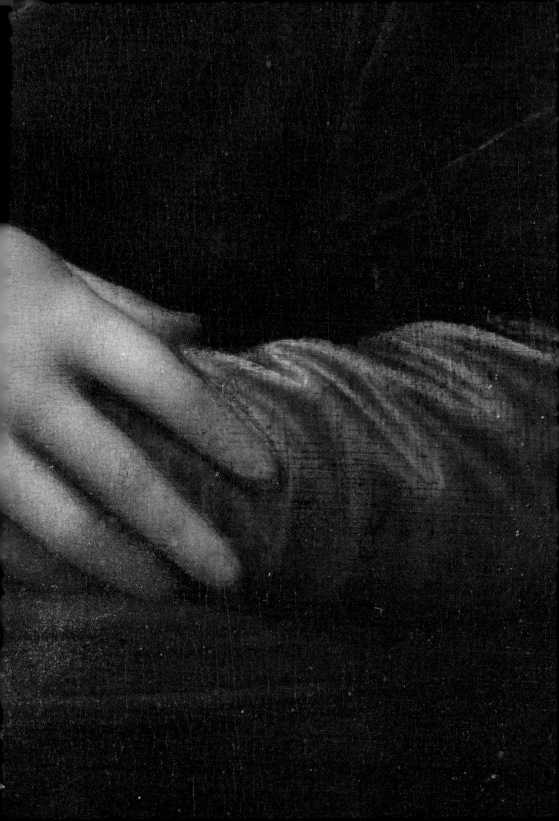

In early 1503, however, Leonardo terminated his employment with Cesare Borgia and returned to Florence, where for the next three years he resumed his career as a painter. Why Leonardo should have decided to devote himself more intensively to his original profession, we do not know. Our only historical source in the opening years of the 16th century is the frustrated marchioness Isabella d'Este, who was still trying vainly to get Leonardo to paint her portrait. In comparison with paintings that she commissioned during this same period from Giovanni Bellini and Pietro Perugino (c. 1448–1523), in which she was very specific about the subjects she wanted, she offered Leonardo a far freer hand. In the end she even suggested that he should paint for her whatever he wanted. It is worth citing in full a letter from Isabella to Pietro da Novellara of 29 March 1501, because it sheds light on the special relationship between patron and artist: "Most Reverend, If the Florentine painter Leonardo should be there in Florence, we ask the reverend father to find out what sort of life he is leading, in other words if he has started upon some work, news of which has reached us, and what sort of work it is. And if you think he is going to be staying there for a while, Your Reverence, please find out if Leonardo would be willing to paint a picture for our study. If he agrees, we are content to leave the invention [i.e. the idea, the conception] and the timing up to him. But should he decline, then try at least to persuade him to paint a small Madonna, pious and sweet, in his own fashion. Then ask him to send us a new drawing of our portrait, because his Illustrious Lord, our Husband, has given away the portrait that Leonardo left here."

It seems at first sight odd that, even when invited to paint a subject of his own choosing and entirely in his own time, Leonardo should not want to work for the Marchioness of Mantua, the most distinguished patroness of the arts in the Renaissance era. Yet during this same period, it has been shown, Leonardo was living on the savings he had transferred to his Florence account before leaving Milan. The artist today known above all as a painter evidently preferred to pursue the "scientific" studies, which brought him in no money and which, indeed, were rather looked down on by his contemporaries. Against this backdrop, it is all the more astonishing that Leonardo should accept, in the spring of 1503, a commission from Francesco del Giocondo (1460–1539) to paint his wife Lisa Gherardini (1479–after 1551?). It is possible that the commission for the *Mona Lisa* (Cat. XXV/ill. p. 235), as the portrait would become known, resulted from personal contacts similar to those that gave rise to other of Leonardo's works, such as the *Portrait of Ginevra de' Benci* and the *Adoration of the Magi*. The Giocondo family belonged to the same social class as Leonardo himself and Ser Piero da Vinci, Leonardo's father, was acquainted with members of Francesco del Giocondo's close circle. In addition, the Giocondo family chapel was located in SS Annunziata in Florence, the same church, in other words, for which Leonardo had begun the cartoon of the Virgin and Child with St Anne at the start of his second Florentine period.

We are relatively well informed about the genesis of the *Mona Lisa*. Lisa del Giocondo, born in 1479, was the daughter of Antonmaria Gherardini. On 5 March 1495 she married Francesco del Giocondo, born in 1460, the son of a wealthy family of Florentine silk merchants. We can assume that, unlike Marchioness Isabella d' Este (see above), a man like Francesco del Giocondo did not commission paintings simply on a whim and regardless of their subject. As a rule, members of the urban middle classes had specific reasons for commissioning works of art, and this is also true of the portrait of the *Mona Lisa*. In the spring of 1503 Francesco del Giocondo had purchased a new house for his young family, while Lisa had given birth to her second son, Andrea, a few months previously – reason enough, in the Florence of the 15th and 16th centuries,

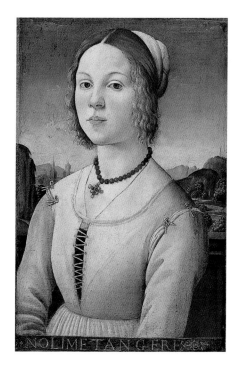

to commission a portrait. In the case of the Giocondo family, moreover, Andrea's safe delivery must have carried particular significance. Levels of infant mortality and death in childbirth were in those days very high, something of which both Francesco and Lisa del Giocondo would have been painfully aware. Francesco had already lost two wives prior to Lisa, on each occasion after about a year of marriage. One of these wives is known to have died shortly after the birth of a child, and it seems likely that both of Francesco's previous wives died either in childbirth or in the weeks immediately following their confinements. Francesco's third wife, Lisa, had evidently survived the birth of her first son Piero (1496), but in 1499 lost a daughter at birth. Childbirth was thus an occasion overshadowed by tragedy for the del Giocondo family. When, in the spring of 1503, some four months after Andrea's birth, mother and son were still doing well, Francesco could allow himself to assume that both would safely survive the happy event. It was this confident that which in all probability prompted Francesco to commission a portrait of his wife to adorn their new home. The portrait of Lisa del Giocondo would never hang in the house for which it was intended, however, since Leonardo did not complete the painting until several years

Master of Santo Spirito (?), **Portrait of a Woman**, c. 1490
Tempera on wood, 45 x 29 cm. Staatliche Museen zu Berlin, Gemäldegalerie

later, probably towards 1510, by which time he was no longer living in Florence.

Leonardo clearly draws in the *Mona Lisa* upon the formal vocabulary of Florentine portraiture of the late 15th century. The half-length figure is turned two-thirds towards the viewer, and a balustrade carried on slender pillars provides the point of transition between the foreground and the background landscape. Formally similarly half-length portraits of young women from the period before 1500 include those by the so-called Master of Santo Spirito (ill. p. 241) and Lorenzo di Credi (ill. p. 242). These in turn look back to earlier Flemish prototypes such as Jan van Eyck's portrait of Isabella of Portugal, now lost (ill. p. 232). But Leonardo went far beyond his predecessors: the portrait of Lisa del Giocondo is very much larger than known Flemish prototypes, and larger too than most examples of contemporary Florentine painting. In the *Mona Lisa* the sitter has also moved much closer to the front edge of the painting; her greater proximity to the viewer increases the intensity of the overall mood, while the landscape background suggests greater spatial depth and atmospheric density. Jagged mountains disappear into the distance against a greenish-blue sky. Within the rocky landscape, a track can be seen on the left and, on the right, a dried-up river bed whose connection to a body of water higher up is not altogether clear. The individual components of the landscape, bereft of vegetation, are reminiscent of similar rock formations in sacred paintings, such as the *Madonna of the Yarnwinder* that Leonardo had begun not long before. There can be no denying the formal affinity between the *Mona Lisa* and depictions of the Virgin, something evident in many Renaissance portraits of women.

The Mother of God was regarded as the ideal to which every honourable woman aspired, and the formal parallels between paintings of the Virgin (ill. p. 233) and portraits of women corresponded to this fact. The smile worn by the *Mona Lisa* is thus related to the smile of the Virgin and as such formed part of the standard repertoire of painters in the

Lorenzo di Credi, **Portrait of a Woman**, c. 1490
Tempera on wood, 75 x 54 cm. Forlì, Pinacoteca Civica

late 15th and early 16th century. Lisa del Giocondo's smile also corresponds to the notion, current in Leonardo's day, that outer beauty was an expression of inner virtue. The beauty of her serenely and modestly smiling face thus serves to reflect her virtuous character. Leonardo had already taken up this idea in his *Portrait of Ginevra de' Benci*, with its explicit message that "Beauty Adorns Virtue" (cf. Ch. I). Even the way in which Lisa del Giocondo has positioned her hands (ill. pp. 238/239) conceals a reference to the virtue of the young female sitter; according to contemporary treatises, hands laid one on top of the other signified chasteness.

The expressive power of the *Mona Lisa* arises not just out of its reinterpretation of older artistic formulae, but also out of its meticulous attention to detail. A gossamer veil covers the sitter's free-flowing hair, while her dark gown reveals intricate embroidery and vertical pleats, particularly below the neckline. The heavier-looking fabric of the mustard-coloured sleeves is lent a natural sheen. Leonardo's subtle use of shading invokes an overall impression of great plasticity, in particular in the face and hands. It is this plasticity, together with the skilfully deployed lighting, which falls across the landscape background and against which the sitter emerges as a three-dimensional volume, which lends the portrait its suggestive quality. Such sophisticated handling of light and shade had been in evidence since the middle of the 15th century, above all in oil paintings by Flemish masters, whose portraits revealed a greater intensity of expression than their Florentine counterparts.

The expressive power of portraiture north of the Alps may have been one of the reasons why Leonardo made such a detailed study of light and shade in his treatise on painting. It is in this context, too, that certain formal elements of the *Mona Lisa* may be understood. Leonardo had been developing his ideas on light and shade since about 1490 (Nathan/

Raphael, **Lady with the Unicorn**, c. 1505/06
Oil on canvas, transferred from panel, 67 x 56 cm. Rome, Galleria Borghese

Delle macchie de l'ombre ch'apariscono
ne corpi da lontano —
Sempre la gola od altra perpendiculare deritura che so/
pra di se abbia alcuno sporto sarà più oscura che la/
perpendiculare faccia d'esso sporto, seguita che quel
corpo si dimostrerà più aluminato che da maggior
soma d'un medesimo lume sarà veduto, vedi m, a,
che non b alu- mina parte al-
cuna del cielo. f. k, d'm b, u'a
lumina il cielo s. k, et in, c, u'a
lumina il cielo h.k, et in, d, il
cielo, g. h, et in. e, il cielo, f. k.
integralmente adunque il pet-
to sarà di pari chiarezza della
fronte naso e mento, ma quello ch'io t'ho da ricordare
de volti è che tu consideri in quelli come in diverse
distantie si perde diverse qualità d'ombre ma solo
resta quelle prime macchie cioè della incassatura/
dell'occhio et altri simili, et nel fine il viso rimane oscu-

Zöllner 2014, Cat. 646, 648–662 and Ch. 16), and following his return to Florence in 1500 took up the subject with renewed intensity. Around 1505, for example, he described in his treatise on painting the effect of light falling from the front on the shading of a face (ill. p. 244). It is a passage that comes remarkably close to describing the illumination of the forehead, nose and chin of the *Mona Lisa* and the corresponding shading of her face: "The throat or other straight perpendicular, which has some projection above it, will always be darker than the perpendicular face of that projection; this occurs because that body will appear most illuminated which is exposed to the greatest number of rays of the same light. You see that *a* is illuminated by no part of the sky *F–K*, and *b* is illuminated by *I–K* of the sky, and *c* is illuminated by *H–K* of the sky, and *d* by *G–K*, and *e* by the whole sky from *F* to *K*. Thus, the breast will be of the same brightness as the forehead, nose, and chin" (McM 523).

In another example, Leonardo describes the specific lighting effects that result when the rays of the midday sun from the south fall on a road running towards the west: "In streets that lead to the west, when the sun is at noon, and the walls are so high that the one turned toward the sun does not reflect on bodies which are in shadow, then the sides of the face take on the obscurity of the sides of the walls opposite to them, and so will the sides of the nose, and all of the face turned to the entrance to the street will be illuminated" (McM 452). Leonardo goes on to describe the effect produced by indirect rays of light that manage to pass below the roofs of the houses and between the walls, and which are reflected onto faces from the pavement and the sides of the houses: "To this there will be added the attractiveness of shadows with pleasing dissolution, which are entirely devoid of any sharp outline. This will come about because of the length of the rays of light […] The length of the above-mentioned light from the sky confined by the edges of the roofs and their façades, illuminates almost as far as the beginning of the shadows which are below the projections of the face, gradually changing in brightness, until it terminates over the chin with imperceptible shading on every side" (McM 452).

Francesco Melzi, **Transcription from Leonardo's Treatise on Painting**
Rome, Biblioteca Apostolica Vaticana, Codex Urbinas, fol. 148r

The distribution of the shadows in the face of the *Mona Lisa* closely follows Leonardo's observations in his treatise on painting, even if the location of the young woman, seated in an open loggia, is difficult to compare with that of someone standing in an open street. In view of this difference between the scenario described in the treatise on painting and the setting of the *Mona Lisa*, however, the question arises as to whether Leonardo was trying in his portrait to simulate specific lighting conditions that could never have existed in Lisa's loggia in real life. The illumination of the face does not correspond with the natural lighting of a loggia, which would normally receive the large part of its light from the side opening onto the landscape. In the portrait, however, Lisa is illuminated by a light source located above and to the left of the upper edge of the panel and not too far from the surface of the painting. The illumination of her face, the genteel window onto her inner nature, thus reveals itself to be an artificial arrangement, one that testifies to the importance, in Leonardo's thinking, of the use of lighting and shading for specific artistic ends. The artificially created situation and the expressive modelling by means of shading are thereby given precedence over the natural lighting conditions of the scene portrayed. It was no longer a question, in Leonardo's painting, of simply the exact reproduction of nature; the artist also sought to achieve an autonomous, painterly effect, which, in the case of the *Mona Lisa*, served the expressive power of the portrait. The heightened expressiveness resulting from this use of light and shadow would be taken even further in Leonardo's later *St John the Baptist* (cf. Ch. X).

The portrait of Lisa del Giocondo exerted a significant influence upon Florentine painting even before it was finished. The young Raphael, who visited Leonardo's workshop on numerous occasions, immediately adopted the compositional format of the older master and established, on the basis of the *Mona Lisa*, a type of portraiture that was to hold good for decades. Examples thereby include the *Lady with the Unicorn* of *c.* 1504 (ill. p. 243), the portrait of *Maddalena Doni* (ill. p. 12) completed soon afterwards and later portraits such as *La Donna Velata* and *Baldassare Castiglione*. None of Leonardo's works would exert more influence upon the evolution of its genre than the *Mona Lisa*. It became the definitive example of the Renaissance portrait and perhaps for this reason is seen not just as the likeness of a real person, but also as the embodiment of an ideal.

VIII

Leonardo in Florence: Battle paintings and "muscular rhetoric"

1504–1506

*Vinci, however, whose painting expresses a degree of
intelligence which has not been equalled, and whose drawing,
as the first in Europe to do so, gives us the impression
of knowing no obstacle (like that of Chinese and Japanese
painters), this Vinci held three of his works to be most
important: the equestrian statue of Francesco Sforza, the
"Last Supper" and the "Battle of Anghiari."*

ANDRÉ MALRAUX, 1951

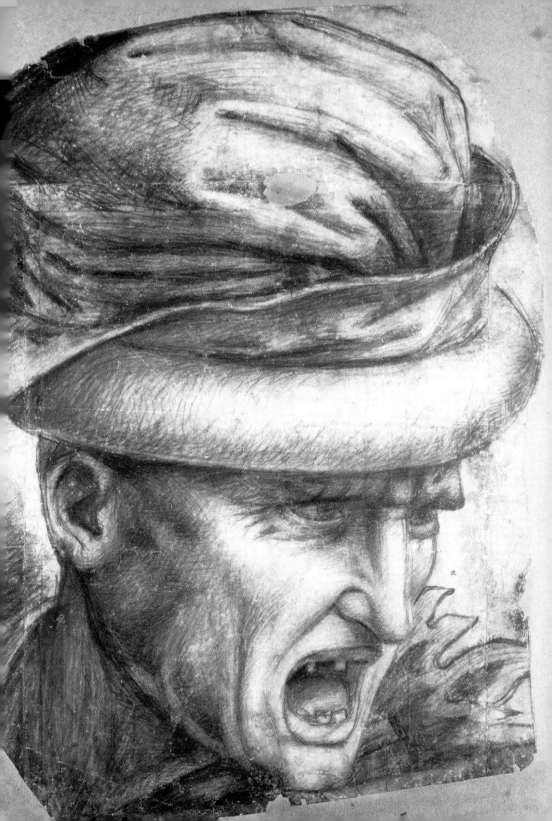

High Renaissance painting may have seen its flowering in the works that arose between 1508 and 1527 in papal Rome, but the roots of the new style reached back to the years 1504 to 1506, when Leonardo, Michelangelo and Raphael were all briefly working in Florence at the same time. Raphael, the youngest of the triumvirate, eagerly took up the innovations of the elder Leonardo, at first in his portraits and paintings of the Holy Family (cf. Ch. VII) and later in his Roman works (cf. Ch. IX). The relationship between Leonardo and Michelangelo was less harmonious, however, and was characterized by one-sided giving on the part of the elder artist. Between the two men, in fact, there seems to have developed not just a fruitful spirit of competition but also a pronounced enmity, something expressly mentioned by their earlier biographers. This same artistic rivalry underlies the works by the two artists for the Grand Council Chamber in the Palazzo Vecchio, the seat of government of the Florentine Republic, namely two monumental wall-paintings commemorating the greatest military triumphs in the city's history.

Leonardo's wall-painting for the Palazzo Vecchio, which he commenced in autumn 1503 and left unfinished in spring 1506, depicted the *Battle of Anghiari* of 1440, when Florentine forces, together with their papal allies, defeated their Milanese opponents near the town of Anghiari. Leonardo made the focus of his painting one of the most important episodes in this battle, the capture of the enemy's standard, enacted by figures larger than life size (ill. p. 249). Leonardo's composition was to appear directly alongside Michelangelo's so-called *Battle of Cascina*, which depicted the raising of the alarm that, in July 1364, warned the Florentine troops of the approaching enemy and led to their emerging victorious from the subsequent skirmish (ill. pp. 254/255). These two paintings, which are today known only from contemporary copies, would have constituted by far the most impressive decoration of any public interior in the early 16th century. No comparable monumental and dramatic secular paintings existed at that time, and the two finished works would have been a first in almost every respect. Even the copies that still survive – most of them the work of mediocre painters – convey the dynamism and drama that would later become the hallmarks of history painting.

Thanks to a document of 4 May 1504, we are well informed about the rather unusual terms of the contract for Leonardo's *Battle of Anghiari*. The very specific stipulations laid down by the council indirectly take account of Leonardo's irregular habits and his very slow method of working, as described by Novellara (cf. Ch. VII). This noteworthy document begins as follows: "... The Magnificent and Sublime Signori, the priors of Liberty and the Standardbearer of Justice of the Florentine people, considering that several months ago Leonardo, son of Ser Piero da Vinci, and a Florentine citizen, undertook to do a painting for the Sala del Consiglio Grande, and seeing that this painting has already been begun as a cartoon by the said Leonardo, he moreover having received on such account 35 *fior[ini] lar[ghi] d'oro* in gold, and desiring that the work be brought as soon as possible

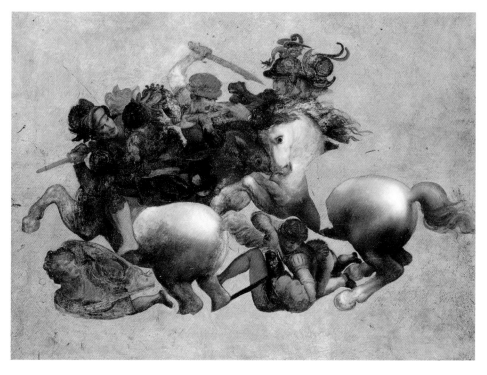

Battle of Anghiari
Copy after Leonardo's wall-painting (Tavola Doria), 1504–1506
Oil on wood, 85 x 115 cm. Private Collection

Page 247
Leonardo?, **Head of Niccolò Piccinino**
(part of the cartoon for the Battle of Anghiari?), 1504
Black chalk, 38.6 x 50.4 mm. Oxford, Ashmolean Museum

to a satisfactory conclusion and that the said Leonardo should be paid a certain sum of money in instalments for that purpose they, the aforesaid Signori, have resolved, etc., that the said Leonardo da Vinci is to have completely finished painting the said cartoon and brought it wholly to perfection by the end of February next (1504) [i. e., 1505] without quibble or objection and that the said Leonardo be given in the meanwhile in payment each month 15 *fior[ini] lar[ghi] d'oro* in gold, the first month understood as commencing on 20th April last."

In the six months or so since starting on the commission, therefore, Leonardo had already got as far as producing a cartoon. It appears, however, that his employers – well aware of his reputation for unreliability – remained anxious to forestall all possible reasons

for a delay in the completion of the work. Thus they go on in this same document to remind Leonardo of the financial penalties he will incur should he renege on the contract. Should he fail to complete the cartoon within the timeframe agreed, moreover, he will be obliged to hand over what work he has completed, the implication being that the execution of the wall-painting will be entrusted to another artist: "And in the event that the said Leonardo shall not, in the stipulated time, have finished the said cartoon, then the aforesaid Magnifici Signori can compel him by whatever means appropriate to repay all the money received in connection with this work up to the said date and the said Leonardo would be obliged to make over to the said Magnifici Signori as much as had been done of the cartoon, and that within the said time the said Leonardo be obliged to have provided the drawing for the said cartoon."

Since the representatives of the Florentine government were well aware that artists frequently failed to meet their contractual deadlines and that effective sanctions against breaches of contract were often impossible to put in place, in the next section of the document they adopt a milder tone. Thus they grant Leonardo the option, should he exceed the deadline for completing the cartoon, of starting work directly on the wall-painting. "And since it might occur that the said Leonardo will have been able to begin painting on to the wall of the said Sala that part which he had drawn and submitted on the said cartoon, the Magnifici Signori, in that event, would be content to pay him a monthly salary befitting such a painting and as agreed upon with the said Leonardo. And if the said Leonardo thus spends his time painting on the said wall the aforesaid Magnifici Signori will be content to prolong and extend the above-mentioned period during which the said Leonardo is obliged to produce the cartoon in that manner and to whatever length of time as will be agreed by the said Magnifici Signori and the said Leonardo."

Ambrogio Lorenzetti
Allegory of Bad Government (detail): personification of Fury, 1337–1340
Fresco. Siena, Palazzo Pubblico

Finally, the employers even concede that Leonardo may finish the cartoon if he so wishes, and they pledge that they will not give a fully finished cartoon to another painter to transfer onto the wall: "And since it might also occur that Leonardo within the time in which he has undertaken to produce the cartoon may have no opportunity to paint on the wall but seeks to finish the cartoon, according to his obligation as stated above, then the aforesaid Magnifici Signori agree that the painting of that particular cartoon shall not be commissioned from anyone else, nor removed from the said Leonardo without his express consent but that the said Leonardo shall be allowed to provide the painting when he is in a position to do so [...]" (MK § 668).

The first half of the agreement thus reveals the employers seeking to impose strict performance targets on the notoriously unreliable Leonardo, while the second half grants him greater room for manœuvre as a paradoxical means of binding him more closely to his obligations.

At the end of the day, however, these subtle tactics were all for naught: although Leonardo did indeed start painting on the wall of the Council Chamber, he used an experimental technique that led to the early ruin of the whole. When lucrative commissions from the king of France subsequently beckoned, he left Florence to seek his fortune once again in Milan (cf. Ch. IX).

As in the case of many other documents and contracts from this era, the text cited above tells us nothing about the actual content of the *Battle of Anghiari*. Details of this nature must have been supplied separately, something of which in the present case we have concrete evidence. Thus we know from a sheet in the Codex Atlanticus that Leonardo was provided with a detailed account of the battle of Anghiari (RLW § 669). He made only limited use of this account in his final composition, however. Further evidence that Leonardo may have deviated from his original plans is found in his preparatory sketches (Nathan/Zöllner 2014, Cat. 42–55; ills. pp. 256, 261, 268). They reveal that the artist had initially envisaged a broad composition incorporating several different events. He appears to have planned various skirmishes between foot soldiers and smaller bands of armed horsemen on either side of the battle for the standard, and on the far right the arrival of a cavalry division (ill. p. 261). In both his cartoon and his final wall-painting, however, Leonardo omitted these previously planned episodes and concentrated exclusively on a single, central battle scene. Only in the physiognomies of the individual riders did he adhere more closely to his preliminary studies (ill. p. 253), whereby two of the soldiers in his drawings retained exactly the same facial features in the final wall-painting.

The surviving copies of the *Battle of Anghiari* (ill. pp. 254/255) primarily show four horsemen fighting furiously for possession of a standard. The dramatis personae comprise, on the left, Francesco Piccinino and his father Niccolò, the two leaders of the Milanese troops. Their opponents on the right are Piergiampaolo Orsini and Ludovico Scarampo,

protagonists of the allied papal and Florentine troops, who were to triumph in the conflict and with whom contemporary viewers would have been able to identify. The physiognomies of the two riders on the left are angry and positively distorted. The features of Niccolò Piccinino, contorted into a loud cry, are impressively captured in a partial copy of the original composition (ill. p. 247), while the fury written on the face of his son Francesco emerges clearly in copies of the whole. Francesco's brutal grimace is accompanied by a contortion of his upper body, as though his torso were merging into the body of the horse. Man and beast become a single creature, whose uncontrolled rage finds appropriate expression in an unnaturally twisted body.

Contemporary viewers must thereby have been reminded of centaurs, creatures made up of the upper body of a human and the lower body of a four-legged animal. Such creatures are known to have carried negative connotations in the mythographical traditions of the Middle Ages, and in other sources, such as the *Etymologiae* by St Isidore of Seville (*c.* 560–636), they are seen as the prototype of the fighter driven by animal instincts. Francesco's centaur-like figure was undoubtedly intended to invoke the same bestial connotations. The physical fusion of horse and rider, at first sight so strange, also makes reference to Francesco's brutish nature, his angry and martial character, something also mentioned in contemporary sources. In this context, it is probably no coincidence that in one of the most famous frescoes in a Tuscan government building, Ambrogio Lorenzetti's (active 1319–1348) *Allegory of Bad Government* (1337–1340) in the Palazzo Pubblico in Siena, Fury (*furor*) is portrayed in the shape of a similar creature. The personification of Fury is namely here composed of the lower body of a four-legged animal, a human upper body and the head of a beast (ill. p. 250). This figure may well have sprung to Leonardo's mind when he came to design his own wall-painting, not least because Ambrogio Lorenzetti's frescoes in Siena belonged to the same genre as Leonardo's *Battle of Anghiari*: both formed the decorations for a civic palace.

Less dramatic in their poses are the two protagonists of the Florentine troops and their papal allies. While there is nothing peaceable about their actions, their faces, seen in profile, are far less distorted and their bodies are not contorted. They represent a different, more balanced ideal of combat, one that Leonardo's contemporaries evidently found less interesting than the negative embodiment of unbridled bellicosity in their opponents. Thus Vasari concentrates in his own description of the painting above all on Niccolò Piccinino and his son Francesco. He was so impressed by the vindictive rage of the figures that he even muddled up the two warring parties.

Francesco Piccinino is characterized not only by the expression of vicious rage on his face but also by his armour, which clearly reveals several of the attributes of Mars, the god of war. Thus the ram on his chest is the animal symbol of Mars, and the horns of Amon on his head and the ram's fleece on his body are both derived from traditional Mars iconography.

Study of the Heads of Two Soldiers, 1503/04
Black and red chalk over metalpoint, 191 x 188 mm
Budapest, Szépmüvészeti Múzeum, Inv. 1175

Pages 254/255
Unknown artist/Peter Paul Rubens
Copy after Leonardo's Battle of Anghiari, before 1550 and c. 1603
Black chalk, pen, ink, heightened with white lead, reworked in watercolour, 452 x 637 mm
Paris, Musée du Louvre

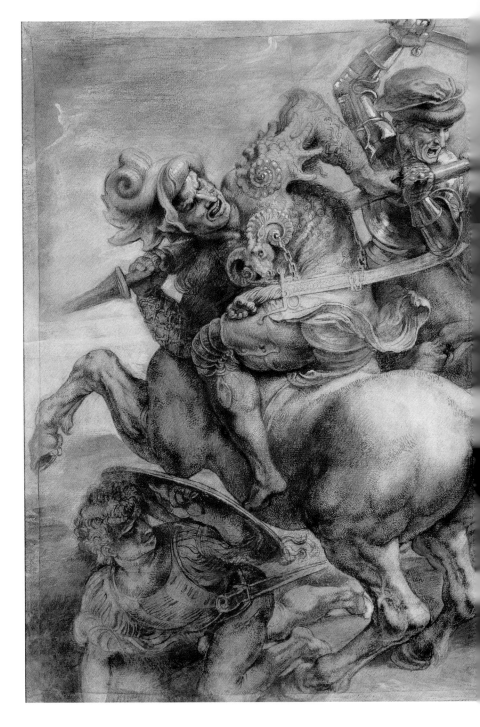

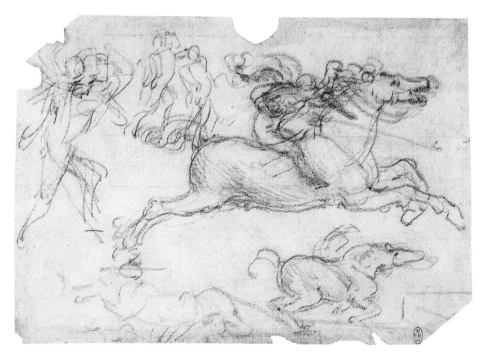

Sketch of Galloping Horsemen and Foot Soldiers, c. 1503/04
Red chalk, 168 x 240 mm. Windsor Castle, Royal Library (RL 12340r)

Pages 258/259
Aristotele da Sangallo, **Battle of Cascina, copy after Michelangelo's cartoon**, c. 1542
Grisaille, 76.4 x 130.2 cm. Holkham Hall, Collection of the Earl of Leicester

The painting thereby alludes to the fact that condottieri such as Niccolò and Francesco Piccinino were considered "children of Mars" and enjoyed a bad reputation; the fact that they sold their services on the battlefield for money made their allegiance ultimately unpredictable. Mars thus stood for an irrational and particularly corrupt form of warfare, quite the opposite of the Florentine ideal of a controlled military operation. In Leonardo's wall-painting, the leaders of the Florentine troops approaching from the right, their faces far less contorted with combative rage, represent the new ideal of warfare being propagated in Florence, namely one employing considered tactical strategy. The helmets of the Florentine soldiers are surmounted in certain copies by a winged dragon, a symbol of circumspection and prudence (*prudentia*; cf. ill. p. 249), and in almost all the rest by the mask of Minerva, the goddess who, according to classical literature, guaranteed prudence in warfare and victory over the rash and thoughtless aggression of Mars. In the portrayal of the central

characters, Leonardo's painting thus reveals an antithetical underlying structure, in which Good (Minerva with *prudentia*) is opposed to Evil (Mars with *furor*).

The motif of fighting horsemen was one that had occupied Leonardo even before the *Battle of Anghiari*. It can be found, for example, in the background of his *Adoration of the Magi* of 1481/82 (cf. Ch. II). In the 1480s Leonardo also produced drawings of battles between riders and dragons, which derive their dynamism from the confrontation between two opposing forces (Nathan/Zöllner 2014, Cat. 99–101; ill. p. 256). Similar horse and rider motifs exhibiting a comparable degree of animation would subsequently resurface in Leonardo's designs for the Trivulzio monument of *c.* 1508–1511 (Nathan/Zöllner 2014, Cat. 74–75; ills. pp. 300, 303). In formal terms, however, Leonardo's earlier drawings of battles between dragons and horsemen differ in an important respect from the composition of the battle for the standard. Whereas the opposing parties in the earlier drawings still maintain a minimum of distance between them, in the *Battle of Anghiari* they are in such close contact that even the horses appear to be fighting one another. The decision to bring the horses so close together that they are able to bite each other was probably a later modification of the originally more broadly spaced design. It does not appear in Leonardo's first exploratory sketch for the composition, but only in the second (Nathan/Zöllner 2014, Cat. 42, 44; ill. p. 461).

This narrowing of the composition looks back to the *Fall of Phaeton*, a classical motif known in Florence from an antique cameo and including two horses in close contact (ill. p. 257). In addition to its aesthetic appeal, the *Fall of Phaeton* carried a decidedly moral message. The young Phaeton had been granted permission by his father Helios to drive the chariot of the sun for one day. But the adventure ended in tragedy when the inexperienced and overly bold youth lost control of the dangerous team of horses, fell out of the chariot and thereby set the world on fire. The arrogant young man had thus set himself a challenge that exceeded his modest capabilities. References to the story of Phaeton could also be found in literature, where they implied a moral condemnation of arrogant behaviour. This is the conclusion underlying Ovid's retelling of the story in his *Metamorphoses* (2.19–332) and echoes again in Dante's *Divine Comedy* (Inferno, 17.111) and in Cristoforo Landino's 15th-century commentary on Dante. In view of the subject's pronouncedly moral interpretation by prominent Florentine

Antique cameo: The Fall of Phaeton
Drawing. Formerly Medici Collection

writers, it is something of an irony of fate that Leonardo should draw upon the Phaeton composition in his *Battle of Anghiari*. With this monumental wall-painting, which owing to problems resulting from Leonardo's choice of technique would rapidly prove impossible to complete, the artist had indeed taken on too much.

The condemnation of arrogant behaviour, which finds its way, through Leonardo's formal reference to the *Fall of Phaeton*, into the *Battle of Anghiari*, is notable in another respect, too, for arrogance was something applicable to both sides in the conflict. In the historical battle of Anghiari, the Milanese troops had overestimated the strength of their forces and had advanced too deep into Tuscan territory. Their arrogance was punished by military defeat. But Leonardo's masters might also be accused of a certain arrogance in regard to their own political actions and their commissioning of the wall-painting. In 1503, namely, Florence was waging a dubious offensive against Pisa. In this case, however, the aggressor who had overstepped itself in military and economic terms proved to be Florence, which was obliged to look for support to the French. The interpretation of the fall of Phaeton as punishment for an arrogant or ill-judged undertaking could therefore be turned against the Florentines themselves, who in their war against Pisa acted particularly unwisely. As earlier in the case of the *Last Supper*, the formal vocabulary of the *Battle of Anghiari* thus offers certain parallels revealing the problematical aspects of the contemporary situation.

The dynamism of Leonardo's wall-painting, which concentrates on the violent clash of enemy horsemen, is utterly foreign to the composition by Michelangelo, which has survived in a copy by Aristotele da Sangallo (1481–1551; ill. pp. 258/259). The younger artist opted for an almost frieze-like arrangement of naked bodies, whose various actions are at first sight puzzling to the uninitiated viewer. But Michelangelo, too, was portraying a specific event in military history, one described in detail in documentary sources. 28 July 1364 was a very hot day, and the Florentine soldiers and generals decided to refresh themselves in the waters of the Arno not far from Cascina. All of a sudden the enemy Pisan troops appeared. Fortunately Manno Donati, a Florentine commander, had not gone bathing with the rest and raised the alarm. This is the moment Michelangelo portrays: some of the soldiers are still getting out of the water, others are already drying themselves and starting to put on their clothes and armour with urgent haste. Several figures are portrayed in particular detail, such as the man in the centre of the composition winding a cloth around his head. He is probably the condottiere Galeotto Malatesta, a professional military leader hired by the city of Florence. When the alarm sounded he was laid low with a temperature and had to be woken up, and soon afterwards he transferred the command to a collective of Florentine men.

The significance of his figure becomes all too clear when we remember the message underlying Leonardo's *Battle of Anghiari*. For there we find the same theme of the unreliability and even dangerousness of hired condottieri, illustrated even more drastically in

Study of Horsemen in Combat and Foot Soldiers (sketch for the *Battle of Anghiari***),** 1503
Pen and ink, 101 x 142 mm. Venice, Gallerie dell'Accademia, Inv. 216

Pages 262/263
Battle between a Rider and a Dragon, c. 1482 (?)
Stylus underdrawing, pen and brush on paper, 139 x 190 mm
London, The British Museum, Inv. 1952-10-11-2

the martial figure of Francesco Piccinino. Michelangelo formulates his warning somewhat less dramatically than Leonardo: the emphasis in his composition is less on belligerent *furor* than on the virtues of vigilance and presence of mind. This presence of mind finds expression above all in the figure raising the alarm in the upper right-hand side of the composition, who probably represents Manno Donati and whose helmet is crowned by a winged dragon. Donati had kept a cool head despite the heat, had neither ventured into the water nor laid down for a rest, and was thus able to warn his comrades about the enemy advance. Significantly, his vigilance is emphasized by a dragon, the symbolic animal that we have already encountered in the *Battle of Anghiari* as a representation of *prudentia*. In Michelangelo's picture it is presence of mind, in the form of prudence and vigilance, which steps in to help, here as a creature raising the alarm.

261

*In the evening I went for a walk with a fellow countryman
and we argued about who was best, Michelangelo or Raphael.
I took the side of the former, he the latter, and we concluded
by jointly singing the praises of Leonardo da Vinci.*
JOHANN WOLFGANG VON GOETHE, 1787

**Anatomical Studies of the Muscles of the Legs and a Comparison
of these Muscles in Man and Horse**, c. 1507
*Pen, two shades of brown ink and red chalk on red prepared paper, 282 x 204 mm
Windsor Castle, Royal Library (RL 12625r)*

Michelangelo even allows an element of visual humour to creep in at this point: his dragon has its mouth wide open, shouting "al'arme" – to arms – like its wearer, Manno Donati. There can be no doubt that Donati's dragon of vigilance is directly related to the same animal appearing on the helmet of Piergiampaolo Orsini in Leonardo's *Battle of Anghiari*. In exploring this relationship, we might even go one step further. Leonardo portrayed his dragon in artistically relatively straightforward profile and concentrated his powers of imagination and design on the physiognomies of the two Piccininis, the generals associated with Mars. Michelangelo, on the other hand, not only strove to achieve intense expressiveness in the individual faces of his figures, but even gave his dragon a facial expression pregnant with meaning. It is as though he wanted to complement and indeed trump the masterly portrayal of human facial expression in Leonardo's *Battle of Anghiari* with the equally masterly portrayal of a brutishly distorted physiognomy.

In their dramatic depiction of armed conflict, the contrast between the two artists' designs could hardly have been greater. Leonardo focused on the violent encounter of opposing forces and characterized the warring factions by means of recognizable attributes. Michelangelo, on the other hand, attached less importance to identifying his figures and dedicated himself all the more intensively to the expressive portrayal of the male nude. He had already experimented with the possibilities offered by the male nude in his so-called *Battle of the Centaurs* of 1492 and again in his marble statue of *David*, completed in 1504 (ill. p. 267).

Leonardo seems to have been impressed by the "muscular rhetoric"of his young but already successful rival: the one surviving drawing by Leonardo of a contemporary artwork is of Michelangelo's *David* (ill. p. 266). Probably as a result of seeing the much talked-about

Detail of **Drawing after Michelangelo's** *David*, c. 1504
Pen and ink and black chalk, 270 x 201 mm
Windsor Castle, Royal Library (RL 12591r)

Michelangelo, **David**, 1501–1504
Marble, height 4.10 m. Florence, Galleria dell' Accademia

*He showed all the bone structure, adding in order all the nerves
and covering them with the muscles: the first attached to the
skeleton, the second that hold it firm and the third that move it. In the
various sections he wrote his observations in puzzling characters
(written in reverse with the left hand) which cannot be deciphered by anyone
who does not know the trick of reading them in a mirror.*

GIORGIO VASARI, 1568

statue of *David* and the expressive figures of the *Battle of Cascina*, Leonardo embarked virtually straight away or not long afterwards upon an intensive study of muscular male nudes (Nathan/Zöllner 2014, Cat. 144–148, 262–263, 273–275; ill. p. 265). From these he moved directly on to the anatomy of the locomotor system (Nathan/Zöllner 2014, Cat. 267, 270, 277–281, 290) before turning his detailed attention to all aspects of the human body.

Leonardo's renewed enthusiasm for the anatomy of the human body, which resulted in some very expressive drawings of muscular male nudes, comes as something of a surprise, for during the period 1500 to 1506 he had been sharply critical of depictions of exaggeratedly muscular male bodies. Thus he rebukes those "who, to seem great draughtsmen, draw their nude figures looking like wood, devoid of grace; so that you would think you were looking at a sack of walnuts rather than the human form, or a bundle of radishes rather than the muscles of figures" (RLW § 488). The revival of Leonardo's interest in expressive male nudes was probably connected with the rise of the young Michelangelo: the rectilinear figural style of the 15th century had now been overtaken by the heroic style of the High Renaissance, which the Florentine painter and sculptor was to elevate to a new ideal with his portrayal of powerful male bodies. In the battle of the two giants, the younger artist, Michelangelo, seems to have made a greater impression upon the elder, Leonardo, rather than the other way round. As the wealth of muscular nudes in the Sistine Chapel would demonstrate a few years later, the rather more restrained style of the Quattrocento, as employed by Leonardo in his *Last Supper*, was already out of date. A new physical ideal began to appear in art, one created by Michelangelo.

Detail of **Study of Naked Soldiers and other Figures**, c. 1503/04
*Pen and ink with traces of black chalk on yellowish prepared paper,
253 x 197 mm. Turin, Biblioteca Reale, Inv. 15577 D.C.*

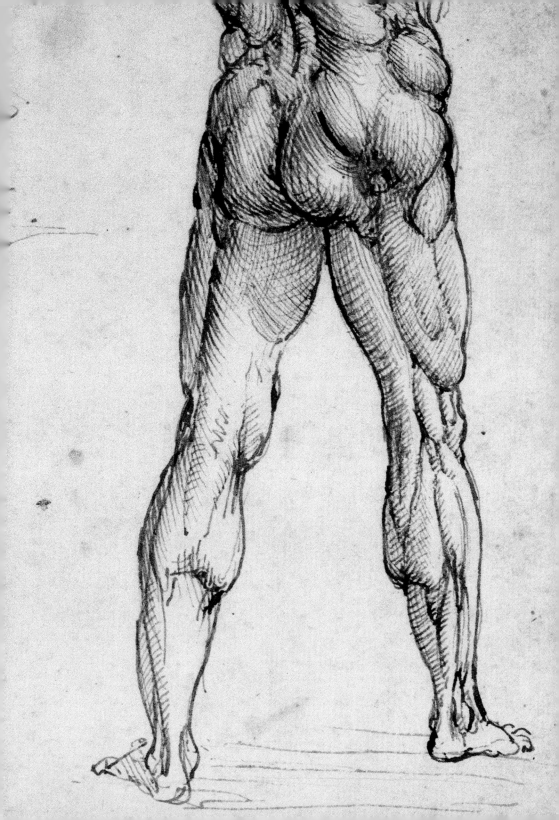

IX

Between Florence and Milan

1506–1510

*[…] at a stroke, he breaks with the traditional
painting of the 15th century; he arrives without errors,
without failings, without exaggerations and as if in
one bound at this judicious and erudite naturalism, far
from servile imitation and an empty, fleeting ideal.*

EUGÈNE DELACROIX, 1860

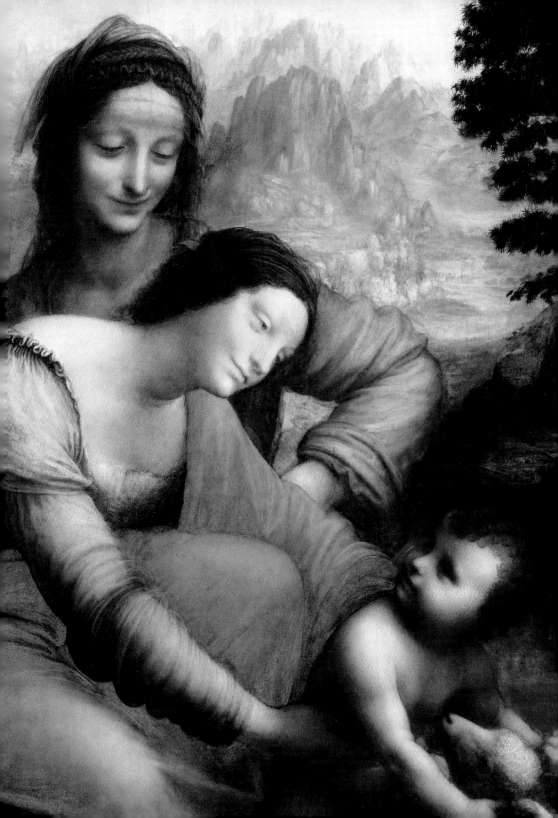

The reasons that prompted Leonardo to break off work on the *Battle of Anghiari* in the spring of 1506, and finally to abandon the painting altogether, were various in nature. Vasari reports of friction between the artist and his employers arising out of the way in which he was paid. Problems to do with Leonardo's unconventional paint medium were another factor, for in the *Battle of Anghiari* – as in the case of the *Last Supper* a few years previously – Leonardo had again decided against executing his mural rapidly *a fresco*. He experimented instead with oil binders with the aim of extending the amount of time his paints were workable on the surface of the wall. Leonardo might also have had personal motives for returning to Milan: in April 1506, just under two years after the death of his father on 7 July 1504, Leonardo's brothers proceeded to cut him out of his father's will, leaving his ties to his family and hence to Florence severely strained. The ongoing dispute over a bonus payment for the second version of the *Virgin of the Rocks* (cf. Ch. III), which had revived itself in 1503, may also have made a trip to Milan necessary. What ultimately caused Leonardo to abandon the *Battle of Anghiari* and leave Florence, however,was probably the fact that a number of other patrons were trying to secure his services and that he was now aware, more than ever before, of his worth as an artist.

Isabella d' Este had been pursuing him for years with requests for a portrait or indeed a painting of any kind. In May 1506 the Marchioness even called in Alessandro Amadori, one of Leonardo's uncles, in the hope of finally achieving the object of her desires, but in vain: the artist had already set his sights even higher. The contacts with the French that he had probably first established in Milan in 1499 (cf. Ch. VI) proved to be the more promising option, for both Charles d'Amboise, the French governor in Milan, and the king of France himself expressed great interest in the work of the Florentine artist.

In the hope of securing an appointment with the French court, on 30 May 1506 Leonardo obtained three months' leave from his work on the *Battle of Anghiari*. An agreement regulating this leave of absence thereby stipulated that the artist had to return to Florence in three months' time; should he fail to do so, he would have to pay the not inconsiderable sum of 150 gold ducats. Despite this threat of a fine, the artist did not return to Florence within the appointed time. With the help of the French governor in Milan, he managed to get the deadline extended several times, making it increasingly unlikely that he would ever fulfil his obligations in Florence.

The French king and Charles d'Amboise (d. 1511) were naturally more attractive as patrons than either the Florentine Republic, rocked by crises and in dire economic straits, or Isabella d' Este, Marchioness of Mantua, whose wishes could not compete with the

Page 271
Detail of **Virgin and Child with St Anne**, c. 1502–1513 (?)
(ill. p. 281)

commissions potentially offered by the most powerful monarch in Europe. In their correspondence with the Florentine government, the French for their part conveyed the impression that they were extraordinarily interested in Leonardo and his art. The clearest evidence of this is a letter of 16 December 1506, in which Charles d'Amboise attempts to pacify an enraged Piero Soderini, the Florentine gonfalonier. On 9 October 1506 Soderini had complained bitterly about Leonardo's breach of contract and referred to his unfulfilled obligations. In his reply, Charles d'Amboise adopts a conciliatory tone, promising that the artist will soon be departing for Florence and praising him in the most effusive terms: "The distinguished works which Master Leonardo da Vinci, your fellow Florentine, has left behind in Italy, and in particular in this city [Milan], dispose all who see them to hold him in particular affection, even if they have never met him. And we must confess that we, too, number amongst those who held him dear even before we met him in person. Having had dealings with him and having experienced his talents [*virtute*] for ourselves, however, we saw truly that his name, made famous through painting, still shines less brightly than it deserves in view of his other talents. And we must admit that in the things he produced as examples at our request, in drawing and architecture and other areas pertinent to our requirements, he satisfied us in a way which not merely matched our expectations but filled us with admiration."

Despite the promises made to Soderini, however, Leonardo's departure from Milan was put off yet again after this letter, following the intervention of the king of France himself. On 12 January 1507 Louis XII informed Francesco Pandolfini, the Florentine envoy at the French court in Blois, that His Majesty wished to meet Leonardo in Milan. Pandolfini reported the king's request, which was evidently issued in the tone of a command, as follows: "This morning, in the presence of the Most Christian King, His Majesty summoned me to him and said: 'Your Signori [government] should write to me. Tell them that I need your painter, master Leonardo, who is living in Milan, because I wish him to make some things for me. See that your Signori charge him with this task and command him to place himself immediately at my service, and that he does not leave Milan before my arrival. He is a good master, and I would like to have a number of things by his hand. And write to Florence in a way that will achieve this end, and do it straight away, and show me the letter being dispatched to Milan.'" Further on, Pandolfini reveals the reason why the king is so eager for Leonardo to enter into his employ in Milan. "All this has been sparked by a small painting by [Leonardo], which arrived here recently and is very greatly admired." The painting in question may have been the – now lost – first version of the *Madonna of the Yarnwinder*, which was probably taken back to France by the man who commissioned it, Florimond Robertet.

Pandolfini goes on to discuss Louis XII's specific intentions. "When I asked His Majesty during our conversation what sort of works he wanted from Leonardo, he

replied: 'A number of small pictures of Our Lady and other things, depending on what springs to mind. Perhaps I will also have him paint my portrait.' In a further conversation that I conducted with His Majesty to the benefit of Your Signori, in which I discoursed on Leonardo's perfection and on his other qualities, His Majesty, adding what he had heard about Leonardo, asked me if I knew him. And when I replied that he was a very dear friend of mine, he replied: 'Write a few lines to him straight away and tell him he is not to leave Milan and that Your Signori will be writing to him from Florence.' And for this reason I wrote a note to the aforementioned Leonardo and told him how favourably His Majesty was disposed towards him [...]"

The Florentines were naturally powerless to deny the wishes of Louis XII. Not long after leaving Florence, Leonardo thus found himself in the service of the Milan representative of the French king, from whom, over the following years, he would receive his most regular income yet (RLW § 1529). Our knowledge about Leonardo's second Milanese period, which was interspersed with brief spells in Florence, remains full of gaps, however. What works of art Leonardo produced, and on what other tasks he was engaged, are questions still not fully answered. We know that he continued in Milan, and later in Rome, the anatomical studies that he had resumed in Florence. He also turned his attention to the illumination of the moon (ill. p. 275) and more generally to the effect of light and shadow on three-dimensional bodies (ill. p. 277).

During more or less the same period, he designed decorations for festivities at the French court in Milan, made himself useful as an architect, was involved on the expan-

Studies and Notes on the Water Balance of the Earth, 1506–1508
Pen and ink, 290 x 220 mm
Seattle, Melinda and William H. Gates III, Codex Leicester, fol. 1B (36r)

Studies on the Illumination of the Moon, c. 1506–1508
Pen and ink, 293 x 221 mm
Seattle, Melinda and William H. Gates III, Codex Leicester, fol. 1A (1r)

sion of irrigation systems and worked on unfinished compositions such as the *Virgin and Child with St Anne* (Cat. XXVII/ill. p. 281). He had probably already begun this picture in Florence, since in formal terms it is a variation, in reverse, of the St Anne composition begun for the church of SS Annunziata in Florence (Cat. XXII/cf. Ch. VII). The *Virgin and Child with St Anne* today housed in the Louvre may possibly even be identical with a panel (*tavola*) for Louis XII mentioned by Charles d'Amboise in January 1507, or with a painting mentioned by Leonardo himself just over a year later.

In spring 1508, in a petition probably addressed to Charles d'Amboise, the artist namely wrote: "I am now sending Salaì to you to explain to Your Lordship that I am almost at the end of my litigation with my brothers, and that I expect to find myself with you this Easter, and to bring with me two pictures of Our Lady, of different sizes, which have in my own time been brought almost to completion for our own most Christian King, or for whomsoever Your Lordship pleases. I should dearly like to know where upon my return to you I might have lodgings, for I should not like to trouble Your Lordship further. And also whether having worked for the most Christian King, my salary is to continue or not" (MK § 619).

Leonardo's letter offers a subtle indication that modes of artistic production were beginning to change. In the period around 1500 there was still no art market in the modern sense; as a rule, artists worked exclusively to commission, producing pictures whose destination was known from the outset. They did not, in other words, build up stocks of paintings that could be sold upon demand. In the case of famous artists whose services were sought after by royal patrons, however, this model was gradually beginning to change. A case in point is Leonardo's *Virgin of the Rocks*, which although originally commissioned to form part of an altarpiece by the Franciscan Confraternity of the Immaculate Conception, was sold to a private individual at the instigation of the artists (cf. Ch. III). The ties that had traditionally bound works of art to specific contexts and functions were thus slowly starting to loosen.

Further evidence of this process can be deduced from the letters, cited above, by Isabella d'Este and Francesco Pandolfini, which indirectly acknowledge a greater autonomy on the part of the artist: thus both Isabella and the French king are relatively non-specific when it comes to the sorts of artworks they wanted Leonardo to paint for them. Leonardo's response to this shift emerges in his letter to Charles d'Amboise, where we learn that he has produced, on his own initiative, paintings of the Virgin in different sizes, either for Louis XII himself or some other interested party.

Studies on Light and Shade, c. 1508
Pen and ink over black chalk, 437 x 314 mm
Windsor Castle, Royal Library (RL 19149v-19152v)

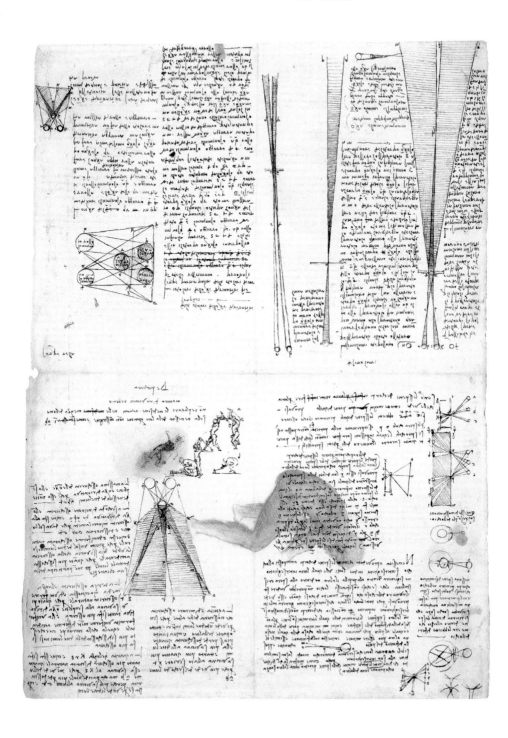

Drapery Study for the Virgin and Child with St Anne, c. 1501 or c. 1510/11 (?)
Black chalk, brush, black wash, white heightening, on white paper, 230 x 245 mm
Paris, Musée du Louvre, Cabinet des Dessins, Inv. 2257

Leonardo's *Virgin and Child with St Anne* may be a similar case of a painting originally conceived for a specific context and as the result of a concrete agreement, but then retained in the master's workshop, either as a basis for further copies (see below) or for sale, should the opportunity present itself, to an art lover. This would explain why Leonardo kept the picture in his possession right up to his death. Certain of the painting's formal properties furthermore suggest that the *Virgin and Child with St Anne* was the culmination of many years of work. In terms of its figural composition, its dynamism and its unusual landscape background, the painting indeed has the character of an artistic legacy, an echo of earlier forms. This is true not only of its pyramidal construction, as deployed in earlier paintings (Cat. III, VI, XI, XXII), and its atmospheric background (Cat. III, IV, V, XXIII), but also the arrangement of its figures, which can also be found in previous drawings (Nathan/Zöllner 2014, Cat. 29, 116–117; ill. p. 52).

In the *Virgin and Child with St Anne*, Leonardo again employs a sequence of interconnected figures – almost as if St Anne and Mary have the same body, portrayed in two different positions. The compositional relationship between the figures, and the fact that St Anne and Mary appear to be of a similar age, serve to emphasize the close family ties between the individuals portrayed. The youthful appearance of both women can also be interpreted as a reference to their ideal age, which is directly connected to the doctrine that both were virgin mothers. St Anne is portrayed as the same age as Mary because of her *Mariaformitas*, her "likeness to Mary": the Marian attribute of a youthful face is transferred from the Virgin to St Anne in order to underline her rank and saintliness.

Alongside the constellation of its figures and its wealth of movement, another striking feature of the *Virgin and Child with St Anne* is the mountainous landscape, which, somewhat in the manner of a vertical backdrop, entirely fills the background (ills. pp. 271, 281). The peaks melting into the distant haze form a high horizon; in the right-hand side of the picture they rise even higher than the head of St Anne and appear more monumental than in Leonardo's early paintings. This increased monumentality may be related to the artist's studies into geology and hydrology, or to his views on the endless cycle of nature and the creation of the earth (Nathan/Zöllner 2014, Cat. 450–451, 453; ill. pp. 284/285). In this context, the chains of mountains in the background might be seen as continents that rose up out of the primeval ocean in prehistory and were eroded over the course of time (RLW § 929, 938, 941, 967, 976). Towards the end of the 1490s Leonardo had observed in this regard that "the summits of mountains for a long time rise constantly" (RLW § 981).

A few years later, he described how mountains and strata of rock were created as a result of the erosive action of flowing water: "The water which flowed down from the land exposed by the sea, after the land had risen up out of the sea [...], began to form various streams in the lower parts of this plain [...] These streams then gradually ate away at

[…] it took me about two weeks to paint the splash.
I loved the idea, first of all, of painting like
Leonardo, all his studies of water, swirling things.

DAVID HOCKNEY, 1976

Studies for the Infant Christ, c. 1501–1510 (?)
Red chalk and white heightening on reddish prepared paper, 285 x 198 mm
Venice, Gallerie dell'Accademia, Inv. 257

Virgin and Child with St Anne, c. 1503–1519
Oil on poplar, 168.4 x 113 cm. Paris, Musée du Louvre, Inv. 776 (319)

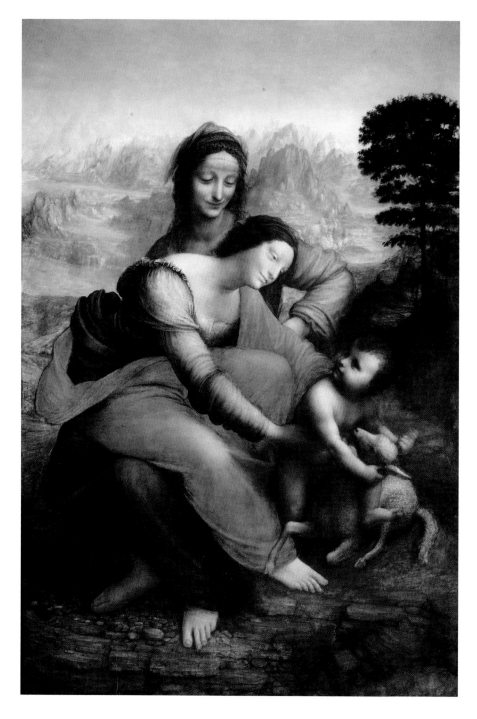

Study for the Virgin and Child with St Anne, c. 1501 (?)
Pen and ink over black chalk, 260 x 197 mm. London, The British Museum, Inv. 1875-6-12-17r

Study for the Head of Leda, c. 1505–1510 (?)
Pen and ink over black chalk, 200 x 162 mm. Windsor Castle, Royal Library (RL 12516r)

Pages 284/285
Explosion of Rock caused by the Bursting of a Water Vein, c. 1508–1511
Black chalk, 178 x 278 mm. Windsor Castle, Royal Library (RL 12387r)

the banks of the rivers, until the walls of these rivers became steep mountains, and when all the water had flowed away, these mountains began to dry and to form rock in strata of greater or lesser width, depending on the thickness of the mud which the rivers deposited in the sea when they flooded" (Ms. F, 11v). The fissured layers of rock visible at the feet of St Anne and the Virgin correspond with this stratification theory, while the mountains in the background recall the land that in ancient times rose out of the sea, as described by Leonardo in his notes on the power of erosion cited above.

Alongside the geological associations of the background landscape bathed in a luminous haze, we should also note the ways in which, even more than in the *Madonna of the Yarnwinder* (cf. ills. pp. 225–227), the treatment of the background in the *Virgin and Child with St Anne* reflects other of Leonardo's observations of nature and experiments. In no other painting by Leonardo is the luminosity of the sky and the way in which it appears blue in the distance captured to such atmospheric effect. The blue colour of the air, in particular, was something that Leonardo tried to explain both in his theoretical writings and with the aid of scientific experiments. Thus he observes: "Beyond the sun and us there is darkness and so the air appears blue" (RLW § 868). In another place, he explains that "the atmosphere assumes this azure hue by reason of the particles of moisture which catch the rays of the sun" (RLW § 300). By way of another example of the blue of the atmosphere (RLW § 304), he offers the following observation: "Again as an illustration of the colour of the atmosphere I will mention the smoke of old and dry wood, which, as it comes out of a chimney, appears to turn very blue, when seen between the eye and the dark distance" (RLW § 300). Leonardo believes he has made a similar observation when looking at "the dark shadows of distant mountains when the air between the eye and those shadows will look very blue". In this same passage the artist also explains why the air appears white directly above the horizon and blue further up, namely because directly above the horizon there is more air between the eye and the darker "sphere of fire" higher up.

In considering the *Virgin and Child with St Anne* in terms of Leonardo's observations on the colour of the atmosphere, however, we should not forget that we are here looking at a religious painting, one whose Christian symbolism had already caught the attention of Pietro da Novellara in the example of the first Florentine version of the St Anne cartoon (Cat. XXII/cf. Ch. VII). Thus the Virgin is trying to separate Jesus from the lamb, the sacrificial animal that symbolizes his Passion, while St Anne, as the personification of the Church, is trying in turn to prevent her from doing so, since the Saviour must be allowed to fulfil his destiny on the Cross.

Pages 287–289
Follower of Leonardo, after a design by Leonardo, **Leda and the Swan**, c. 1505–1515 (?)
Oil on wood, 130 x 78 cm. Florence, Galleria degli Uffizi, Inv. 1890 (9953r)

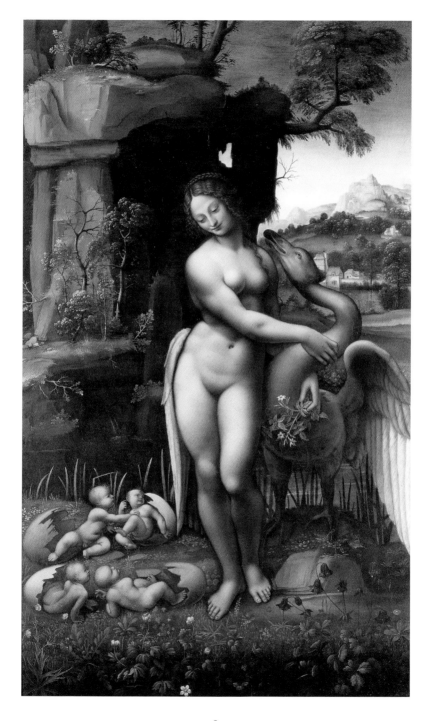

As in Novellara's interpretation of the constellation of the figures, so too there is religious symbolism in the background landscape (cf. Ch. III): the emptiness of nature, largely untouched by human hand, the low-lying valley that, although unsuitable for cultivation, is nevertheless made fertile by heavenly rain, the clear and bright light, the cool mist that absorbs the heat of the sun ("Cortina dei cieli, cielo senza nuvole, aria leggera, profumata, primavera./Nuvola luminosa, splendida, chiarissima, candida, leggera, serena, pura, mattutina, cha dà pioggia, piena di ruggiada, che tempera l'adore del sole, che si leva dal vapore dell'umidità, che sale ai cieli per il calore del sole vero") – all these elements are known from Marian chants of supplication of the day. They were used in daily prayers and understood as metaphors for Mary, who miraculously gave birth to Jesus untouched by human hand.

The motif of a natural landscape untouched by human hand as a symbol of the Immaculate Conception is possibly found again in the contrast between the rugged mountains, largely devoid of vegetation, and the tree on the right-hand edge of the panel. This latter is a tall, broad-leafed tree that strictly speaking has no place in a high-altitude setting. The rocks in Leonardo's painting place the scene well above the tree line, a location, in other words, where deciduous trees no longer grow, or at least not to this size. In portraying a flourishing tree within a barren mountainous landscape, Leonardo is probably referring to St Anne, who was at first infertile and then, late on in life, conceived her daughter with divine, not human, assistance. The contrast between the tree and the mountains is thus also indebted to a religious symbolism and serves to illustrate Anne's initial earthly infertility and subsequent immaculate conception.

It was during the years in which he was trying to complete the *Virgin and Child with St Anne* that Leonardo probably also produced his *Leda and the Swan*, a painting today known to us only through copies. Leonardo evolved his *Leda* – a subject evidently very

Follower of Leonardo (Cesare da Sesto?), **Leda and the Swan**, c. 1505–1515 (?)
Oil on wood, 96.5 x 73.7 cm. Salisbury, Wilton House Trust, Collection of the Earl of Pembroke

popular in the 16th century – from a number of earlier, formally related designs. In probably the earliest of his sketches for the project (Nathan/Zöllner 2014, Cat. 56–58, 62; ill. p. 283), he concentrated primarily on the figure of Leda kneeling (ill. p. 294), a motif which bears formal similarities to the kneeling figure of St Jerome (Cat. IX/cf. Ch. II) and is preserved in a painting by Giampietrino (*c.* 1500–1540; Cat. XXVIII/ill. p. 295). Although the swan is missing in this version of the *Leda* composition, the animated figure is clearly derived from Leonardo's drawings. Over the following years, Leonardo took the motif of the slightly bending figure of Leda being tenderly importuned by the swan and turned her into a standing nude with the

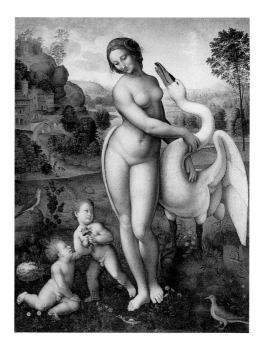

same iconographical attributes (Cat. XXIX/ills. pp. 287, 290, 291). The subject of both the drawings and the copies of the painting is one of the amorous adventures of Zeus, the father of the gods, who used to pursue young women (and sometimes also young men) in the guise of a wild creature or some other seemingly innocent form. In Leda's case, as we know, he took the shape of a swan. In one of his drawings, Leonardo portrays Zeus, as a swan, nestling his right wing around Leda, who turns tenderly towards him and lays her left hand gently on his head. Her right hand points to the children who have just hatched from their eggs.

More monumental in its overall effect is the version of the composition in which Leda is standing, as known to us from paintings based on Leonardo's original design. The swan here appears more insistent – it is standing upright, stretching its neck upwards and holding the young woman more firmly with one wing. Leda turns away from her lover with her eyes lowered but also now clasps him with both hands. The frontal view of the female nude offered by the painted copies of Leonardo's composition reinforces their erotic character. Leda's pose and her plastically modelled curves furthermore establish a link with antique statues of Venus and hence directly with love. The erotic nature of the theme also

Follower of Leonardo, after a design by Leonardo, **Leda and the Swan**, after 1505-1510
Tempera on wood, 112 x 86 cm. Rome, Galleria Borghese

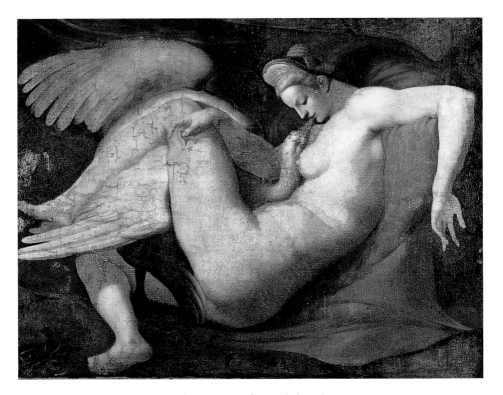

Unknown artist, after Michelangelo,
Leda and the Swan, after 1530
Oil on canvas, 105.4 x 141 cm. London, The National Gallery

reveals itself in the middle ground, with its many bulrushes – marsh plants of the genus *Typha latifolia*, to give them their correct botanical name. These bulrushes, which appear in both the drawings and the paintings, bear dense cylindrical flower heads that, when they burst, scatter their seeds far and wide over water and land – nature's way of making sure that a plant will increase and multiply. The sexual connotations of the bulrush, and by implication of the picture itself, could hardly be clearer. In the copy of the picture in the Uffizi (Cat. XXIXa/ill. p. 287), however, the bulrushes are missing. Here, the erotic character of the painting is underlined by the columbine in the foreground, which was considered an aphrodisiac.

Since Leda was lusted after and loved by the greatest and most powerful of all the gods, Zeus himself, the subject was especially suitable for high-ranking court patrons. They too at times considered themselves superior to all the rest, and generally ensured that they took to themselves the most beautiful and fertile women.

It should be noted at this point, however, that Leonardo's *Leda and the Swan* clearly differs from the version handed down from antiquity and in copies after a design by Michelangelo (ill. p. 292). In contrast to the usual prototype, Leonardo portrays not the sexual act itself, but two other facets of the story with very different connotations: on the one hand, the tenderness between the two lovers, and on the other, the children produced by the union of Leda and Zeus. It is conceivable that Leonardo, by not making the lusty Zeus the express focus of the scene, was taking into account the wishes of a client.

Just as we have suggested in the case of the *Virgin and Child with St Anne*, however, it is also conceivable that Leonardo produced his *Leda* design with only potential – and not specific – customers in mind. The possibility cannot be ruled out that the master supplied only cartoons, which were then turned into paintings by pupils such as Giacomo Salaì (*c.* 1480–1524). Leonardo then simply added the finishing touches. We even have concrete proof that this procedure existed; Vasari, for example, claims that some of the works attributed to Salaì in Milan were retouched by Leonardo. Pietro da Novellara describes a similar phenomenon in his letters of 3 and 14 April 1501 (cf. Ch. VII), where he writes that Leonardo "has no time for the brush" and manages only "to put his hand […] from time to time" to the copies being made by his apprentices. It is possible that the two oldest versions of the *Madonna of the Yarnwinder* (Cat. XXIII–XXIV) and the best copies of *Leda and the Swan* (Cat. XXIXa–b) were produced in this way. A number of versions of the *Virgin and Child with St Anne* (Cat. XXVII/see above) may also have been completed in this fashion, with Leonardo just supplying a preparatory drawing of the overall composition, together with a number of detail drawings, and leaving his pupils to execute the actual painting. The fact that some of the early copies of the *Virgin and Child with St Anne* presuppose a familiarity with Leonardo's drapery studies (ill. p. 278) lends support to this theory.

Another indication that Leonardo's drawings served as the startingpoint for independent works by some of his apprentices can be found in Giampietrino's "Kneeling Leda" (Cat. XXVIII/ill. p. 295), beneath which lies an underdrawing of Leonardo's *Virgin and Child with St Anne*. The picture was evidently originally planned to be a *St Anne*, based on a cartoon by Leonardo, but was then changed to a *Leda*, also based on a design by Leonardo. Similar methods of production, whereby pupils executed paintings on the basis of a cartoon by their master, were employed in the workshop of Pietro Perugino, for example – albeit on a very much larger scale. The number of copies turned out by members of Leonardo's workshop would have been lower, however, since unlike Perugino, Leonardo was working on many other projects at the same time, not all of them related to art.

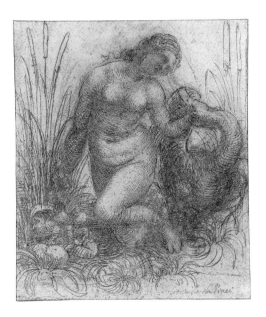

Study for a Kneeling Leda and the Swan, c. 1505–1510

Pen and ink over black chalk, 125 x 110 mm. Rotterdam, Museum Boijmans van Beuningen, Inv. 446

Pages 295–297
Giampietrino, after a design by Leonardo, **Leda and Her Children**, c. 1508–1513 (?)
Oil (and tempera?) on alder, 128 x 105.5 cm. Kassel, Gemäldegalerie Alte Meister, Inv. 966

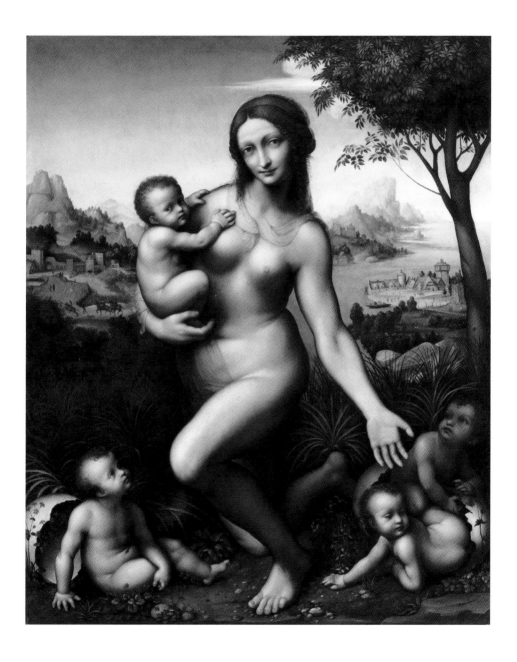

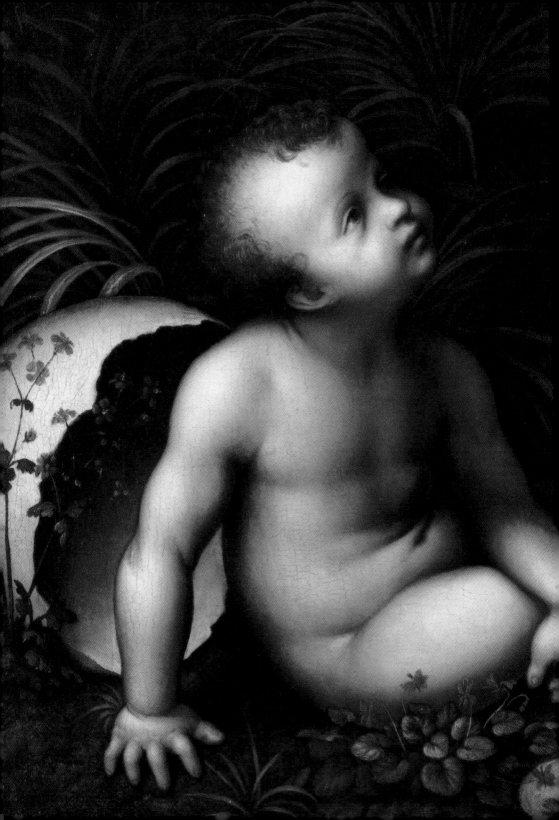

X

The last years

As for his use of light, it seemed that Leonardo was always anxious not to portray it in all its brightness, as if wishing to reserve it for somewhere more appropriate. He also painted areas of shadow with a great intensity so as to maintain contrasts. Through these skilful means, he arrived at all that nature can achieve in his marvellous representation of faces and bodies. And in this respect he was superior to all, so that in one word we can say that Leonardo's light was divine.

GIAN PAOLO LOMAZZO, 1590

In the opening years of the 1500s, the possibility of a truly large-scale artistic project once again raised its head. In Milan, Leonardo had the opportunity to revive his plans for an equestrian statue, although now no longer for the deposed Ludovico Sforza, but for Giangiacomo Trivulzio (1441–1518), who as commander of the French troops and archenemy of the Duke of Milan had played a decisive part in the taking of Milan. In his first will of 2 August 1504, Trivulzio had set aside a large amount of money to provide for a worthy memorial after his death. In the summer of 1507, however, it would seem that Leonardo showed him a set of ambitious designs that so impressed him that he abandoned his originally more modest plans in favour of a monumental tomb. Whatever the case, in Trivulzio's second will of 22 September 1507 the talk is of a considerably grander tomb project. In planning the monument, Leonardo compiled a very comprehensive list of the labour and material costs involved (RLW § 725). This estimate is one of the most detailed of its kind and, in its itemization of the specific cost of each aspect of the work, goes far beyond the documentation that survives, for example, in the case of Michelangelo's tomb for Pope Julius II. (r. 1503–1513).

In response to his potential client's grandiose expectations, Leonardo initially returned to the fascinating idea of a wildly rearing horse, which seemed technically more viable on the smaller scale envisaged for the Trivulzio monument (ill. p. 300). Compared with his earlier designs for the Sforza monument (cf. Ch. IV), he actually increased the dynamism of the movements of horse and rider, in particular by intensifying the expressive power of the body of the horse. Leonardo underlined the monumentality of the design by placing it on top of a tall plinth, which was intended to house beneath it a recumbent effigy of the deceased and which was supported on four columns, each with the sculpted figure of a prisoner tied to it. Leonardo could look back to one of his own drawings, namely a pen and ink sketch of St Sebastian dated on stylistic grounds to the 1480s (Nathan/Zöllner 2014, Cat. 142), for the motif of the twisting, bound figure. In including the four captives on the corner pillars of the Trivulzio monument, however, Leonardo was probably following Michelangelo's first, 1505 design for the tomb of Pope Julius II, which had also envisaged wounded figures – in this case, dying slaves – bound to the four corners of the tomb. In deploying design features inspired by the tomb of Julius, Leonardo and his client were thus aiming to create a monument of the grandest possible kind. But despite these aspirations and Leonardo's impressive designs, after years of planning Trivulzio eventually decided

Page 299
Detail of **St John the Baptist**, c. 1513–1516 (?)
(ill. p. 311)

Studies for the Trivulzio Monument, c. 1508–1511
Pen and ink, 280 x 198 mm. Windsor Castle, Royal Library (RL 12355r)

Sestertius of Titus (after Vico, 1548)
Copperplate engraving

Sestertius of Claudius (after Vico, 1554)
Copperplate engraving

against the project. As before in the case of the Sforza monument, external circumstances prevented the realization of an equestrian monument, which would have far eclipsed all existing examples of the genre and whose dynamism would have anticipated the animated forms of the Baroque era.

During his second Milanese period Leonardo devoted less and less of his time to painting. His focus appears to have shifted instead towards anatomical drawing, which – in its graphic immediacy and perfection – appears at his hand to become an alternative mode of artistic expression. Unlike the early anatomical drawings of Leonardo's first Milanese period, these later studies are based much more extensively on dissections of the human body. Having made his own exact observations from life, Leonardo now distanced himself from the textbook theories that had previously been a major influence on his views (cf. Ch. V). He concentrated increasingly on the mechanisms of bodily movement, providing impressive proof of his acute talent for observation and illustration (ill. p. 307).

The anatomical accuracy of his drawings of the superficial anatomy, the muscles and the skeletal system is not matched, however, by his studies of the deeper layers of the human body – something which probably reflects the enormous technical difficulties that Leonardo had to overcome in his ground-breaking research. Thus he was able to draw a four to five-month-old foetus, but in order to show the womb around it, he had

Study for the Trivulzio Monument, c. 1508–1511
Pen, ink and red chalk, 217 x 169 mm. Windsor Castle, Royal Library (RL 12356r)

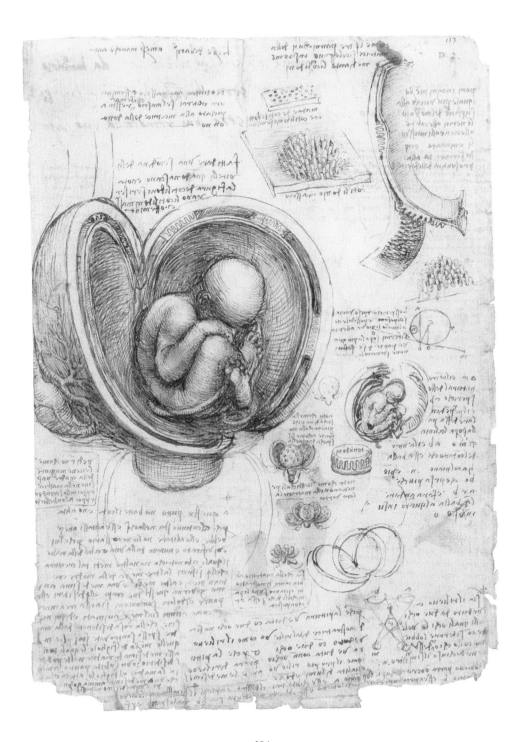

to rely on what he knew of animal anatomy (ill. p. 304). When it came to the anatomy of the heart he adopted a similar procedure, basing some of its details on the heart of an ox (Nathan/Zöllner 2014, Cat. 348). Nonetheless, for centuries Leonardo's studies remained the most precise anatomical drawings anywhere, admired by the few fortunate enough to see them, but so far ahead of their time that they were of no immediate use to medical practitioners.

As the letter of 16 December 1506 cited above (cf. Ch. IX) makes clear, Leonardo's second sojourn in Milan was closely bound up with the favour and affection in which he was held by the French governor, Charles d'Amboise. When the latter died in 1511, the artist once again lost his most important patron. It was probably as a result of this loss, which at a personal level, too, affected Leonardo more deeply than the overthrow of Ludovico Sforza twelve years earlier, that in September 1513 the artist accepted the protection of Giuliano de' Medici (1479–1516), whom he followed to the papal court in Rome. Giuliano's brother, Giovanni, had recently been elected Pope Leo X (r. 1513–1521) and it must have seemed to Leonardo, by now 61 years old, that there was a good prospect of employment at the court of the new Medici Pope. But his hopes were to be disappointed.

In Rome Leonardo had particular trouble with his German assistant, about whose insolent behaviour he complained bitterly in a letter to his patron: "I was so greatly rejoiced, most Illustrious Lord, by the desired restoration of your health, that my own illness almost left me. But I am greatly vexed at not having been able to completely satisfy your Excellency's wishes by reason of the wickedness of that German deceiver, for whom I left nothing underdone by which I could have hoped to please him." In the second half of the letter he then goes into greater detail about the craftsman's misconduct: "The next thing was that he made himself another workshop and pincers and tools in his room where he slept, and there he worked for others; afterwards he went to dine with the Swiss of the guard, where there are idle fellows, in which he beat them all; and most times they went two or three together with guns, to shoot birds among the ruins, and this went on till evening" (RLW § 1351). While Leonardo was dealing with trifling affairs of this kind, he was probably also executing smaller paintings. Vasari describes one such work in such detail that its existence is hard to doubt: "At that time for Baldassare Turini of Pescia, who was Pope Leo's datary, Leonardo executed with extraordinary diligence and skill a small picture of the Madonna and Child. But either because of the mistakes made by whomever primed the panel with gesso, or because of his own capricious way of mixing any number of grounds and colours, it is now spoilt."

Studies of the Foetus in the Womb, c. 1510
Pen, two shades of brown ink and wash over red chalk, 304 x 220 mm
Windsor Castle, Royal Library (RL 19102r)

Commissions for large-scale decorative schemes, such as those already executed by Raphael and Michelangelo, were nevertheless to elude Leonardo during this period. He devoted himself nonetheless to Leo X's project to drain the Pontine marshes south of Rome, to which end he executed an extremely detailed drawing of the area in question (Nathan/Zöllner 2014, Cat. 478). He also conducted a wide range of experiments that seemed rather strange to his contemporaries and which Vasari describes as follows: "Leonardo used to get the intestines of a bullock scraped completely free of their fat, cleaned and made so fine that they could be compressed into the palm of one hand; then he would fix one end of them to a pair of bellows lying in another room, and when they were inflated they filled the room in which they were, and forced anyone standing there into a corner. […] He perpetrated hundreds of follies of this kind, and he also experimented with mirrors and made the most outlandish experiments to discover oils for painting and varnish for preserving the finished works."

It is probably to these experiments with oils and varnishes that one of Leonardo's last paintings, the *St John the Baptist*, which today hangs in the Louvre, owes its appearance (Cat. XXX/ill. p. 311). The painting, whose dating remains the subject of some controversy, is considered the most impressive example of Leonardo's so-called *sfumato* technique, an artistic procedure described in antiquity by Pliny and at the end of the Middle Ages by Cennino Cennini and perfected by Leonardo in oil painting. This procedure involves the application of multiple layers of thin, translucent glazes, which give rise within the painting to an extremely wide and subtle range of tonal values. Outlines thereby become blurred into soft transitions from areas of light and dark and hence lend plasticity to the figure being portrayed. The painterly effect of this process depends, amongst other things, on experimentation with oils, which can be carefully built up layer upon layer and which make it possible to arrive at an almost monochrome portrayal of the subject that relies on fine nuances of light and shade alone. In his *St John the Baptist*, Leonardo also deploys *sfumato* as a means of conveying a sophisticated pictorial message: illuminated by a light source that must lie outside the pictorial space, the Baptist emerges from the almost black bacground as a figure of light. Leonardo thus translates into paint the idea underlying the composition as a whole, namely that John the Baptist is not the source but only the recipient of and witness to God's light, which is shining down on him. The painting thereby lends visual expression to the opening verses of St John's Gospel, which speak of the one who was sent to bear witness to the light. *Sfumato* is thus not simply an autonomous artistic means of expression, but also serves to convey the religious content of the picture. Shadow,

Anatomical Analysis of the Movements of the Shoulder and Neck, c. 1509/10
Pen, three shades of brown ink and wash over black chalk, 292 x 198 mm
Windsor Castle, Royal Library (RL 19003v)

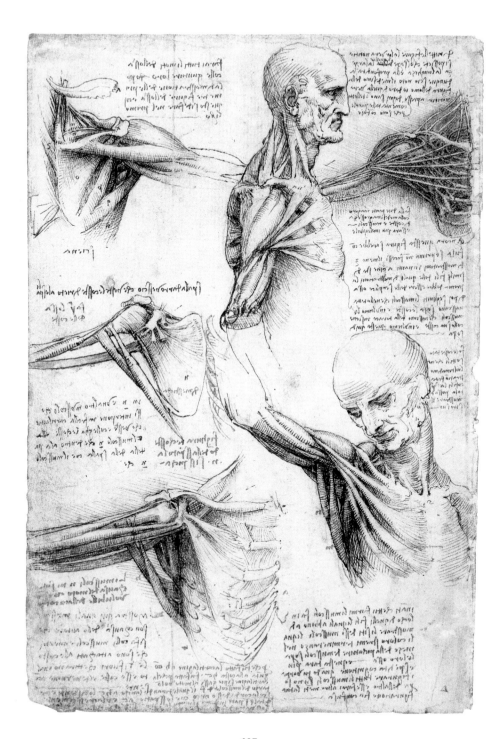

the second dominant formal element of the painting, might be understood analogously: it was seen as a symbol of God made flesh in the body of Jesus Christ and thus points, like the light, to the Son of God who will come directly after John. Just like the painting's light, its shade thus also conveys a religious symbolism.

Uncertainty still surrounds the origins of the *St John the Baptist*, since no reliable documentation relating to the date of the painting has survived. The gesture of the right hand (ill. p. 299) would at first sight seem to date the panel to Leonardo's second period in Florence, where the gesture was widely known in art. Thus it is found in St John compositions from the early 15th century (cf. Ch. II), in Leonardo's own *Adoration of the Magi* and, towards the end of the 1400s, in Domenico Ghirlandaio's panels for the high altar of Santa Maria Novella. But the painting's *sfumato* technique, here taken to its furthermost extreme, and its massive influence on Raphael's Roman works, argue in favour of a later dating. Furthermore, the subject matter itself – John the Baptist as the witness to God's light – is strongly connected with papal Rome, where, as Leo X, Giovanni de' Medici was currently pontiff.

Indeed, the theme of St John the Baptist as the witness to God's light was taken up by Raphael and his workshop in several paintings executed between 1517 and 1518 at the papal court in Rome. One such is the *Young St John* attributed to Giulio Romano (*c.* 1499–1546) and Raphael, which was probably commissioned to mark Pompeo Colonna's election as cardinal (ill. p. 308). Although this large-format canvas differs from Leonardo's *St John* in its composition, the two works nevertheless reveal a number of significant parallels. Thus each portray the saint as a solitary figure, and both are dominated by the contrast between the brightly lit flesh of the saint and the darkness of the background. Giulio Romano was clearly familiar with Leonardo's *St John*, and it would have seemed appropriate to honour

Raphael and Giulio Romano. **Young St John**, 1517–1520
Oil on canvas, 165 x 147 cm. Florence, Galleria degli Uffizi

the pope indirectly, whose civilian name was Giovanni (John), with a painting of St John as the witness to God's light.

Serving as a witness to the light is also the theme of Raphael's *Portrait of Leo X with Cardinals Giulio de' Medici and Luigi de' Rossi*, executed between 1517 and 1518 (ill. p. 309). Several elements of the composition point to this theme: the pronounced contrast between areas of light and dark, the Bible, which lies open in front of the Pope, and the golden ball topping the back of the papal chair. In the lavishly illuminated Bible, Raphael gives us the opening verses of the Gospel according to St John – "In the beginning was the Word, and the Word was with God" ("In principio erat Verbum et Verbum erat apud Deum") – and thus

the beginning of the section that ends with the reminder that John himself was not the light, but was sent by God to be a witness to the light. It was in this role that the man who commissioned the portrait, Giovanni de' Medici, alias Leo X, evidently also saw himself. In the golden ball gleaming in the divine light on the back of the chair, moreover, the Pope and his artist Raphael invest the theme with a personal dimension: the ball, or *palla*, was the heraldic device of the Medici family. Indeed, this Medici symbol reflects the divine light brightest of all, since the window through which daylight falls into the room is mirrored on its rounded surface. Thus the divine light not only shines on the symbol of the Pope's family, but is also reflected by this symbol in order to fall on other members of the papal entourage. The play upon light in the *Portrait of Pope Leo X* may perhaps be understood as a conscious artistic exercise by Raphael, who as the painter becomes the master of light. Leonardo had already explored the same theme in his *St John the Baptist*.

Leaving aside the discussion of the painting in its historical context, it has recently become popular to try and interpret Leonardo's *St John* from a biographical point of view. The gentle shading lends the flesh a soft, delicate appearance and thereby an androgynous quality, which has been read as an expression of Leonardo's homoerotic leanings.

Raphael, **Portrait of Leo X with Cardinals Giulio de' Medici and Luigi de' Rossi**, c. 1517/18
Oil on wood, 155.2 x 118.9 cm. Florence, Galleria degli Uffizi

Yes, da Vinci promises heaven:
look at this raised finger [...]
But Raphael, he gives it to us.
PABLO PICASSO, 1949

Pages 311–313
St John the Baptist, c. 1513–1516 (?)
Oil on walnut, 69 x 57 cm. Paris, Musée du Louvre, Inv. 775 (MR 318)

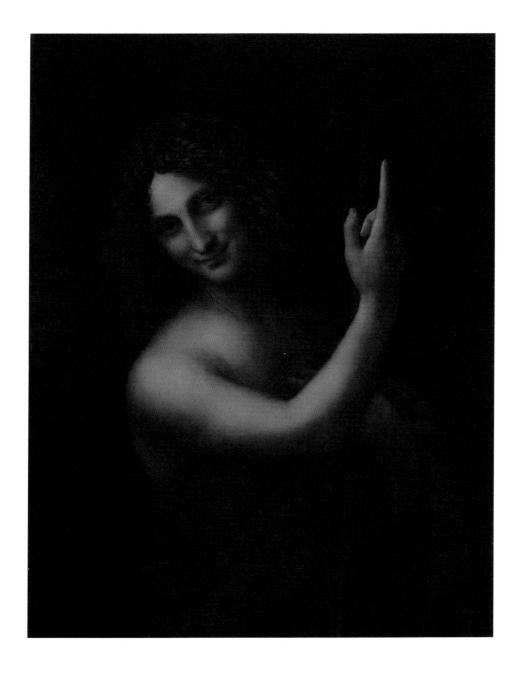

This quality is even more pronounced in the so-called *Angel of the Annunciation*, a variation upon Leonardo's *St John*, which is today ascribed to his pupil and friend Giacomo Salaì (ill. p. 314). Salaì joined Leonardo's workshop in 1490 at the age of just ten and remained there until Leonardo's death. Although Salaì was clearly a particularly unpleasant character (RLW § 1458), Leonardo seems to have developed a special relationship with the young man, one which was perceived as homosexual even in the 16th century. This, too, may have contributed to Leonardo's *St John* and Salaì's *Angel of the Annunciation* being interpreted as homoerotically inspired or sexually ambiguous works.

Both the theme of St John and its sexual ambiguity resurface in another painting, today entitled *Bacchus*, by a pupil of Leonardo (Cat. XXXI/ill. p. 315). The original composition undoubtedly portrayed St John the Baptist: the here full-length figure is sitting in front of a landscape background, which opens up on the left into a view of a river valley and a mountain range. With the gesture of his right hand John is pointing towards the one who will follow him, in other words Jesus Christ. Christian symbolism is also found in other parts of the composition: the deer in the background, for example, was regarded as a symbol of Christ and the Baptism, while the aquilegia in the foreground expresses the Christian hope of redemption, which would be achieved through Christ and the sacrament of baptism. But the beautiful, naked youth in the wilderness quickly came to be viewed in more than just a religious light. An unknown painter of the 17th century lent St John the attributes of Bacchus, painting an ivy wreath on his head and transforming his staff, formerly topped with a cross, into a thyrsus (the staff carried by Bacchus). This transformation of the saint into a lusty pagan god highlighted an ambiguity that was already present in the original figure of St John, and which Cassiano del Pozzo described in 1625 as follows:

Giacomo Salaì (?), **Copy after Leonardo's Annunciation Angel (?)**, after 1513
Tempera (?) on wood, 71 x 52 cm. Basle, Kunstmuseum

Workshop of Leonardo (?), **St John the Baptist
(with the Attributes of Bacchus)**, c. 1513–1519
Oil on wood, transferred to canvas, 177 x 115 cm. Paris, Musée du Louvre, Inv. 780

Perspective View of a Palace (Romorantin), c. 1518
Black chalk, 180 x 245 mm. Windsor Castle, Royal Library (RL 12292v)

Pages 316/317
**Old Man Seated on a Rocky Outcrop, seen in right-hand Profile,
with Water Studies**, c. 1513
Pen and ink, 152 x 213 mm. Windsor Castle, Royal Library (RL 12579r)

"John the Baptist in the wilderness. The figure, one third less than life size, is extremely delicate, but it is not very pleasing because it does not inspire reverence; it is lacking in propriety and likeness."

The design for the painting of St John the Baptist represents – assuming the dating proposed above is correct – the most important testament to Leonardo's brief spell in Rome, which concluded in 1516. Following the death of his patron Giuliano de' Medici in March, Leonardo remained in the Eternal City for a few more months before departing for France in the winter of 1516/17 to join the court of François I (reg. 1515–1547). Together with his assistants and friends, Leonardo was given a fine residence in Cloux, not far from the royal château in Amboise, and a remarkably generous salary, although it is not entirely clear what professional commitments he undertook in the remaining two years of his life.

He was certainly engaged on a canalization project in the Sologne (an area south of the Loire between Amboise and Orléans) and on drawing up plans for a new royal palace in Romorantin, a small town south of Blois. A number of drawings relating to this latter project still survive (Nathan/Zöllner 2014, Cat. 502–503; ill. p. 318). He also took a role in organizing and supplying the decorations for court festivities in Amboise and Cloux.

In France, at the court of Europe's most powerful monarch, Leonardo – alongside Titian (1488–1576), Michelangelo and Raphael the greatest painter of his day – appears to have abandoned painting altogether. Leonardo's diminishing creative energies in these last years of his life probably reflected his deteriorating state of health, as identified by Antonio de Beatis, secretary to Cardinal Luigi of Aragon, who in a letter of 10 October 1517 described the 65-year-old artist as suffering from partial paralysis, although still able to draw well: "In one of the outlying towns the Monsignore, together with the rest of us, went to visit Signor Leonardo da Vinci the Florentine, and old man of over 70 [*sic*], a quite outstanding painter of our age, who showed His Eminence three pictures, one of a certain Florentine lady from life for the late Giuliano de' Medici, another a young John the Baptist, and a third the Madonna and Child seated on the lap of St Anne, all perfect. Nothing more that is fine can be expected of him, however, owing to the paralysis that has attacked his right hand. A Milanese, who was educated by him and paints excellently, lives with him. Although Leonardo can no longer paint with his former sweetness he can still draw and teach others." Even at this late stage, therefore, the possibility cannot be excluded that pupils of Leonardo, in particular Francesco Melzi and Giacomo Salaì, were executing or finishing off paintings based on the master's designs and under his supervision.

Evidence of a waning output is also offered by Leonardo's late drawings, scarcely one of which can be dated with any certainty to the final two years of the artist's life. No paintings at all from this period can be confidently attributed to Leonardo's own hand. Leonardo's last years thereby appear to have been characterized by the same lack of productivity typical of many earlier phases of his career. The drawings of his latter years, however, betray no signs of the artist's age: alongside enigmatic allegories, we find studies of cats, dragons and horses in animated and humorous poses (Nathan/Zöllner 2014, Cat. 109 and 162; ill. p. 321). More intense and powerful in their composition than the sketches from his youth, these drawings are imbued with an almost childlike energy. They give the impression that the elderly Leonardo, his mind as lively as ever, was making a return to drawing and thus to the origins of his own art. His energetic sketches and his pictorial visions of fabulous creatures continue to exercise all the charm of an art that – unaffected by the age of the artist and the passage of time – retains its youthful freshness. The two images of Leonardo that have endured to this day, one as a youth and the other as an old man (cf. Ch. I), ultimately correspond to his œuvre as an artist, in which the immediacy of youthful invention is paired with the full maturity of an inquiring mind.

Leonardo's disposition was so lovable that he commanded everyone's affection. He owned, one might say, nothing and he worked very little, yet he always kept servants as well as horses. These gave him great pleasure as indeed did all the animal creation which he treated with wonderful love and patience.
GIORGIO VASARI, 1568

Sheet of Studies of Cats, a Dragon and other Animals, c. 1513–1515
Pen, ink and wash over black chalk, 270 x 210 mm
Windsor Castle, Royal Library (RL 12363r)

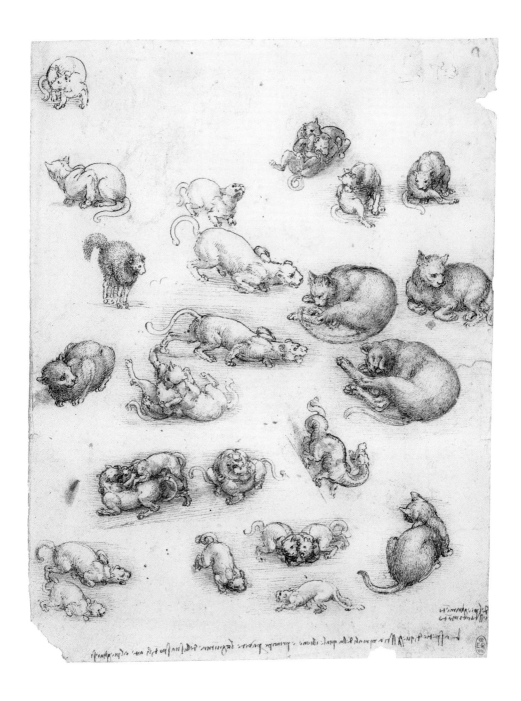

Catalogue raisonné of the paintings

Today I read Leonardo da Vinci's book on painting and now understand why I have never been able to understand anything in it before.

Remarks on the catalogue

The following catalogue raisonné contains the cartoons and paintings by Leonardo da Vinci's own hand, a number of early copies of his lost paintings and cartoons, together with more contentious attributions, insofar as these are rationally justified. Also included are two paintings by Andrea del Verrocchio to which Leonardo is known or at least assumed to have contributed.

I have confined myself as a rule to a brief discussion of the technique, condition, provenance, attribution and patronage of the works in question. More detailed descriptions and interpretations are found, in the majority of cases, in the main text. The sources mentioned in the catalogue section (letters, contracts, poems and early descriptions of paintings) are also cited, in translation, in the main text. The bibliographical references do not aim to be exhaustive.

Details relating to the technique in most cases comprise generic descriptions, and not scientific analyses.

In the case of early commentators on Leonardo's works, and specifically Luca Pacioli (1498), Antonio de Beatis (1517), Antonio Billi (active c. 1516–1530), Paolo Giovio (c. 1523–1527), Sabba da Castiglione (1546) and the Anonimo Gaddiano (c. 1537–1547), the reader is referred not to the original sources but to their reproduction in Luca Beltrami (1919), Carlo Vecce (1998, pp. 349–363) and Edoardo Villata (1999).

I

I

Andrea del Verrocchio and Leonardo (?)
Tobias and the Angel, c. 1470–1472 (?)
Tempera on poplar, 84.4 x 66.2 cm
London, The National Gallery, Inv. 781

This well-preserved panel incorporates narrow vertical strips of wood pieced onto its left- and right-hand sides (1 and 2 cm wide respectively). It was restored in 1867 and 1966. The painting, which may originally have served as a domestic altarpiece, was in the collection of Conte Angiolo Galli Tassi in Florence in the 19th century and was acquired for the National Gallery in London in 1867. Earlier attributions to Antonio Pollaiuolo, Francesco Botticini and Pietro Perugino have now been dismissed. Its authorship by Verrocchio has been widely accepted, in particular since the detailed analysis by Günther Passavant

(1959). Suida (1954), Brown (1998) and Marani (1999) have furthermore sought to prove, on stylistic grounds, that Leonardo was also involved on the painting. These authors consider the dog at Archangel Raphael's feet and the fish held by Tobias to be the work of Leonardo, who is known to have produced studies of animals of a similar kind (the drawings that Marani uses to support his argument date from a later period, however). The attribution of the dog and fish to Leonardo is chiefly based on the claim that Verrocchio was insufficiently experienced in the naturalistic representation of flora and fauna and so turned to his pupil for help. It is an argument that lacks cogency, however, since Verrocchio in fact demonstrates an impressive naturalism in his paintings, as evidenced by his Madonnas in London and Berlin (ill. p. 29).

The picture, which is based on an episode from the Book of Tobit (4: 3–4), owes its origins to the increasing veneration of archangels in Florence in the final third of the 15th century. Antonio del Pollaiuolo's Tobias picture in the Galleria Sabauda in Turin, which originally adorned an interior pillar of Or San Michele in Florence, is considered the formal starting-point for Verrocchio's painting (Passavant, 1959).

LITERATURE: Davies, 1951, no. 781; Suida, 1954, pp. 317–318; Passavant, 1959, pp. 106–121, and 1969, pp. 53–54; no. 19; Brown, 1998, pp. 47–73; Marani, 1999, pp. 28–31, 338.

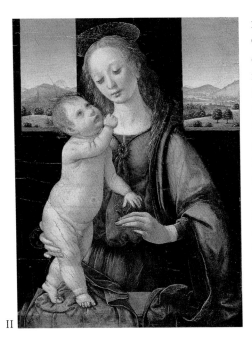

II

II
Lorenzo di Credi
**Madonna of the Pomegranate
(Dreyfus Madonna),**
c. 1470–1472 (?) or later
*Tempera and oil (?) on oak, 15.7 x 12.8 cm
Washington, DC, National Gallery of Art,
Samuel H. Kress Collection, Inv. 1144 (K1850)*

The painting, executed on a single piece of
oak, is in good overall condition, although
it is somewhat marred by abrasion in the
landscape and the Virgin's cloak and neck
– something that Shapley (1968) traces back
to a restoration of 1930. The problematic
nature of this restoration, which sought to
"Leonardize" the painting by intensifying its
shading, is discussed by Brown (1998).
The painting was auctioned as a work by
Leonardo at Christie's in London in April

1864. It passed into the collection of Louis
Charles Timbal in Paris, where it was pur-
chased by Gustave Dreyfus in 1872. In 1930
it was sold by his heirs to Joseph Duveen
in New York and in 1951 was acquired by
Samuel H. Kress, who presented it to the
National Gallery. Guiffrey (1908) pro-
nounced the painting to be a work by
Lorenzo di Credi, albeit revealing the
influence of Andrea del Verrocchio and
Leonardo. On the basis of the treatment of
the draperies and the composition, Suida
(1929) attributed the painting to Leonardo.
This attribution was for a long time largely
dismissed, but has recently attracted sup-
port from Marani (1989 and 1999) and
Arasse (1998). Marani sees Leonardesque
elements in the painterly treatment of the
Virgin's hair and dress and in the tech-
nique and ground. The flawed handling of
the Child's anatomy, however, and the not
particularly Leonardesque character of the
background landscape point away from an
attribution to Leonardo. Problematic, too, is
the wood of which the panel is made: the
use of oak as a support was typical neither
of Leonardo nor of other painters trained
in Florence. Arguing against an attribution
to Leonardo is also the fact that the *Dreyfus
Madonna* reveals no signs of the fingerpaint-
ing found in other early works by Leonardo
(cf. Brown, 1998, p. 157; Brachert, 1969, 1974,
1977 and below, Cat. IV–V, VII, IX–X,
XIII, XVI).
If its dubious attribution to Leonardo, which
Brown (1998) has also recently rejected, were
in fact correct, this tiny painting would be
of outstanding importance for our under-
standing of Leonardo's early œuvre. In order

to substantiate its still thoroughly uncertain authorship by Leonardo, further evidence of its earlier provenance would also be useful. The possibility cannot be excluded, on the other hand, that the *Dreyfus Madonna* is simply a variation upon a similar Madonna type from Verrocchio's workshop. A comparison might be drawn in this context with the large-format *Madonna* from the circle of Lorenzo di Credi, dating from around 1471, from the monastery of Camaldoli (today in the Museo di Camaldoli), whose provenance can be traced without interruption right back to the 18th century (Smyth, 1979, p. 224; *Maestri e botteghe*, 1992, p. 71). A drawing attributed to Lorenzo di Credi in the Kupferstichkabinett in the Dresden Staatliche Kunstsammlungen (reproduced in Marani, 1999, p. 22) repeats the motif of the *Dreyfus Madonna* almost exactly. This drawing is moreover closely related to the *Madonna of the Carnation* in Munich (Cat. III).

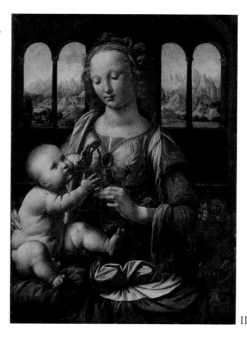

III

The *Dreyfus Madonna*, in which the Christ Child stands on a parapet in front of the Virgin, corresponds to a type that Leonardo's teacher, Andrea del Verrocchio, developed from formally similar paintings from the workshop of Giovanni Bellini, and which he propagated in Florence at the beginning of the 1470s (Grossman, 1968). Its most interesting facet is the iconographical detail of the open pomegranate, a symbol of the Passion of Christ, which the Virgin holds in her left hand and of which the infant Jesus has taken a seed with his right hand.

LITERATURE: Guiffrey, 1908, pp. 7, 10; Suida, 1929, pp. 15–17; Grossman, 1968; Shapley, 1968, pp. 113–114; Smyth, 1979, pp. 224–229;

Marani, 1989, no. 1; *Maestri e botteghe*, 1992, p. 71; Arasse, 1998, pp. 334–336; Brown, 1998, pp. 157–160; Marani, 1999, pp. 18–22.

III

Madonna of the Carnation (Madonna with a Vase of Flowers), c. 1472–1478 (?)

Tempera (?) and oil on poplar (?), 62.3 x 48.5 cm
Munich, Bayerische Staatsgemäldesammlungen,
Alte Pinakothek, Inv. 7779 (1493)

The panel, which is made up of two boards, was trimmed on the left by approximately 1.5 cm and on its other sides by a few millimetres. Narrow vertical strips were then later added to the left and right, measuring roughly 1.5 and 0.5 cm respectively. A crack in the bottom right-hand corner, visible only on the back, was repaired in 1913 with two small pieces of wood. At some

point in time, part of the back was planed off in an attempt to reduce the panel's pronounced warp. There is noticeable wrinkling of the paint on the front of the panel, caused by early shrinkage of the oil medium and particularly apparent in the face of the Virgin. This wrinkling reflects Leonardo's still experimental handling of oils: in his attempt to prevent his colours from drying too fast and thus to give himself more time to work on the Virgin's face and neck, he probably mixed his pigments with a little too much oil (Sonnenburg, 1983). Leonardo in fact experimented with the use of various oils as binders in the 1470s (Calvi, 1925/1982, pp. 51–52).

For the architectural elements of the middle ground (arcades, window jambs, columns, window seat) Leonardo scored precise underdrawings into the ground, as are also found in the *Annunciation*, for example (Cat. V). These clean lines, executed with the aid of dividers and a ruler, deviate in places from the outlines in the final painting. A number of pentimenti can be identified in the head and shoulder of the Christ Child (which were both originally larger) and in the Virgin's left shoulder (Möller, 1937, p. 22). The painting was cleaned in 1889/90 by the restorer Alois Hauser, who retouched a few small sections of the background top left and a somewhat larger area lower left, in particular the parts of the ring finger and little finger of the Virgin's right hand where they border onto the left-hand edge of the panel, and part of Jesus's right foot. The Virgin originally held a cloth between the thumb and index finger of her right hand (today barely visible, but reliably documented in a copy of the painting in the Louvre; see below). The Virgin's lower left arm has also been retouched, the red of the fabric evidently having faded (in a similar fashion to the reds in the *Baptism of Christ*, Cat. IV). The gold filigree decoration on the Virgin's sleeve and neckline has also been repainted (information supplied by Jan Schmidt).

The provenance of the *Madonna of the Carnation* cannot be traced very far back. It is first documented in the upper corridor of Wetzler's apothecary shop in Günzburg on the Danube. Yet to be substantiated are suggestions that, prior to this, the painting was located in Burgau Monastery just a few kilometres away, or alternatively that it was brought from Italy by Auxilianus Urbani, an Italian collector who married into the Günzburg apothecary family in 1792 (Möller, 1937). Whatever the case, the painting formed part of the estate of the widow Therese Wetzler and was auctioned after her death for just 22 marks. It was purchased by Albert Haug, who shortly afterwards, in 1889, sold it for 800 marks to the Alte Pinakothek – its valuation price at that time was 8000 marks. Whether the painting represents the Madonna mentioned by Vasari (1550) as being in the possession of the Medici Pope Clement VII, cannot be stated with certainty. Emil Möller (1937) and David Brown (1998) have nevertheless identified two details which suggest that the picture may have been commissioned by the Medici. Thus the capitals of the two window columns and the pilasters largely correspond to the capitals of Michelozzo's Palazzo Medici in Florence; furthermore, the four glass balls

hanging down from a cushion at the very bottom of the panel may be interpreted as *palle medicee* (Medici heraldic devices).

The attribution of the *Madonna of the Carnation* to Leonardo, originally proposed by Adolf Bayersdorfer immediately after purchasing the picture, was at first by no means unanimously accepted. The thorough study of the painting conducted by Möller (1937) eventually allowed the panel to be confidently assigned to Leonardo, an attribution that remained largely unchallenged during the last 30 years of the 20th century and was substantiated afresh by the meticulous study conducted by Brown (1998). Supporting this attribution are, in particular, the insecurity evident in the artist's handling of oils, for which there are no direct parallels in the works of Verrocchio, the masterly treatment of the Virgin's robes and the crystal vase and the atmospheric landscape background. The dating of the painting remains a subject of contention, but in recent literature is placed between 1470 and 1478.

Since Suida (1929, p. 20 and fig. 4), a drawing of the head of the Virgin in the Louvre (Inv. 18 965) has been related by some to the Munich panel. Its attribution to Leonardo is not generally accepted, however. Although Möller (1937, pp. 10–14) refers to a number of original drawings by Leonardo, these correspond only approximately to the final painting. A fairly accurate copy of the painting (wood, 60 x 59 cm), probably by a Northern master of the 16th century (perhaps Johann König, *c.* 1586–*c.* 1635, active in Augsburg, Venice and Rome), is housed in the Louvre (Inv. 1603, Béguin, 1983, p. 88).

Marani (1999, pp. 38, 73) mentions a further copy in a private collection in Florence and a large-format variation from the circle of Ridolfo Ghirlandaio in the Walters Art Gallery in Baltimore.

LITERATURE: Vasari, 1550, p. 549; Vasari, 1965, p. 260; Möller, 1937; Heydenreich, 1953, I, pp. 33–34, II, p. IV; Kultzen, 1975, pp. 58–60; Sonnenburg, 1983, pp. 24–26, 54–90 and 75; Heydenreich, 1985, pp. 33–36; Brown, 1998, pp. 127–136.

IV

Andrea del Verrocchio and Leonardo
The Baptism of Christ,
c. 1470–1472 and c. 1475
Oil and tempera on poplar, 180 x 151.3 cm
Florence, Galleria degli Uffizi, Inv. 8358

The support is composed of a total of six boards, three wider and three very narrow, glued together vertically, whereby the narrow board on the left-hand side is additionally secured with four iron nails. As evident from the borders on all four sides, the panel has not been trimmed. The back reveals a number of brush drawings of nude figures in the manner of the Pollaiuolo brothers and other motifs (Natali, 1998, p. 259); these bear no direct compositional relationship to the *Baptism of Christ*, however. Fingerprints typical of Leonardo are found on the body of Christ (Brown, 1998, p. 136). Small areas of damage – for example in the head of the angel on the left and in the lower section of the painting, where the shrinking of the wood had caused the paint to flake off (Sanpaolesi, 1954) – were retouched when the painting was restored in 1998.

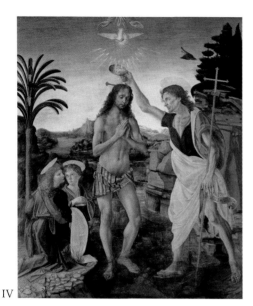

IV

The colours have greatly faded in a number of places, for example in Christ's loincloth and John's cloak. Passavant (1959 and 1969) refers to a restoration carried out in the late 19th century, in the course of which the lower section of the painting, Christ's loincloth and the angel on the far left may have been altered, to a degree that can no longer be precisely determined. Following its most recent restoration, the painting now seems altogether more homogeneous than before, albeit also somewhat flatter.

The panel was painted in at least two separate phases by two or even three different artists (*Maestri e botteghe*, 1992, p. 38). Verrocchio is thought to have started the painting in *c.* 1470 or a little later and to have executed the overall composition as well as large parts of the picture in tempera. The underdrawing on the gesso ground, still visible in places, is entirely by his hand.

At a later date – *c.* 1475/76 (Kemp, 1981, p. 60) or even as late as *c.* 1480 (Passavant, 1969, p. 196) – the panel was then reworked by Leonardo using oil-based paints, at that time still uncommon in Florence. Following detailed technical analysis, Leonardo is now credited with considerable involvement on the composition: as well as executing the angel on the far left entirely in oils, he also reworked in oils the figure of Christ, originally laid down in tempera by Verrocchio, as well as the river bed and large parts of the background landscape, with the exception of the rocks on the right (Sanpaolesi, 1954; Natali, 1998, p. 66). This discovery falls in line with Vasari's assertion that Leonardo painted the angel in the *Baptism of Christ* on which Verrocchio was working. Recent investigations using infrared reflectography have revealed that the background above the heads of the two angels originally featured a more conventional landscape, one characterized more by trees than by rocks and water (*Lo sguardo degli angeli*, 1998, pp. 70 and 130).

The painting was first housed in the Vallombrose church of San Salvi, directly outside the walls of Florence. From there it passed to the convent of Santa Verdiana, probably in 1564, to the Accademia di Belle Arti in Florence in 1810 and in 1914 to its present home. Albertini (1510) was probably referring to this painting when he stated that "uno Angelo di Leonardo da Vinci" was to be found in San Salvi. Antonio Billi (p. 61) and the Anonimo Gaddiano (p. 89) also name a *Baptism of Christ* in San Salvi amongst the works of Andrea del Verrocchio. Vasari summarizes the information provided by

Albertini, Billi and Gaddiano when he identifies the angel on the far left as the work of Leonardo. Richa's reference (1754, I, p. 395) to the preservation in San Salvi of a relic of St John perhaps provides indirect support for the case for San Salvi as the original destination of the Baptism painting. This leads Passavant (1969, pp. 62 and 58) to conclude that the church of San Salvi may have included a chapel dedicated to St John, for which Verrocchio's painting provided the altarpiece.

Although several of the drapery studies attributed to Leonardo (Nathan/Zöllner 2014, Cat. 166–167, 169, 182) have been related to the angel in the Baptism of Christ (von Seidlitz, 1909; Arasse, 1998), none of these studies corresponds accurately enough to the robes of the angel in the painting. Unconvincing, too, is the attempt to relate the drawing of the head of a young man in profile, dated to December 1478 (Nathan/Zöllner 2014, Cat. 192), to the angel in the Baptism of Christ (von Seidlitz, 1909). Leonardo is believed to have executed his sections of the panel at a relatively late date, for example 1478 (Marani, 1999). Passavant, who conducted a very thorough analysis of the painting, even considers it possible that Leonardo reworked the painting in the early 1480s (Passavant, 1969, p. 196).

As regards who commissioned the painting, Antonio Natali (1998) suggested the Vallombrose monk Simone di Michele Cione, who was probably Andrea del Verrocchio's brother. Natali also discusses the iconography of the painting (cf. main text, p. 29), which he sees as drawing not only upon the Gospels (Matthew 3:3–17; Mark 1:9–11; John 1:26–36) but also upon the Catena aurea of St Thomas Aquinas.

LITERATURE: Albertini, 1510; Benedettucci, 1991, p. 61 (Billi); Frey, 1892, p. 89 (Anonimo Gaddiano); Gelli, 1896, p. 62; Vasari, 1550, pp. 448–449 and 547; Vasari, 1568, IV, p. 22; Vasari, 1965, p. 258; von Seidlitz, 1909, I, pp. 40–46; Sanpaolesi, 1954, pp. 29–32; Passavant, 1959, pp. 58–88; Passavant, 1969, pp. 57–60 and no. 21; Berti, 1979, p. 588; Kemp, 1981, pp. 58–61; Marani, 1989, no. 6; *Maestri e botteghe*, 1992, p. 38 (N. Pons); Brown, 1998, pp. 27–31, 43, 136–145; Arasse, 1998, pp. 46–52; Natali, 1998; *Lo sguardo degli angeli*, 1998.

V

Annunciation, c. 1473–1475 (?)
Oil and tempera on poplar, 100 x 221.5 cm
Florence, Galleria degli Uffizi, Inv. 1618

The relatively well-preserved and fully intact wooden panel (borders on all four sides) consists of five boards, 3.5 cm thick, glued together horizontally. Towards the end of the 19th century, the boards were planed off on the back to reduce their thickness. Several areas of flaking paint, in particular in the architecture behind the Virgin and in the lower part of the wall behind the angel, were retouched when the painting was restored in 2000 (*L'Annunciazione*, 2000, pp. 95–120). This restoration has also rendered more legible the wings of the angel (retouched at some point in the past by another hand), the row of trees and landscape behind the angel and the interior on the right-hand edge of the composition. Since the painting reveals

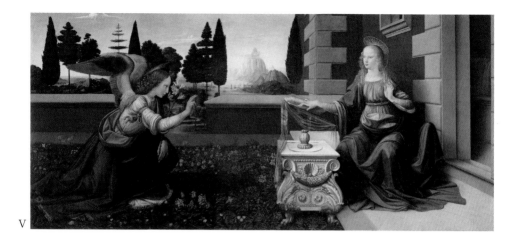

V

no traces of *spolvero* (pounce powder), it is assumed (Sanpaolesi, 1954) that the under-drawing for the figures was carried out in freehand (the validity of this conclusion, drawn from the absence of *spolvero*, has been challenged, however; Keith/Roy, 1995; Hiller von Gaertringen, 2001). Perspective lines were scored directly into the ground, particularly in the right half of the picture. X-rays also reveal the scored outlines of a window in a completely different place, namely parallel to the rear wall. It follows that the stretch of wall leading away from the right-hand foreground behind Mary was not part of the original conception. X-rays have also revealed that the head of the Virgin has undergone significant altera-tions: the first version of the area around her hair was removed and then completely repainted (Brachert, 1974). The panel also exhibits numerous pentimenti (Sanpaolesi, 1954; *L'Annunciazione*, 2000): the angel's head was originally lower, and the Virgin's right hand shorter, its little finger neither raised nor bent. In the first version, too, her dress

was adorned with a chain and decorative pendant. Evidence of Leonardo's charac-teristic fingerpainting is found in several places within the *Annunciation*, for example on the underside of the lectern, in the head of the angel, in the sky and in the landscape background (Brachert, 1974). These tech-nical details thus show the artist executing his painting in a relatively spontaneous and immediate fashion.

Until May 1867 the painting was housed in the sacristy of the church of San Bartolomeo a Monteoliveto (outside Florence), whose monks believed it to be a work by Domenico Ghirlandaio. It is unclear whether this church was the destination for which the painting was originally intended. After passing into the collection of the Uffizi, the picture was provisionally exhib-ited as a work by Leonardo. The case for this attribution was greatly strengthened by the publication in 1907 of a pen and ink drawing, housed in Oxford (Nathan/Zöllner 2014, Cat. 3), which is undoubtedly by Leonardo and which is considered a study for the

right sleeve of the angel of the *Annunciation*. Leonardo's now widely accepted authorship of the panel is nevertheless rejected by Passavant (1969) and Wasserman (1984). Wasserman sees Leonardo as responsible primarily for the overall layout and points to the weak execution of the head of the angel, which does not bear comparison with the angel in the *Baptism of Christ*.

Consensus regarding the dating of the painting has yet to be reached. Marani (1989) at first proposed a date of *c.* 1470. Ottino della Chiesa (1967) and, a second time, Marani (1999) date the panel to 1472–1475, a period broadly in line with older research, while Arasse (1998) suggests the years 1473–1475 and Pedretti (1973) assumes a date of *c.* 1478. On the basis of current scholarship, the traditional dating of the *Annunciation* to *c.* 1473–1475 or a little later seems the most plausible. The arguments for an early dating are founded on the painting's supposedly flawed perspective. These "errors" (seen in the cornerstones of the building on the right, for example, which appear too long) can be traced at least in part to the fact that the artist constructed his perspective composition from a viewpoint that lies some two to three metres to the right of the painting and assumes that the viewer is looking slightly up at the painting (*L'Annunciazione*, 2000, p. 37–59). It is by no means, therefore, whether clear distortions in the perspective should really be judged the result of technical incompetence or whether they should be understood as a response to the proposed location of the final painting. Another striking feature of this picture is Leonardo's use of an "out-of-focus" perspective in the back-ground, where blurred and hazy outlines evoke the impression of greater distances (Veltman, 1986). In other respects the linear perspective follows the conventions familiar from Verrocchio's workshop (Kemp, 1990). The original destination and function of the painting remain the subject of conjecture. The suggestion that, like Baldovinetti's *Annunciation* in San Miniato al Monte in Florence, it formed part of an ensemble still seems the most likely. While the Oxford drawing (Nathan/Zöllner 2014, Cat. 3) is firmly accepted as a study for Gabriel's sleeve, attempts to link other drawings by Leonardo with the painting are less convincing. Thus a drapery study in the Louvre (Nathan/Zöllner 2014, Cat. 183), which is regularly related to the Virgin's robes (Ottino della Chiesa, 1967, p. 88), reveals just as many differences as similarities to the final *Annunciation*.

Many elements of the picture, such as the plants, the landscape, the port, the sea and the mountains in the background, are possibly charged with a Marian symbolism (Salzer, 1893, p. 530; Cardile, 1981/82, Liebrich, 1997, pp. 87–88, 158–161; *L'Annunciazione*, 2000, pp. 47–55). It is no more possible to establish the meaning of each individual element, however, than to determine the correct botanical identity of all the plants (Morley, 1979, p. 559).

LITERATURE: Poggi, 1919, p. III; Ottino della Chiesa, 1967, no. 2; Pedretti, 1973, pp. 30–31; Brachert, 1974; Cardile, 1981/1982; Wasserman, 1984, pp. 54–56; Veltman, 1986, pp. 338–345, Pl. 17.2; Marani, 1989, no. 2; Kemp, 1990, pp. 44–45; Liebrich, 1997, pp. 87–88, 158–161; Arasse, 1998,

pp. 293–296; Brown, 1998, pp. 75–99; Marani, 1999, pp. 48–62; *L'Annunciazione*, 2000.

VI

Benois Madonna, c. 1478–1480
Oil on wood, transferred to canvas,
49.5 x 31 cm
St Petersburg, Hermitage

When the painting was transferred from wood to canvas in 1824, a strip measuring 1.5 cm wide was added to the bottom edge of the composition; the painting was thus originally probably only 48 cm high. The picture, which like many panel paintings transferred to canvas is in only mediocre condition, was given an additional canvas backing in 1924. Infrared reflectography has revealed numerous pentimenti. Thus the head of the Child was somewhat bigger in an earlier draft of the painting, the Virgin probably held in her left hand a small bunch of flowers (rather than the grasses now visible), her hair probably framed her left temple and the sleeve of her right arm may have been somewhat fuller.

The provenance of the *Benois Madonna* can only be traced back as far as the beginning of the 19th century. The painting, which was previously in the possession of A. I. Korsakov (1751/53–1821), is first mentioned in 1827 in an inventory of the collection of Alexander Petrovich Sapozhnikov, which also describes the transfer of the paint to canvas (Kustodieva, 1994). The picture subsequently passed into the collection of Léon Benois. After being exhibited in St Petersburg in 1908/09, the painting was purchased by the Hermitage from M. A.

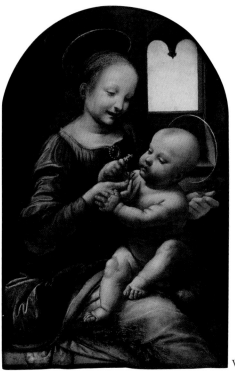

VI

Benois for 150 000 roubles (Poggi, 1919; Kustodieva, 1994).

Passavant (1969) believes that the *Benois Madonna* is inspired by Desiderio da Settignano's (*c.* 1430–1464) *Panciatichi Madonna*; all other authors see the influence as being the other way round.

The *Benois Madonna* has been attributed to Leonardo by art historians, including even the sceptical Gustavo Frizzoni, from the early years of the 20th century onwards (Gronau, 1912; Poggi, 1919). The dating of the painting, however, remains the subject of controversy even today. Heydenreich (1953) dates the start of work on the panel to 1478 and proposes that Leonardo reworked the painting in 1506 in order to offer it to

the king of France (Beltrami, 1919, no. 183; Villata, 1999, no. 240). Arasse (1998) dates the work to 1478–1480, Kemp (1981) to 1480, while Pedretti (1973) sees it in an even later context, believing the composition to contain references to the *Virgin and Child with St Anne*. However, numerous sketches of the Virgin by Leonardo (Nathan/Zöllner 2014, Cat. 110–121; ills. pp. 52, 229) bearing similarities to the *Benois Madonna* can be consistently dated to the years between c. 1475 and 1480, suggesting on compositional grounds that the painting dates from this period. At the same time the treatment of its draperies reveals a certain relationship with later paintings such as the *Virgin of the Rocks* (Cat. XI) and the *Portrait of Cecilia Gallerani* (Cat. XIII), so that the possibility that the St Petersburg painting arose during the 1490s cannot be entirely excluded. Its compositional parallels with the *Virgin and Child with St Anne* are less compelling than they seem and cannot be considered grounds for a late dating: Leonardo is known to have taken up earlier motifs on occasions. The plant in the hand of the infant Jesus is probably a crucifer and thus a symbol of the Passion (Suida, 1929, p. 22; Morley, 1979, p. 559).

The *Benois Madonna* corresponds to a type that is found in many of Leonardo's drawings (Nathan/Zöllner 2014, Cat. 110–119, 121; ills. pp. 52, 229) and that was evidently particularly popular. It exists in numerous copies and variations, as found for example in the Gemäldegalerie in Dresden (Lorenzo di Credi), the Galleria Colonna in Rome, the Galleria Sabauda in Turin and the Museum der bildenden Künste in Leipzig (Gronau, 1912).

LITERATURE: Gronau, 1912; Poggi, 1919, pp. IV–V; Heydenreich, 1953, I, p. 210; Passavant, 1969, p. 220; Pedretti, 1973, pp. 27–28; Kemp, 1981, pp. 54–58; Berti, 1984; Kustodieva, 1994, no. 115.

VIIa
Portrait of Ginevra de' Benci,
c. 1478–1480
Oil and tempera on poplar, 38.8 x 36.7 cm
Washington, DC, National Gallery of Art,
Ailsa Mellon Bruce Fund, 1967, Inv. 2326

VIIb
Leonardo (?)
Portrait of Ginevra de' Benci,
reverse, c. 1478–1480
Tempera (and oil?) on poplar, 38.8 x 36.7 cm

On the banderole the beginning of a hexameter: "VIRTVTEM FORMA DECORAT" ("She adorns her virtue with beauty"/"Beauty adorns virtue")
Despite the fact that, at some point prior to 1780 (Möller, 1937/38), the panel was cut down by 12 to 15 cm along the bottom and by approximately 1 cm on the right-hand side, the condition of the portrait can be described as good. During the course of restoration in 1991 (Bull, 1992; Gibson, 1991), small areas of damage were discovered and retouched, in particular on the bridge of Ginevra's nose and in the juniper bush just to the left of her head and in the top right-hand corner. As emerges from a comparison with older photographs, the larger of the two trees on the right, beside Ginevra's shoulder, has altered as a result of this restoration: it now lacks a branch on the left

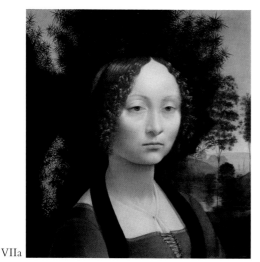

VIIa

spolvero and a cartoon, in this case, for example, along the lower edge of the right eye, on the bridge of the nose, on the upper lip and along the right-hand outline of the face (Gibson, 1991, p. 162; Bambach, 1999, p. 23). The *Portrait of Ginevra de' Benci* (1457–*c*. 1520) was commissioned, with a likelihood bordering on certainty, by the Venetian diplomat and humanist Bernardo Bembo (1433–1519) during his second stay in Florence, which lasted from July 1478 to May 1480 (Fletcher, 1989; Kress, 1995). The possibility that it was commissioned during Bembo's first stay in Florence, in 1475/76, is less plausible in view of the chronological evolution of Leonardo's paintings. Bembo's personal device (comprising a laurel branch, a palm branch and a motto) is found in a modified form on the back of the portrait. After its completion, the painting evidently remained in Florence, where it is located by artist biographers (Billi, 1527–1530, the Anonimo Gaddiano, 1542–1547, and Vasari, 1550 and 1568). The painting clearly did not go to Venice, either because Bembo didn't pay for it (Fletcher, 1989) or because it was presented as a gift to Ginevra, with whom Bembo enjoyed a poetically inspired platonic relationship (Walker, 1968). The portrait (at this stage considered a work by Lucas Cranach) is definitely known to have been in the possession of Prince Wenzel of Liechtenstein in Vienna (later in Vaduz) from 1733 onwards, but had probably entered the family collection in the previous century (Möller, 1937/38, p. 207; Brown, 1998). In 1967 the portrait was acquired for the National Gallery in Washington, DC; it was thereby the last original painting by Leonardo to be sold on the open art market.

and the lower third of its trunk has become distinctly more slender.

As a consequence of its unusual width, the panel, which is about 1 cm thick and consists of a single board, includes a relatively high proportion of pithy sapwood. With the shrinking of the wood, wrinkling (as seen, for example, to the right of Ginevra) appeared early on in the surface of the paint, which contains a high proportion of oil (Möller, 1937/38, p. 188). Papillary lines from the ball of the hand, the fingers and the thumb are found in various parts of the panel, for example between Ginevra's left shoulder and the water (Brachert, 1969). The painting also reveals several pentimenti: the original iris of Ginevra's left eye clearly shows through to the right of the final version. Less obvious is the fact that Ginevra's left cheek was originally a little broader. This portrait and that of Cecilia Gallerani (Cat. XIII) are the only surviving panel paintings by Leonardo that have been demonstrated beyond a doubt to have employed

The painting was attributed to Leonardo, albeit with strong reservations, by Waagen (1866), although this attribution was by no means unanimously accepted. Thus Poggi (1919) was inclined to attribute the portrait to an as yet unidentified artist from the circle of Verrocchio. Only since Emil Möller (1937/38) completed his thorough investigations into the technique of the painting and the person of Ginevra has the portrait been accepted almost unreservedly as a work of Leonardo. This attribution rests primarily on the fact that early sources are comparatively precise in naming the portrait as a work of Leonardo, and also on the fact that the sitter has been confidently identified as Ginevra de' Benci on the basis of the juniper bush (ital. *ginepro*, a play upon the name Ginevra) flourishing behind her head and by the device of Bernardo Bembo on the reverse of the portrait (Möller, 1937/38; Fletcher, 1989). Without the link established between Leonardo and the portrait in the early sources and the identification of the sitter via the juniper bush and Bembo's emblem, however, Leonardo's authorship would probably still be a matter of debate, for it is hard to relate the portrait in stylistic terms to other early works by the artist. In the wake of Möller's analyses, the contributions by John Walker (1968), Jennifer Fletcher (1989) and David A. Brown (1998) have in particular furthered our understanding of the painting.

A silverpoint drawing by Leonardo (Nathan/Zöllner 2014, Cat. 155), which can be dated to *c.* 1478, and which shows a woman's hands as they might be folded in a portrait, has traditionally been associated

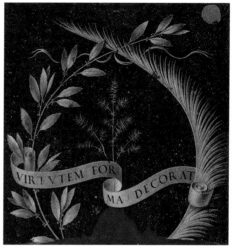

VIIb

with the *Portrait of Ginevra de' Benci* and used to reconstruct the missing lower section of the portrait (most recently by Brown, 1998). This portrait drawing, whose format argues against its connection with the *Ginevra de' Benci* (Arasse, 1998), reveals a certain similarity to the so-called *Dama col mazzolino*, a marble portrait bust by Verrocchio (Florence, Bargello), which in turn brings it into line to some extent with the conventions of contemporary Florentine portraiture.

The overall layout of the painting nevertheless reveals the influence of Flemish portraiture, as represented for example by Hans Memling's *Portrait of a Man with a Coin of Nero* (Antwerp) and *Portrait of a Young Man* (Florence, Uffizi; ill. p. 54) and by Petrus Christus's *Portrait of a Young Woman* (Berlin; Hills, 1980; Kress, 1995; cf. main text p. 55). The suggestion that the portrait arose in connection with Ginevra de' Benci's marriage to Luigi di Bernardo Niccolini in 1474 (Marani, 1999), or that it was initially

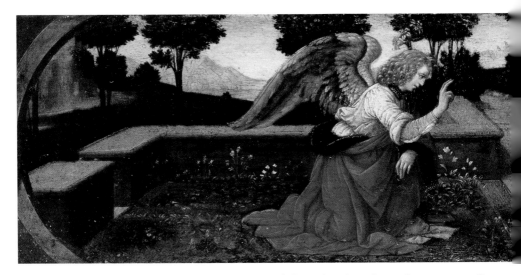

envisaged as an engagement portrait, which was then transformed into a sort of friendship painting for Bembo with the addition of the device on the back (Brown, 1998, 2001), does not strike me as particularly plausible. Furthermore, the painting does not correspond in its details with the pictorial type of the bridal portrait (Kress, 1995). The composition of the *Ginevra de' Benci* is taken up in a portrait of a woman ascribed to Lorenzo di Credi (New York, The Metropolitan Museum of Art), in which the sitter is also seated in front of a juniper bush. She holds a gold ring in her left hand, which in this case probably identifies the painting as a marriage portrait. For an interpretation, see the commentary on the reverse of the *Portrait of Ginevra de' Benci* and the main text.

The paint on the reverse is badly damaged at the bottom, which may have been one of the reasons why the panel was trimmed. Noteworthy is the tempera-like character of the medium, which Dülberg (1990,

p. 24) has also found on the reverse of other portraits. Differences in the painting technique employed on the front and back of the portrait, and the fact that the plants are in part executed by a right-handed artist (Möller, 1937/38), raise some doubts as to whether Leonardo painted the back of the portrait himself. On stylistic grounds, John Shearman (1992, p. 118) considers the reverse to be originally the work of a Venetian artist. Although this suggestion is not backed up by current scholarship, investigations have revealed that the inscription originally painted on the back of the portrait read not "VIRTVTEM FORMA DECORAT", but "VIRTV[S ET] HONOR" (Brown, 1998, p. 121). Since this was Bembo's motto, it is possible to speculate that Bembo had perhaps initially commissioned his own portrait from a Venetian artist, the back of which Leonardo then altered and finished off, before proceeding to execute the portrait of Ginevra de' Benci on the front.

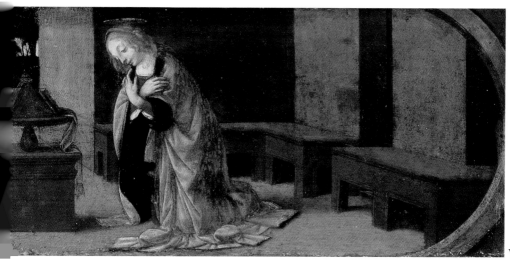

VIII

References to Ginevra's virtue are yielded by the inscription and by the symbolism of the plants – juniper, laurel and palm – and the painted porphyry marble. Mundy (1988, pp. 38–39) relates the imitation marble to the start of the 35th book of Pliny's *Historia naturalis*, where portraits are discussed immediately after painted stone.

LITERATURE: Benedettucci, 1991 (Billi), p. 102; Frey, 1892, p. 111 (Anonimo Gaddiano); Vasari, 1550, p. 551; Vasari, 1568, IV, p. 39; Vasari, 1965, p. 266; Poggi, 1919, pp. XXII–XXIII; Möller, 1937/38; Walker, 1968; Brachert, 1969; Shapley, 1979, I, pp. 251–255; Cropper, 1986; Fletcher, 1989; Dülberg, 1990, pp. 23–24, 134–124, no. 166; Gibson, 1991; Zöllner, 1994, pp. 63–65; Kress, 1995, pp. 237–255; Arasse, 1998, pp. 402–404; Brown, 1998, pp. 101–121; Bambach, 1999, pp. 23, 100; Marani, 1999, pp. 38–48; Brown, 2001, no. 16.

VIII

Lorenzo di Credi, after a design by Leonardo (?)
Annunciation, c. 1478 or 1485
Tempera on poplar, 16 x 60 cm
Paris, Musée du Louvre, Inv. 1602A (1265)

The fully intact panel (with borders on all four sides), which measures some 2 cm in thickness, has suffered from woodworm and the painting itself is in mediocre condition (dalli Regoli, 1966). The panel originally formed the central section of the predella of an altarpiece commissioned from Andrea del Verrocchio c. 1475 for the mortuary chapel of Donato de' Medici, who died in December 1474, in Pistoia cathedral (Passavant, 1959, 1969; dalli Regoli, 1966). The unfinished altarpiece remained in Verrocchio's workshop for a long time and was completed by Lorenzo di Credi largely in the period between 1478 and 1486. The two other sections of the predella are today housed

in the Liverpool Art Gallery and the Worcester Art Museum.

When the *Annunciation*, together with other paintings from the Campana Collection in Rome, reached the Musée Napoléon III in 1861 and in 1863 passed from there to the Louvre, it was initially attributed to Domenico Ghirlandaio, then to Lorenzo di Credi and finally to Leonardo. This last attribution, which possibly goes back to a local tradition in Pistoia (Salvi, 1656–1662), has always met with opposition, for example from dalli Regoli (1966), who points to the technical affinity of the present painting with Credi's predella panel in Worcester. Recently, however, alongside Ottino della Chiesa (1967), Pedretti (1973) and Marchini (1985), a number of advocates of Leonardo's authorship have emerged. In connection with this possible attribution, Marani (1999, pp. 67–69) cites a drawing in the Uffizi ([428E recto] Inv. 328E recto), which is occasionally linked with Leonardo. Quite apart from the fact that its authorship is entirely unsubstantiated, however, its large format rules it out as a preliminary study for the small predella panel (Brown, 1998).

Previous attributions to a single or several artists (Verrocchio, Lorenzo di Credi, Leonardo) pose a number of difficulties. It is hard to imagine, for example, how several artists, amongst them Leonardo, could have worked on such a small predella panel. It is equally hard to position this *Annunciation* within the chronology of Leonardo's early works: supporters of the attribution favour a date between 1478 and 1480, something impossible to marry from a stylistic point of view with the *Portrait of Ginevra de' Benci*

from this same period, which is technically clearly superior to the Paris *Annunciation*. The latter's use of very coarse pigments also speaks against Leonardo's authorship of the painting (Hours, 1954). The only alternative would be to date the *Annunciation* considerably before 1478, which is equally out of the question since even the main altarpiece was at that stage still unfinished. A more sensible solution would seem to be the suggestion, made most recently by Arasse (1998), that the panel was executed by Lorenzo di Credi after a design by Leonardo. This is supported by its compositional similarity to the Uffizi *Annunciation* attributed more plausibly to Leonardo (Cat. V). In view of the above arguments, the picture should be dismissed once and for all from Leonardo's œuvre.

LITERATURE: Salvi, 1656–1662, II, p. 422; Poggi, 1919, pp. II–III; Hours, 1954, pp. 21–22; dalli Regoli, 1966, pp. 111–114, no. 32; Ottino della Chiesa, 1967, no. 11; Passavant, 1969, p. 212; Pedretti, 1973, pp. 29–30; Béguin, 1983, p. 90; Arasse, 1998, p. 46; Brown, 1998, pp. 151–157; Marani, 1999, pp. 67–68.

IX

St Jerome, c. 1480–1482

Oil and tempera on walnut, 102.8 x 73.5 cm
Rome, Pinacoteca Vaticana, Inv. 40 337

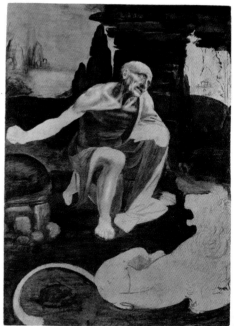

IX

The panel, made up of two boards of different widths and planed off on the back, has suffered badly from woodworm. The paint extends all the way to the edges of the panel (information kindly supplied by Arnold Nesselrath, Rome). At some unknown point in time, the head of St Jerome and two neighbouring sections of the panel were sawn out of the painting. The individual parts were later pieced back together again. The panel reveals damage in a number of places, particularly in the lion's back and the rocks on the left-hand edge of the painting (Colalucci, 1993). It was last restored in 1930 and 1993.

Like the *Adoration of the Magi* (Cat. X) probably executed just a little later, the *St Jerome* for the most part gets no further than the design stage. Only the head of the saint, his right leg and parts of the landscape are developed in underpainting. There are no signs of the use of an auxiliary *spolvero* cartoon (Bambach, 1999, p. 23). The design of a crucifix on the right-hand edge of the picture was scored directly into the ground. Leonardo has rubbed the paint with his hand in a number of places, for example in the background, and thereby anticipates the impression of flowing transitions (*sfumato*) for which he would later become famous. *St Jerome* thus provides another example of the fingerpainting and handpainting technique already seen in the *Portrait of Ginevra de' Benci* (Cat. VII; Brachert, 1969; Colalucci,

1993). Beneath the layer of paint in the left-hand background, above the horizon, is the sketch of a palm tree.

The provenance of the *St Jerome* cannot be traced with certainty beyond the first quarter of the 19th century. The painting is first mentioned in the second volume of Carl Friedrich von Rumohr's *Italienische Forschungen*, published in 1827 (II, p. 308). Rumohr had seen it in Rome in the possession of Cardinal Joseph Fesch, in whose estate it was still to be found upon his death in 1839. Between 1846 and 1857 the cardinal's heirs sold the *St Jerome* to Pope Pius IX. Since then the painting has remained in the uninterrupted possession of the Pinacoteca Vaticana. The *St Jerome*, together with the *Benois Madonna* and the *Portrait of Cecilia Gallerani*, numbers amongst

the few paintings by Leonardo that have been loaned out to exhibitions in recent years (for example to Tokyo in 1993 and to Bonn in 1998).

The persuasive arguments expounded by Ost (1975, pp. 8–9) have cast doubt on the view, still held by some (Marani, 1989; Arasse, 1998, p. 344), that the *St Jerome* formed part of the collection of Angelica Kauffmann in Rome at the start of the 19th century. More fiction than fact is similarly the story put about by Cardinal Fesch (Poggi, 1919), who claimed to have discovered the main section of the sawn-up painting in Rome *c.* 1820 and then to have purchased the head of the saint a few years later from a Roman cobbler, who was using it as the seat of a stool. The claim by Ottino della Chiesa (1967) that Leonardo's *St Jerome* formed the basis of an engraving of 1784 by C. G. Gerli is also untenable. Gerli's illustration of a St Jerome is in fact based on drawings from Leonardo's circle (Ost, 1975, p. 7; Marani, 1989).

The early sources contain no references to Leonardo's *St Jerome*. In an inventory compiled by Leonardo in Milan in or after 1495, the artist mentions "certain figures of Saint Jerome" (RLW § 680), but whether the panel today housed in the Vatican was amongst them is doubtful to say the least. The *St Jerome* nevertheless seems to have been known in Milan towards the end of the 15th century (Marani, 1989). It is also unclear whether the Vatican painting is identical with one of the two St Jerome pictures mentioned as forming part of Salaì's estate in 1525 (Shell/Sironi, 1991, pp. 104–105; Villata, 1999, no. 333). Leonardo's

painting thus appears to have left virtually no traces in the history of art. Despite its mysterious past and fictitiously embellished provenance, the *St Jerome* – together with the *Adoration*, *Last Supper* and *Mona Lisa* – numbers amongst the paintings whose attribution to Leonardo has never been seriously doubted.

There is widespread agreement, too, regarding the dating of the painting. On the basis of its similar ground and the identical manner in which the composition is sketched, it is assumed to have arisen in the same period as Leonardo's *Adoration*, which was commissioned in March 1481 and was left unfinished in Florence in 1482. The *St Jerome* was probably commenced before the *Adoration*, for the large-format painting for the monks of San Donato would hardly have allowed him time for a further commission. Indeed, the contract for the *Adoration* expressly stipulates that Leonardo is not to take on any other commissions (Beltrami, 1919, no. 16; Villata, 1999, no. 14). Since the rock formations in the *St Jerome* resemble those of the *Virgin of the Rocks* (Cat. XI), however, the possibility that the picture arose at the start of Leonardo's first Milan period cannot be entirely excluded.

The composition of the *St Jerome* is derived from a kneeling figure (modelled out of wax, wood or clay) commonly found in Quattrocento workshops (Ost, 1975). Ost further claims that Vitruvius's theory of proportion, to which Leonardo devoted himself in 1490, is already reflected in the measurements of the *St Jerome*, but his thesis is undermined by the inaccuracy of these measurements. Leonardo's picture is based

in formal terms upon older interpretations of the subject and upon the writings of Jerome himself, in which the saint describes his penance in the desolate wilderness and at the foot of a cross, here barely visible on the right-hand edge of the painting (Rice, 1985, pp. 78–79; cf. main text, p. 69). The inclusion of the lion as the saint's attribute also falls in line with pictorial convention.

The *St Jerome* may possibly have been intended for the Ferranti chapel in the Badia in Florence (Cecchi, 1988), which Filippino Lippi subsequently furnished with an altarpiece of the same subject *c.* 1489/90 (Scharf, 1935, pp. 26–27). This suggestion is lent credence by the fact that Filippino Lippi also took over similar commissions for the chapel of St Bernard in the Palazzo Vecchio in Florence and for San Donato a Scopeto, both of which were originally awarded to Leonardo but which the latter failed to complete. If the *St Jerome* was indeed destined for a side altar in the Badia, the commission was probably secured by Leonardo's father, Piero da Vinci, whose family had maintained a tomb in the Badia since 1472 (von Seidlitz, 1909, I, pp. 10 and 379; Zöllner, 1995, pp. 60–61).

LITERATURE: Poggi, 1919, pp. V–VI; Ottino della Chiesa, 1967, no. 13; Ost, 1975; Rice, 1985; Cecchi, 1988, p. 70; Marani, 1989, no. 8; Colalucci, 1993; Zöllner, 1995, pp. 60–61; Arasse, 1998, pp. 344–350; *Hochrenaissance im Vatikan*, 1998, pp. 552–553.

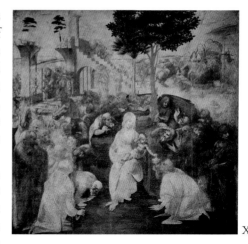

X

X

Adoration of the Magi, (p. 343 before, p. 345 after 2017 restoration), 1481/82
Oil on wood, 243 x 246 cm
Florence, Galleria degli Uffizi, Inv. 1594

The altarpiece, which is in good overall condition, is made up of ten boards glued together vertically and reinforced by two crosspieces of a more recent date. Around the edges of the panel, the paint has severely crumbled in places. A peripheral border cannot be made out, which suggests that the panel was primed and painted without first being mounted in a frame. Seven almost rectangular notches of up to 5 cm in depth, probably made at a later date, are located along the top edge of the panel. The painting resembles an enormous sketch, in which Leonardo has set down the figures and the background architecture with a brush. The sketch-like nature of the composition is also evidenced by numerous pentimenti, as seen for example on the right-hand edge of the panel, where Leonardo has altered the

position of one of the horse's heads, and in the horsemen fighting in the background, where a second design still lies alongside the first. Furthest developed are the figures in the right-hand foreground, the older man on the far left and the crowns of the two trees. Least developed of all, however, are the main characters: Mary and Jesus, the eldest and the youngest king in front of them on the left, the second king in front of them on the right, and Joseph behind them.

According to current scholarship and in contrast to the view expressed by Sanpaolesi (1954), the painting reveals no traces of *spolvero*. Nor does it appear to contain scored underdrawing such as that found in the background of the *Madonna of the Carnation* (Cat. III) and in the perspective construction of the *Annunciation* (Cat. V). Brachert (1969) has also discovered several places in this painting where Leonardo has rubbed the paint with his hand and his fingers. The visibility of many compositional details has been compromised by the – at least two – coats of varnish that cover the lower half of the painting in particular, and that have greatly yellowed since their application in the 18th or 19th century. It remains to be seen whether a restoration can bring fresh information to light. Leonardo abandoned work on the *Adoration* in 1482/83 when he left Florence for Milan. It is uncertain whether the painting ever reached the monks of San Donato a Scopeto who commissioned it, and whose monastery, sited in front of Florence's Porta Romana, was destroyed in 1529. It was probably located from 1529, and certainly before 1568, in the home of Amerigo Benci in Florence, where

Vasari saw it (Vasari, 1568, IV, p. 27). It is documented from 1621 as being in the possession of the Medici, until passing to the Uffizi in 1670. After 1753 it was transferred to the Medici villa in Castello, outside Florence, before returning permanently to the Uffizi in 1794 (Poggi, 1919).

Of Leonardo's surviving works from his first Florentine period, the *Adoration* is the only one documented by a contract (cf. main text, pp. 71/72). It can be deduced from this contract, drawn up in July 1481, that in March 1481 Leonardo was commissioned by the monks of San Donato a Scopeto to paint a panel for their high altar, which was to be completed within 24 or at the most 30 months (Beltrami, 1919, no. 16; Villata, 1999, no. 14). Leonardo's father, a notary who had worked for the monks (von Seidlitz, 1909, I, p. 59; Vecce, 1998, p. 65) may have played a part in securing this commission for his son (Zöllner, 1995, p. 60–61). There is no longer any doubt that the altarpiece in question was the *Adoration* by Leonardo today in the Uffizi (a summary of older theories is found in Wiemers, 1996). The complicated terms of the contract, which required the artist to meet numerous expenses in advance out of his own pocket, probably contributed to the fact that the painting was never finished. Whatever the case, it is clear from the sources that Leonardo was unable to fulfil the financial obligations imposed by the contract. In 1496 the commission for the altarpiece passed to Filippino Lippi (ill. p. 86).

Several of Leonardo's drawings (Nathan/ Zöllner 2014, Cat. 1, 2, 5–14) have been linked with the *Adoration of the Magi*, but

only two of them can definitely be considered true preliminary studies (Nathan/Zöllner 2014, Cat. 5–6; ills. pp. 78/79, 82). The remaining sketches, which possibly relate to a planned *Adoration of the Shepherds,* in places employ the same motifs as found in the *Adoration of the Magi.* Even if they cannot be considered immediate studies for the *Adoration of the Magi,* these drawings nevertheless testify to Leonardo's process of pictorial invention (*Leonardo & Venezia,* 1992; Wiemers, 1996).

The altarpiece shows the adoration of the Christ Child by the Three Kings from the East (Matthew 2:11), whose identification within this painting remains the subject of contention. The older man behind and to the left of the Virgin is probably meant to be Joseph; the bearded figure who is bowing low in the left-hand foreground is probably the eldest king (Caspar) and the kneeling young man beside him the youngest king (Melchior). The figure who has sunk to his knees in the right-hand foreground is probably the second king (Balthasar), who is presenting his gift of frankincense.

The formal starting-point for Leonardo's composition was the small-format *Adoration of the Magi* by Sandro Botticelli for the del Lama family (ill. p. 84). From Botticelli Leonardo adopts the grouping of his figures, which no longer bears any resemblance to the Epiphany processions that wound their way through earlier Florentine paintings of the same subject (Hatfield, 1976; Arasse, 1998, p. 352). The monumental, classicizing architecture in the left-hand background is also directly inspired by Botticelli's *Adoration.* In his monumentalization of

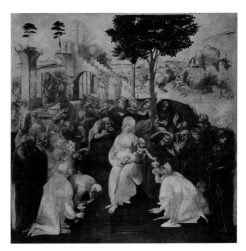

the composition, Leonardo looks back to Fra Angelico's altarpiece for San Marco (ill. p. 87), which was also destined for a high altar. The architecture of the background, which is traditionally understood as a reference to the palace of King David and thus to the Old Testament, has been recently interpreted by Natali (1994) not just as a ruin, but simultaneously as a building site. Natali identifies the elderly bearded figure standing in front of the steps as the architect and the as yet unclothed figures on the steps as the labourers. He suggests that the steps themselves may be related to the Medici villa in Poggio a Caiano or to the steps leading up to the gallery in San Miniato al Monte in Florence (Natali, 1994). The battling horsemen in the background may refer to a scene that took place before the Magi reached Bethlehem and in which they got into a fight amongst themselves (Sterling, 1974). Doubt has been cast on this interpretation, however (Natali, 1994, p. 155). It is also possible to explain the scene of mounted combat from a formalistic point

of view: Leonardo is here portraying one of his favourite motifs, horsemen engaged in battle, one that he would take up again in his wall-painting of the *Battle of Anghiari* (Cat. XXVI).

Of the iconographical interpretations of the overall composition, three deserve particular mention: 1.) Margit Lisner (1981) sees the presentation of the frankincense by the second king as the central motif of the composition. Since this gift directly recalls the Sacrifice of Christ celebrated at the altar, the motif serves to link the altarpiece with the Eucharist in the appropriate manner of its day. The broadleafed tree (a walnut or carob tree?) rising on top of the mound is also traditionally linked in Augustinian thinking with the Sacrifice of Christ. Lisner interprets the tree further left as a symbol of Christ's triumph over death (pp. 214–215). The identification of the trees is the subject of contention, however (von Seidlitz, 1909, I, p. 391; Morley, 1979, p. 559; Wiemers, 1996, pp. 322, 381). 2.) Natali (1994) draws upon apocryphal sources, Augustinian writings and Old Testament prophets (in particular Isaiah) in his interpretation of the figures, the tree in the middle, the architecture and the battling horsemen in the background. 3.) Starting from the fact that the *Adoration* was commissioned by Augustinian monks, Fehrenbach (1997) seeks to explain the painting in terms of an Augustinian metaphysics of light. The most concrete interpretation to date, however, remains that of Lisner, whose identification of the eucharistic significance of the moment portrayed is confirmed by similar observations by Kemp (1981, p. 72) and Arasse (1998, p. 352).

LITERATURE: Vasari, 1568, IV, p. 27; Vasari, 1965, p. 261; Müller-Walde, I, 1897, pp. 121–123; von Seidlitz, 1909, I, pp. 58–70; Calvi, 1919; Beltrami, 1919, no. 16; Poggi, 1919, p. 5; Sanpaolesi, 1954, pp. 42–44; Ottino della Chiesa, 1967, no. 14; Brachert, 1969; Sterling, 1974; Kemp, 1981, pp. 67–78; Lisner, 1981; *Leonardo & Venezia*, 1992, pp. 188–201; Natali, 1994; Wiemers, 1996, pp. 227–324; Fehrenbach, 1997, pp. 89–114; Arasse, 1998, pp. 350–363; Vecce, 1998, pp. 65–66; Bambach, 1999, pp. 23, 246; Villata, 1999, no. 14.

XI

The Virgin of the Rocks (The Virgin and Child with the Infant St John and an Angel), 1483–1484/85

Oil on wood, transferred to canvas, 197.3 x 120 cm
Paris, Musée du Louvre, Inv. 777 (MR 320)

XI

The painting, which was transferred from panel to canvas in 1806, is in only mediocre condition. Its legibility is hampered by retouching in the region of the rocks and a varnish that has yellowed markedly with age. While the figures are preserved in relatively good condition, the dark sections of the background landscape have suffered particular damage (Brachert, 1977). The overall depth of the paint is considerably less than in the second version of the *Virgin of the Rocks*, in London (Cat. XVI; Wolters, 1952).

The *Virgin of the Rocks* was originally commissioned by the Milan-based Confraternity of the Immaculate Conception for a chapel in the church of San Francesco Grande in Milan. The painting, which is described in early documents simply as a generic "Nostra Donna" (Villata, 1999, nos. 23 and 67) and even in 1506 non-specifically as an "imago gloriosissime Virginis Marie cum filio e Sancto Ioanne Baptista" (Villata, 1999, no. 226, p. 193), portrays the Virgin Mary, the Christ Child making a sign of blessing, the infant St John and an archangel, probably Uriel, who is traditionally associated with St John. Leonardo's painting formed the central panel of a large altarpiece. It was flanked by two pictures of angels making music, painted by Ambrogio de Predis, which like the second version of the *Virgin*

of the Rocks are today housed in the National Gallery in London (ill. p. 101). Reliefs portraying episodes from the life of Mary and sculptures of prophets completed the pictorial programme. The altarpiece also incorporated a wooden statue of the Virgin, which was probably the true object of veneration (Venturoli, 1993; Casciaro, 2000, pp. 73–79). The origins of the commission, for which Leonardo was probably recommended by Ludovico il Moro (Vegh, 1992, p. 275), are extensively documented (Ottino della Chiesa, 1967; Glasser, 1977; Sironi, 1981; Cannell, 1984). On 8 May 1479 the Franciscan Confraternity of the Immaculate Conception arranged for the ceiling of its

chapel in San Francesco to be frescoed. One year later, the woodcarver Giacomo del Maino was commissioned to produce a large retable for the same chapel; on 7 August 1482, following its completion, this wooden structure was valued at 710 *lire imperiali* (Venturoli, 1993, p. 424). Forming part of the retable was a statue of the Virgin, which was to be adorned with a valuable pearl necklace (Sironi, 1981, nos. I, II). This statue was completed at the latest by 22 November 1482, when the said pearl necklace was delivered to the Confraternity. The work to be undertaken on the *Virgin of the Rocks*, which was to be integrated within del Maino's retable, is also reliably documented in a detailed contract of 25 April 1483. This contract contains an itemized list of all the elements of the picture and pledges Leonardo and his two partners, Ambrogio and Evangelista de Predis, to gild the retable and to complete the altarpiece by the following 8 December (the Feast of the Immaculate Conception; cf. main text, pp. 111/112). By this it probably means 8 December 1484 rather than 1483, since a deadline of just seven months to complete the altarpiece would have been too tight (by way of comparison, the contract for the *Adoration* envisaged a time frame of 24 to 30 months). The terms of payment are also calculated on the basis of about 20 monthly instalments. The overall fee for the painting was agreed at 800 lire (200 ducats), of which the first instalment of 100 lire was paid to the artists on 1 May 1483. From July 1483 onwards they were to receive 40 lire a month (Ottino della Chiesa, 1967; Sironi, 1981; Venturoli, 1993). When the work

was completed they were also to receive a bonus, to be calculated by Fra Agostino Ferrari and two other members of the confraternity. The artists appear to have met the deadline laid down in the contract. A recently published document shows that, at the end of December 1484, the artists received 730 lire, taking the money paid to them for their work almost up to the agreed total. The first version of the *Virgin of the Rocks* must thus have been all but finished by this point in time (Shell/Sironi, 2000). Following its completion, however, disagreements arose, which resulted in a legal dispute lasting some 20 years. The documentation relating to this litigation is incomplete and contradictory, however (Cannell, 1984). In the next surviving document, which recent scholarship dates to between 1491 and 1493 (but which earlier scholars such as Beltrami date to *c.* 1502), Ambrogio de Predis and Leonardo (Evangelista de Predis had died at the start of 1491) plead their case to the ruler of Milan (i.e. Ludovico il Moro if the petition dates from 1491/92), asking him to use his influence to increase the amount of the bonus payment agreed in 1483. The 800 lire they have already been paid is barely sufficient, so the artists claim, to cover the expenses they incurred in executing the altarpiece. They want the confraternity to pay them a bonus of 100 ducats (i.e. 400 lire) instead of the mere 25 ducats they have already been offered, and they ask that two external experts should be brought in to value the painting, since the members of the confraternity have no idea about art. They also imply that the painting has already

attracted offers from other would-be buyers (Beltrami, 1919, no. 120; Villata, 1999, no. 67). This first petition was evidently unsuccessful, for it was followed in the spring of 1503 by another letter on the same subject (Beltrami, 1919, nos. 121–122; Villata, 1999, no. 175). Milan had by now fallen to the French, and the artists calculated that they would have a better chance of increasing their fee under the new regime.

This documentation can be interpreted in a number of different ways. One possibility is that all the documents relating to the *Virgin of the Rocks* that are or can be dated later than the first petition of 1491/93 in fact relate to the second version of the painting. If this is the case, the second version may have been commenced very soon after the completion of the first, but must have taken several years actually to complete, since the final payment was only made on 23 October 1508. It may have been finished on 8 August 1508, for on this day the artists were granted permission to remove the picture from the altar in order to make a copy of it (see below). A second possibility is that the documents relate only to the second version as from 1506, and that this second version was evidently considered finished in October 1508, since the artists received their last and final payment for their work on the 23rd of that month (Beltrami, 1919, no. 199; Villata, 1999, no. 264). A third possibility is that the document, which has been dated only on the basis of circumstantial evidence to the period 1491–1493, was in fact composed between 1500 and March 1503. In this case, all the documentation after 1500 could be related to the second version of the *Virgin of the Rocks*.

In the years following its completion, the Paris version of the *Virgin of the Rocks* must have been either sold, given away or confiscated, for otherwise there would have been no need to paint a second version (Cat. XVI). Over this question, too, controversy still reigns (summary in Cannell, 1984). It is possible that the artists indeed sold the painting to a third party and then executed a copy – the London version – for the confraternity. If such a buyer really existed, it was probably Ludovico il Moro. Ludovico could then – according to one popular theory – have sent the first version to Innsbruck in 1493 on the occasion of the marriage of his niece Bianca Maria Sforza to Emperor Maximilian. It would be to this painting that early biographers are referring when they record that an altarpiece (Benedettucci, 1991, p. 102; Frey, 1892, p. 112), and specifically a *Natività* (Vasari, 1550, p. 550), commissioned from Leonardo by Ludovico, were sent to the emperor in Germany. 35 years later, on the occasion of another marriage – that of Maximilian's niece Eleonora to François I – the painting was again dispatched as a gift, this time to France (Horne, 1903; Gould, 1985). It is also possible, however, that the painting was only sent to France in 1570, as a present for Charles IX (Gould, 1994). It is also conceivable that the picture was purchased by Louis XII in 1499 or that it was confiscated after the French took Milan (Wasserman, 1984, p. 80). Cannell (1984) argues along similar lines, although he believes that the first version of the *Virgin of the Rocks* was requisitioned by Charles d'Amboise in 1508 and sent to France.

The very different theory propounded by Hannelore Glasser, namely that Leonardo and his colleagues executed the second version of the painting for San Gottardo a Corte in the old Milanese ducal palace, is now widely dismissed. Glasser and earlier Davies (1951, p. 211) were thereby drawing upon historical guides to the city of Milan, in which it is claimed – for example in Carlo Torre (1674, p. 203) and Serviliano Latuada (1738/1997, IV/X, pp. 238–239; Glasser, 1977, pp. 262–264) – that the *Virgin of the Rocks* comes from San Gottardo a Corte. Perhaps we should interpret this information differently from Glasser: it is possible that, as early as *c.* 1485 or not much later, Ludovico il Moro acquired the first version of the *Virgin of the Rocks* destined for San Francesco in order to install it in San Gottardo a Corte. In this case, the second version would have been commenced shortly afterwards to replace the painting taken by Ludovico, but finished only many years later. The first version could then have been confiscated from San Gottardo by Louis XII in 1499. Indeed, there are indications that the Paris version of the painting entered the collection of the French king considerably earlier than 1570, as demonstrated in particular by a book of hours produced for Claude, queen of France (H.-P. Kraus Collection, New York, fol. 15v), in approximately the second half of 1517 (Sterling, 1975, pp. 12–15; Béguin, 1983, p. 73). The miniaturist who illuminated the prayer book was undoubtedly familiar with the Paris painting: he not only takes up its figures, but also arranges them in front of a rocky grotto. Moreover, the copies of original paintings by Leonardo

mentioned by Abbé Guilbert in 1731 suggest that the *Virgin of the Rocks*, together with Leonardo's *Leda, Mona Lisa, Belle Ferronière* and *St John the Baptist* adorned François I's *appartement des bains* in Fontainebleau (Dimier, 1900, p. 281). In the 17th century the painting was housed in the *cabinet des peintures* in Fontainebleau (Dan, 1642, p. 135; Brejon de Lavergnée, 1987, no. 391), from where in the 18th century it moved to Versailles and finally, *c.* 1800, to the Louvre. Thanks to the contract of 25 April 1483 and two inventories of 1781 and 1798, we have a relatively good idea of the overall configuration of the original retable, which no longer survives (Malaguzzi-Valeri, II, 1915, p. 395; Venturoli, 1993, pp. 35–37). The main altarpiece was surrounded by half a dozen smaller sculptures, together with seven larger and six smaller reliefs showing scenes from the life of Mary (cf. main text, pp. 111/112). Art-historical interpretations have almost always focused on Leonardo's panel alone, however, and revolve primarily around the theological notion of Mary's *immacolata conceptio*, i. e. her immaculate conception by St Anne. They are based less on a convincing elucidation of Leonardo's composition than on the fact that, in the years immediately preceding 1483, the Franciscans in Milan and elsewhere had lent their energetic support to the contentious issue of the Immaculate Conception of the Virgin. The first detailed interpretation along these lines was proposed by Levi d'Ancona (1955 and 1957); further interpretations in the same vein are found most recently in Ferri Piccaluga (1994a), who on the basis of Amadeo Mendes da

Silva's *Apocalypsis nova* assigns the painting an almost heretical content. It is extremely difficult, however, to establish a credible connection between the dominant elements of the composition (such as the combination of individuals portrayed, the presence of Uriel and the rocks) with the doctrine of the Immaculate Conception. Indeed, in 1483 there was no standard pictorial formula for a *Maria immacolata* (Vegh, 1992, p. 282) upon which Leonardo and his clients could have drawn. Titian's *Assunta* in the Frari church in Venice, completed in 1518, also shows that the Immaculate Conception was a notion, which at that time could be expressed only indirectly (for example through the Assumption and Coronation of the Virgin, which prove her *immacolata conceptio*), rather than through its own distinct imagery. A better understanding of Leonardo's picture may perhaps be gained by moving away from an "immaculistic" interpretation of the composition. In all likelihood, the confraternity associated the notion of the "Immacolata" primarily with the statue of the Virgin (de Vecchi, 1982; Vegh, 1992, p. 283), which also adorned the retable, either concealed behind Leonardo's panel or displayed on the level above it (Venturoli, 1993; Casciaro, 2000, pp. 73–79).

The iconography of Leonardo's panel, on the other hand, can be deduced from the constellation of the figures, within which Mary appears as the Virgin of the Protecting Cloak. Thus St John, as the figure with whom the Franciscan Confraternity particularly identified, is presented under the protection of the Virgin and praying to Christ, who is at the same time blessing him. John, like the rocky landscape, may also be understood as a reference to specific elements of Franciscan theology, since St Francis received the stigmata in front of a cleft and fissured mountain. The rocks may also conceal a moral message based on the letters of Seneca (*To Lucilius*, 4.12; del Bravo, 2000). The iconography of the painting is discussed in greater detail in the main text (cf. p. 97) and throughout the literature. Thus Robertson (1954) interprets the rocks as a place of refuge for the Virgin and the faithful in line with medieval exegesis of the Song of Songs (2.13–14), while Marilyn Aronberg-Lavin (1955, pp. 96–100) finds an explanation for the meeting of Christ, John and Uriel in a cleft in the rocks in the writings of Domenico Cavalca and St Bridget and emphasizes the significance of Florentine antecedents. Joanne Snow Smith (1983, 1987) points out the typical Franciscan associations of the split mountain; Vegh (1992) stresses the role of the Virgin as the instrument of divine grace; and Stefaniak (1997) proposes a symbolic interpretation of the chasm opening up in front of Mary on the basis of patristical sources. Earlier interpreters see the *Virgin of the Rocks* as portraying the flight of the Virgin, Christ and John into the wilderness, as described in the Protevangelium of James (17–22) (Goldscheider, 1960, pp. 178–179).

Two original drawings by Leonardo in Windsor Castle and Turin can be considered direct studies for the *Virgin of the Rocks* (ills. pp. 93, 99). Two sheets in the Codex Arundel in the British Museum (fol. 253v, 256r) carry very faint sketches for the head, the right foot and the left hand of the infant

St John. A study of a Virgin of *c.* 1482–1485 (ill. p. 96), now in New York, reveals a compositional similarity to the *Virgin of the Rocks.* Davies (1951, p. 210) identifies a number of other drawings by Leonardo and his circle that can be linked more or less convincingly to the *Virgin of the Rocks.* A drawing attributed to Leonardo showing the head of the infant St John (Paris, Louvre, Inv. 2347; reproduced in Marani, 1999, p. 125) should probably be regarded as a copy.

An up-to-date inventory of early copies of the Paris version of the *Virgin of the Rocks* (Malaguzzi-Valeri, II, 1915, pp. 416–425, ill. 459–465; Davies, 1951, p. 210; Ottino della Chiesa, 1967, p. 95; Pedretti, 1993; Ferri Piccaluga, 1994b) has yet to be compiled. The Statens Museum for Kunst in Copenhagen is home to a high-quality variation upon the Paris version (oil on canvas, 144.5 x 119.5 cm), which probably formed the basis of the copies of an almost identical size in the collection of the Contessa Luisa Treccani in Milan and in a private collection in Paris (formerly in the Cheramy Collection). Considerably inferior in quality is the copy in the collection of Joseph M. B. Guttmann in Los Angeles (formerly in the Hurd Collection, New York). Two other copies are housed in the museums of Nantes (182 x 146 cm) and Caen (59 x 46 cm).

LITERATURE: Benedettucci, 1991, p. 102; Frey, 1892, p. 112; Vasari, 1550, p. 550; Vasari, 1965, p. 262; Torre, 1674, p. 203; Latuada, 1738, pp. 238–239; Malaguzzi-Valeri, I, 1915, pp. 406–425; Beltrami, 1919, nos. 23–24, 120–122; Wolters, 1952, p. 143; Levi d'Ancona, 1955; Aronberg-Lavin, 1955; Levi d'Ancona, 1957, pp. 73–79; Glasser, 1977, pp. 208–270, 308–392; de Vecchi, 1982; Béguin, 1983, pp. 72–74; *Il francescanesimo in Lombardia,* 1983; Cannell, 1984; Snow Smith, 1983, 1987; Vegh, 1992; Venturoli, 1993; Gould, 1985, 1994; Marani, 1999; Villata, 1999, nos. 23, 67, 175; Casciaro, 2000, pp. 73–79; Shell/Sironi, 2000.

XII

Giovanni Antonio Boltraffio (?)
and Leonardo (?)
Portrait of a Musician, c. 1485
Tempera and oil on wood (walnut?), 44.7 x 32 cm
Milan, Pinacoteca Ambrosiana, Inv. 99

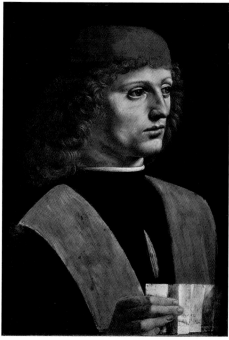

XII

The portrait, which is probably painted on a single board, is in good overall condition, despite some retouching (towards the back of the head, for example). Parts of the picture, including the red cap, the clothing and possibly the left hand, are unfinished (Suida, 1929). The painting reveals no visible borders around its periphery and may have been slightly trimmed along the bottom. The paint has suffered damage in particular in the bottom right-hand corner, where restoration carried out in 1905 revealed the sheet of music today visible in the musician's hand (Beltrami, 1906). The shading of the neck and the left-hand side of the upper lip are not particularly successful, something that may be linked with retouching. In all other respects, the execution of the finely modelled face is of high painterly quality.

The *Portrait of a Musician* may have passed from the collection of Galeazzo Arconati to the Ambrosiana as early as 1637 (Rossi/Rovetta, 1997), although the painting is firmly documented there only from 1672, when it is described as a work by Leonardo. In an inventory of 1686 it is then attributed to Bernardino Luini, only to be corrected back to Leonardo at a later stage (Poggi, 1919).

In view of the somewhat rigid pose of the young man and the hardness lent to his flesh by the shading, which is reminiscent of Boltraffio and Ambrogio de Predis, the portrait's attribution to Leonardo by Beltrami, Suida, Clark, Heydenreich, Goldscheider, Bora, Marani and others seems dubious. It is supported, on the other hand, by the presence of a number of parallels with the *Portrait of Cecilia Gallerani* (Cat. XIII), which has been definitely attributed to Leonardo. Thus the artist uses walnut as his support for both panels, a wood not commonly employed by Lombard artists but one that Leonardo himself recommends (RLW § 628). Similarities with the *Portrait of Cecilia Gallerani* have also been revealed by X-radiography, offering further support for the argument that the *Portrait of a Musician* was executed by Leonardo's own hand. It is now accepted that Leonardo executed the face, while Boltraffio is credited with

XIII

Angelicum ac divinum opus. Alternative candidates include the lutenist Francesco da Milano, the Flemish singer Giovanni Cordier (Poggi, 1919), Josquin des Prez, who was also connected with Milan Cathedral (Clercx-Lejeune, 1972) and Leonardo's friend Atalante Miglioriti (Marani, 1999, p. 165).

LITERATURE: Beltrami, 1906; Poggi, 1919, pp. XXV–XXVI; Suida, 1929, pp. 89–90; *I Leonardeschi ai raggi "X"*, 1972, pp. 1–3; Brown, 1983; Falchetti, 1969 (1986), p. 260; Bora, 1987, pp. 299–304; Rossi/Rovetta, 1997, p. 71; Marani, 1999, pp. 160–166.

XIII
Portrait of Cecilia Gallerani
(Lady with an Ermine), 1489/90
Oil on walnut, 55 x 40.5 cm
Cracow, Muzeum Narodowe, Czartoryski Collection, Inv. 134

the entire upper body (Bora, 1987, p. 18). The rigid pose, which directly contradicts Leonardo's advice on how to portray figures (TPL 319, 320, 357), together with the clearly inferior quality of the present portrait when compared with the *Portrait of Ginevra de' Benci* (Cat. VII) and the somewhat unconvincing foreshortening of the left-hand side of the musician's face, nevertheless continue to cast considerable doubt on Leonardo's authorship.

The identity of the young man remains uncertain. Since Beltrami (1906), many have suggested the name of Franchino Gaffurio, born in 1451, a musician at the ducal court and choirmaster of Milan Cathedral. In this context, the inscription on the sheet of music, "CANT[OR] ANG[ELICVM]", has been interpreted as referring to Gaffurio's

The panel, which consists of a single piece of wood, in all probability comes from the same tree as the support of the so-called *Belle Ferronière* in the Louvre (Cat. XV). Apart from a few small areas of damage, the painting, which retains its original dimensions (borders on all four sides), is in very good condition. The paint, which is built up somewhat higher in the areas of flesh than elsewhere, is evenly applied in a manner similar to the equally well preserved *Mona Lisa* (Cat. XXV).

Remains of *spolvero* are found in the outlines of the figure and head and in the drawing within the face, while traces of underdrawing scored directly into the ground can be identified above all in the right arm, right

hand, left hand, bridge of the nose and start of the hair (Fabjan/Marani, 1998, pp. 76–77, 83–90; Bambach, 1999, p. 23). The finger-prints typical of Leonardo's painting from this period can be identified in Cecilia's face and on the ermine's head (Brachert, 1977, p. 99).

The background was originally prob-ably a shade of harmonious grey-blue, later completely repainted in a dark colour (Fabjan/Marani, 1998, p. 87). The theory, often repeated, that the right-hand background once showed an open win-dow (Marani, 1989) was not confirmed by recent research (Fabjan/Marani, 1998, pp. 82–84). An inscription top left ("LA BELLE FERONIERE / LEONARD D'AWINCI") was probably added in the early 19th century.

The painting is described in a sonnet (cf. main text p. 148), published in 1493, composed by the court poet Bernardo Bellincioni, who died in 1492, and is men-tioned in 1498 in correspondence between Isabella d' Este and Cecilia (Beltrami, 1919, nos. 88–89; Villata, 1999, nos. 129–130), in whose possession the portrait seems to have remained until her death in 1536. The pic-ture possibly surfaces in the collection of Rudolf II in Prague in 1612. Towards the end of the 18th century, it was purchased in Italy by Prince Adam Jerzy Czartoryski as a pre-sent for his mother (Shell/Sironi, 1992). The portrait is documented in the collection of the Czartoryski princes in Pulawy from 1809 onwards (Poggi, 1919, pp. XVIII–XIX). Between 1830 and 1876 it accompanied its owner to Paris and then Cracow, where it went on public display in 1882. In autumn 1914, following the outbreak of the First World War, it passed to the Gemäldegalerie in Dresden, but in 1920 returned to Cracow. In 1939 it was taken as war booty to Ber-lin, where it was exhibited in the Kaiser-Friedrich-Museum. It was also earmarked for the "Führer's Museum" planned in Linz. It was returned to the Muzeum Narodowe in 1946 (Fabjan/Marani, 1998, pp. 78–79).

As in the case of the *Portrait of Ginevra de' Benci* (Cat. VII) and the *Madonna of the Carnation* (Cat. III), the attribution of the *Portrait of Cecilia Gallerani* to Leonardo came to be widely accepted only in the 20th cen-tury. After Paul Müller-Walde drew atten-tion to the painting in 1889, in 1900, at the 3rd Congress of Polish Art Historians in Cracow, Jan Boloz-Antonievicz linked it with the portrait of Cecilia Gallerani attrib-uted to Leonardo in the sources. When war broke out, the painting was evacuated to Dresden, where it subsequently went on show. This intensified the debate over its authorship, which was increasingly attrib-uted to Leonardo (Poggi, 1919). This trend continued between the wars and after the Second World War. No one today doubts the attribution to Leonardo, which as in the case of the *Portrait of Ginevra de' Benci* is supported by a wealth of information per-taining to the sitter.

The *Cecilia Gallerani* has appeared in a relatively large number of exhibitions: in Warsaw in 1952, in Moscow in 1972, in Washington, DC, in 1991/1992, in Malmö in 1993/1994, in Rome and Milan in 1998 and in Florence in 1999. No other painting by Leonardo travelled the world so widely in the 20th century.

As in the case of the *Ginevra de' Benci* and the *Mona Lisa*, we are well informed about the young woman in the portrait (Shell/Sironi, 1992; Moczulska, 1995; Fabjan/Marani, 1998, pp. 51–65 [J. Shell]). She was born Cecilia Bergamini in 1473 and in 1483, at the age of 10, was formally ("pro verba") betrothed to Giovanni Stefano Visconti. After this betrothal was dissolved in 1487, and at the latest in 1489, Cecilia became the mistress of Ludovico il Moro, whom she bore a son, Cesare, on 3 May 1491. In July 1492 Cecilia married Ludovico Carminati. She died in 1536.

The animal in Cecilia's arms, zoologically not altogether correctly described as an ermine, was considered a symbol of purity and virtue. It also served as a reference to Ludovico Sforza, Cecilia's lover and the man who commissioned the portrait. The ermine, in Greek *galée*, is also seen as a play upon the name Cecilia Gallerani. The presence of this symbolic animal has led the portrait to be interpreted in numerous ways, of which we may summarize the most important here: Carlo Pedretti (1990) sees in the portrait a political allegory of the relationship between Ferdinand I of Naples and Ludovico il Moro, whom Ferdinand appointed a member of the Order of the Ermine in 1488.

A very different train of thought is pursued by Krystyna Moczulska (1995), who examines the significance of the ermine and the weasel in classical literature and in popular belief and who relates the symbolic animal directly to Cecilia's personal situation, namely her pregnancy. Cecilia is thus connected with the story of Alcmena in Ovid's *Metamorphoses* (9.283–323) and Aelian's *De natura animalium* (2.37). Alcmena was made pregnant by Zeus, whose wife Hera tried to prevent the birth of her child, Hercules. Hera was thereby aided by the servant Galanthis, whom she subsequently turned into a weasel.

In late 1489/early 1490 Cecilia Gallerani and Ludovico il Moro found themselves in a similar situation: Cecilia was pregnant by her lover Ludovico, who was shortly due to marry Beatrice d'Este, for whom the imminent birth of an illegitimate child sired by her future husband was a vexation. According to popular belief, finally, the weasel was an animal that protected pregnant women.

LITERATURE: Bellincioni, 1493, *c.* 6v–7r (Beltrami, 1919, pp. 207–208; Villata, 1999, no. 72c); Beltrami, 1919, nos. 88–89; Poggi, 1919, pp. XVIII–XIX; Suida, 1929, pp. 91–93; Villata, 1999, no. 129; Kwiatkowski, 1955; Marani, 1989, no. 12; Brown, 1990; Pedretti, 1990; Bull, 1992; Shell/Sironi, 1992; Moczulska, 1995; Fabjan/Marani, 1998.

XIV

Giovanni Antonio Boltraffio (?),
after a design by Leonardo
Litta Madonna, c. 1490
*Tempera (and oil?) on wood, transferred
to canvas, 42 x 33 cm*
St Petersburg, Hermitage, Inv. 249

XIV

Despite having been transferred from panel to canvas in 1865 and having suffered some damage to the Virgin's cloak, the picture is in comparatively sound condition. Owing to relatively pronounced abrasion of the top layer of paint, however, it today gives a somewhat flat impression.

Compared with other small-format Madonnas by Leonardo, the painting can claim a relatively well-documented provenance. In 1784 it was purchased from Giuseppe Ro by Prince Belgioso; in 1813 it passed into the collection of the Litta family in Milan and in 1865 was sold by Antonio Litta to Tsar Alexander II. Earlier references to the painting must be considered unreliable: it is doubtful, for example, whether this is the same panel seen in 1543 in the Contarini collection in Venice by Marcantonio Michiel (Frimmel, 1888, p. 110). The Madonnas possibly explored in a drawing of 1478 (Nathan/Zöllner 2014, Cat. 192) and listed by Leonardo in the Codex Atlanticus of c. 1482 (324r/888r, RLW § 680) cannot be credibly linked to the *Litta Madonna*, since the painting cannot have arisen prior to Leonardo's first Milanese period.

According to the latest scholarship, the attribution of this Madonna to Leonardo can no longer be upheld. The existence of preliminary drawings in Leonardo's own hand nevertheless imply that the artist was involved in its design. Two of these drawings, in Paris and Frankfurt (Nathan/Zöllner 2014, Cat. 17–18; ill. p. 126), can be dated to c. 1490, which is now assumed to be the date of the painting itself. Two further preparatory drawings for the *Litta Madonna* – a drapery study in Berlin (Kupferstichkabinett, Inv. 4090) and a head of the Christ Child in Paris (Fondation Custodia, Inv. 2886) – are attributed to Leonardo's pupil Giovanni Antonio Boltraffio. Detailed studies by Brown (1990) and Fiorio (2000) have concluded that the painting was executed by one of Leonardo's pupils, based on designs by the master and under his direct supervision, as evidenced by the above-mentioned drawings. It is likely that this pupil was Boltraffio. This theory is supported by the figural type employed for the Christ Child, which is similar to that found in other works by Boltraffio.

XV

XV
Portrait of an Unknown Woman
(La Belle Ferronière), c. 1490–1495
Oil on walnut, 63 x 45 cm
Paris, Musée du Louvre, Inv. 778

Apart from small areas of damage on the sitter's décolletage and forehead, the painting is in good condition. The walnut panel probably originates from the same tree as the *Portrait of Cecilia Gallerani* (Cat. XIII; Fabjan/Marani, 1998), which suggests a dating of not much later than 1490. The paint is applied in a manner and depth similar to the *Cecilia Gallerani*. A very fine craquelure is apparent in particular in the areas of the flesh, whereby it differs from the craquelure found in the *Cecilia Gallerani* and *Mona Lisa* in the unevenness of its distribution (Wolters, 1952, p. 144). There are signs of retouching in the left-hand side of the face – where the hair originally did not extend quite so far down (Wolters) – and on the edge of the lower jaw. Hours (1954) also considers the band across the forehead – a *ferronière* (see below) – to be a later addition. The provenance of the *Belle Ferronière* can probably be traced back to the time of François I, albeit not entirely smoothly. In c. 1542 the painting was apparently one of a number of works by Italian masters – including the *Virgin of the Rocks* and *St John the Baptist* – adorning the *appartement des bains* in François I's Fontainebleau palace (Dimier, 1900, p. 281; Brejon de Lavergnée, 1987, p. 100). The first incontestable proof of its whereabouts, however, is supplied only a century later by Père Dan, who saw the portrait in the royal collection at

Important early copies and variations upon the *Litta Madonna* are found in the Fogg Art Museum in Cambridge, Mass., and in the Castello Sforzesco (Fiorio, 2000, D5, D15) and Museo Poldi Pezzoli in Milan. In the late 1400s or early 1500s Zuan de Andrea made the composition the subject of an engraving and thereby created one of the earliest reproductions of a Leonardo work (Bartsch, 1811, vol. XIII, p. 298, no. 225; after Kustodieva, 1994). An overview of these copies and variations can be found in Gukovskij (1959, p. 77).

LITERATURE: Poggi 1919, pp. 40, XXXIV and LXI; Gukovskij, 1959; Béguin, 1983, p. 84; Pedretti, 1989; Sedini, 1989, pp. 198–199; Brown, 1990; *Leonardo & Venezia*, 1992, no. 74 (D. A. Brown); Kustodieva, 1994, no. 116; Fiorio, 2000, no. A3 and pp. 16, 27–29.

Fontainebleau in 1642. Towards the end of the 17th century the painting was transferred to the collection of Louis XIV in Paris, before travelling in 1692 to Versailles, where it remained until 1784 (Poggi, 1919). In the 19th century the *Belle Ferronière* is listed in every Louvre inventory (Brejon de Lavergnée). It is not impossible, finally, that the "Florentine lady" seen by Antonio de Beatis in Leonardo's Cloux workshop in October 1517 was in fact the *Belle Ferronière* (Villata, 1999, no. 314).

The very high quality of the painting, the similarities in technique that it shares with other paintings by Leonardo and the fact, mentioned above, that its walnut support was probably cut from the same tree as that used for the *Portrait of Cecilia Gallerani*, leave little doubt that this is a work by Leonardo. And indeed, with the exception of Goldscheider (1960, p. 198), Wasserman (1984) and Béguin (1983), it is accepted wholeheartedly or with just a few reservations by the majority of modern critics. The identity of the sitter remains unclear, however. Carlo Amoretti (1804) suggested Lucrezia Crivelli, who was the mistress of Ludovico il Moro from *c.* 1495. The Codex Atlanticus (167v–c/ 456v) contains some Latin verses that were probably composed around this same period (Amoretti, 1804, p. 31; RLW § 1560 [incomplete]; PRC, II, pp. 386–387). To link these verses with the *Belle Ferronière*, however, means accepting the relatively late date for the portrait of *c.* 1495. It is also possible, however, to see the young woman in the portrait as Beatrice d'Este or as Cecilia Gallerani, now a few years older (Ottino della Chiesa, 1967).

The story, regularly repeated in the literature of recent years, that the *Belle Ferronière* owes its title to having been confused with another painting (Ottino della Chiesa, 1967; Brejon de Lavergnée, 1987, nos. 16 and 17; Marani, 1989), may not fit the facts; the name may equally well derive from the brow band, or *ferronière*, which is worn by the sitter and which was especially popular in Milan (Goldscheider, 1960). In compositional terms, the painting is closely related to a portrait type found across northern Italy, in which a stone parapet separates the viewer from the pictorial space. This same type surfaces in the works of Antonello da Messina (ill. p. 147) and Giorgione, for example, and is ultimately indebted to earlier Flemish models.

LITERATURE: Dan, 1642, p. 132; Amoretti, 1804, p. 31; Poggi, 1919, pp. XXXII–XXXIII; Suida, 1929, pp. 93–95; Hours, 1954, pp. 22–23; Goldscheider, 1960, p. 198; Ottino della Chiesa, 1967, no. 28; Béguin, 1983, p. 81; Brejon de Lavergnée, 1987, no. 16.

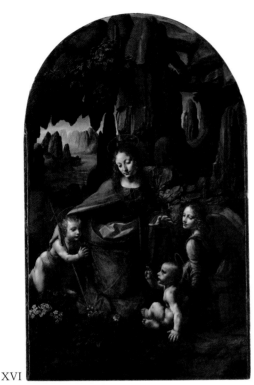

XVI

XVI
The Virgin of the Rocks (Virgin and Child with the Infant St John and an Angel), c. 1495–1499 and 1506–1508

Oil on poplar (parqueted), 189.5 x 120 cm
London, The National Gallery, Inv. 1093

The painting, which comprises several boards glued vertically together and whose overall condition may be described as good, reveals intact borders 2 cm in width on its left- and right-hand sides. At the bottom and top of the panel, the paint extends all the way to the edges, where traces of a frame can nevertheless still be made out. In contrast to the Paris version, the painting remains unfinished in several places,

for example in the right hand of the angel. Numerous pentimenti demonstrate that the painting is not just a simple copy of the first version. Thus the head of the Christ Child was originally higher up and turned more towards the viewer. Corrections were also made to the position of Jesus's legs, the infant St John's head and the Virgin's outstretched left hand.

Whether the haloes worn by Christ, Mary and St John, and St John's staff – all of which are absent from the Paris version – were added to the present version in Leonardo's own day remains a matter of dispute (Davies, 1951, p. 204; Marani, 1999, p. 139). John's banderole, bearing the inscription "ECCE A/GNIVS" (John 1:29) is probably original, however (Davies, 1951, pp. 204–205). Fingerprints of the kind typical of Leonardo are found primarily in a lower paint layer. Brachert (1969, pp. 97–99; 1977, pp. 11–17) suspects that a first layer of paint was laid down on the still unframed panel by Leonardo himself. In the reworked sections on top of the original paint layer, he sees – like most critics before him – the hand of Ambrogio de Predis.

On stylistic grounds, Marani (1999, pp. 140–142) has recently attributed parts of the rocky landscape and the flora to Marco d'Oggiono. In contrast, the analysis by Ann Pizzorusso (1997) of the geologically incorrectly portrayed rocks leads her to conclude that neither Leonardo nor Marco d'Oggiono is likely to have executed the painting. On the basis of surviving documents, however, and the technique employed in the two paintings (Brachert), the *Virgin of the Rocks* can most probably be regarded as the product

of artistic collaboration between Leonardo and Ambrogio de Predis. In accordance with the stipulations of the Confraternity of 27 April 1506 (Beltrami, 1919, no. 170; Villata, 1999, no. 226), Leonardo thus personally put the finishing touches to a painting which he himself had begun but which Ambrogio de Predis had then substantially completed (Beenken, 1951). Recent research suggests that a cartoon of Leonardo's composition was employed for the London *Virgin of the Rocks* (Plazzotta/Keith/Scailliérez, 2002 [in preparation]).

Opinions differ as to the precise dating of the London *Virgin of the Rocks*. While David A. Brown (1978) and Pietro Marani (1999, pp. 137–142) consider it possible that work on the painting commenced even before the mid-1490s, most other critics favour a starting date of between 1495 and 1499 (Cannell, 1984, p. 100; Marani, 1989). Whatever the case, the painting was completed only at some point between 1507 and 1508. The two final payments of 26 August 1507 and 23 October 1508 mark the end of the long-running legal dispute (cf. Ch. XI) and indicate that the work was considered finished (Beltrami, 1919, nos. 192, 199; Villata, 1999, nos. 251, 264). On the basis of current scholarship, however, it is impossible to say with absolute certainty to which of the two versions the documents from 1503 onwards refer. Thus the petitions of *c.* 1491–1493 and of 1503 mentioned in the context of the Paris version (Cat. XI), in which Leonardo and Ambrogio de Predis attempt to secure themselves a higher bonus payment, probably refer to the first version of the *Virgin of the Rocks*.

On 27 April 1506, however, the altarpiece is then suddenly described as being unfinished. This information has been automatically related to the second version, since the first was clearly already complete, as evidenced by the earlier documents of 1491/93 and 1503, in which the artists demand an increased bonus. How we should interpret a document of 18 August 1508, however, in which it is agreed that Ambrogio de Predis should make a copy of the *Virgin of the Rocks* (Sironi, 1981, no. VIII; Villata, 1999, no. 258) remains unclear. If this copy was indeed executed and if it should be the version that today hangs in London, then all attempts to date the start of work on this second version to the 1490s are invalid. The London *Virgin of the Rocks* would in this case be a copy of the Paris version that was executed under Leonardo's supervision. It is also possible, however, that Ambrogio de Predis executed a third version, which has either been lost or has yet to be identified (Gould, 1981, 1985).

We can be more confident, at least, about the subsequent fate of the London version following the settlement of the legal dispute. From 1508 at the latest, the painting must have been in the Confraternity's chapel in San Francesco Grande (Villata, 1999, no. 258), where it remained, together with the two angels painted by Ambrogio de Predis (today also in the National Gallery, ill. p. 114), throughout the whole of the 16th and 17th centuries. In 1781 it probably passed to the Ospedale di Santa Caterina della Ruota, where it was purchased for 1582 lire four years later by the English painter Gavin Hamilton. It was exhibited

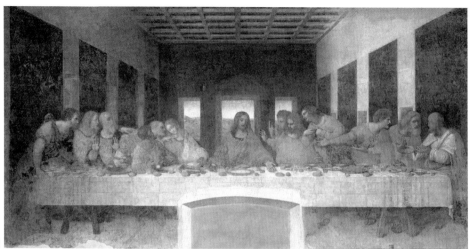

XVII

in London for the first time that same year, and in 1786 sold to Lord Landsdown, and subsequently to the Earl of Suffolk, and finally, in 1880, to the National Gallery for nine thousand pounds (Davies, 1951, p. 211). One of the best early copies of the London *Virgin of the Rocks* can be found in the church of Santa Giustina in Milan (also known as the copy of Affori). The tempera panel, measuring 87 x 66 cm, is considered to be the work of Bernardino Luini (*Zenale e Leonarde*, 1982, p. 65). Two small-format copies (54 x 48.5 cm and 56.2 x 44.2 cm), occasionally attributed to Marco d'Oggiono, are housed in the Castello Sforzesco in Milan and in the Pinacoteca Malaspina in Pavia (Marani, 1990, pp. 141, 165), while three others can be seen in the National Gallery in London (NG 1861) and in the museums of Vercelli and Naples (Capodimonte; Malaguzzi-Valeri, II, 1915, pp. 416–425, ill. 467–470, 472–474; Vezzosi, 1983, p. 145).

LITERATURE: Poggi, 1919, pp. VI–XII; Beenken, 1951; Davies, 1951, pp. 204–219; Hours, 1954; Brachert, 1969; Brachert, 1977; Glasser, 1977, pp. 208–270, 308–392; Brown, 1978; Sironi, 1981; Cannell, 1984; Gould, 1985; Marani, 1989, no. 14; Gould, 1994. See also Cat. XI.

XVII
The Last Supper, c. 1495–1497
Tempera on plaster, 460 x 880 cm
Milan, Santa Maria delle Grazie,
north wall of the Refectory

The *Last Supper* in the refectory of Santa Maria delle Grazie in Milan was considered Leonardo's most famous painting even in his own day, but its condition had already started to deteriorate within some 20 years, as noted by Antonio de Beatis in his diary at the end of December 1517, and also mentioned in later sources (Brambilla Barcillon/Marani, 1999, pp. 36–38). The wall-painting, executed not in *buon fresco* but in a mixed technique, has been the object of repeated restoration campaigns,

of which the most significant were carried out in 1726, 1770, 1821–1853, 1903–1908, 1924, 1947–1952 and 1977–1999. The most recent campaign seems to have halted the painting's deterioration, which had been in part accelerated by earlier restoration attempts. It has thereby brought back to light the colourfulness of the original composition, together with numerous details. This is true, for example, of the wall-hangings with their *millefleurs* patterns, the illusionistic entrances to imaginary monastic cells between them and a number of objects on the table. The latest restoration has even uncovered the nail hole in Christ's temple, which formed the starting-point of the perspective system governing Leonardo's composition.

Leonardo executed his wall-painting in a technique that is sooner typical of panel painting, as also found north of the Alps (Bertelli, 1986). He applied a thick layer of egg tempera on top of a chalk ground bound with glue. The ground contains only a very small amount of oil. Accurate analysis of the binding medium used is problematical, however, owing to the many restorations carried out on the painting (Kühn, 1985). Beneath the imprimatura (primary coat) lies a rough compositional structure, sketched in a reddish colour, in the manner of a sinopie (a preparatory drawing commonly used for frescoes before the introduction of cartoons). Leonardo drew the outlines of the figures on top of the imprimatura in thin black paint. There are no documented traces of *spolvero*. Scored into the plaster in the top section of the painting, however, are numerous lines relating to the perspective of the coffered ceiling, whereby these lines do not always correspond to the final composition. Small departures from the original underdrawing are found everywhere, for example in the dimensions of the two windows and the door in the background, which were originally some 5 cm wider (Kühn, 1985; Bertelli, 1986; Brambilla Barcilon/Marani, 1999, pp. 423–431; Bambach, 1999, p. 23).

The *Last Supper* was probably commissioned not by the Dominican monks of Santa Maria delle Grazie themselves but rather by Ludovico Sforza. The coats of arms of members of the ducal family that appear in the lunettes above the painting (Cat. XVIII), as well as a note written by Ludovico on 29 June 1497 (see below) and a payment receipt issued by the ducal administration, all point to this conclusion (Beltrami, 1919, nos. 76–77; Villata, 1999, nos. 116–117). De Beatis (cf. Ch. VI) also indirectly implies that the painting was commissioned by Ludovico (Müller-Walde, III, 1898, p. 230; not in Villata, 1999). It can be assumed that the decision to paint the north wall of the refectory arose in conjunction with the plans to extend and decorate the monastery complex of Santa Maria delle Grazie. With the laying of the foundation stone for the new choir on 29 March 1492, Ludovico il Moro took the first step towards creating a family mausoleum in which he, his family and his closest associates would one day be buried (and in some cases actually were). Further clues to the dating of the commission are provided by the aforementioned lunettes, which were probably painted between 1495 and 1496, and by the fact that, towards the end of 1494, work on the Sforza monument was suddenly halted. In November of that

year, namely, Ludovico sent the bronze earmarked for the equestrian monument to Ferrara to be turned into cannon. Only after this abrupt termination of Leonardo's intensive work on the large-scale project was it possible for him to start on the *Last Supper*. He is calculated to have completed it in 1497, on the basis of the reference to the composition in Pacioli's *Divina proportione*, where the *Last Supper* is discussed in glowing terms in the third chapter, written several months before the dedication, which is dated 9 February 1498. Pacioli also points to the fact that the painting focuses upon the moment at which Christ announces that "One of you shall betray me" (Matthew 26:21), something also confirmed by the inscriptions accompanying the five earliest engravings of the *Last Supper* (*Leonardo e l'incisione*, 1984).

Christ's announcement of his impending betrayal and the portrayal of the different reactions this produces amongst his disciples are the central object of the composition. In order to assemble a suitably wide range of facial expressions and physical gestures, in the mid-1490s Leonardo made studies of the poses and physiognomies of his contemporaries. This practice is described a few years later by Giovanbattista Giraldi (see below) and in Leonardo's own notes (Codex Forster II, fol. 2r, 6r, 62v–62r; RLW § 665–667; Villata, 1999, nos. 102–104). Several studies for the heads of the individual apostles and other drawings testify to the artist's meticulous preparations for the final composition (Nathan/Zöllner 2014, Cat. 19–26; ills. pp. 185, 192, 194, 196, 198; Möller, 1952, pp. 16–48; Brambilla Barcilon/Marani,

1999, pp. 22–36). A poem of *c.* 1497–1499, written by the Milanese court poet Gaspare Visconti, probably also makes reference to Leonardo's efforts to portray the disciples in a variety of different poses and wearing a wide range of facial expressions (Zöllner, 1992).

The identities of the individual apostles in the *Last Supper* (Steinberg, 1973, pp. 407–409) are derived from the inscriptions with which they are accompanied in a contemporary copy in Ponte Capriasca (Lugano). Not all art historians are in agreement over this, however; Möller (1952, pp. 54–60) interprets additional sources and the relationships between the apostles to propose an alternative identification, albeit one that has attracted little support. On the basis of the Ponte Capriasca copy, the apostles are currently identified, from left to right, as Bartholomew, James the Younger, Andrew, Judas, Peter, John, Thomas, James the Elder, Philip, Matthew, Thaddeus and Simon the Zealot.

As regards the specific iconographical interpretation of the composition, there are primarily two prevailing lines of thought. For Leo Steinberg (1973) and a number of earlier authors, the painting portrays first and foremost the introduction of the sacrament of the Eucharist. Steinberg sees this interpretation confirmed above all by the fact that Jesus is pointing with both hands to the bread and wine, and thus to the symbols of the Eucharist. This view is supported either fully or in part by the majority of authors (Wasserman, 1983; Rossi/Rovetta, 1988; Rigaux, 1989, Vecce, 1998, pp. 153–154), with the exception of

Creighton Gilbert (1974), while others have contented themselves with seeing in the painting both the introduction of the Eucharist and Christ's announcement of his betrayal (Brambilla Barcilon/Marani, 1999, pp. 17–21; Marani, 1999, pp. 221–222). In the wake of Steinberg's interpretation, attempts have been made to interpret the iconography of the *Last Supper* against the backdrop of Dominican support for the doctrine of Transubstantiation (i.e. the actual presence of the body and blood of Christ during Mass). A role may also have been played in this regard by Vincenzo Bandello (the uncle of Matteo Bandello, see below), who in 1495 was elected prior of the monastery and who may have contributed to the iconography of the painting (Rossi/Rovetta, 1988, pp. 58–66; Rigaux, 1989). More convincing, in my opinion, is the argument put forward by Creighton Gilbert (1974) and based on other treatments of the same subject. It is a fact that almost all portrayals of the Last Supper in the second half of the 15th century establish a clear connection with the Eucharist by means of symbolic objects (chalice, host). In Leonardo's painting, however, this unambiguity is lacking. Furthermore, Last Suppers with a predominantly eucharistic symbolism are rarely found in refectories, but primarily within altarpieces (as predella panels, for example) and thus in works destined to be viewed in a context liturgically undoubtedly linked with the Eucharist. On another note, it is to be doubted whether Bandello, who was appointed prior only in 1495, exerted much influence upon the iconography – particularly since the composition is more likely to have been dictated by the person who commissioned it, Ludovico il Moro. Creighton Gilbert's interpretation, which up till now has been given insufficient consideration, thus possesses a greater degree of plausibility.

The perspective system employed within the composition has been the subject of numerous and contradictory studies (Brachert, 1971; Steinberg, 1973, pp. 346–360; Naumann, 1979; Polzer, 1980; Kemp, 1981; Kemp, 1990; Bora, 1999, pp. 29–31, 44–45). All agree, however, that the ideal point from which to view the painting is some four to four and a half metres (Bora) above floor level and thus much higher than normal eye level. The ideal viewing distance is thereby calculated by Naumann (1979) as 10.29 metres, by Polzer (1980, p. 245) as 9.20 metres and by Kemp (1981, p. 196) and Bora (1999, pp. 29–30) as 8.80 metres. The still prevalent assumption that the perspective system is founded on a musical canon of proportion (Brachert, 1971; Kemp, 1981, pp. 196–198; Kemp, 1990) does not stand up to scrutiny. As Elkins (1991) aptly noted, Brachert's proposed perspective grid deviates too greatly from the actual dimensions of the painting. The answer is perhaps much simpler than the many attempts at reconstruction suggest: the orthogonals converge fairly precisely in the head of Christ, in line with the notion, at that time widespread, of locating the vanishing-point in a particularly important place (Edgerton, 1975, pp. 26–31; Perrig, 1986, pp. 26–27). Leonardo also steered away from portraying his *Last Supper* as if viewed from some way below, as popular in Milan in the artistic circle of Donato Bramante and Vincenzo Foppa (Bora, 1999).

A highly unusual feature of Leonardo's composition, and a first in the modern history of Last Suppers, is the arrangement of Jesus's disciples into groups of figures displaying powerful emotions. This may be connected with the division of the wall directly above into three lunettes containing Sforza coats of arms (Cat. XVIII), whose genealogical programme is typical of Ludovico's dynastic ambitions (Giordano, 1993; Welch, 1995), which would reach a provisional peak with the birth of his first legitimate son, Massimiliano, on 25 January 1493 and the death of the rightful Duke of Milan, Gian Galeazzo Sforza, on 21 October 1494. Equally part of the overall artistic programme of the refectory are the four lunettes on the longitudinal walls adjacent to the end walls, revealing two empty shields and two prophets. The longitudinal walls were further decorated with (today largely destroyed) portraits of saints and other holy individuals venerated by the Dominicans, accompanied by 22 inscriptions (Martelli, 1980). These inscriptions, which derive from the Bible and the Augustinian Rule, refer to the community of happily dining servants of the Lord. A further 20 inscriptions, of which only two are preserved, identify the Dominican saints in the portraits. Lastly, the refectory was decorated on the south wall with a fresco of the Crucifixion by Giovanni Donato Montorfano, which bears his signature and the date 1495. To the right and left of this fresco are the portraits, today barely discernible, of the donors Ludovico il Moro, Beatrice d'Este and their children. Since Vasari (1568) these have been regularly

attributed to Leonardo, particularly since Ludovico states in a note of 29 June 1497 that Leonardo is to paint something else on the south wall (Marani, 1987, pp. 90–93). The figures are today in such a poor condition, however, that it is impossible to make a credible attribution. On the other hand, the wooden arrangement of the figures and the clumsy execution of the outlines argue against an attribution to Leonardo, as does the fact that – in contrast to the *Last Supper* – traces of *spolvero* are here clearly in evidence (Bertelli, 1986, p. 40).

The *Last Supper* is mentioned in early sources more frequently than any other painting by Leonardo, for example by Luca Pacioli in 1498, Gaspare Visconti in 1497–1499 and Antonio de Beatis in 1517, as well as by Paolo Giovio *c.* 1523–1527, Antonio Billi *c.* 1527–1530, Sabba da Castiglione in 1546 (Villata, 1999, no. 345) and by the Anonimo Gaddiano *c.* 1537–1547. The painting was the subject of more detailed discussion by Matteo Bandello in 1554 (Poggi, 1919, p. 22; Villata, 1999, no. 346), Giovanbattista Giraldi (*Discorsi intorno al comporre de i romanzi*, 1554, pp. 193–196; Poggi, pp. 19–20) and finally by Vasari (1568). Particularly informative are

XVIII

the descriptions of the painting by Bandello, who was born in 1485 and who resided in Santa Maria delle Grazie until 1501, and Giraldi, who records the lengthy process through which Leonardo arrived at his final composition (cf. above). An interesting piece of information is also provided by the historian Gaspare Bugatti, who mentions the *Last Supper* in 1570 and at the same time refers to a payment by Ludovico il Moro of 50 ducats a year (Beltrami, 1919, no. 262).

No other of Leonardo's works has been more frequently copied than the *Last Supper*. The most important copies are today found in the Da Vinci Museum in Tongerlo (ill. p. 205), the Royal Academy in London (formerly Certosa di Pavia, currently on loan to Christ Church, Oxford) and in Ponte Capriasca, Lugano. Comprehensive inventories of *Last Supper* copies are found in Steinberg (1973, pp. 402–407) and Brambilla Barcilon/Marani (1999, pp. 74–79).

LITERATURE: Pacioli, 1498/1509, pp. 41/191, 59/212 (Ch. 3 and 23); de Beatis, 1517 (Beltrami, 1919, no. 239; Villata, 1999, no. 314); Bandello and Giraldi (in Poggi, 1919, p. 19–22); Benedettucci, 1991, p. 102; Frey, 1892, p. 112; Vasari, 1550, p. 550;

Vasari, 1568, IV, pp. 29–33; Vasari, 1965, pp. 262–263; Poggi, 1919, pp. XIV–XVI; Möller, 1952; Steinberg, 1973; Gilbert, 1974; Martelli, 1980; Polzer, 1980; Kemp, 1981, pp. 195–199; Heydenreich, 1982; Wasserman, 1983; *Leonardo e l'incisione*, 1984, nos. 37–40; Rossi/Rovetta, 1988; Rigaux, 1989; Elkins, 1991, pp. 159–161; Vecce, 1998, pp. 153–157; Bertelli, 1986; Kemp, 1990, pp. 46–49; Welch, 1995, pp. 233–235; Bambach, 1999, p. 23; Bora, 1999; Brambilla Barcilon/Marani, 1999.

XVIII
Three lunettes above the Last Supper, c. 1495/96
Tempera and oil on plaster,
width at base 335 cm (central lunette)
and 225 cm (left- and right-hand lunettes)
Milan, Santa Maria delle Grazie,
north wall of the Refectory

The lunettes, which are mentioned in none of the earlier sources, formerly lay completely concealed beneath other painting probably carried out in the decades before 1720. They came to light during restoration work by Giuseppe Mazza in

1775 and were fully uncovered in 1853/54. Executed in mixed technique like the *Last Supper*, they are in extremely poor condition and survive only in fragmentary form, making them difficult to assess. The most recent restoration programme, which concluded in 1999, has nevertheless yielded a convincing reconstruction of the original compositions. The identification of lines scored into the plaster and freehand underdrawing, coupled with the nature of the media, has thereby provided support for the traditional attribution of the lunettes to Leonardo (Kühn, 1985; Bambach, 1999, p. 23; Brambilla Barcilon/Marani, 1999, pp. 100, 418–440).

The middle lunette portrays the coat of arms of Ludovico il Moro and his wife Beatrice d'Este, surrounded by a garland wreath and set against a now reddish (but originally blue) ground. The shield is divided into eight fields, in which the *biscia viscontea* (the heraldic animal adopted by the Sforza from the Visconti, namely a snake devouring a Saracen) alternates with the heraldic devices of the d'Este and the imperial eagle (today barely visible). The composition is flanked by the following inscription: "LV[DOVICVS] MA[RIA] BE[ATRIX] EST[ENSIS] SF[ORTIA] AN[GLVS] DV[X] [MEDIOLANI]" (Ludovico Maria Sforza, Beatrice d'Este, Anglus, Duke of Milan).

The lunette to the left (from a heraldic point of view, to the right) shows the coat of arms of Ludovico's first-born son, Massimiliano Sforza, also surrounded by a garland. The shield in this case is divided into the *biscia viscontea* on the left (dexter, or right, in heral-

dic terms) and on the right (sinister) three eagles, one above each other, representing the heraldic emblem of Pavia, the title that traditionally passed to the first son of the Duke of Milan. The flanking inscription reads: "M[ARIA] M[A]X[IMILIANVS] SF[ORTIA] AN[GLVS] CO[MES] P[A]P[IAE]" (Massimiliano Maria Sforza Anglus, Count of Pavia).

In the case of the third lunette (heraldically speaking, on the left), only the basic structure can today be deciphered. It probably contained the arms of Ludovico's second-born son, Francesco, consisting of a double representation of the *biscia* and the imperial eagle. The inscription, however, does not give Francesco's name: "SF[ORTIA] AN[GLVS] DVX BARI" (Sforza Anglus, Duke of Bari). Since Francesco became Duke of Bari only in 1497, this lunette may have been executed shortly beforehand.

Their form alone makes these lunettes genealogical documents of the first order. Thus the garlands directly recall those that commonly surround portraits documenting the genealogy of ruling families, such as the Visconti (Gamberini/Somaini, 2001, p. 22) and the d'Este dynasties (Ferino-Pagden, 1994, p. 25). The inscriptions refer to the titles claimed by Ludovico and his legitimate sons. Following the death, on 21 October 1494, of Gian Galeazzo Sforza, the rightful ruler of Milan, on 26 May 1495 Ludovico il Moro was officially installed as Duke of Milan. The lunettes were probably painted very soon after this, and refer both to the new office now held by Ludovico (DVX MEDIOLANI) and his wife Beatrice and to Massimiliano Sforza's

title of Count of Pavia. Since the right-hand lunette does not yet contain the name of Ludovico's second son Francesco, it was probably executed before 1497, since it was only in this year that he was awarded the interim title of Duke of Bari (Malaguzzi-Valeri, 1915, II, pp. 43–57; Mulas, 1994).

The coats of arms employ heraldic devices taken from the Visconti, such as the *biscia* and the eagle (Bologna, 1989), and incorporate the name "ANGLVS", which is a reference to Angera on the southwestern shores of Lago Maggiore, from where – so legend had it – the Visconti dynasty, which for so long ruled Milan, originally came (Welch, 1995, p. 234). Ludovico took the additional name of Maria in memory of his grandfather, Filippo Maria, the last male representative of the Visconti, who had been succeeded by Ludovico's father, Francesco Sforza. With the inscriptions and heraldic shields in the lunettes above the *Last Supper*, however, Ludovico is not merely celebrating the genealogical origins and branches of his family. He even appears to have looked into the future, planning an artistic continuation of his dynastic programme. Thus a fourth lunette, revealing no trace of an inscription and bearing an empty shield, is located beneath the arch on the west wall directly adjacent to the *Last Supper*. A further lunette on the east wall opposite was destroyed in the bombing of 1943. It would seem that these lunettes were intended to contain the coats of arms of future legitimate Sforza descendants.

LITERATURE: Möller, 1952, pp. 2, 179; Kühn, 1985; Marani, 1989, no. 16; Brambilla Barcilon/Marani, 1990; Welch, 1995,

XIX

pp. 233–235; Brambilla Barcilon/Marani, 1999, pp. 100, 418–440.

XIX
Sala delle Asse, c. 1496–1497
Tempera on plaster
Milan, Castello Sforzesco, Sala delle Asse

The decorative scheme in the northeast tower of the Castello Sforzesco is in poor condition. In the upper sections of the lateral walls it portrays 16 trees whose boughs are interwoven with golden braids into a dense canopy spreading across the ceiling vault. At the very centre of the ceiling are the joint arms of Ludovico and Beatrice: on the left (the heraldic right) the imperial eagle and *biscia viscontea*, and on the right the

eagle and lilies of the d'Este. The painting was later hidden beneath a coat of white-wash and remained concealed right up to the 19th century. It was uncovered over the winter of 1893/94 and restored by Ernesto Rusca in 1901–1902, in the course of which it was extensively repainted. In a more recent restoration of 1953/54, Constantino Baroni endeavoured to reverse Rusca's reworkings, but the question as to how much of the decorative scheme now visible is the work of Leonardo remains open to debate.

In the course of Baroni's restoration, previously ignored monochrome paintings on the lower section of the wall were also exposed. These portray rocks and roots, as today visible on the north wall, but were concealed behind wooden panelling even after the first restoration efforts of the early 20th century. These "rock paintings" (Hoffmann, 1972) begin some 2 metres above the present floor level and appear to form the base of the bower above. Leonardo may have personally contributed to the design for the decorative scheme and executed parts of it himself. Gualtero Bascapè, Ludovico il Moro's head chancellor, may be referring to Leonardo's work in the "camera grande da le asse" in two letters of 21 and 23 April 1498 (Villata, 1999, nos. 127, 128). The room probably derived its name from the fact that its walls were clad, even at an early stage, with panels, or asse (von Seidlitz, 1909, I, p. 435). This interpretation of Bascapè's letters is disputed, however (Marani, 1989; Vecce, 1998, pp. 176–177). It is equally unclear whether letters and drafts of letters relating to the so-called camerini might be connected with the Sala delle Asse

(Beltrami, 1919, nos. 67, 70, 73, 93; Villata, 1999, nos. 101, 108, 109, 113 [RLW § 1345]).

The painted trees can possibly be identified as mulberry trees (Lat. Morus) and may thus be intended as a reference to Ludovico il Moro. Other elements of the decorative scheme also point to Ludovico, such as the coat of arms in the centre of the ceiling and the painted panels on all four sides, whose inscriptions were reconstructed by Luca Beltrami (1902), in three cases with the assistance of the diaries of Marino Sanudo (fol. 535). The fourth original inscription was altered by the French following their conquest of Milan in 1499 and Ludovico's military defeat. This amended inscription was then replaced by yet another one, dated to 1901, which referred to Rusca's recently completed restoration. This inscription has since been removed and the panel is today empty.

The three reconstructed original inscriptions relate to political events that link Ludovico's fortunes with those of Emperor Maximilian I. The first inscription refers to the marriage of Ludovico's niece Bianca Maria Sforza to Emperor Maximilian I in 1493: "LVDOVICVS MEDIOLANI DVX, DIVO MAXIMILIANO ROMANORVM REGI BLANCAM NEPOTEM IN MATRIMONIVM LOCAVIT ET CVM EO ARCTIOREM AFFINITATE IPSA BENEVOLENTIAM INJVNXIT – ANNO SALVTIS LXXXXIII SVPRA MCCCC" ("Duke Ludovico of Milan has married his niece Bianca to the divine Maximilian, King of the Romans, and with this alliance secured himself sincere good-will – in the year of Grace 1493").

The second inscription relates to the Sforza claim to the duchy of Milan following the death of Filippo Maria Visconti, and to Maximilian's support for Ludovico: "LVDOVICVS MEDIOL[ANI] DVX / MEDIOL[ANI] DVCATVS TITVLVM JVSQVE / QVOD MORTVO DVCE PHILIPPO AVO / IN GENTE SFOR-TIANA OBITENERE / NON POT-VERAT AB DIVO MAX[IMILIANO] RO[MANORVM] / REGE IMPERA-TOREQVE / MAGNVS CVMVLA-TVS/HONORIBVS ACCEPIT / – AN[NO] SAL[VTIS] LXXXXIII SVPRA MCCCC" ("Duke Ludovico of Milan has accepted from the divine Maximilian, King and Emperor of the Romans, the title and the right to the Milanese duchy, which he could not inherit for the house of Sforza after the death of his grandfather, Duke Filippo – in the year of Grace 1493").

The third inscription refers to the journey that Ludovico made with his wife Beatrice to Germany, in order to secure the support of Maximilian against the French king Charles: "LVDOVICVS MEDIOL[ANI] DVX CVM / ITALIAM CAROLI FRANCORVM REGIS / ARMA SVSPECTA TEN[E]RENT / CVM BEATRICE CONIVGE IN GERMANIAM / TRAJECIT ET VT DIVVS REX / CAROLI CONATIBVS IN / ITALIA SE OPPONERET / OBTINVIT / – AN[NO] SAL[VTIS] LXXXXVI SVPRA MCCCC" ("Duke Ludovico of Milan, when the mistrusted soldiers of the Frankish King Charles held Italy in their power, journeyed to Germany with his wife Beatrice and caused the divine

King [Emperor Maximilian] to oppose Charles in Italy with force – in the year of Grace 1496").

The dynastic significance of the Sala delle Asse is something stressed by Martin Kemp (1981), who derives the symbolism of the tree from Ludovico's imprese (personal emblems) and also spotlights the motif of family allegiance, which finds expression both in the coat of arms in the centre of the ceiling and via the intertwining branches of the trees and the knots woven by the gold braid. Evelyn Welch (1995) adopts a similar position and again points to the family politics underlying the decorative scheme for the Sala dell Asse. This political dimension played less of a role in earlier interpretations.

Eva Börsch-Supan (1967) aligns the scheme with the antique and post-antique tradition of painted garden interiors; Joseph Gantner (1958), who even believes he sees a corpse portrayed in the base zone, relates the Sala delle Asse to Leonardo's visions of deluges and the end of the world; Volker Hoffmann sees in it the Vale of Tempe described by Aelian in *De natura animalium* (3.1) and by other antique authors; Dawson Kiang (1989) relates the decorative programme to the symbolism of the mulberry tree, as illustrated in a contemporary play, Gaspare Visconti's *Pasitea*. Kiang's interpretation and that of other authors are based on the contentious assumption (Emboden, 1987, p. 134) that the tree portrayed in the Sala delle Asse is indeed intended as a mulberry. It is also possible, however, to identify it as a *Diospyros Lotus*, also known as an *ermellino* or an *albero di S. Andrea*, which in

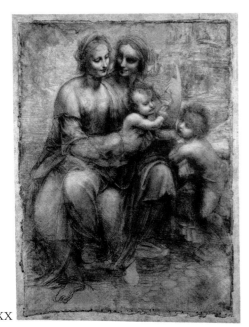

XX

Italy is found in Mantua (von Seidlitz, 1909, I, p. 435).

LITERATURE: Lomazzo, 1584/1974, II, p. 374; Beltrami, 1902; von Seidlitz, 1909, I, pp. 252–256; Poggi, 1919, pp. XIII–XIV; Gantner, 1958, pp. 233–236; Börsch-Supan, 1967, p. 244–251; Hoffmann, 1972; Kemp, 1981, pp. 182–189; Kiang, 1989; Marani, 1989, no. 18; Giordano, 1995, pp. 29–32; Welch, 1995, pp. 235–236.

XX
Burlington House Cartoon (Virgin and Child with St Anne and the Infant St John), 1499–1500 or c. 1508 (?)

Charcoal, with white chalk heightening, on brownish paper, mounted on canvas, 141.5 x 106.5 cm (max. dimensions)
London, The National Gallery, Inv. 6337

The cartoon, which is made up of eight sheets of paper of the so-called *folio reale* size (Bambach, 1999), was probably glued onto a canvas between 1763 and 1779, whereby the individual sheets, saturated with glue, somewhat shrank as they dried out. After a bullet fired from a sawn-off shotgun caused extensive damage in the area of the upper body of St Anne in 1987, the cartoon subsequently underwent extensive restoration, completed in 1989 (Harding/Braham, 1989). The edges of the cartoon, previously partially concealed, were thereby exposed. Earlier restorations were carried out in the 18th century and in 1826 and 1962. The cartoon shows no clearly recognizable signs (pricked or scored outlines) of having been intended for transferral or indeed of having actually been transferred onto a support (Bambach, 1999, p. 266; Harding/Braham, 1989).

Apart from a few minor gaps and contradictions in the 16th and 17th centuries (Hendy, 1963, pp. 49–58; Pedretti, 1968, p. 25), the provenance of the *Burlington House Cartoon* is well documented overall. After Leonardo's death, the cartoon passed into the possession of Bernardino Luini (1480/85–1532), whose *Holy Family* (Milan, Pinacoteca Ambrosiana; ill. p. 220) is directly derived

from Leonardo's composition. According to the Milanese painter and art theoretician Gian Paolo Lomazzo, the cartoon was still in the possession of Aurelio Luini, Bernardino's son, towards the end of the 1500s (Lomazzo, 1584/1974, II, p. 150). In 1614 a cartoon of the Virgin and Child with St Anne and the infant St John, probably identical with the *Burlington House Cartoon*, surfaced in the estate of Pompeo Leoni in Milan. Towards the end of the 1600s Padre Resta saw the cartoon in Galeazzo Arconati's collection in Milan (Bottari/Ticozzi, 1822, III, pp. 481–482). From 1721 it was briefly in the possession of the Casnedi family, also in Milan, before passing into the Sagredo collection in Venice. In 1763 it was purchased by Robert Udny and in 1779 passed to the Royal Academy of Arts in Burlington House in London. In 1962 it was sold to the National Gallery for £ 800,000.

Few other questions have provoked such fierce debate within the Leonardo literature than that of the chronology of the various versions of the *Virgin and Child with St Anne*. The *Burlington House Cartoon* is traditionally considered Leonardo's first treatment of the subject and is thought to have been executed around 1499–1500. Up till 1950, virtually all critics accepted 1499–1500 as the date of the cartoon. On the basis of this dating and a corresponding statement by Padre Resta at the end of the 17th century, Jack Wasserman (1971) also assumes that the *Burlington House Cartoon* arose in 1499 as the design for a painting that the French king Louis XII commissioned from Leonardo in October 1499 as a present for his wife, Anne de Bretagne. This assumption is lent support by the information provided by Resta and by the fact that Anne de Bretagne came from Nantes, where St Anne was particularly venerated. Anne de Bretagne was also pregnant during this same period, and since St Anne was the patron saint of pregnant women and mothers, a picture of St Anne would have been a natural choice for a commission.

A later dating for the *Burlington House Cartoon* was first proposed by Arthur Popham, who initially (1946) put the execution of the cartoon at *c.* 1499 but later revised it to the period 1501–1505 (Popham/Pouncey, 1950). He arrived at this dating in part on the basis of an analysis of the sketches housed in the British Museum for Leonardo's *Virgin and Child with St Anne* (Nathan/Zöllner 2104, Cat. 27–28; ill. p. 282). These same sketches, and hence also the *Burlington House Cartoon*, were subsequently dated by Carlo Pedretti (1968) on stylistic grounds to as late as 1508–1509. This late dating of the cartoon and the drawings in the British Museum has been supported by Martin Kemp and Jane Roberts (Kemp, 1981, pp. 220–227; Kemp/Roberts, 1989, p. 150), Allan Braham (Harding/Braham, 1989) and others. As far back as 1969, however, Wasserman took direct issue with Pedretti and raised convincing objections to his late dating of the cartoon, pointing out contradictions in Pedretti's argument (1968) and the unreliability of the late dating of Leonardo's sketches in the British Museum. Wasserman also cites a drawing in Oxford of a *Virgin and Child with St Anne* by Michelangelo, which can be dated to *c.* 1501,

as well as a number of Florentine works by Filippino Lippi executed before 1502, which clearly demonstrate a prior knowledge of the *Burlington House Cartoon.*

Doubts regarding Pedretti's late dating of the *Burlington House Cartoon* and the sheet in the British Museum are also shared more recently by Marani (1992), insofar as he points to the proximity of the cartoon to the monumentality of the *Last Supper* and again brings Michelangelo's *St Anne* drawing in Oxford into the debate. The late dating is also rejected by Fehrenbach (1997), who sees typical characteristics of Leonardo's drawings of the 1490s in the hatching of the cartoon.

An early date for the *Burlington House Cartoon* is argued both by Cécile Scailliérez (2000, pp. 42–43) and Daniel Arasse (1998), who convincingly argues that the London cartoon marks the start of Leonardo's St Anne compositions. A new twist to the debate has been added by Marani (1999), who links the composition of the cartoon with antique sculptures that Leonardo could have studied during a visit to Tivoli, probably in the spring of 1501. There is no concrete evidence, however, that Leonardo actually saw these sculptures in 1501. It is certainly not possible to deduce a date for the *Burlington House Cartoon* from this. Echinger-Maurach (2000, pp. 137, 147–148) arrives at a dating similar to that proposed by Marani (1999) on stylistic grounds: she sees a close conceptual relationship between the *Burlington House Cartoon* and Leonardo's *Madonna of the Yarnwinder* (Cat. XXIII and XXIV).

The arguments heard up till now are based for the large part on stylistic analyses, which are ultimately unable to provide a firm date for the cartoon. The dating suggested by Wasserman (1971), in line with earlier scholarship, seems to me the most plausible. What makes Wasserman's argument convincing is not his assumption that Louis XII commissioned the composition from Leonardo, however, since the most important source for this theory, Padre Resta, is considered unreliable (Pedretti, 1968). Rather, it is the compositional development that can be traced through Leonardo's various treatments of the St Anne theme, which lends credence to a dating of the cartoon to *c.* 1500. Thus the cartoon, with its closely juxtaposed figures, appears to be a preliminary step towards the *Virgin and Child with St Anne* in the Louvre, whose comparatively self-contained composition appears to have reached a more advanced stage of pictorial resolution.

It is hard to imagine that the St Anne composition that Leonardo began developing *c.* 1501, and that we know in its final form as the painting in the Louvre (Cat. XXVII), could have arisen before the compositionally far less evolved figural arrangement of the *Burlington House Cartoon.* It is nevertheless impossible to rule out with certainty a late dating either for the sheet in the British Museum or for the *Burlington House Cartoon.* Both the recto and verso of the sheet of St Anne sketches in the British Museum (Nathan/Zöllner 2104, Cat. 27–28; ill. p. 282) reveal clear compositional links with the *Burlington House Cartoon* and also – with some provisos – with a drawing in the Louvre (Nathan/Zöllner 2104, Cat. 29). Of no value to the discussion of the *Burlington*

House Cartoon is a drawing of the *Virgin and Child with St Anne* in a private collection (Vezzosi, 1982, no. 21; Arasse, 1998, fig. 310), whose attribution to Leonardo is dubious. A question mark also hangs over the authenticity of a pen and ink drawing for a *Virgin and Child with St Anne* in Venice (Nathan/Zöllner 2104, Cat. 30).

Iconographical interpretations of the *Burlington House Cartoon* have been largely overshadowed by the controversy surrounding its dating. Most convincing is the hypothesis that the composition was intended for the king of France. Claims that the figure of Joseph is or should be visible in the top right-hand corner of the cartoon, and that the woman behind Mary is not St Anne but St Elizabeth, and that the cartoon thus portrays not a Virgin and Child with St Anne but a Holy Family with St Elizabeth and the infant St John (Schug, 1968 and 1969; Keynes, 1991), have failed to gain widespread acceptance. Nevertheless, the infrared reflectogram of the cartoon published by Schug (1968) reveals outlines that resemble the head of Joseph in Luini's *Holy Family* (see below).

In contrast to other works by Leonardo – such as the *Virgin of the Rocks* and the *Virgin and Child with St Anne*, for example – the *Burlington House Cartoon* does not appear to have been the subject of many copies or variants. The few that exist include first and foremost Bernardino Luini's *Holy Family* (c. 1530; ill. p. 220) and Francesco Melzi's *Pomona and Vertumnus* (c. 1518–1522, oil on poplar, 185 x 134 cm, Berlin, Gemäldegalerie). In Melzi's painting, the figure of Pomona, on the left, corresponds to that of Mary in Leonardo's cartoon. Melzi's *Flora* in St Petersburg is also indebted to Leonardo's Mary. The figures of Mary and the Christ Child are also directly cited in an altarpiece of c. 1515–1520 attributed to either Fernando de Llanos or Leonardo da Pistoia and today housed in the Gemäldegalerie in Berlin (Pedretti, 1973, fig. 124). The majority of early variations thus testify to the continuing presence of the cartoon in Milan. Marani (1999, p. 293) names another, probably later copy, perhaps based on Luini's *Holy Family*. An interesting variation upon the arrangement of the figures in the *Burlington House Cartoon* is found in Giulio Romano's *Holy Family* ("La Perla") of c. 1520, today in the Prado in Madrid.

LITERATURE: Benedettucci, 1991, p. 103; Frey, 1892, p. 112; Vasari, 1550, pp. 551 and 554; Vasari, 1568, IV, pp. 38, 47–48; Vasari, 1965, pp. 265–266; Lomazzo, 1584/1974, II, p. 150 (*Trattato*, 2.17); Popham, 1946, pp. 59–61; Popham/Pouncey, 1950, II, pp. 66–69; Hendy, 1963, pp. 49–58; Ottino della Chiesa, 1967, no. 30; Clark/Pedretti, 1968, I, p. 95; Pedretti, 1968; Schug, 1968 and 1969; Wasserman, 1969, 1970, 1971, pp. 312–325; Pedretti, 1973; Kemp, 1981, pp. 220–221; Béguin, 1983, pp. 77–79; Harding/Braham, 1989, pp. 4–6; Popham/Kemp 1994, pp. XVII–XIX, 48–50, no. 176; Arasse, 1998, pp. 446–450; Bambach, 1999, pp. 43, 250, 265–266, 272; Marani, 1999, pp. 256–264; Scailliérez, 2000, pp. 37–38.

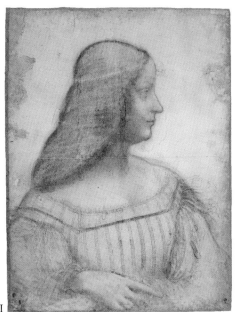

XXI

XXI
Half-length Portrait of a Young Woman in Profile (Isabella d'Este),
December 1499 to March 1500 (?)
Black and red chalk on paper, pricked, 63 x 46 cm
Paris, Musée du Louvre, Inv. M. I. 753

The young woman seen in profile in the Paris cartoon is probably Isabella d'Este (1474–1539), Marchioness of Mantua. The cartoon, which is attributed to Leonardo with some reservations, reveals pronounced damage along its edges and in numerous other places. It has also been reworked by a foreign hand, then pricked and finally reworked again. In the view of Carmen Bambach (1999), the tiny and very regular perforations are untypical of Leonardo and were probably only pricked some time after the cartoon was completed (Viatte, 1999, p. 7).

There is no evidence that the cartoon was actually transferred to a painting. It was probably intended as the basis for further cartoons from which paintings could then have been made (Bambach, 1999; Viatte, 1999), without Isabella having to sit for her portrait again. This would correspond with the fact that the Marchioness did not like sitting for portraits (Ferino-Pagden, 1994, p. 88).

The provenance of the cartoon cannot be traced very far back. Originating from the Calderara collection, in 1855 it is described in the catalogue of the collection of Giuseppe Vallardi in Milan, from where it passed in 1860 to the Louvre (Viatte, 1999). The identification of the sitter goes back to Charles Yriarte (1888), who compared the portrait cartoon with a medal bearing Isabella's portrait by Gian Cristoforo Romano of 1498 (Ferino-Pagden, 1994, pp. 106, 373–378 [K. Schulz]). This identification has since been widely accepted. It remains uncertain, however, whether the two portraits mentioned by Isabella in her correspondence refer to the Paris cartoon. The Marchioness had already indicated her interest in Leonardo's portraits in a letter of 26 April 1498 (Beltrami, 1919, no. 88; Villata, 1999, no. 129). From a letter sent to Isabella by Lorenzo Gusnascos (or Gusnagos) and dated 13 March 1500 (Beltrami, 1919, no. 103; Villata, 1999, no. 144), and from a letter of 14 May 1504, which Isabella wrote to Leonardo (Beltrami, 1919, no. 142; Villata, 1999, no. 191), it also emerges that the artist had already executed a portrait of the Marchioness during his stay in Mantua between the end of December 1499 and

the beginning of March 1500, but had taken it with him to Venice. This portrait was probably a chalk drawing and may be identical with the Paris cartoon. In a letter of 29 March 1501 that Isabella wrote to Pietro da Novellara (Beltrami, 1919, no. 106; Villata, 1999, no. 149), she mentions a second portrait, which her husband, Francesco Gonzaga, had given away. Isabella therefore asks Leonardo to send her another drawing of her portrait ("uno altro schizo del retratto nostro"). In Isabella's correspondence, therefore, we can distinguish between at least two portraits: one that Leonardo took with him to Venice in March 1500, and another that Francesco Gonzaga gave away, much to the regret of his wife.

The suggestion that the portraits of Isabella d'Este also included a painting (Marani, 1989, p. 100) does not stand up to scrutiny, since Leonardo worked very slowly and is unlikely to have completed a work of this kind during his few months in Mantua. Furthermore, the correspondence usually speaks of a *schizo*, which most probably means a cartoon (cf. bibliographical references to Isabella's correspondence in Cat. XXV).

The portrait of Isabella d'Este, whose face is seen in profile while her upper body is slightly angled towards the viewer, adopts a format typical of traditional court portraiture in northern Italy (cf. main text, p. 215) and employed, for example, in genealogical portraits of the d'Este family (Viatte, 1999, pp. 16, 28–38). The pose, which is also found on coins and in portraits of rulers, was probably chosen by the Marchioness herself (Brown, 1990, p. 58–61).

The four copies and variations upon the Paris portrait of Isabella d'Este, as housed in the Uffizi, the Staatliche Graphische Sammlung in Munich, the Ashmolean Museum in Oxford (62.9 x 48.4 cm) and in the British Museum in London (Bambach, 1999, p. 414), fail to match the quality of the Louvre cartoon.

LITERATURE: Yriarte, 1888; Beltrami, 1919, nos. 88, 103, 106, 142; Suida, 1929, pp. 149, 276; Serullaz, 1965, no. 11; Ottino della Chiesa, 1967, no. 29; Kemp, 1981, pp. 215–216; Béguin, 1983, pp. 85–86; Marani, 1989, no. 19; Ferino-Pagden, 1994; Vecce, 1998, pp. 187–188; Bambach, 1999, pp. 111–114, 263, 277; Viatte, 1999; Villata, 1999, nos. 129, 149, 144, 191.

XXIIa
Brescianino (Andrea Piccinelli), after a design by Leonardo
Virgin and Child with St Anne, 1501
Oil (?) on wood, 129 x 96 cm
Lost, formerly Berlin, Kaiser-Friedrich-Museum

XXIIb
Unknown artist, after Brescianino
Virgin and Child with St Anne, 1501 (?)
Oil (?) on wood, 129 x 94 cm
Madrid, Museo Nacional del Prado,
Inv. 505 (899)

Leonardo had already designed a cartoon of St Anne, the Virgin, the Child and a lamb in the spring of 1501. The existence of this cartoon of 1501, which probably followed on chronologically from the *Burlington House Cartoon* (Cat. XX), is reliably documented by a letter of 3 April 1501 from Fra Pietro

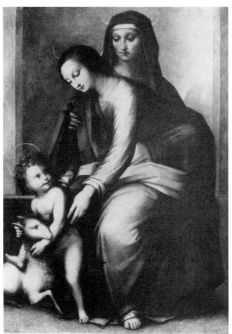

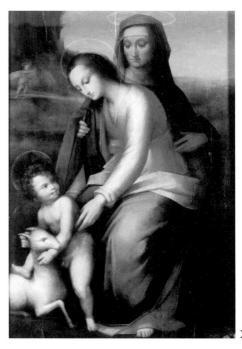

XXIIa

XXI

da Novellara to Isabella d'Este (Beltrami, 1919, no. 107; Villata, 1999, no. 150; cf. main text, pp. 221/222). Novellara writes of life-sized figures that nevertheless manage to fit into a small, still unfinished cartoon, and of the fact that the infant Jesus is slipping out of his mother's arms and taking hold of a lamb; Mary herself is half-rising from St Anne's lap. The composition that Novellara describes in such precise detail is also found in two almost identical paintings by other artists. The better-known of these two pictures is attributed to Brescianino, active in Siena in 1507 and in Florence in 1525, and was housed from 1829 until its destruction in 1945 in the Kaiser-Friedrich-Museum in Berlin (Meyer/Bode, 1878, p. 47; Posse, 1909, p. 139); the other, still surviving version hangs in the Prado in Madrid (Suida,

1929, p. 131; Nathan, 1992, pp. 97–98). The Madrid version is probably a copy of the Berlin picture – as suggested, for example, by the corrected position of St Anne's left hand in the Madrid panel. The copyist also extended the landscape background. The figures in both copies are not especially Leonardesque in character, suggesting that the copyist had seen an unfinished cartoon; this would fall in line with Novellara's observations. This suggestion is supported by the palette employed in the Berlin painting, as known to us from a description written at the beginning of the last century: "The grey of the niche is taken up everywhere, particularly in the shading of the reddish flesh. The colours of the draperies are cool and glassy. Mary in a light crimson dress and blue cloak, whose lining

shimmers in pink and grey where it spills across her lap. St Anne's robes are a dark purplish-grey, in line with her darker, reddish-brown flesh. Russet hair of the Child" (Posse, 1909).

Two of Leonardo's surviving drawings also reveal similarities with the St Anne cartoon described by Pietro da Novellara and copied by Brescianino. Thus the figures on the verso of a sheet preserved in the British Museum and in a St Anne sketch in the Louvre are all oriented towards the left (Nathan/Zöllner 2104, Cat. 28–29). The Paris drawing also shows – in contrast to the later Louvre painting – an elderly looking St Anne.

A further testament to the St Anne cartoon described by Novellara is Raphael's 1507 *Holy Family with a Lamb* in the Prado (ill. p. 222), which takes up Leonardo's composition in its overall layout and corresponds both to the description by Novellara and to the painting by Brescianino in the compact arrangement of its figures. The stepped heights of the figures in Leonardo's and Raphael's compositions is modelled on Filippino Lippi's *Adoration of the Magi* for San Donato a Scopeto (Florence, Uffizi; ill. p. 86).

The composition described by Novellara, copied by Brescianino and taken up by Raphael reappears in mirror image (and more differentiated in the movement of the figures) in the Louvre *Virgin and Child with St Anne* (Cat. XXVII). It has yet to be agreed whether, in addition to the first version of 1501 and the version represented by the Louvre painting, a third variation on the theme also existed. Vasari namely describes

a cartoon of St Anne, the Virgin, the infant Christ, a lamb and the infant St John, which was exhibited in SS Annunziata in Florence at the beginning of the 16th century. According to Vasari, the king of France later asked Leonardo to turn this cartoon into a painting, with no success. Vasari's account may be pure invention, and even if the cartoon really did go on display, he would have known about it at best from hearsay. Since he probably never saw the cartoon at first hand, the possibility exists that he has mixed up two different compositions by Leonardo: the *Burlington House Cartoon*, which indeed includes both an infant Jesus and an infant St John, and the cartoon copied by Brescianino, which shows the infant Christ with a lamb. It is also conceivable, however, that Leonardo executed another St Anne design in 1501 or a little later (Nathan, 1992).

The assertion, based on Vasari's description and for a long time accepted as true, that a *Virgin and Child with St Anne* that Leonardo commenced in 1501 was intended for the high altar of SS Annunziata, and that Leonardo contributed to the design of the retable (Pedretti, in: Vezzosi, 1982, nos. 37–42; Pedretti, 1983; Hartt, 1986, p. 112), can no longer be upheld (Wasserman, 1970; Nelson, 1997). It is more likely that the design described by Novellara and copied by Brescianino was destined for the altar dedicated to St Anne in the Giacomini-Tebalducci chapel in the apse of SS Annunziata, in which a *Virgin and Child with St Anne* painted by Antonio di Donnino Mazzieri in 1543 still hangs today (Paatz, 1940, I, pp. 104–105, 165). Padre Eugenio

XXIII

him to paint a St Anne composition. It is nevertheless highly likely that Leonardo was acquainted with this family (Villata, 1999, no. 178). A detailed study of the Giacomini-Tebalducci chapel would be useful.

LITERATURE: Vasari, 1550, p. 551; Vasari, 1568, IV, p. 38; Vasari, 1965, p. 265–266; Meyer/Bode, 1878, p. 47; Posse, 1909, p. 139; Suida, 1929, p. 131; Popham/Pouncey, 1950, p. 67; Nathan, 1992.

XXIII
Giacomo Salaì (?),
after a design by Leonardo
Madonna of the Yarnwinder,
c. 1501–1507 (?)
Oil on wood, 50.2 x 36.4 cm
New York, Private Collection

Casalini (1998) draws attention to this chapel and attempts to argue that it was the intended destination of the *Burlington House Cartoon* (or rather, an altarpiece based on its design). This argument becomes more probable when applied to Brescianino's version of *Virgin and Child with St Anne* (or rather, to its cartoon).

Leonardo's connections with SS Annunziata derive from the fact that his father had worked for the monastery as a notary from at least 1471 (Tonini, 1876, p. 44). It was probably here, too, that Leonardo met Francesco del Giocondo, who would subsequently commission the *Mona Lisa* (Zöllner, 1995, p. 70). At present, however, we can only speculate on the precise nature of Leonardo's links with SS Annunziata and on the possibility that the Giacomini-Tebalducci family may have commissioned

Despite having been transferred first from its original wood panel to canvas and then in 1976 back to panel, the painting is in good condition. In the course of restoration in 1976 and its transferral back to panel, a pentimento was discovered, revealing that Christ's left leg was originally positioned further to the left. At the same time, it was also established that three strips of canvas had been glued onto the original wood panel prior to the application of the ground – a procedure highly unusual for Leonardo but widespread in medieval Tuscan painting.

In a restoration undertaken before 1911, several areas of overpainting were removed, namely a loin cloth covering Christ's genitals and some retouching to Mary's left hand and beneath the right foot of the Child (Möller, 1926, p. 67). Infrared reflectography

of the New York *Madonna of the Yarnwinder* has revealed an underdrawing that differs in one important detail from the composition visible today: a group of figures was originally planned beside the Virgin's right shoulder (Kemp, 1994, fig. 33–34). This group of figures was either intended to portray a Nativity (Gould, 1992) or the Virgin and Child with Joseph, who is making a playpen or crib for his foster son (Kemp, 1992, pp. 269–270; Bury, 1992, p. 188). A corresponding scene is found in the background of several copies of the painting (Vezzosi, 1983, ill. 53–56).

The provenance of the small-format panel can be traced back to Henry Petty-Fitzmaurice, the third Marquis of Landsdown, who purchased the painting in 1809 – so at least runs the catalogue accompanying the Giffard Sale of 1879 at Christie's in London. The painting, attributed to Leonardo, was sold by Christie's to Cyril Flower, later Lord Battersea, from whom it passed in 1908 to Nathan Wildenstein and René Gimpel in Paris, and in 1928 to Robert Wilson Redford in Montreal. In 1972 it was sold to its present owner. Since then the painting has frequently gone on public display: in Vinci in 1982, in Naples in 1983, in Rome in 1984, in Edinburgh in 1992 (in the company of the Buccleuch version, Cat. XXIV) and in Arezzo in 2000 (Starnazzi, 2000, p. 64).

Following the sale of the *Portrait of Ginevra de' Benci* (Cat. VII) to the National Gallery in Washington, DC, in 1967, the New York *Madonna of the Yarnwinder*, together with the Buccleuch version (Cat. XXIV) of the same subject, currently remains the only privately-owned painting that some established art historians believe may be linked directly with Leonardo (an overview is provided by Vezzosi, 1983, p. 68; Bury, 1992; Gould, 1992). The debate that erupted afresh in particular following the Edinburgh exhibition of 1992 has yet to produce a consensus on the question of attribution. After a comparison with the *Mona Lisa*, commenced only shortly afterwards, and in view of the description of the original in the sources (see below), it must be concluded, however, that the *Madonna of the Yarnwinder* is a workshop product. Only the design stems from Leonardo; the actual painting was carried out largely by an assistant (with the two most likely candidates being Sodoma or Salai). The underdrawings revealed by infrared reflectography nevertheless make it clear that the present painting is not a copy executed at a much later date.

Leonardo started work on the composition of the *Madonna of the Yarnwinder* in the spring of 1501 for Florimond Robertet, secretary to the king of France. We owe this information to a letter by Pietro da Novellara of 14 April 1501 (Beltrami, 1919, no. 108; Villata, 1999, no. 151), in which the painting is described and interpreted (cf. main text, p. 230). In his highly detailed description, Novellara also mentions a little basket of yarns (*canestrino dei fusi*) on which the infant Jesus is resting his foot. Since this basket appears neither in the two best versions of the painting nor in infrared reflectograms, Leonardo's original painting must be considered lost. A final reference to a lost original is possibly found in a letter by Francesco Pandolfini of 12 January 1507

(Beltrami, 1919, no. 183; Villata, 1999, no. 240). The letter refers to a small picture by Leonardo that is housed in Blois and that the French king considers to be exceptionally fine.

Yet to be fully answered is the raised question (Starnazzi, 2000) as to whether the mountains in the background draw upon the topography of the Aretine hinterland. The processes of erosion that can be observed in the foothills of the Apennines may well have influenced Leonardo's portrayals of mountains. Not in doubt, however, is the connection between the mountains in the *Madonna of the Yarnwinder* and the landscape background of the *Mona Lisa* and the *Virgin and Child with St Anne*. This connection raises a number of questions with respect to the dating of the painting. While it must have been painted after April 1501, just how much later is difficult to determine. Whatever the case, the underdrawing visible in infrared reflectograms suggests that the New York version of the *Madonna of the Yarnwinder* arose within Leonardo's immediate circle (Kemp, 1994), and probably not all too long after Robertet's original commission, leading Arasse (1998) to date the present painting to the period between 1501 and 1507.

A similar dating is suggested by Pandolfini's letter of 1507, mentioned above. The *Madonna of the Yarnwinder* would thereby call into question the late dating currently accepted for the landscape in the *Mona Lisa*, since the bridge visible in the present background presupposes a familiarity with a similar bridge in the *Mona Lisa* (cf. Cat. XXV).

A red chalk drawing by Leonardo in Windsor Castle is generally accepted as a preliminary study for the *Madonna of the Yarnwinder* (ill. p. 228); a variation upon this drawing in Venice (Accademia, no. 141) is by a different hand. Further drawings from Leonardo's circle, together with numerous painted versions of varying degrees of quality, are found in Vezzosi (1983, pp. 62–65) and in the catalogue section in Kemp (1992). The authenticity of many of these copies and variations needs to be reviewed, however.

LITERATURE: Möller, 1926; Vezzosi, 1982 and 1983; Béguin, 1983, p. 87; Bury, 1992; Gould, 1992; Pedretti, 1992; Kemp, 1994; Arasse, 1998, pp. 325–327; Echinger-Maurach, 2000, pp. 133–136, 146–147; Starnazzi, 2000.

XXIV
Workshop of Leonardo, after a
design by Leonardo
Madonna of the Yarnwinder,
1501–1507 or later (?)
Oil on wood (poplar?), 48.3 x 36.9 cm
Drumlanrig Castle, Scotland, in the collection
of The Duke of Buccleuch & Queensberry, KT

XXIV

The background of this small-format picture has in the past been extensively retouched. The area of water behind the Virgin's head, in particular, was added at a later date. Large sections of the middle ground, which also appears to have been reworked at a later stage, give the impression of being unfinished. Möller (1926, p. 67) believed that the original landscape beneath the overpainting was executed by Leonardo himself. The Virgin and Child appear to have undergone significantly less revision. The Virgin's blue cloak, which has darkened with age, is furrowed almost everywhere with large cracks in the manner of a craquelure caused by early paint shrinkage.

This version of the *Madonna of the Yarnwinder* is first documented in the collection of the Duc d'Hostun et de Tallard, from where, in 1756, it passed into the possession of George Montague. Since 1767 the painting has formed part of the collection of the Dukes of Buccleuch (Kemp, 1992, and 1994, p. 262). It was exhibited, together with the version now in New York, in the Burlington Fine Arts Club in London in 1898 and in Edinburgh in 1992.

Since the painting was first discussed in depth by Möller (1926), art historians have regularly sought to attribute it directly to Leonardo or have assumed, as most recently in the case of Arasse (1998), that substantial parts of it were executed by the master himself. The areas of obvious weakness within the painting, such as the sky, the surface of the water and the landscape, have been put down to retouching by another hand. The pronounced distortions in the faces of the Virgin and Child nevertheless argue emphatically against an attribution to Leonardo. The broad cracks in Mary's cloak are also evidence of technical shortcomings, which one would not expect to find in panel paintings dating from Leonardo's artistic maturity. We must therefore assume that here, even more than in the New York version, only the original design can be attributed to Leonardo.

LITERATURE: As above, Cat. XXIII, in particular Möller, 1926, and Kemp, 1992 and 1994.

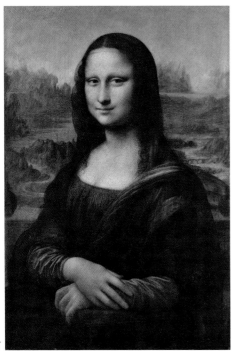

XXV

XXV
**Portrait of Lisa del Giocondo
(Mona Lisa)**, 1503–1506 and later (1510?)
Oil on poplar, 77 x 53 cm
Paris, Musée du Louvre, Inv. 779

Apart from a crack to the left of centre, which is secured with a dovetail at the rear, the painting is in an excellent state of repair. The panel, which consists of a thin sheet of poplar, reveals fully intact borders around its periphery, which contradicts the notion, still current, that the painting was trimmed by several centimetres on its right and left-hand sides (Hours, 1954, p. 16; Ottino della Chiesa, 1967; Vecce, 1998, p. 422; Prater, 1999). The paint has been built up in a large number of thin layers

in what must have been a lengthy process (Wolters, 1952). The subtle painterly execution is one of the finest in all of Leonardo's paintings. Transparent glazes containing a high proportion of binder combine to create extremely soft transitions, an effect that is heightened by the yellowish varnish. This varnish distorts the colour of the clothing and the sky, however, as emerges above all in the top quarter of the picture, where small areas of damage and sections that have not darkened with age reveal a fresher palette tending more to blue. A number of pentimenti can be seen on the fingers, where there may also have been some retouching.

The painting is probably identical with the portrait that Antonio de Beatis saw on 10 October 1517 (Beltrami, 1919, no. 238; Villata, 1999, no. 314) in Leonardo's workshop in Cloux (see below). It is subsequently named, along with a number of other paintings by Leonardo, in the 1525 inventory of Salaì's estate. Like the *Virgin and Child with St Anne*, therefore, it must have returned to Milan in 1519, immediately after Leonardo's death (Shell/Sironi, 1991; Villata, 1999, no. 333). The painting listed as forming part of Salaì's estate is mentioned again in a Milanese notarial document of 1531, where it is valued at a considerably lower sum, however (Villata, 1999, no. 347). Why Leonardo's painting should have been mentioned again in 1531 has yet to be satisfactorily explained. The issue is further complicated by a published document, which might be evidence that Salaì sold some pictures to a representative of the French king in 1518 (Jestaz, 1999).

Although neither individual paintings nor the name of Leonardo are specified in the document, the enormous purchase price of the equivalent of 6250 *lire imperiali* suggests that Salaì was here selling his master's most important paintings (by way of comparison, the Leonardo paintings in Salaì's estate of 1525 [Shell/Sironi, 1991] were valued at just half this amount, while back in 1494, the agreed price for the *Virgin of the Rocks* was 800 *lire imperiali*). It is consequently possible that the *Mona Lisa* may have been acquired for François I as early as 1518 (the document published by Bertrand Jestaz in 1999 nevertheless needs further evaluation). Whatever the case, over the following years the portrait eventually reached Fontainebleau, something also confirmed by Vasari in his *Life of Leonardo*, which he had written by 1547. In *c.* 1542 the painting was on display in François I's *appartement des bains*, where it hung in the company of Leonardo's *Leda*, *Belle Ferronière* and *St John the Baptist* (Dimier, 1900, p. 281; Zöllner, 1997, p. 466). The *Mona Lisa* remained in the royal collection in Fontainebleau for the next two centuries. After Vasari (1550), it is mentioned by Cassiano del Pozzo (1625) and Père Dan (1642, p. 136), who also claimed that François I had bought the painting for 12 000 francs (Poggi, 1919, p. XXII). Towards the end of the 18th century, the portrait moved to Versailles and from there to the Tuileries in Paris, after which it returned to Versailles. Between 1800 and 1804 it hung in Napoleon's bedchamber, before finally passing to the Louvre (Ottino della Chiesa, 1967, p. 103; Zöllner, 1997). A stir was created on 21 August 1911 when the painting was stolen by Vincenzo Perugia, an Italian decorator (McMullen, 1976; Reit, 1981; Chastel, 1989). After Perugia had attempted to sell the portrait in Florence in the winter of 1913, it was recovered and then exhibited several times before being returned to France. Further exhibitions followed in Washington, DC, and New York in 1963 and in Tokyo and Moscow in 1974.

The most famous painting in the world was executed for the Florentine silk merchant Francesco del Giocondo (1460–1539), who commissioned the portrait of his wife, Lisa Gherardini (1479–after 1551?), probably to mark the birth of their second son, in December 1502, and the fact that they were moving into their own home in the spring of 1503 (Zöllner, 1993; 1994). We owe the first reference to the identity of the client and the approximate date of the commission – the period from 1500 – to Giorgio Vasari, who was certainly acquainted with members of the Giocondo family (Zöllner, 1993, 1995, p. 70) and may even have known Francesco or his wife Lisa. The commission for the portrait can be dated relatively precisely, too, from the fact that the young Raphael leaned closely upon Leonardo's *Mona Lisa* in the early female portraits (*Lady with the Unicorn*, Rome, Galleria Borghese, ill. p. 243, and a preliminary drawing for this portrait in the Louvre; *Maddalena Doni*, Florence, Palazzo Pitti, ill. p. 12), which he executed in Florence between the end of 1504 and 1506 (Zöllner, 1994, pp. 20–24; Kress, 1999). These portraits by Raphael and earlier Florentine portraits of women undoubtedly confirm, moreover, that Leonardo's *Mona Lisa* forms part of a portraiture tradition

that developed towards the end of the 15th century in Florence and found its consummate expression at Leonardo's hands after 1500 (cf. main text, p. 242).

How much of the portrait of Lisa del Giocondo Leonardo completed before the end of his second Florentine period in 1506 remains a matter of debate. On the basis of Vasari's assertion that the portrait was still unfinished after four years, it can be assumed that Leonardo completed the painting at some point after 1506. Although the precise date remains a matter of contention, over the last few years there has been a growing tendency to place the finished *Mona Lisa* amongst Leonardo's later works. Thus Carlo Pedretti (1957, pp. 133–141; 1973, and elsewhere), Martin Kemp (1981, pp. 263–270), Carlo Vecce (1998, pp. 324–326) and Pietro Marani (1989; 1999, pp. 187–207), for example, suggest that while the basic composition may have been formulated in *c.* 1503–1506, the portrait proper was completed much later, in 1513–1514 or 1516. This late dating is arrived at on stylistic grounds, with the design of the landscape, for example, being cited as evidence that the panel was completed after 1510. This argument is unconvincing, however, since desolate, alpine-style landscape backgrounds are also found in many of Leonardo's earlier paintings, such as the *Annunciation* (Cat. V), the *Madonna of the Carnation* (Cat. III), the *St Jerome* (Cat. IX) and the *Virgin of the Rocks* (Cat. XI and XVI). In the New York version of the *Madonna of the Yarnwinder* (Cat. XXIII), which was probably executed under Leonardo's supervision by 1507 at the latest, this design principle reaches a provisional climax. If we date the *Madonna of the Yarnwinder* to before 1510 and assume that Leonardo exerted a direct influence upon its execution, it is hardly possible to view the landscape background in the *Mona Lisa* as a product of the years 1513 to 1516. We should also consider in this context the motif of the bridge, which appears in a very similar constellation in both the *Mona Lisa* and the New York version of the *Madonna of the Yarnwinder*. Bridges of this type – long, carried on arches and in the immediate vicinity of a barren rocky landscape – were unusual in Florentine paintings of this period (the bridges and landscapes in works by Baldovinetti and Botticini, for example, are quite different). The distinctly Leonardesque constellation of landscape and bridge found in the *Madonna of the Yarnwinder* thus speaks clearly against a late dating for the *Mona Lisa*. The portrait may thus possibly have been finished before 1510. Whatever the case, it remained in Leonardo's possession at least until 1518 (Jestaz, 1999) and possibly right up to his death (see above).

In view of the contradictory information provided by the early sources and of countless gaps in the surviving documentation, there have been no lack of attempts to query the identity of the sitter, given by Vasari as Lisa del Giocondo. The Anonimo Gaddiano introduced an element of confusion early on when he wrote of a portrait of Piero di Francesco del Giocondo. Piero was Lisa del Giocondo's eldest son, born in May 1496 and hence just seven years old in *c.* 1503. It is most unlikely that Leonardo would have painted his picture; individual

portraits of children were found primarily in court circles, not amongst the urban middle classes. More plausible is the suggestion that the Anonimo Gaddiano derived his information several years later from Piero del Giocondo, now an adult.

No less confusion was spread by Antonio de Beatis, who in October 1517 saw in Leonardo's workshop the portrait of a "certain Florentine lady", which he described in a letter as being for Giuliano de' Medici. Even though, in the same letter, Antonio de Beatis got Leonardo's age wrong and thought he was right-handed (Gould, 1975, pp. 110–111), we must take his statements seriously. It was probably indeed the *Mona Lisa* that he saw, but by now it would have been far too embarrassing to admit that the now famous Leonardo da Vinci, painter to the French king and previously active at the papal court in Rome, still kept in his workshop a picture that he had begun 14 years previously for an unknown Florentine merchant. For this reason, possibly, the portrait is instead described as a commission for the late Giuliano de' Medici, who had died one year earlier. Whatever the case, it is not possible to arrive, as Carlo Pedretti (1957) and more recently Carlo Vecce (1998, pp. 324–326, 334, 422) attempt to do, at a reliable identification of the portrait's sister on the basis of the account by de Beatis.

In view of the fact that the *Mona Lisa* falls into a specific genre of Florentine portraiture from the years between 1490 and 1508, alternative suggestions as to the identity of the young female sitter are rendered largely implausible. It has been frequently emphasized, moreover, that these suggestions rest on no solid foundations (Brown/Oberhuber, 1978, pp. 61–64; Shell/Sironi, 1991, pp. 98–99; Zöllner, 1993, pp. 115–116, 130–131). Only the suggestion that the sitter might be Isabella d'Este can claim a certain plausibility (Stites, 1970, pp. 329–337; Tanaka, 1976/1977; 1983, pp. 141–146, 286–287). Isabella d'Este's correspondence suggests, however, that despite her repeated requests, the Marchioness failed to persuade Leonardo to paint a portrait of her (Beltrami, 1919, nos. 103, 106–108, 110, 141, 142, 143, 152, 157, 173; Villata, 1999, nos. 144, 149–151, 154, 190, 191, 192, 200, 210, 227).

Amongst the various interpretations of the painting, the thesis that has attracted most support is that put forward by Donald Strong (1982), who sees in the *Mona Lisa* the symbolic triumph of Virtue over Time. Others view the background landscape in more concrete terms as a reflection of Leonardo's geological studies and as an illustration of his anthropomorphic world view (Perrig, 1980; Webster-Smith, 1985). It may be possible to interpret the water in the upper right-hand corner of the composition as a primeval sea, as it was described, for example, by Giovanni Villani (Kemp, 1981, p. 265). Lisa's smile is perhaps derived from literary conventions (Dante, Firenzuola; Kemp, p. 267; Arasse, 1999, p. 408) or from a type that Leonardo assimilated from Verrocchio's workshop (Gombrich, 1986). More recent interpretations attempt to understand the painting in terms of a specific Florentine portrait typology and the tastes and expectations of Florentine patrons. It can also be argued that Leonardo's use of *sfumato* enabled him to go beyond traditional conventions

governing the portrayal of female virtue (Zöllner, 1993, 1994; Kress, 1995, 1999). The interpretations proposed in the 19th century, which on occasion view the *Mona Lisa* as a "femme fatale", are today of only historical interest (Boas, 1940; Turner, 1993). Qualitatively good copies of the *Mona Lisa* are found in the Louvre in Paris, in the Prado in Madrid (ill. p. 9), in the Liverpool Art Gallery, in the Walters Art Gallery in Baltimore (Chastel, 1989), in the Hermitage in St Petersburg and in the Oslo Museum of Art. Further copies in smaller museums and in private collections deserve more detailed study, particularly since numerous copies were made between the 17th and the 19th centuries and in connection with the theft of the *Mona Lisa* in 1911 (Reit, 1981). Several copies (Zöllner, 1993, p. 133) and Leonardo's original painting feature painted pillars on either side of the sitter. In a number of variations (e. g. Baltimore, Liverpool, Oslo, Vernon Collection, New York; Earl of Wemyss Collection), as also in Raphael's *Lady with the Unicorn* (ill. p. 243) and its preparatory study, the pillars are considerably wider than in the original. Both the copies and the portraits by Raphael may therefore be derived from a cartoon by Leonardo showing broader pillars than the ones in the final painting. It is also possible, however, that the copyists widened the very narrow pillars in the original, or that wider pillars appeared on the *Mona Lisa*'s original frame, now lost. Examples of such frames are to be found in the 15th century (Dülberg, 1990, no. 168).

Not a copy in the true sense, but rather a variation upon the original, is the so-called *Monna Vanna*, a seated female figure whose upper body is naked. The best-known versions of the *Monna Vanna* are a cartoon in Chantilly and a painting in the Hermitage in St Petersburg. Starting from Antonio de Beatis's same reference to the portrait of a Florentine lady for Giuliano de' Medici (Beltrami, 1919, no. 238; Vecce, 1990, p. 56; Villata, 1999, no. 314), it has been repeatedly attempted to link the cartoon in Chantilly with this portrait. Thus Arasse (1998, p. 466) takes up the hypothesis put forward by Brown (1978b), who proposes that the *Monna Vanna* represents the portrait of one of Giuliano de' Medici's mistresses, which Leonardo commenced in Rome between 1513 and 1516, but which he left unfinished. The cartoon in Chantilly, according to this hypothesis, goes back to this portrait. This argument is unconvincing, however, since de Beatis was probably referring to the *Mona Lisa*. The numerous variations upon its theme by French artists would sooner seem to suggest that the *Monna Vanna* arose only after Leonardo's death, as a derivation of the *Mona Lisa*. It is barely conceivable, moreover, that the anatomically unfortunate rendering of the *Monna Vanna*'s nose, upper arm and lower arm could go back to a design by Leonardo, or that the master could have transformed the subtle angling of the *Mona Lisa*'s upper body into such an unhappy pose. LITERATURE: Vasari, 1550, p. 552; Vasari, 1568, IV, pp. 39–40; Vasari, 1965, pp. 266–267; Frey, 1892, p. III (Anonimo Gaddiano); Dimier, 1900, pp. 279–284; Poggi, 1919, pp. XXII–XXIII; Pedretti, 1957; McMullen, 1976; Brown/Oberhuber, 1978; Kemp, 1981, pp. 263–270; Reit, 1981; Strong, 1982; Béguin,

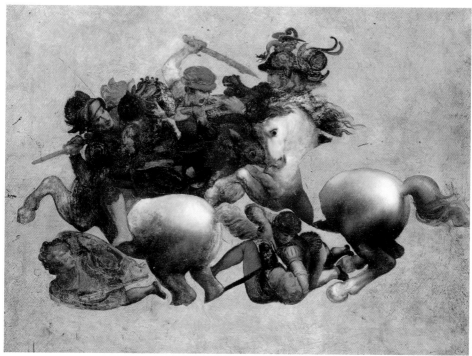

XXVI

1983, pp. 74–76; Brejon de Lavergnée, 1987, no. 4; Chastel, 1989; Marani, 1989, no. 21; Shell/Sironi, 1991; Zöllner, 1993, 1994, 1997; Kress, 1995; Arasse, 1998, pp. 386–412; Kress, 1999.

XXVI
Battle of Anghiari, Copy after Leonardo's wall-painting (Tavola Doria), 1504–1506
Oil on wood, 85 x 115 cm
Private Collection

Leonardo's most prestigious commission as a painter was his wall-painting of the *Battle of Anghiari* for the Sala Grande (Sala del Gran Consiglio) of the Palazzo Vecchio in Florence. This wall-painting, which the artist abandoned unfinished in the spring of 1506 having working on the project for less than three years and which was destroyed in the middle of the 16th century, portrayed a scene from the Battle of Anghiari of 1440, in which the Florentines won a victory over the Milanese troops near the small town of Anghiari. Leonardo probably painted his composition not on the west wall (Travers Newton/Spencer, 1982) but on the southern half of the east wall of the Sala Grande. Michelangelo's so-called *Battle of Cascina* was to appear on the other half of the same wall. Assuming that the two paintings were indeed intended for the east wall, they would each have covered an area of some 7 x 17.5 metres (Micheli, 1971; Farago, 1994, p. 304; Bambach, 1999b, pp. 107–108).

The very extensive documentation (Iser-meyer, 1964; Pedretti, 1968, pp. 58–78; Bambach, 1999, pp. 38, 292) relating to Leonardo's work on the *Battle of Anghiari* can be summarized as follows: in autumn 1503 the Florentine government, under the leadership of Piero Soderini, commissioned Leonardo to design and execute the wall-painting. The original contract for this commission, which is mentioned in a supplementary agreement of 4 May 1504 (see below), is believed lost. On 25 October Leonardo was given the key to the Sala del Papa in the monastery of Santa Maria Novella, where he was supposed to produce the cartoon for the painting (Villata, 1999, no. 183). The handing over of the key was followed by a number of payments, in December 1503 for renovations to the roof of the Sala del Papa (in Villata, 1999, no. 205, under December 1504), in January 1504 for the supply of wood and in February 1504 for joinery and masonry work as well as for further deliveries of materials, which may relate to the erection of scaffolding in the Sala del Papa (Beltrami, 1919, nos. 132, 134, 136–137; Villata, 1999, nos. 187–188). The above-mentioned supplementary contract of 4 May 1504 (Beltrami, 1919, no. 140; Villata, 1999, no. 189) states that Leonardo has so far received 35 gold ducats. The artist is required by the same contract to complete the cartoon he has already begun at the latest by the end of February 1505, or alternatively to paint parts of the design on the wall (cf. main text, p. 248). Further payments for Leonardo's work as a painter were made in June 1504, together with payments for materials needed for the cartoon and possibly for the construction of scaffolding (Beltrami, 1919, nos. 145–146; Villata, 1999, no. 194). A delivery of painting materials is recorded on 30 August 1504, and documented a month later on 31 October is a payment instruction to the sum of 210 lire, corresponding to 30 gold ducats and relating to Leonardo's fee for the months of June and July (Beltrami, 1919, nos. 151, 153; Villata, 1999, nos. 199, 201). In December 1504 payments were issued for minor works in the Sala Grande and in February and March 1505 for a mobile scaffolding (Beltrami, 1919, nos. 154, 159–160; Villata, 1999, nos. 206, 211–212), something also mentioned by Vasari. Receipts that have survived for April, August and October 1505 relate primarily to materials for the scaffolding, for the substitute cartoon (see below) and for the actual painting (Beltrami, 1919, nos. 160, 165–166; Villata, 1999, nos. 218, 221–222). An indication of the progress of the commission is also provided by a note (Codex Madrid II, fol. 2r; Villata, 1999, no. 219) of 6 June 1505, in which Leonardo speaks of having started painting in the Grand Council Chamber. An analysis of Leonardo's purchases of cartoon paper from this same period confirms that he must have started work on the wall-painting at about this time: on 30 April 1505 the artist bought a substantial quantity of cartoon paper with which to make a copy of his original cartoon. This substitute cartoon was the one used to transfer the composition onto the wall (Beltrami, 1919, no. 165; Villata, 1999, no. 218; Bambach, 1999b, pp. 116–127).

Leonardo then appears to have worked on the wall-painting without interruption

until the spring of 1506. From a document of 30 May 1506, we learn that the artist has been granted a three-month leave of absence, on condition that he returns promptly at the end of this period (Beltrami, 1919, no. 176; Villata, 1999, no. 229). Leonardo failed to honour this commitment, however, and spent the next few years chiefly in Milan under the protection of the French king. The wall-painting remained unfinished, prompting the Florentine Signoria to complain bitterly on 9 October 1506 about their artist's breach of contract (Beltrami, 1919, no. 180; Villata, 1999, no. 236).

A dozen or so drawings by Leonardo's own hand (Nathan/Zöllner 2014, Cat. 42–55; ills. pp. 253, 256, 261) and various contemporary copies give us an idea of what the original *Battle of Anghiari* must have looked like (*Leonardo & Venezia*, 1992, pp. 256–279; Piel, 1995; Zöllner, 1998, with a critical discussion of the relevant copies). The drawings (in particular Nathan/Zöllner 2014, Cat. 43, 45) reveal that the artist was thinking, in the early stages at least, of a broad composition incorporating several episodes from the battle. In both the original cartoon and the wall-painting itself, however, Leonardo reduced his composition to just one central group of mounted figures in combat, in other words to the decisive encounter in the battle, in which the Milanese on the left are on the point of losing their standard to the Florentine troops storming in from the right. The fact that Leonardo condensed his composition into the dramatically heightened portrayal of a single, decisive moment is evidenced by the copies based on the wall-painting itself (such as the so-called *Tavola Doria*, the copy in the Uffizi and a pen drawing from the Ruccellai Collection) and by drawings copied from the cartoon, which include the variation by Peter Paul Rubens in the Louvre (ill. pp. 254/255) and its derivatives (The Hague, Los Angeles). An up-to-date and detailed discussion of these copies can be found in Zöllner (1998). The most comprehensive overview of all the relevant visual and documentary material to be published to date is that by Friedrich Piel (1995), the value of whose contribution is compromised, however, by his unlikely hypothesis that the *Tavola Doria* (undoubtedly the best of the painted copies of the wall-painting) is an original by Leonardo and represents the "trial panel" mentioned in a description by the Anonimo Gaddiano (Frey, 1992, p. 114). In view of the tight deadline by which the wall-painting had to be completed, and Leonardo's protracted manner of working, it is unlikely that he would have executed a trial version of the *Battle of Anghiari*. The panel referred to by the Anonimo Gaddiano was probably one in which Leonardo was experimenting with technique – it was exposed to an open fire – and would certainly not have extended to a detailed figural composition.

As a starting-point from which to create his wall-painting, Leonardo was provided with details about the real-life Battle of Anghiari by his employers. In the Codex Atlanticus (74r–b and v–c/201; RLW § 669), we find an account of the battle written by Signoria secretary Agostino Vespucci, which goes back to Leonardo Dati's *Trophaeum*

Anglaricum of *c.* 1443 (PRC, I, pp. 381–382; Meller, 1985; Cecchi, 1996). Leonardo's final composition, however, was not in fact based on the information supplied by Vespucci, in which the capture of the Milanese standard is not mentioned. The battle for the standard is only described by two contemporary sources (Rubinstein, 1991, p. 281–283), namely the original Dati (Meller, 1985) and Neri di Gino Capponi, who writes in his *Commentarii* that the leader of the Florentine troops charged into battle with 400 riders in order "to attack and capture the enemy flag" (Capponi in Muratori, 1731, col. 1195). On the basis of historical sources (Flavio Biondo, Gino Capponi, Leonardo Dati, Niccolò Machiavelli etc.), it is possible to identify the battling horsemen with some certainty. The figures thus portray, from left to right, Francesco Piccinino and his father Niccolò, the commanders of the Milanese troops, and Piergiampaolo Orsini and Ludovico Scarampo (or Michelotto Attendolo?), two leaders of the allied papal and Florentine forces (Meller, 1985).

Efforts to reconstruct Leonardo's original intentions (e. g. by Pedretti, 1968; Gould, 1954; Farago, 1994) have also been joined by attempts to analyse the political iconography of the painting in the context of the overall decorative programme of the Sala Grande in the Palazzo Vecchio (Hartt, 1983; Rubinstein, 1991; Zöllner, 1998). Mention should also be made of the studies by Olle Cederlöf (1959/1961), who interpreted such iconographical details as the ram's head on Francesco Piccinino's chest and who pointed out the importance of *cassone* [marriage chest] painting

for Leonardo's composition, an influence today attracting renewed attention (Polcri, 2002). Furthermore, it can be assumed that contemporaries would also have understood the two paintings by Leonardo and Michelangelo as an artistic battle between the two masters (dalli Regoli, 1994). The Anonimo Gaddiano and Vasari even suggest that an enmity existed between Leonardo and Michelangelo (Frey, 1892, p. 115; Vasari, 1568, IV, pp. 41–43), something that must have been born during this time. From Leonardo's biographers (Billi, Vasari) we can also deduce that Leonardo was using an experimental painting technique, one that would be responsible for the rapid deterioration of the paint surface.

LITERATURE: Benedettucci, 1991, p. 103 (Billi); Frey, 1892, pp. 112, 114 (Anonimo Gaddiano); Vasari, 1550, pp. 552–553; Vasari, 1558, IV, pp. 41–43; Vasari, 1965, pp. 267–268; Lessing, 1935; Suter, 1937; Wilde, 1944; Pedretti, 1968; Kemp, 1981, pp. 234–247; Hartt, 1983; Held, 1985, pp. 85–88; Meller, 1985; Rubinstein, 1991; dalli Regoli, 1994; Piel, 1995; Cecchi, 1997; Zöllner, 1998; Bambach, 1999b; Polcri, 2002.

XXVII
Virgin and Child with St Anne,
c. 1503–1519
Oil on poplar, 168.4 x 113 cm
Paris, Musée du Louvre, Inv. 776 (319)

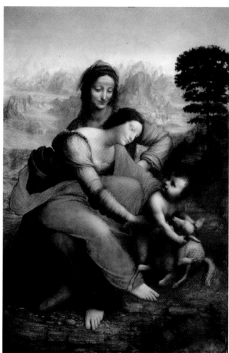

XXVII

The support consists of four boards glued vertically together and reinforced at the rear with two softwood crosspieces. Two strips of oak with a combined width of 18 cm were added on, probably at some later date, to the two vertical sides of the panel. The picture thus originally, and at least until 1683 (as per an inventory of Charles Le Brun of 1683, in Brejon de Lavergnée, 1987, no. 390), measured only 112 cm wide. The painting, which remains unfinished in a number of places, is in only medio-cre condition. Whether or not to embark on a restoration is currently the subject of heated debate (information kindly supplied by Cécile Scailliérez, June 2001). A vertical crack is clearly visible on the front and runs just to the left of centre from the top of the panel more or less to the Virgin's chest. The most finished elements of the composition are the heads of the figures and parts of the landscape. A varnish that has darkened with age covers the painting and takes away some of its brilliancy. While the figures are unanimously considered to be the work of Leonardo himself, some authors see the hand of an assistant in sections of the back-ground (Goldscheider, 1960). Descriptions of the state of the painting vary (Wolters, 1952; Hours, 1954; Béguin, 1983).

The provenance of the painting is well documented. Antonio de Beatis mentioned seeing the painting during the visit he paid to Leonardo's workshop in Cloux in 1517 (Beltrami, 1919, no. 238; Villata, 1999, no. 314). There are two possibilities as to what happened to the painting in the years that followed. It may have been sold, along with a number of other paintings by Leonardo, to the king of France at the end of 1518; a document of 1518 speaks of a very high sum of money being paid to Leonardo's pupil Salaì, which possibly relates to a sale of paintings (Jestaz, 1999; Villata, 1999, no. 347; cf. Cat. XXV). Alternatively, following Leonardo's death it may have been taken back to Milan by Salaì, only to return shortly afterwards to France. A painting of St Anne certainly appears in the inventory of Salaì's estate drawn up in 1525 (Shell/Sironi, 1991, pp. 104–108; Villata, 1999, no. 313) and in

another Milanese inventory of 1531 (Villata, 1999, no. 347). The first theory is supported by a passage from Paolo Giovio's short biography of Leonardo of *c.* 1523–1527: "There still survives a panel painting of the infant Jesus, who is playing with Mary his Mother and his grandmother Anne. The French king bought the painting and put it on display in his chapel" (Beltrami, 1919, no. 258; Villata, 1999, no. 337). Similar information – albeit possibly relating to a cartoon – is provided by Antonio Billi, who in 1527–1530 wrote of Leonardo: "He produced numerous wonderful drawings, including a Madonna with St Anne, which went to France" (Benedettucci, 1991, p. 103). This information was then repeated by the Anonimo Gaddiano (*c.* 1537–1547). Vasari subsequently amended the second edition of his *Lives of the Artists* (1568) to include the same reference to a cartoon of St Anne that had been taken to France. A Virgin and Child with St Anne and a lamb is lastly also described by Gerolamo Casio between 1525 and 1528, although no mention is made of the painting's location (Villata, 1999, no. 336). We owe another description of the painting to the humanist Janus Lascaris (1445–1535), who was in the employ of the French king between 1518 and 1534 (Goukowsky, 1957). Antonio da Trento, an artist documented in Fontainebleau from 1537 to 1540, also executed a woodcut after Leonardo's *Virgin and Child with St Anne* (Hind, 1949). Between *c.* 1518/19 and 1540 the picture is thus known to have been in France, although not in the *appartements des bains* in Fontainebleau with Leonardo's other paintings. After this, however, we lose track of the *Virgin and Child with St Anne* – until 1629, when it was supposedly purchased by Cardinal Richelieu in Casale Monferrato in Italy. In 1636 the Cardinal gave it to the king of France (Villot, 1849, no. 293; Poggi, 1919, p. XIX), and it subsequently appears in virtually all the inventories of the royal collections and the Louvre (Brejon de Lavergnée, 1987; Béguin, 1983).

The *Burlington House Cartoon*, which is dated to 1499–1501 and portrays St Anne, Mary, the infant Jesus and the infant John the Baptist (Cat. XX), is traditionally seen as the first of Leonardo's St Anne compositions. We know of a second version of the subject (without an infant St John, but with a lamb) from the description provided by Fra Pietro da Novellara in a letter of 3 April 1501 and from two more or less contemporary copies (Cat. XXIIa and b). Vasari (1568) describes what may be a third version including both a lamb and the infant St John. In the view of Johannes Nathan (1992), support for the existence of this third version is provided by a sketch of a *Kneeling Leda* of *c.* 1501 (Nathan/Zöllner 2014, Cat. 56), on which the study for a St Anne composition can be made out underneath the Leda drawing. If we accept this interpretation, then the Louvre *Virgin and Child with St Anne* represents the fourth version of the subject. This fourth version must also date from Leonardo's second Florentine period of 1500–1506, since Raphael took up its pyramidal composition in several works from around 1507 (see below).

Three sheets containing altogether five preparatory studies by Leonardo have been linked with the *Virgin and Child with*

St Anne. These are the sheets housed in London, Paris and Venice (Nathan/Zöllner 2014, Cat. 27–30; ill. p. 282), whereby the attribution of the verso of the London drawing is disputed and a question mark also hangs over the pen and ink sketch in Venice. To these may be added the sketch discovered by Nathan (1992) on the Windsor sheet RL 12 337 (Nathan/Zöllner 2014, Cat. 56) beneath a drawing for a Leda composition. All of these studies relate to an early phase of the design process. The sketches in London and Paris, in particular, make it clear that the individual stages in the evolution of the final composition are mutually interconnected and are also closely related to the *Burlington House Cartoon* (Cat. XX), the Brescianino version (Cat. XXIIa) and the present painting in the Louvre. On the basis of Novellara's oft-cited letter of 3 April 1501, which provides us with the only really solid date, we may assume that Leonardo had by this point in time more or less arrived at the final design for his St Anne composition. In his subsequent drawings for the *Virgin and Child with St Anne* (Nathan/Zöllner 2014, Cat. 31–38; ills. pp. 278, 280; and possibly also RL 12 528 and 12 531), Leonardo was simply concerned with details.

The controversy over the dating of the various versions of the *Virgin and Child with St Anne* has forced the discussion of its iconography into the background. Without knowing the specific context in which the commission arose, moreover, it is impossible to be categorical about its meaning. The fact that we do not know for whom the painting was executed or where it was destined to be hung means that its iconography can be interpreted in all sorts of different ways. Thus it has been connected, for example, with Louis XII's veneration of St Anne (Wasserman, 1971), with Maximilian I (Schapiro, 1956) and with the Florentine Republic, within which Leonardo may have been seeking to re-establish his position as an artist with a picture – executed on his own initiative – of St Anne, who was associated with Republican aspirations (Kemp, 1981, p. 226). For the present, however, we should confine ourselves primarily to generalized interpretations. Thus Pietro de Novellara (1501, Villata, 1999, no. 151) and Casio (*c.* 1525/28, Villata, 1999, no. 336) interpret the lamb as a symbol of the Passion and St Anne as the personification of the Church. The painting can also be viewed in conjunction with the revival in the cult of St Anne, which took place in the 1490s (Schapiro, 1956). It is also possible to interpret the landscape in the background as a reflection of Leonardo's "scientific" studies (Gantner, 1958, pp. 109–116, 137–160; Perrig, 1980; Fehrenbach, 1995, pp. 183–190) or in terms of religious symbolism (Battisti, 1991). There is no disputing the extraordinary influence exerted by Leonardo's *Virgin and Child with St Anne*, whose pyramidal composition has become a defining feature of the High Renaissance. Before moving to Rome in 1508, Raphael drew on the painting (and/or its cartoon) in several of his works (e. g. the *Esterhazy Madonna* in Budapest, the *Madonna of the Goldfinch* in the Uffizi, *La Belle Jardinière* in the Louvre, the *Madonna of the Meadow* in Vienna and the *Canigiani Holy Family* in Munich). Over the next

20 years Leonardo's composition appears to have impacted first and foremost painting in Milan, since the majority of the surviving copies of the *Virgin and Child with St Anne* were executed by Lombard artists (see below). Some of these copies also contain echoes of the landscape of the Louvre version of the *Virgin and Child with St Anne*. The painting in its present form must therefore have been largely completed at some point between 1508 and 1513, the years corresponding to Leonardo's second and lengthier Milanese period. This suggestion is supported by the Kassel *Leda and Her Children* (Cat. XXVIII), which arose in Milan *c.* 1508–1513 and which presupposes a detailed knowledge of the *Virgin and Child with St Anne*.

Qualitatively the best copies and variations upon the *Virgin and Child with St Anne* are found in the Uffizi in Florence (wood, 99 x 77 cm), the Wight Art Gallery of the University of California in Los Angeles (wood, 177.8 x 114.3 cm, formerly Leuchtenberg Collection, St Petersburg, from S. Maria presso S. Celso in Milan), the Strasburg University Gallery (oil on canvas, 187 x 127 cm, from S. Eustorgio in Milan), the Brera in Milan (wood, 158 x 108 cm) and the Prado in Madrid (105 x 74 cm). The Brera copy was probably based on a now lost cartoon of the *Virgin and Child with St Anne* (formerly in the Esterhazy Collection), whose provenance can be traced back to the collection of Padre Resta in the 17th century (Verga, 1931, no. 825; Poggi, 1919, p. XX). The variations in Los Angeles, Strasburg and the Prado all presuppose a knowledge of original drawings by Leonardo (e. g. ill.

p. 278 for Mary's draperies; Müller-Walde, V, 1899) or a lost cartoon. Good copies in which St Anne has been omitted hang in the Muzeum Narodowe in Poznan (oil on wood, 110 x 87 cm) and in the Museo Poldi-Pezzoli in Milan (Ottino della Chiesa, 1967, pp. 108–109; Marani, 1990, pp. 112, 146; Scailliérez, 2000, figs. 9, 11). The copies, which in many cases differ from the original painting in their palette and design of the draperies, deserve more detailed analysis.

LITERATURE: de Beatis, 1517 (Beltrami, 1919, no. 238; Villata, 1999, no. 314); Salai's estate, 1525 (Shell/Sironi, 1991, pp. 104–108); Giovio, 1527 (Villata, 1999, no. 338); Benedettucci, 1991, p. 103 (Billi); Casio, 1528 (Villata, 1999, no. 336); Frey, 1892 (Anonimo Gaddiano), p. 112; Poggi, 1919, pp. XVI–XXII; Suida, 1929; Heydenreich, 1933; Wolters, 1952, pp. 136–137; Hours, 1954, pp. 19–20; Schapiro, 1956; Ottino della Chiesa, 1967, no. 35; Clark/Pedretti, 1968, nos. 12 526–12 533; Béguin, 1983, pp. 77–79; Marani, 1987; Nathan, 1992; Bambach, 1999, pp. 250–251.

XXVIII

Giampietrino, after a design by Leonardo
Leda and Her Children, c. 1508–1513 (?)
Oil (and tempera?) on alder, 128 x 105.5 cm
Kassel, Staatliche Kunstsammlungen,
Gemäldegalerie Alte Meister, Schloss
Wilhelmshöhe, Inv. 966

Leonardo appears to have explored the subject of this painting – the young Leda with her children, born of her union with Zeus in the shape of a swan – in two different compositions, one in which Leda

is kneeling down and the other in which she is standing upright (Cat. **XXIXa** and b). The kneeling version of the composition is traditionally dated earlier than the standing version. Both differ from conventional treatments of the Leda theme and from mythological texts (*Leonardo e il mito di Leda*, 2001 [Nanni]) by concentrating not on the portrayal of the sexual act but on the person of Leda, who is presented between the amorous swan and their joint offspring (dalli Regoli, 1991). Whereas the kneeling version survives in just one good copy by an artist from Leonardo's circle, in which the swan is in fact absent altogether, the standing version is known to us from numerous copies.

XXVIII

The "Kneeling Leda", first documented in Paris in 1749, was purchased as a work by Leonardo by Landgrave Wilhelm VIII von Hesse-Kassel in 1756. Since at that time one of the children and the shells of the eggs were concealed beneath overpainting, the panel was initially thought to portray *Caritas* (inventory of 1783). The overpainting was removed between 1806 and 1835. After the picture was impounded by Napoleonic troops in 1806, it was put up for sale in Paris in 1821 and subsequently in England, where it was auctioned by Christie's in London in 1833. It was bought by William VIII of Holland, in whose possession the *Leda* remained until 1850, when it entered the collection of the Prince of Wied in Neuwied. In 1962 the painting finally returned to Kassel. It was restored in 1962 and 1983/84.

The painting, which shows Leda alone with her children Castor, Pollux, Helen and Clytemnestra, is now unanimously attributed to Giampietrino (probably identical with Giovan Pietro Rizzoli, *c.* 1495–1540), who is named together with other assistants and pupils by Leonardo himself in a note from the years 1497–1500 (CA 264r/713r; RLW § 1467). Giampietrino was chiefly active in and around Milan in the first decades of the 16th century and his early work reveals numerous references to Leonardo. The dates that have been suggested for the Kassel painting range between 1505–1510 (Marani, 1998), 1530–1540 (Lehmann, 1980; Brammer, 1990) and 1515–1520 (*Leonardo e il mito di Leda*, 2001, p. 118 [Lehmann]). It has also been argued that the landscape background was painted by Bernazzano, a Netherlandish artist working alongside Cesare da Sesto in Milan, on the grounds that the architecture contains certain northern elements (Lehmann, 1980).

Since similar landscapes are found in many of the known works by Giampietrino, however, the suggestion that Bernazzano may have contributed to this one remains inconclusive. The layout of the landscape background, the mountains bathed in blue mist and the deciduous tree concluding the right-hand edge of the composition furthermore recall the *Virgin and Child with St Anne* in the Louvre.

Giampietrino's painting is significant not least because it bears witness to Leonardo's original composition for a "Kneeling Leda", which is otherwise known to us only in drawings – even if the swan is omitted from the Kassel picture. Amongst Leonardo's own preliminary studies for the composition (Nathan/Zöllner 2014, Cat. 56–58; ill. p. 294), those in Chatsworth and Rotterdam come closest to Giampietrino's picture (Nathan/Zöllner 2014, Cat. 57–58). Jürgen Lehmann (1980) also relates a page of the *Codex Atlanticus* (289r) to the overall composition and the drawings RL 12 515–12 518 to Leda's head (Nathan/Zöllner 2014, Cat. 59–62; ill. p. 283). The chronology of the drawings for the "Kneeling Leda" remains a matter of debate. They are traditionally considered to date from *c.* 1503–1506, since what are probably the first studies on the subject appear on a sheet in Windsor Castle, which is connected with the *Battle of Anghiari*. On this same sheet (Nathan/Zöllner 2014, Cat. 56), Johannes Nathan (1992) has identified a study by Leonardo for the version of the *Virgin and Child with St Anne* described by Vasari, and has consequently dated it to 1501–1504 (?). If this is correct, the subsequent studies for

the "Kneeling Leda" should all be dated somewhat earlier.

Probably the most important aspect of the Kassel *Leda* has emerged from the results of infrared reflectography carried out in 1984–1989. These investigations have brought to light not only an underdrawing for the figures visible today, but also clear traces of the composition of Leonardo's *Virgin and Child with St Anne* in the Louvre. The St Anne composition was evidently transferred to the wood support of the Kassel painting with the aid of a cartoon – or so demonstrable traces of *spolvero* would appear to imply (Brammer, 1990; *Leonardo e il mito di Leda*, 2001). In view of the similarities already noted in the background landscapes, it is possible that Giampietrino had Leonardo's *Virgin and Child with St Anne* in front of him even while he was working on *Leda and Her Children*. He may even have used Leonardo's original cartoon. Whatever the case, as parallels between his own *Leda* panel and other paintings and drawings by Leonardo seem to imply, he had very direct access to the works of his master. These considerations clearly suggest that Giampietrino executed the "Kneeling Leda" in Milan under the supervision of Leonardo himself, in other words between 1508 and 1513. A later dating for the panel is less plausible, since the *Virgin and Child with St Anne* was available for consultation in Milan at the latest until 1516 (Leonardo's emigration to France) and possibly only until 1513 (Leonardo's move to Rome). The suggestion that the painting arose only after *c.* 1520, when the *Virgin and Child with St Anne* may have returned to

Milan with Salaì (cf. Cat. XXVII), seems to me unlikely in view of its many references to Leonardo's original drawings, which support a dating before Leonardo's death. In formal terms, the motif of the kneeling Leda does not go back directly to antique models (Allison, 1974; Kemp/Smart, 1980), but to the kneeling figure already used in Leonardo's *St Jerome* (Cat. IX; dalli Regoli, 1991, p. 11). Without knowing more about the context of the commission, we can only speculate about the painting's possible underlying symbolism (cf. Cat. XXIXa and b). LITERATURE: Allison, 1974; Kemp/Smart, 1980; Lehmann, 1980, pp. 130–133; Kemp, 1981, pp. 270–273; Brammer, 1990; dalli Regoli, 1991; Marani, 1998; *Leonardo e il mito di Leda*, 2001.

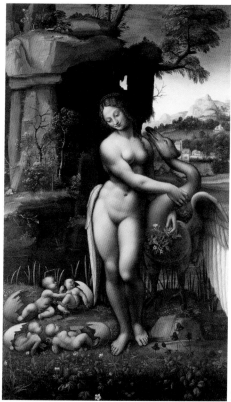

XXIXa

XXIXa

Follower of Leonardo,
after a design by Leonardo
Leda and the Swan, c. 1505–1515 (?)
Oil on wood, 130 x 78 cm
Florence, Galleria degli Uffizi, Inv. 1890 (9953r)

XXIXb

Follower of Leonardo (Cesaro da Sesto?)
Leda and the Swan, c. 1505–1515 (?)
Oil on wood, 96.5 x 73.7 cm
Salisbury, Wilton House Trust,
Collection of the Earl of Pembroke

Leonardo's original painting of a standing Leda and the Swan is considered lost. It is known only from written sources and a number of copies, of which the best are today housed in Wilton House, the Uffizi and the Galleria Borghese in Rome (ill. p. 291). A drawing by Raphael after the "Standing Leda" (Windsor Castle, RL 12 759) and about a dozen other copies testify to the popularity of the motif (Vezzosi, 1983). Since the painted copies vary in their details both amongst themselves and also in comparison with the Raphael drawing, it has been assumed since Müller-Walde (1897, II, pp. 142–143) that Leonardo executed two different cartoons of his "standing Leda" composition (Meyer zur Capellen, 1996, pp. 108–113, 231–232). It is possible, however, that these variations are the result of liberties taken by the copyists, something particularly likely in the case of Raphael. There

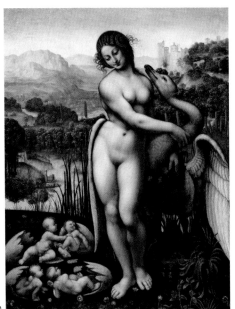

XXIXb

reigns no consensus regarding the attribution of the two "Standing Leda" compositions illustrated here.

A large-format Leda, ascribed to Leonardo himself, is named in the inventory of Salaì's estate of 1525 and by the Anonimo Gaddiano (Frey, 1892, pp. 111, 369) and Lomazzo (*Idea*, Ch. 2, 1590/1973, I, p. 249; *Trattato*, 2.15, 1590/1974, II, p. 144; *Rime*, Milan 1587, p. 246, after Pedretti, 1964a). In 1624 Cassiano del Pozzo describes a Leda by Leonardo housed in Fontainebleau, where it is again recorded towards the end of the 17th century. Since 1775, however, it has been considered lost (Poggi, 1919, p. XXXVI). The descriptions by Lomazzo and Cassiano del Pozzo relate to a "Standing Leda" composition, as we know it from surviving copies. A large-format cartoon of a "Standing Leda" is recorded in the Arconati Collection in Milan in March 1671 (Calvesi, 1985).

Amongst Leonardo's original drawings, the standing Leda as a full-length figure appears in three fairly unremarkable sketches: in the *Codex Atlanticus* (156r–b/423r) and on the recto and verso of a sheet preserved in Windsor Castle (RL 12 642). Mention should also be made of a now barely decipherable drawing (or tracing?) of a "Standing Leda" on a sheet (fol. D, Cat. 388) included in Leonardo's Manuscript B, compiled in 1487–1490. The drawings of musical instruments and weapons on this sheet were originally dated to *c.* 1487–1490, but following the discovery of the sketch of a Leda beneath them were put back to the period after 1505 (Pedretti, 1964). The arguments used to support this revised dating are in urgent need of review, however.

Considerably more detailed than the sketches of Leda's full-length figure are Leonardo's studies of her head (Nathan/Zöllner 2014, Cat. 59–62; ill. p. 283), to which he evidently attached great importance. A number of Leonardo's drawings of plants are also thought to bear some connection with Leda (Clark/Pedretti, 1968, no. 12 419; Nathan/Zöllner 2014, Cat. 414–424). The now widely accepted dating of these sheets and other studies for the Leda to the period *c.* 1505–1510 or even 1513/14 (Kemp/Smart, 1980; Kemp, 1981, p. 275) is not unproblematic, since it is based almost entirely on stylistic arguments. The only concrete clue to the dating of the designs for a "Standing Leda" is provided by Raphael's pen drawing in Windsor Castle, which arose between autumn 1504 (when Raphael arrived in

Florence) and June 1506 (when Leonardo left for Milan). It is possible, however, that Leonardo or one of his pupils took up the Leda composition again at a later date and in several versions. In view of the numerous early replicas of the "Standing Leda", one might even suspect that Leonardo executed certain compositions, such as the *Leda* and possibly also the *Virgin and Child with St Anne*, only as cartoons, from which his pupils and assistants then painted a number of copies. It is amongst such copies, which may have been executed under Leonardo's supervision, that the versions of the *Leda and the Swan* in the Uffizi (**XXIXa**) and Wilton House (**XXIXb**) belong. The provenance of the version in the Uffizi (earlier in the Spiridon Collection) can be traced back to 1874 (*Leonardo e il mito di Leda*, 2001, no. III.5). The well-preserved painting is of extraordinarily high quality. The same is true of the Wilton House panel, whose provenance can be traced back at least as far as 1730 and which probably stems from the Arundel Collection (*A Catalogue of Paintings*, 1968, no. 224). A version in the Galleria Borghese in Rome is of equally high quality and was probably executed between 1515 and 1520 (*Leonardo e il mito di Leda*, 2001, pp. 40–44 and 144). This version differs considerably from those in the Uffizi and the Wilton House in the execution of the children.

Two attempts to link Leonardo's ideas for a *Leda* with possible patrons also point towards a relatively early dating. Thus it has long been conjectured that Leonardo's first designs for a Leda composition arose in conjunction with the Sforza marriages at the Milanese court and/or with the subsequent births of the first legitimate sons of Gian Galeazzo Sforza and Ludovico Sforza (Müller-Walde, 1897, II, p. 140; Calvesi, 1985). Ludovico il Moro is certainly known to have had an interest in antique Leda compositions (dalli Regoli, 1991, p. 10). Romano Nanni, on the other hand, sees Leonardo's *Leda* subject in the context of the paintings with which Isabella d'Este wanted to furnish her "studiolo" (*Leonardo e il mito di Leda*, 2001, pp. 40–44). Even if these two theories cannot currently be verified, they indicate that it may yet be possible to establish a context for Leonardo's *Leda* designs. From a formal point of view, Leonardo had evolved the motif of the standing Leda from antique representations of Venus. His adherence to classical models is nevertheless markedly limited. The degree to which Leonardo actually drew upon antiquity is something that should be viewed with altogether more scepticism (dalli Regoli, 1991, p. 13).

LITERATURE: Frey, 1892, pp. 111, 369; Müller-Walde, 1897, II; Poggi, 1919, pp. XXXVI–XXXVIII; Clark/Pedretti, 1968, nos. 12 419, 12 516; *A Catalogue of Paintings*, 1968, no. 224; Kemp/Smart, 1980; Kemp, 1981, pp. 270–277; Vezzosi, 1983; Calvesi, 1985; Hochstetler Meyer, 1990; dalli Regoli, 1991; *Leonardo e il mito di Leda*, 2001.

XXX

XXX
St John the Baptist,
c. 1513–1516 (?)
Oil on walnut, 69 x 57 cm
Paris, Musée du Louvre, Inv. 775 (MR 318)

The painting, which is executed on a walnut panel (information kindly supplied by Elisabeth Ravaud), is in good condition. X-rays have revealed that, in terms of the overall depth of the paint, the *St John the Baptist* is similar to the *Mona Lisa* and the *Belle Ferronière* (Hours, 1954 and 1962). The very careful application of the paint, often in transparent layers, has also produced the *sfumato* effect for which Leonardo became famous. In its barely perceptible transitions from light to shade, the painting resembles the *Mona Lisa*. Even more than in the latter portrait, however, the appearance of the painting is distorted by the varnish, which has darkened with age.

The painting, whose dating in particular remains the subject of dispute, was in Leonardo's workshop in Cloux in October 1517 (de Beatis, 1517) and either in Salaì's estate in Milan in 1525 (Shell/Sironi, 1991) or sold to an agent of the French king in 1518 (Jestaz, 1999). The Anonimo Gaddiano mentions a John by the hand of Leonardo, whereas Vasari (1568) describes an Annunciation angel that may be identical with the *St John* (Ottino della Chiesa, 1967, p. 110; Marani, 1989, pp. 145–147). Around 1542 the painting appears to have formed part of the collection assembled by the French king at Fontainebleau, which also included Leonardo's *Mona Lisa, Belle Ferronière, Virgin of the Rocks* and *Leda* (Dimier, 1900, p. 282). Quite how it spent the remainder of the 16th century, however, we do not know. In 1625 Louis XIII exchanged the *St John* for a portrait of Erasmus by Hans Holbein and a *Holy Family* by Titian owned by King Charles I of England. In 1649 the banker Eberhard Jabach purchased the painting when the collection of Charles I was sold. It then passed into the possession of Cardinal Mazarin and in 1661 back to the French king (Cox-Rearick, 1972, no. 22F), before entering the collection of the Louvre after the French Revolution.

Since the second half of the 20th century, the *St John* has increasingly been accepted as an original work by Leonardo, in particular since X-rays established that it is painted in a technique typical of Leonardo (Hours, 1954 and 1962). Thus Ottino della Chiesa

(1967), Kemp (1981), Marani (1989; 1999) and Arasse (1998), for example, all agree that the painting was executed by Leonardo alone. Controversy nevertheless continues to surround the dating of the panel. The most plausible time frame for its execution was for many years considered to be 1513–1516 (Béguin, 1983; Ottino della Chiesa, 1967), on the grounds that the *St John* takes Leonardo's *sfumato* to its most logical conclusion and that the influence of this technique is seen most strongly in Raphael's late Roman works (Weil Garris Posner, 1974). An earlier dating of around 1504/09 was proposed in the late 19th century by Paul Müller-Walde (III, 1898, pp. 225–249), however, and Pedretti (1973, pp. 166–167) has more recently put forward a dating of *c.* 1509 using the same arguments. Müller-Walde, Pedretti and later even Martin Kemp (1981, p. 339) cite, as grounds for an earlier dating, a sheet in the *Codex Atlanticus* (fol. 489/179r–a) on which one of Leonardo's pupils has drawn the raised hand of St John in pale strokes. Since a directly related sheet in the *Codex Atlanticus* (359ra/997r) is dated to 3 May 1509, the authors conclude that Leonardo commenced his *St John* painting during this period. They also find support for a date prior to 1510 in the prominence, in Florentine art, of St John iconography. A closer comparison between the painting and the drawing, however, reveals as many differences as similarities (for example in the positions of the middle finger and thumb). It is probable that the sheet in the *Codex Atlanticus* simply shows a variation upon a commonly used pointing gesture, as deployed by other artists

and not least by Leonardo himself in the *Adoration of the Magi*, the *Last Supper* and in the *Burlington House Cartoon* (Weil Garris Posner, pp. 66–67; Fehrenbach, 1997, p. 288), as well as in a number of drawings (Nathan/Zöllner 2014, Cat. 16, 143, 154; ill. p. 93). Despite these objections, Villata (1997, 1999b) continues to adhere to the early dating and draws attention, like Suida (1929) before him, to works by Piero di Cosimo, which take up the pointing gesture made by St John. Without new information regarding the background to the *St John* commission, however, datings of this kind must remain hypothetical. On the basis of the arguments put forward by Weil Garris Posner, however, a dating of 1513–1516, corresponding to Leonardo's stay in Rome, seems to me the most plausible, in particular since the iconography of St John seems to have played a certain role not just in Florence, but also in Rome under the Medici Pope Leo X (cf. main text, p. 309).

It is possible that Leonardo designed another composition formally related to the *St John*, namely the angel of the Annunciation described by Vasari (1568), which is known from copies in the Kunstmuseum in Basle (ill. p. 314), in the Ashmolean Museum in Oxford and in the Hermitage in St Petersburg (Marani, 1989, pp. 145–147, see above). This Annunciation angel is also found in the qualitatively poor drawing by a pupil, probably dating from between 1503 and 1506, on a sheet in Windsor Castle (Nathan/Zöllner 2014, Cat. 105). On the basis of this and other drawings by pupils (CA 395r and Venice, Accademia, no. 138), as well as two remarks by Vasari (Vasari,

XXXI

(1992) and Villata (1999b, pp. 148–158) opt for more elaborate interpretations.

Good copies of the *St John* are housed in the Pinacoteca Ambrosiana in Milan (attributed to Salaì; Bora, 1987), in the Collection Chéramy in Paris (Ottino della Chiesa, 1967, p. 110) and in Naples (Capodimonte, Inv. 895 and 1040; Vezzosi, 1983, p. 144). The two versions in Naples are probably based on the copy in the Ambrosiana.

LITERATURE: de Beatis, 1517 (Beltrami, 1919, no. 238; Villata, 1999, no. 314); Shell/Sironi, 1991; Benedettucci, 1991, p. 102 (Billi, 1527–1530); Frey, 1892, p. 111 (Anonimo Gaddiano); Poggi, 1919, p. XXIII; Hours, 1954, pp. 20–21, and 1962, pp. 126–128; Ottino della Chiesa, 1967, no. 37; Weil Garris Posner, 1974, p. 22; Kemp, 1981, pp. 339–344; Béguin, 1983, pp. 79–80; Bora, 1987; Barolsky, 1989; Marani, 1989, no. 24; Villata, 1997 and 1999b.

1550, p. 552; Vasari, 1568, IV, p. 50; VI, p. 603–604 [*Life of Rustici*]), it has lastly even been concluded that, between 1507 and 1508, Leonardo was involved in the production of a group of figures by Giovanni Francesco Rustici, including a St John the Baptist, for the Baptistery in Florence (Müller-Walde, 1898; Kemp, 1988). Whether the problematic drawings and the vague information provided by Vasari allow conclusions of this magnitude remains open to debate, however. With regard to interpretations of the *St John* composition, particular attention should be drawn to Paul Barolsky (1989), according to whom the painting illustrates the opening verses of St John's Gospel, which set out John's role as a witness to God's light. Kreul

XXXI
Workshop of Leonardo (?)
St John the Baptist (with the Attributes of Bacchus), c. 1513–1519 (?)
Oil on wood, transferred to canvas, 177 x 115 cm
Paris, Musée du Louvre, Inv. 780

The painting is not in good condition, primarily owing to the damage it suffered in the process of being transferred from panel to canvas. The top layer of paint is missing in a number of places, and several flaws in the surface of the flesh impair the overall effect of the painting. Retouching in the late 17th century gave St John the attributes that transformed him into Bacchus: a wreath of ivy (or vine leaves?) on the head of the

former saint, a panther or leopard skin and a thyrsos (the staff of Bacchus, created out of John's original staff). The plants in the foreground and parts of the landscape background have survived without alterations and in good condition (Suida, 1929; Hours, 1954). A number of areas of 19th-century retouching were removed in 1947 (Wolters, 1952, pp. 143–144). The Louvre painting is possibly identical with the large-format *St John* mentioned in the 1525 inventory of Salaì's estate (Shell/Sironi, 1991, p. 104). Whatever the case, it is named by Cassiano del Pozzo in 1625 in his description of the royal art collection in Fontainebleau and is mentioned by Père Dan and Charles Le Brun in 1642 and 1683 respectively. The attributes of Bacchus must have been added shortly after this, since in an inventory of 1695 the corresponding entry has been corrected to "Baccus dans un paysage" (Poggi, 1919, p. XXXV). It is listed in subsequent catalogues under this new title.

Whether or not this painting may be attributed to Leonardo has always been a matter of contention. Suida and others have ruled out Leonardo's authorship even as regards the composition. Artists associated with the painting in the earlier literature include Bernazzano (credited chiefly with the landscape), Cesare da Sesto, Marco d'Oggiono, Salaì (in connection with the figure) and Francesco Melzi (Poggi, 1919; Suida, 1929, p. 155). More recent critics, however, see evidence of Leonardo's own hand beneath the areas of overpainting (Rudel, 1985; Marani, 1989), leading to renewed support for the possibility of an attribution to the master himself (Arasse, 1998, pp. 470–473;

Marani, 1999, pp. 330, 340). The arguments put forward by Poggi (1919) and Suida (1929) still remain valid, however: nowhere in Leonardo's drawings and notes or in the early sources do we find any mention of a St John composition corresponding to this one. The less than fortunate seated pose and indeed the whole layout of the painting (which recalls the *Leda* in the Uffizi) thus argue against an attribution to Leonardo, as do the exaggerated silhouetting of the feet and the excessive shading of the face.

While Fritz (1960) proposes a genuinely Christian interpretation of the painting as St John in the wilderness (with the aquilegia in the foreground as a symbol of the hope of Salvation, and the deer in the background as a symbol of the Baptism), Arasse (1999) sees the painting sooner as a pagan or Dionysian understanding of the divine as current at the papal court in Rome under Leo X. The picture looks back in many of its details to an earlier compositional type, as represented by Jacopo del Sellaio's *St John* in the National Gallery in Washington, DC, for example; echoes of this same type can also be seen in the *Baptism of Christ* (Cat. IV).

A damaged and reworked red chalk drawing of *St John*, attributed to Leonardo on very weak grounds, was housed in the Museo del Sacro Monte in Varese until 1974 (Pedretti, 1973, p. 173). It is now lost and is occasionally cited as a preparatory study for the present painting. A copy attributed to Cesare da Sesto or Bernardino Luini hangs in the National Gallery in Edinburgh. Further copies, which have yet to be studied in depth, are named in Suida (1929) and Ottino della Chiesa (1967).

LITERATURE: Poggi, 1919, pp. XXXIV–XXXVI; Suida, 1929, pp. 153–155; Hours, 1954, pp. 22–23; Fritz, 1960; Ottino della Chiesa, 1967, no. 36; Marani, 1989, no. 25; Arasse, 1999, pp. 470–471.

XXXII

Workshop of Leonardo, after a design by Leonardo
Christ as Salvator Mundi, 1507 or later (?)
Oil on walnut, 65.5 x 45.1–45.6 cm, Private collection, planned for Louvre Abu Dhabi

The Salvator Mundi, painted on a walnut panel, was rediscovered in April 2005 at an auction in New Orleans, presented to the public for the first time in summer 2011, shown in November that same year in an exhibition at the National Gallery in London (Syson/Keith 2011), and in November 2017 auctioned by Christie's in New York. This Salvator Mundi is probably identical with a painting documented at the start of the 20th century in the possession of Sir Francis Cook, which was at that time considered a workshop product from Leonardo's circle and which received no attention in the earlier literature on account of its poor condition. Between 2005 and 2017 the picture underwent several restorations by Dianne Dwyer Modestini. The findings and results of these restorations have only been partially published to date (Wintermute in: Gouzer/Wetmore 2017, pp. 17–22; Modestini in: ibid., pp. 63–93; Modestini 2014). A definitive assessment of the painting is therefore not yet possible. Technical investigations have thus far revealed no underdrawings. They have, however, brought to light traces of spolvero in the area of the lips and incised lines along the upper contour of the head, as well as a number of pentimenti, for example in the fingers of the left hand and the thumb of the right hand, from which an argument for the panel's attribution to Leonardo is also derived. Further details on the results of the restoration are found in the above-mentioned reports by the conservator, in which parallels in terms of painting technique between the Salvator Mundi and Leonardo's works and artistic theory are also discussed. In contrast to every other painting produced after 1496 and undisputedly attributed to Leonardo, there is no mention of a Salvator Mundi by his hand either in contemporary documents or early biographies. Only in the inventory of the Milan estate of Leonardo's pupil Salaì, drawn up in 1525, do we find a reference to "Uno Cristo in modo de uno dio Patre" (Shell/Sironi 1991, p. 398). Since this "Christ in the manner of a God the Father" is valued in the inventory substantially less, for example, than the Virgin and Child with St Anne (Cat. XXV) and the Mona Lisa (Cat. XXVII), the object in question was probably a workshop painting from Leonardo's circle – possibly even the New York Salvator Mundi.

The 1525 inventory of Salaì's estate suggests only the possibility that Leonardo may have produced at least one design for a Salvator Mundi painting. More reliable information about a Leonardo Salvator Mundi is provided by a number of paintings of the same subject by his school (Heydenreich 1964; Snow-Smith 1982; Vezzosi 1983, pp. 147–150; Fiorio 2005; see also Preface) and

two sheets in Windsor Castle with in part autograph drapery studies by Leonardo (Cat. D40–41). A 1650 etching by the Bohemian artist Wenzel Hollar, with its "Leonardus da Vinci pinxit" inscription, even seems to indicate that Leonardo not only designed a Salvator Mundi, but also executed a corresponding painting (Snow Smith 1982, pp. 28–31; Gouzer/Wetmore 2017, p. 38). In view of the fact that Hollar worked for the English royal family, it has also been conjectured that his etching was based on an original painting by Leonardo in the collection of the English king. According to this theory, the Salvator Mundi copied in 1650 by Hollar would still have been in the estate of Charles I, executed in 1649, in 1651 and in the possession of James II at the latest in 1666; the picture subsequently entered the collection of John Sheffield, from whose estate it was sold in 1763 (Syson/Keith 2011, p. 302; Gouzer/ Wetmore 2017, pp. 14 and 18).

Research into the phases of Hollar's career, and more recent analyses of the inventories of the English royal collection, have cast considerable doubt on this reconstruction of the "English" provenance of the New York Salvator Mundi (Lewis 2019). According to the current state of scholarship, the painting thus has no securely documented provenance for the 16th and 17th centuries. Nor has any reliable information yet been uncovered regarding its fate in the 18th and 19th centuries. The Salvator Mundi only reappears at the start of the 20th century, namely in the collection of Sir Francis Cook (1817–1901), who acquired the painting in 1900 through the agencies of his advisor Charles Robinson (1824–1913; A Catalogue of

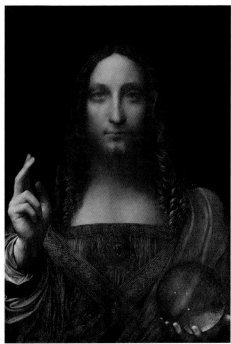

XXXII

Paintings 1913, p. 123). After the death of Sir Francis in 1901, the painting passed to his son Sir Frederick Cook (1844–1920). On 25 June 1958 the furniture retailer Warren E. Kuntz from New Orleans bought the Salvator Mundi for £45 at the Cook Collection sale at Sotheby's. It is astonishing, to say the least, that the experts who attended that auction, and who included leading experts such as Sir Kenneth Clark and Ellis Waterhouse, did not recognise the painting's qualities. The Salvator Mundi remained in the possession of Kuntz and subsequently his heirs until 2004. In April 2005 the New York art dealers Alexander Parrish and Robert Simon purchased the painting (Simon, press release, 7 July 2011; Brewis 2011; Kemp 2018, p. 190) at an auction at the St. Charles Gallery in

New Orleans (New Orleans Auction 2005, no. 664). The New York Salvator Mundi subsequent underwent the above-mentioned series of restorations and was presented at the major London Leonardo exhibition in 2011 (Syson/Keith 2011, pp. 300–303). It was exhibited once again towards the end of 2012 by the Dallas Museum of Art. The following year it was bought for US$ 82 million by the Swiss art dealer Yves Bouvier, who sold it on to the Russian billionaire Dmitry Rybolovlev for US$ 127.5 million (Kemp 2018, pp. 206–209). On 15 November 2017, finally, the painting was sold at auction by Christie's in New York for US$ 450.7 million. Prince Badr bin Abdullah of Saudi Arabia acted as buyer. The real buyer is now considered to be Saudi Crown Prince Mohammed Bin Salman, who, according to press reports, acquired it for the Emirate of Abu Dhabi's Department of Culture and Tourism, and specifically for its Louvre Abu Dhabi (cf. Kemp 2018, pp. 206-209). At the time of writing (January 2019), the painting has not yet arrived there. That the design for the New York Salvator Mundi stems from Leonardo himself, is beyond dispute: several workshop versions of the same subject, as well as the above-mentioned drapery studies, make the existence of such a design more than likely. Whether the New York Salvator Mundi is a largely autograph work by Leonardo is a question that remains open. Luke Syson (2011), Martin Kemp (2011; 2018), Francis Ames-Lewis (2012, pp. 200–204) and Dianne Dwyer Modestini (2014; 2018), as well as the authors of the New York auction catalogue (Gouzer/Wetmore 2017), all attribute the work more or less unreservedly to Leonardo. Pietro Marani (2012; 2013) assumes that it is based on a prototype painting by Leonardo and considers it very probable that the New York panel can be attributed to the master. Vincent Delieuvin (2016, p. 286) is more cautious, writing that "an original version [of Leonardo's Salvator Mundi] appears to have resurfaced". Several reviewers of the London Leonardo exhibition of 2011 have argued explicitly against an attribution to Leonardo (Hope 2012; Robertson 2012; Bambach 2012), as have Carlo Pedretti (2011) and Jacques Franck (Bétard 2018). A number of arguments against the attribution can be found on the ArtWatch UK website maintained by Michael Daley. I myself have expressed the view, in earlier editions of this book (2015; 2017; 2018) and in a review of the London Leonardo exhibition (Zöllner 2012), that the New York Salvator Mundi is a high-quality product of Leonardo's workshop, that Leonardo probably worked on the painting himself, and that its poor condition and the inadequate documentation of its restoration make a serious attribution impossible. Doubts over Leonardo's sole authorship are also harboured by Matthew Landrus (2018), who proposes Bernardino Luini as co-author of the New York Salvator Mundi. Jacques Franck (Bétard 2018) attributes the New York painting to the above-mentioned Salaì, and Carmen Bambach (2012) to Giovanni Antonio Boltraffio. Differences between certain details in the surviving variants of the Salvator Mundi had already led Ludwig Heydenreich (1964) and, following him, Maria Teresa Fiorio (2005) to conclude that Leonardo created not an original painting of

the subject, but simply a cartoon that then served as the basis for a number of works by his pupils. Heydenreich's theory has received renewed support from the variants and copies of a Salvator Mundi going back to Leonardo that have only come to light in recent years, as well as from other evidence. Thus Leonardo's workshop practice (Delieuvin 2012; see Preface) and a letter by Fra Pietro da Novellara of 3 April 1501 (Villata 1999, no. 150) suggest that Leonardo himself painted less and less in the years after 1500 and left it up to his pupils to turn his designs into paintings, which he would then occasionally rework. Giorgio Vasari, too, alludes to this same practice in his Life of Leonardo. In the discussion until now surrounding the attribution and provenance of the New York Salvator Mundi, the view has often been expressed that the painting was a commission for King Louis XII of France (Syson/Keith 2011, p. 303; Gouzer/Wetmore 2017, pp. 14, 38). This theory ultimately goes back to a monograph by Joanne Snow-Smith (1982), who sees, in a Salvator Mundi from the collection of the Marquis de Ganay in Paris, an original painting by Leonardo. She thereby suspects that the picture was commissioned by Louis XII and executed between 1507 and 1513. As grounds for her argument, Snow-Smith points to the veneration of Christ as Salvator Mundi by the French royal family and to a specific Salvator Mundi iconography on which, she argues, Leonardo drew for his design. The attribution of the painting from the Ganay Collection has failed to find acceptance, however. Only Carlo Pedretti (in Pedretti/Barbatelli 2017, pp. 143–145) has recently

once again put forward Joanne Snow-Smith's hypothesis. There is no secure basis on which to situate a Salvator Mundi design chronologically within Leonardo's oeuvre. One starting-point are the above-mentioned two sheets with drapery studies by Leonardo (Cat. D40–41), which are traditionally dated to around 1504 (RL 12524 and 12525). Dates put forward in recent years vary widely. Maria Teresa Fiorio (2005, p. 276) assigns the creation of the design to the 1490s, while Luke Syson locates it within the period around 1500 (Syson/Keith 2011, p. 298f; Gouzer/Wetmore 2017, p. 22) and Carlo Pedretti in the years 1510 to 1515 (Pedretti/Barbatelli 2017, p. 143).

A more concrete point of orientation for the dating of the New York panel is offered by the fresco of a Salvator Mundi in Forlì, which Heydenreich introduced into the debate at an early stage (1964) and which is today attributed to Melozzo da Forlì, Bramante or Bartolomeo della Gatta. The New York Salvator Mundi does indeed come very close to the fresco in Forlì in its overall composition and in several details. This can be seen most notably in Christ's blessing hand, for example in the positions of the index finger, middle finger and thumb, and in the creases in the skin of the palm, and similarly in the air of transported reverie that characterizes Christ's expression both in the New York Salvator Mundi and the Forlì fresco. None of the other possible visual sources proposed so far (Syson in Syson/Keith 2011, p. 303; Ekserdjian in: Gouzer/Wetmore 2017, pp. 127–141) exhibit comparable formal parallels. Since corresponding trips by Leonardo to Urbino are

documented only as from 1502 (RLW 1034, 1038, 1041), Heydenreich considers this the earliest date from which Leonardo could plausibly have addressed the Salvator Mundi subject. Since Leonardo was still based at this time in Florence, however, and committed to a number of unfinished commissions (Cat. XVI, XXII, XXV–XXVI), he probably only embarked on a Salvator Mundi at a later date.

Other Salvator Mundi compositions from Leonardo's circle may also prove helpful in narrowing down the date of the New York painting (Fioro 2005). Of particular interest in this regard is a recently discovered Salvator Mundi by Leonardo's pupil Salaì, which is today housed in the Pinacoteca Ambrosiana in Milan (Marani 2013; Delieuvin 2016; Bétard 2018). Since the painting is signed by the artist and dated 1511, it offers a concrete point of reference when considering the chronology of Leonardo's designs for a Salvator Mundi. Salaì indeed orients himself to his master's design both in the composition and in a number of details. The almost imperceptibly higher position of Christ's right eye in Salaì's painting also corresponds with the arrangement in the New York Salvator. On the basis of all these considerations, it is probable that Leonardo created a Salvator Mundi design between 1502 and 1511, whereby the New York painting could also have been painted after 1511. The New York Salvator Mundi surpasses all other versions of the subject from Leonardo's circle in terms of its quality. Details such as the modelling of Christ's blessing hand, the execution of the filigree embroidery border around the neckline, and

above all the suggestive handling of light and the sfumato all testify to a very high standard of technical accomplishment. The fingernails outlined with fine shading, which recall similar features in the Mona Lisa (Cat. XXV) and St John the Baptist (Cat. XXX), also argue in favour of an attribution to Leonardo, as do the shadowy eyes and heavy eyelids. The Salvator Mundi nonetheless also exhibits weaknesses. The flesh tones of the blessing hand, for example, appear pallid and waxen as in a number of workshop paintings. Christ's ringlets also seem to me too schematic in their execution, the larger drapery folds too undifferentiated – especially on the right-hand side. They do not bear comparison with the Mona Lisa, for example. The restorations made to the panel, and the photographs that have been released to the public thus far (Modestini 2014; 2018, pp. 411–420; Gouzer/Wetmore 2017; Panza 2018), make it clear that the paint substance of the New York Salvator Mundi was no longer in its original condition even when the painting was discovered in 2005. Areas of heavy damage that have meanwhile been restored and are no longer visible concern in particular the background as a whole and Christ's forehead and hair. Parts of the draperies at the lower edge of the panel also had to be remodelled, as did the eye areas and the crystal orb in Christ's left hand. The problematic nature of some of these incursions and additions is illustrated by the remodelling of the crystal, which was carried out on the basis of a photograph (!) of a painting inspired by Leonardo's Salvator Mundi design, attributed to Girolamo Alibrandi and today housed in San Domenico Maggiore in

Naples (Lewis 2019; Preface, fig. 7). Lastly, if we compare the New York Salvator Mundi in its current state with photographs of the painting in 2005, 2008, 2011 and 2017, it furthermore becomes clear that the painting's sfumato effect to a certain extent goes back to its most recent restoration. In view of the painting's poor original condition and extensive restoration, and given that the findings of the restoration campaign have still not been published in full, the picture's attribution to Leonardo consequently remains a matter of dispute. The controversy over the attribution and provenance of the New York Salvator Mundi has largely thrust questions of content into the background. This is the case, for example, with the omega-shaped drapery fold, which recalls the wound in Christ's side and his Passion (Snow-Smith 1982, p. 59). The crystal globe in Christ's left hand may allude to his role as ruler and saviour of the world (Snow-Smith 1982, p. 57f; Syson/Keith 2011, p. 302; Gouzer/ Wetmore 2017, p. 31) or to Leonardo's optical theories (Kemp 2011). A reference to Leonardo's studies of geometry may be seen in the meticulously executed ornamental bands that trim Christ's robe (Snow-Smith 1982, p. 52). The intersecting ornamental bands of the outer garment have also been interpreted as a crossed stole (Heydenreich 1964, note. 23; Snow-Smith 1982, pp. 58 and 87). An aspect of the New York Salvator Mundi that has been wholly ignored up till now is the exclusively blue raiment worn by Christ. This uniform drapery colour is unusual in a portrait of Christ painted on panel in this epoch, but is found in French and Netherlandish book illumination.

Blue robes furthermore played a central ceremonial role in the coronation of French kings, who were anointed in a reference to the anointing of Christ. Further research in this area could be useful. A look at the book illumination of this period seems to me more promising, however. In books of hours from the beginning of the 15th century onwards, representations of Christ as Salvator Mundi are frequently found in conjunction with the prayer of St Veronica. This very popular prayer was recited in front of a portrait of Christ as Salvator Mundi. It is possible that the New York Salvator Mundi should be understood as an example of this practice of devotion and prayer in the early modern era (see Preface).

LITERATURE: Heydenreich 1964; Snow-Smith 1982; Syson/Keith 2011, pp. 300–303; Kemp 2011; Bambach 2012; Zöllner 2012; Robertson 2012; Marani 2012; 2013; Modestini 2014; Gouzer/Wetmore 2017; Kemp 2018; Lewis 2019; Dalivalle/Kemp/Simon 2019.

Bibliographical References

I The young artist in Florence 1469–1480

Ottino della Chiesa, 1967, p. 83; Ost, 1980, and Arasse, 1998, pp. 28–33 (Leonardo's portraits and suspected self-portraits); Ciardi/Sisi, 1997; Nova 1999 (Leonardo's "image"). – Wittkower, 1989, pp. 92–95 (Leonardo's reserved nature). – Kris/Kurz, 1980, pp. 37–46 (topos of the youth of the artist) – Bambach, 1991, pp. 87–88 (*Achademia Leonardi Vinci* signet). – Goffen, 1976, pp. 85–114 (compositional types employed by Bellini in his devotional panels). – Brown, 1998, and Marani, 1999, pp. 12–75 (pictorial formulae from Verrocchio's workshop). – Natali, 1998, and *Lo sguardo degli angeli*, 1998 (technique and iconography of the *Baptism of Christ*). – Gilbert, 1980, pp. 145–146 (Dominici's description of the function of private devotional panels). – Chastel, 1979 (Leonardo's Madonnas). – *L'annunciazione di Leonardo*, 2000, and Cardile, 1981/1982 (type and iconography of the *Annunciation*). – Voragine, 1993, I, p. 197 (Nazareth as "flower"); Liebreich, 1997, pp. 87–88, 158–161, and *L'annunciazione di Leonardo*, 2000, p. 30 (religious symbolism of the landscape in the *Annunciation* [Arasse]). – Baxandall, 1988, pp. 49–56, 67–68 (sources of Annunciation types and their gestures).

Leonardo on the design of horizons:
"*E questi tali orizonti fanno molto bel vedere in pittura. Ver'è che si de' fare alcune montagne laterali con gradi di colori diminuiti, come richiede l'ordine della diminutione de colori nelle lunghe distantie*" (TPL 936).

Frey, 1892, p. 112; Zöllner, 1995, pp. 60–61; Marani, 1999, pp. 78–79 and Brown, 1998, p. 150 (Leonardo's altarpiece for the chapel of St Bernard). – Cropper, 1986; Fletcher, 1989; Zöllner, 1994, pp. 60–64; Kress, 1995, pp. 237–255; Tinagli, 1997, p. 88, and Woods-Marsden, 2001 (*Ginevra de' Benci* and the influence of Petrarch upon Bernardo Bembo and Ginevra); Petrarch, *Canzoniere*, 359. – Pope-Hennessy, 1966, pp. 101–105 (psychology of the portrait). – RLW § 1416, 1444, 1454 (Leonardo's acquaintance with Giovanni de' Benci).

II Professional breakthrough in Florence 1480–1482

Rice, 1985, pp. 75–81, and Ost, 1975 (tradition of *St Jerome*). – Voragine, 1993, II, p. 213 (legend of St Jerome); Fehrenbach, 1997, p. 149 (church in the background of *St Jerome*).

St Jerome's letter to Eustochium:
"*Ille igitur ego, qui ob gehennae metum, tali me carcere ipse damnaveram, scorpionum tantum socius et ferarum, saepe choris interceram puellarum. Pallebant ora jejuniis, et mens desideriis aestuabat in frigido corpore, et ante hominem sua jam in carne praemortuum, sola libidinum incendia bulliebant. Itaque omni auxilio destitutus, ad Jesu jacebam pedes, rigabam lacrymis, crine tergebam; et repugnantem carnem hebdomadarum inedia subjugabam. Non erubesco infelicitatis meae miseriam confiteri [...]. Memini me clamantem diem, crebro junxisse cum nocte, nec prius a pectoris cessasse verberibus, quam rediret, Domino increpante, tranquillitas. [...] Et mihimet iratus et rigidus, solus deserta penetrabam. Sicubi concava vallium, aspera montium, rupium praerupta cernebam, ibi meae orationis locus, ibi illud miserrimae carnis ergastulum.*"
"*Quia enim impossibile est in sensum hominis non irruere innatum medullarum calorem, ille laudatur, ille praedicatur beatus, qui ut coeperit cogitare sordida, statim interficit cogitatus, et allidit ad petram: petra autem Christus est (1. Cor. 104)*" (St Jerome, letter to Eustochium, 22.6–7, Migne, *Patrologia Latina*, XXII, col. 398–399).

Contract for the *Adoration of the Magi* of July 1481:
"*Lionardo di ser Piero da Vinci si à tolto a dipignere una nostra pala per l'altare magiore per infino di marzo 1480, la quale debba havere compiuta infra mesi 24, vel al più infra mesi 30. Et in caso non l'avessi compiuta, perdessi quello n'avessi fatto, et fussi in nostra libertà di farne la volontà nostra. Per la quale de' havere un terzo d'una possessione in Valdelsa, che fu di Simone padre di frate Francesco, la quale lasciò con questo incarico: con questo che habiamo termine, poi l'arà compiuta, tre anni se noi la volessimo torre in noi per fiorini 300 di sugello. Et in questo predecto tempo non ne possa fare alcuno contracto. Et lui debba mettere di suo i colori, l'oro et ogni altra spesa n'occorressi. Et più debba pagare di suo tutto quello si*"

spenderà per fare la dota di fiorini 150 di sugello in sul Monte a la figliuola di Salvestro di Giovanni. fiorini 300. Anne havuto fiorini ventotto larghi a fare noi la sopradecta dota, perchè lui disse non havere il modo di farla, et il tempo passava, e a noi ne veniva preiudicio.fiorini 28 larghi.
Et più de' dare per colori tolti per lui delli Iniesuati, che montò fiorini uno et mezzo larghi. Lire 4, soldi 2, denari 4" (Beltrami, 1919, no. 16; Villata, 1999, no. 14; English translation by Kemp/Walker, 1989, p. 268).

Wackernagel, 1938/1981, pp. 338–339; Baxandall, 1988, pp. 5–8; Rubin, 1994, and Kemp, 1997, pp. 80, 171–220 (contracts, prices and terms of payment for altarpieces). – Scharf, 1935, no. XVI (contract for Filippino Lippi's *Adoration*). – Zöllner, 1995, pp. 60–61 (on the contract for Leonardo's *Adoration*). – Hamilton, 1901, pp. 95–97; Kehrer, 1908, p. 63, and Mâle, 1910 (mystery plays and gestures in the cult of the Magi). – Marzik, 1987, p. 280 (*aposkopein* gesture). – Gandelmann, 1992 (pointing gestures in the fine arts). – Wohl, 1980, pl. 130, 180, cat. 21, and Ruda, 1993, cat. 67c (gesture of the raised index finger, particularly in portrayals of St John from the circle of Domenico Veneziano and Filippo Lippi). – Voragine, 1993, I, p. 82 (Star of Bethlehem, root of David and *Adoration*). – Lisner, 1981 (Eucharistic interpretation of Leonardo's *Adoration*). – Natali, 1994 (interpretation of the background of the *Adoration*). – Sterling, 1974 (iconography of the battling horsemen in the *Adoration*). – Hood, 1993, pp. 46–47, 97–121, and Merzenich, 2001, pp. 98–109 (Fra Angelico, development of the square altarpiece). – Wiemers, 1996, pp. 277–234 (Leonardo's compositional process and iconography of the *Adoration*). – Gombrich, 1986 (facial types in Leonardo's works). – Hatfield, 1970, and Trexler, 1997, pp. 67–123 (social significance of the cult of the Magi and of age dualism in Florence).

III A fresh start in Milan 1483–1484
Zubov, 1968, pp. 9–10; Leverotti, 1983, pp. 586–590, and Zöllner, 1995 (Leonardo's professional situation

and general financial circumstances in Milan). – Marani, 1984 (Leonardo's studies on naval warfare). – Venturoli, 1993 (the *Virgin of the Rocks* as a screen). – Robertson, 1954; Kemp, 1981, p. 96, and Snow Smith, 1983, 1987 (iconography of the rocks). – Aronberg Lavin, 1955 (St John iconography and the life of John according to Giovanni Cavalca). – Battisti, 1991, and Stefaniak, 1997 (symbolism of the landscape and the chasm in the *Virgin of the Rocks*). Franciscan iconography of the rocks in the "Little Flowers of St Francis":
"Ivi a pochi dì, standosi santo Francesco allato alla detta cella e considerando la disposizione del monte, e maravigliandosi delle grandi fessure ed aperture de' sassi grandissimi, si puose in orazione; e allora gli fu rivelato da Dio che quelle fessure così maravigliose erano state fatte miracolosamente nell'ora della passione di Cristo quando, secondo che dice il Vangelista, le pietre si spezzarono. E questo volle Iddio che singularmente apparisse in su quel monte della Verna, a significare che in esso monte si dovea rinnovellare la passione del nostro Signore Gesù Cristo nell'anima sua per amore di compassione, e nel corpo suo per impressione delle stimmate." ("*Della seconda considerazione delle sacre sante stimmate*", Casolini, 1926, p. 216; English translation by Snow Smith, 1987, p. 68).

Perrig, 1980 (the earth as a living being).
Leonardo on the earth as a living being:
"L'omo è detto da li antiqui mondo minore, e cierto la ditione d'esso nome è bene collocata, impero chè, siccome l'omo è composto di terra, acqua, aria e foco, questo corpo della terra è il simigliante. Se l'omo à in sé ossi, sostenitori e armadura della carne, il mondo à i sassi, sostenitori della terra; se l'omo à in sé il lago del sangue, dove crescie e discrescie il polmone nello alitare, il corpo della terra à il suo oceano mare, il quale ancora lui crescie e discrescie ogni sei ore per lo alitare del mondo. Se dal detto lago di sangue dirivano vene, che si vanno ramificando per lo corpo umano, similmente il mare oceano enpie il corpo della terra d'infinite vene d'acqua" (RLW § 929).
"Raggiransi l'acqua con continuo moto dall'infime profondità de' mari alle altissime sommità de' monti, non osservando la natura delle cose gravi, e in questo caso fanno

come il sangue delli animali, che sempre si move dal mare del core e scorre alla sommità delle loro teste, e chi quivi rompesi le vene, come si vede una vena rotta nel naso, che tutto il sangue da basso si leva alla altezza della rotta vena. [...] Vanno le vene scorrendo con infinita ramificatione pel corpo della terra" (RLW § 963).

"Il corpo della terra, a similitudine de' corpi de li animali, è tessuto di ramificationi di vene, le quali son tutte insieme congiunte, e son constituite a nutrimento e vivificatione d'essa terra e de' sua creati. Partono dalle profondità del mare, e a quelle dopo molta revolutione ànno a tornare per li fiumi creati dalle alte rotture d'esse vene" (RLW § 970).

Appendix to the contract for the *Virgin of the Rocks* listing the work to be undertaken on the altarpiece, dated 25 April 1483:

"Lista de li hornamenti se ano a fare a l'ancona dela conceptione dela gloriossa Vergene Maria posta nela ghesia de Sancto Francesco in Milano.
Primo. Vollemo che tuta l'anchona, videlicet li capitoli de intaglie con li figure excepto li volti, ognia cossa sia posto a oro fino de pretio de libre 3 soldi 10 per centenaro.
Item la nostra dona nel mezo sia la vesta de sopra brochato d'oro azurro tramarino.
Item la camora brocato d'oro de lacha fina in cremesi a olio.
Item la fodra dela vesta brocato d'oro verdo a olio.
Item li zarafini posti de senaprio sgraffiati.
Item lo Deo padre, la vesta de sopra brocato d'oro azurro tramarino.
Item li angelli sieno hornati de sopraoro, li camesi internisati in la fogia grecha a olio.
Item le montagne e sassi lavorati a olio divisati de più collori.
Item li quadri vodi sieno angelli, 4 per parte differentiati del'uno quadro e l'altro, videlicet uno quadro che canteno et l'altro che soneno.
Item in tucto li altri capitolli dove sia la nostra dona sia ornata come quella de mezo, et li altre figure grege hornati de diversi colori ala fogia grega o moderna, che sieno in tucta perfetione cossi li caxamenti, montagne, suficte, piani de dicti capitolli. et ognia cossa facta ad olio, et de reconzare l'intagli che non stieno bene.

Item le sibillie hornati, li campi facte ad una cuba in forma de caxamento, e li figure le veste differentiate l'una de l'altra, tucte facte ad olio.
Item li cornixoni pilastrati capitelli et ognia intaglio, posto d'oro come è dicto de sopra, senza alchuno collore nel mezo.
Item la tavolla de mezo facta depenta in piano la Nostra Dona con lo suo fiollo e li angolli facta a olio in tucta perfetione con quelli doy profeti vanno depenti piani, con li colori fini come è dicto de sopra.
Item la bancheta hornata come li altri capitolli de intorno.
Item tucti li volti e le mane, ganbe, che sono nude, sieno colorite a olio in tucta perfetione.
Item e'logo dove è lo putino sia messo doro lavorato, in guisa de gradiza" (Beltrami, 1919, no. 24; Villata, 1999, no. 23; English translation by Kemp/Walker, 1989, pp. 268–270).

Stites, 1970, pp. 125–126, and Kemp/Walker, 1989, pp. 268–270 (commentary on the documents relating to the *Virgin of the Rocks*). – Villata, 1999, no. 67 (documents relating to the dispute over the additional payment for the *Virgin of the Rocks*). – Summers, 1972, and Baxandall, 1986, pp. 11–12, 48 (on the term *maniera*). – Ferino-Pagden, 1990, and Hegel, 1995, 4.2, pp. 488–489 (shift of emphasis from cult value to artistic value).

IV Beginnings as a court artist in Milan 1485–1494

Giordano, 1993, 1995, and Welch, 1995 (Sforza cultural policy). – Villata, 1999, nos. 25–33 (documents relating to Leonardo's activities for the Milan Cathedral authorities). – Heydenreich, 1929, and Pedretti, 1980 (Leonardo as an architect). – Schofield, 1989 and 1991 (Leonardo as an architect in Milan). – Feldhaus, 1922; Galuzzi, 1987, and Marani, 1984 (Leonardo as a technician and military engineer). – Malaguzzi-Valeri, 1915–1923, and Warnke, 1986 (position of court artist). – RLW § 710–723, and II, pp. 1–3; Fusco/Corti, 1992 (sources for the Sforza monument).

Letter from Galeazzo Maria Sforza to Bartolomeo da Cremona, head of the ducal works, of 26 November 1473:

"Perché voressimo fare fare la imagine del Illustrissimo Signore nostro patre de bona memoria, de bronzo ad cavallo, et metterlo in qualche parte di quello nostro castello di Milano, o lì nel revelino verso la piaza o altrove dove stesse bene, volemo et commettemoti che tu faci cercare per quella nostra città che lì fosse magistro che sapesse fare questa opera et lavorarla in mettalo, et se in dicta nostra città non se trovasse magistro che la sapesse fare, volemo che tu investighi de intendere et sapere se in altre città et parte se trovasse magistro che sapesse fare questo, ma el vole essere tale che faza dicta imagine et cavallo tanto ben quanto se possa dire, la quale imagine sia grande quanto era la persona de sua Signoria et el cavallo sia de bona grandeza, et trovandose tale magistro, ne avisa et così ancora ne avisa quanto potria montare questa spesa, computato mettallo, magisterio et ogni altra cosa, perché volemo se cerchi ad Roma, Firenze et tutte altre città dove se trovasse questo magistro che sia excellente per effecto in questa opera" (Fusco/Corti, 1992, p. 12).

Piero Alamanno's letter of 22 July 1489 concerning problems with the Sforza monument:
"[…] El Signor Lodovico è in animo di fare una degnia sepultura al padre et di già ha ordinato che Leonardo da Vinci ne facci il modello, cioè uno grandissimo cavallo di bronzo, suvi il duca Francesco armato: et perché Sua Excellentia vorrebbe fare una cosa in superlativo grado, m'à decto per sua parte vi scriva che desiderrebbe voi gli mandassi uno maestro o dua, apti a tale opera: et per benchè gli habbi commesso questa cosa in Leonardo da Vinci, non mi pare si consuli molto la sappi condurre" (Beltrami, 1919, no. 36; Villata, 1999, no. 44).

Court poet Baldassare Taccone's poem on Leonardo's Sforza monument, 1493:
*"Vedi che in Corte fa far di metallo,
per memoria dil padre un gran colosso:
i' credo fermamente e senza fallo
che Gretia e Roma mai vide el più grosso.
Guarde pur come è bello quel cavallo:
Leonardo Vinci a farlo sol s'è mosso
statuar, bon pictore e bon geometra:
un tanto ingegno raro al ciel s'impetra.
Et se più presto non s'è principiato,*

*la voglia del Signor fu semper pronta;
non era un Lionardo ancor trovato
qual di presente tanto ben l'impronta,
che qualunche che 'l vede sta amirato,
et se con lui al parangon s'afrunta
Fidia, Mirone, Scoppa e Praxitello,
diran ch'al mondo mai fusse el più bello"* (Beltrami, 1919, no. V; Villata, 1999, no. 73).

Leonardo da Vinci's Sforza Monument Horse, 1995 (Sforza monument in general). – Sabba da Castiglione, Ricordi, 1546, no. 109, after Villata, 1999, no. 345 (Gascony archers destroy the model for the Sforza monument). – Cunnally, 1993 (numismatic sources for the equestrian monument). – Wegener, 1989 (condottieri tombs and the *dexileos* motif). – Steinitz, 1970; Kemp, 1981, pp. 167–169; Kemp/Roberts, 1989, no. 83, and Kemp/Walker, 1989, pp. 238–248 (Leonardo's commissions for court pageants and allegories).
Description of the "Festa del Paradiso":
"La sequente operetta composta da Meser Bernardo Belinzon è una festa o vero ripresentatione chiamata Paradiso, qual fece far il Signor Ludovico in laude della Duchessa di Milano: et chiamasi Paradiso però che v'era fabricato con il grande ingegno et arte di Maestro Leonardo Vinci fiorentino il Paradiso con tutti li setti pianeti che girava, et li pianetti erano represental da homini in forma et habit che se descriveno dalli poeti, li quali pianette tutti parlan i' laude della prefata Duchessa […]" (Bellincioni, Rime, 1493, 4v–5r, after Villata, 1999, no. 72e).

Brown, 1983/1984, and Bora, 1987 (Leonardo's Milanese portraits). – Malaguzzi-Valeri, I, 1915, pp. 37, 503–504; Shell/Sironi, 1992, and Moczulska, 1995 (Cecilia Gallerani). – Kemp, 1997, pp. 320–321 (on Bellincioni's ode to the *Portrait of Cecilia Gallerani*, c. 1490–1492).
Bellincioni's ode to the *Portrait of Cecilia Gallerani*:
*"'Di che te adiri, a chi invidia hai, natura?'
'Al Vinci, che ha ritrato una tua stella,
Cecilia sì belissima hoggi è quella*

che a' suoi begli ochi el sol par umbra oscura.'
'L'honor è tuo, se ben con sua pictura
la fa che par che ascolti et non favella.
Pensa quanto sarà più viva et bella,
più a te fia gloria in ogni età futura.
Ringratiar dunque Ludovico or poi
et l'ingegno et la man di Leonardo
che a' posteri di lei voglian far parte.
Chi lei vedrà così ben che sia tardo,
vederla viva, dirà; basti ad noi
comprender or quel che è natura et arte.'"
(Bellincioni, *Rime*, 1493, c. 6v–7r, after Villata, 1999, no. 72c).

Ode to Leonardo's *Portrait of Lucrezia Crivelli*, probably by the poet Antonio Tebaldeo, c. 1497:
"Ut bene respondet naturae ars docta, dedisset
Vincius, ut tribuit cetera, sic animam.
Noluit, ut similis magis haec foret, altera sic est:
possidet illius Maurus amans animam.
Hujus quam cernis nomen Lucretia, divi
omnia cui larga contribuere manu.
Rara huic forma data est, pinxit Leonardus, amavit
Maurus, pictorum primus hic, ille ducum.
Naturam et superas hac laesit imagine divas
pictor; tantum hominis posse manum haec doluit.
Illae longa dari tam magnae tempora formae,
quae spatio fuerat deperitura brevi.
Has laesit Mauri causa, defendet et ipsum
Maurus, Maurum homines laedere diique timent"
(Beltrami, 1919, no. VII; Villata, 1999, no. 122; dating after PRC, II, pp. 386–387).

Pope-Hennessy, 1966, pp. 101–154; Shearman, 1992, pp. 112–124; Zöllner, 1991, 1994, pp. 65–70, and Tinagli, 1997, pp. 88–89 (expression of the soul in the portrait).

V The artist and "science"
Leonardo's yearning for knowledge, expressed in a poetic vision:
"E tirato dalla mia bramosa voglia, vago di vedere la gran copia delle varie e strane forme fatte dalla artifiziosa

natura, ragiratomi alquanto infra gli ombrosi scogli pervenni all'entrata d'una gran caverna dinanzi alla quale restato alquanto stupefatto e ignorante di tal cosa piegato le mie rene in arco e ferma la stanca mano sopra il ginocchio e colla destra mi feci tenebra alle abbassate e chiuse ciglia. E spesso piegandomi in qua e in là per vedere dentro vi discernessi alcuna cosa, e questo vietatomi per la grande oscurità, che là entro era, e stato alquanto, subito s'alse in me 2 cose, paura e desiderio, paura per la minacciosa oscura spilonca, desiderò per vedere se là entro fusse alcuna miracolosa cosa [...]" (RLW § 1339).

O'Malley/Saunders, 1952, and Keele/Pedretti, 1978–1980 (Leonardo's anatomical studies). – Zöllner, 1987, and Alberti, 2000, pp. 168–177, 189–190, 258–261, 328–329 (theory of proportion in Leonardo and earlier). – RLW, I, pp. 14–22; Blunt, 1940, pp. 48–57; Kristeller, 1976, II, pp. 164–206; Buck, 1987, pp. 202–228, and Zöllner, 1999 (status of the fine arts in the 15th century). – Dionisotti, 1962, and Zöllner, 1999 (Leonardo's poor education, Puteolano's attack on the fine arts). – Pedretti, 1991, and Fusco/Corti, 1992 (odes to Leonardo's Sforza monument); RLW, I, pp. 13–101; Richter, 1949, and Farago, 1992 (the *Paragone*, the comparison of the arts in Milan). – Kemp, 1971; Keele, 1983, pp. 60–68; Zöllner, 1992, 1999, and Laurenza, 2001, pp. 13–25 (*senso comune*, Leonardo's physiology and art). – Gombrich, 1954; Kwakkelstein, 1994, and Laurenza, 2001 (physiognomy in Leonardo). – Corpus Hippocraticum, *De genitura*, 1–8 (sperm and brain). – Villata, 1999, no. 269 (Pacioli on Leonardo's employment by Ludovico Sforza, 1496–1499). – Seidlitz, 1909, I, pp. 282–286; Zöllner, 1995, pp. 68–69; Villata, 1999, no. 136 (Ludovico Sforza makes Leonardo a gift of a vineyard and vows to pay him better).

VI From the Last Supper to the fall of Ludovico Sforza 1495–1499
Müller-Walde, III, 1898, p. 220; Poggi, 1919, pp. 19–22, and Villata, 1999, nos. 124–124c, 314, 337 (references to and descriptions of the *Last Supper* by Luca Pacioli, Antonio de Beatis and Paolo Giovio).

Description of Christ's announcement of his betrayal by Luca Pacioli, early 1498:
"*E tanto la pictura immita la natura quanto cosa dir se possa. El che agli occhi nostri evidentemente appare nel prelibato simulacro de l'ardente desiderio de nostra salute, nel quale non è possibile con magiore atentione vivi gli apostoli immaginare al suono de la voce de l'infabil verità quando disse: 'Unus vestrum me traditurus est'; dove, con acti e gesti l'uno a l'altro e l'altro a l'uno con viva e afflicta admiratione par che parlino: sì degnamente con sua ligiadra mano el nostro Leonardo lo dispose*" (Pacioli, *Divina proportione*, Venice, 1509, Ch. 3, c. 3r–v, after Villata, 1999, no. 124).

Description of the *Last Supper* by Antonio de Beatis, December 1517:
"*In lo monasterio di Santa Maria de le Gratie, quale fo facto dal signor Ludovico Sforza, assai bello et bene acteso, fo visto nel refectorio de fratri, chi sonno del ordine di san Dominico de observantia, una cena picta al muro da messer Lunardo Vinci, qual trovaimo in Amboys, che è excellentissima, benché incomincia ad guastarse non so si per la humidità che rende il muro o per altra inadvertentia. Li personaggi di quella son de naturale retracti de più persone de la corte et Milanesi di quel tempo, di vera statura. Li anche si vede una sacrestia ricchissima de paramenti de borcato, facti pure dal predicto signor Ludovico*" (Pastor, 1905, p. 176; Villata, 1999, no. 314 [incomplete]).

Description of the *Last Supper* by Paolo Giovio:
"*In admiratione tamen est Mediolani in pariete Christus cum discipulis discumbens, cuius operis libidine adeo accensum Ludovicum regem ferunt, ut anxie spectando proximos interrogavit, an circumciso pariete tolli posset, ut in Galliam vel diruto eo insigni caenaculo protinus asportaretur*" (Villata, 1999, no. 337).

Möller, 1952; Steinberg, 1973; Gilbert, 1974, and Wasserman, 1983 (Leonardo's *Last Supper*); Rossi/Rovetta, 1989, and Rigaux, 1989 (on the history of the genre of the *Last Supper*).
Description of the *Last Supper* by Giovanbattista Giraldi:

"*Questi, qualhora voleva dipingere qualche figura, considerava prima la sua qualità et la sua natura, cioè se deveva ella essere nobile, o plebea, gioiosa, o severa, turbata, o lieta, vecchia, o giovane, irata, o di animo tranquillo, buona o malvagia. Et poi, conosciuto l'esser suo, se n'andava ove egli sapea, che si ragunassero persone di tal qualità, et osservava diligentemente i lor visi, le lor maniere, gli habiti, et i movimenti del corpo. Et trovata cosa, che gli paresse atta a quel, che far voleva, la riponeva collo stile al suo libriccino, che sempre egli teneva a cintola. Et fatto ciò molte volte et molte, poi che tanto raccolto egli havea, quanto gli pareva bastare a quella imagine, ch'egli voleva dipingere, si dava a formarla, et la faceva riuscire maravigliosa. Et posto, ch'egli questo in ogni sua opera facesse, il fe con ogni diligenza in quella tavola, ch'egli dipinse in Milano nel convento de i frati Predicatori, nella quale è effigiato il Redentor nostro co' suoi discepoli che sono a mensa*" (Giovanbattista Giraldi, *Discorsi*, Venice 1554, pp. 193–196, after Poggi, 1919, p. 19).

Gombrich, 1966/1954 (Leonardo's *componimento inculto*). – Leonardo's own notes on the figures in the *Last Supper*:
"*Uno che beveva e lasciò la zaina nel suo sito e volse la testa inverso il proponitore. Un altro tesse le dita delle sue mani insieme e con rigide ciglia si volta al compagnio, l'altro colle mani aperte mostra le palme di quelle e alza le spalle inverso li orechi e fa la bocca della maraviglia. Un altro parla nell' orechio all'altro, e quello che l'ascolta si torcie inverso lui e gli porgie li orechi, tenendo un coltello nel' una mano e nell'altra il pane mezzo diviso da tal coltello. L'altro, nel voltarsi tenendo un coltello in mano, versa con tal mano una zaina sopra della tavola. [...] L'altro si tira inderieto a quel che si china e vede il proponitore infra 'l muro e 'l chinato*" (RLW § 665–666).

Gombrich, 1986 (facial types in Leonardo).
Leonardo on the habit amongst artists of always painting the same types:
"*Sommo difetto è de' pittori replicare li medesimi moti e medesimi volti e maniere di panni in una medesima istoria, e fare la magiore parte de' volti, che somigliano a'lloro maestro, la qual cosa m'ha molte volte datto admiratione,*

perche n'ho cognosciuti alcuni, che in tutte le sue figure pare
havervisi ritratto al naturale, et in quelle si vede li atti e li
modi del loro fattore" (TPL 108).

Gaspare Visconti's sonnet on Leonardo's repetition
of types, 1497–1499:
"Un depentor fu già che non sapea
desegnare altra cosa che un cupresso,
per quel che Orazio nei suoi versi ha messo
dove insegnar poetica intendea.
Un n'hanno questi tempi che in la idea
tien ferma sì la effiggie di se stesso,
che'altrui pinger volendo, accade spesso
che non colui ma se medesmo crea.
E non solo il suo volto, ch'è pur bello
secondo lui, ma in l'arte sua suprema
gli acti e' suoi modi forma col penello.
Vero è che lascia quel che più par prema,
cio è l'andra a passo del cervello
ciascuna volta che la luna scema:
unde a far bon poema
e far che quadri tutta l'opra bene,
mancano i ceppi, i lacci e le catene"
(Visconti, 1979, no. 168, pp. 117–118).

Battaglia, IV, 1966, p. 512, no. 20; Kemp, 1976, 1983;
Zöllner, 1992, and Laurenza, 2001, pp. 111–126
(automimesis)
Leonardo's views on automimesis:
"Quel pittore che avrà goffe mani le farà simili nelle sua
opere, e quel medesimo l'intervrà in qualunque membro,
se lungo studio non gliel vita. Adunque tu pittore guarda
bene quella parte che ài più brutta nella tua persona e in
quella col tuo studio fa bono riparo. Imperochè se sarai
bestiale, le tue figure paranno il simile e sanza ingiegnio,
e similmente ogni parte di bono e di tristo che ài in te, si
dimostrerà in parte in nelle tue figure. [...] E se tu fussi
brutto eleggieresti volti no belli e faresti brutti volti come
molti pittori, che spesso le figure somigliano il maestro"
(RLW § 586–587).

Leonardo's physiological explanation for automi-
mesis:

"E havendo io piu volte considerato la causa di tal difetto,
mi pare, che sia da giudicare, che quella anima, che reg-
gie e governa sciascun corpo, si è quella, che fa il nostro
giuditio inanti sia il proprio giuditio nostro. Adonque ella
ha condotto tutta la figura del homo, com'ella ha giudicato
quello stare bene, o' col naso longo, o' corto, o' camuso, e
cosi li afermò la sua altezza e figura. Et è di tanta potentia
questo tal giudito, ch' eglio move le braccia al pittore e fa gli
replicare se medesimo, parendo à essa anima, che quella sia
il vero modo di figurare l'homo" (McM 86).

Leonardo recommends a model figure as a means
to prevent automimesis:
"Debbe il pittore fare la sua figura sopra la regola d'un
corpo naturale, il quale comunemente sia di proportione
laudabile. Oltre di questa far misurare se medisimo et
vedere, in che parte la sua persona varia assai o' poco a
quella antidetta laudabile. E fatta questa notitia, debbe
riparare con tutto il suo studio, di non incorrere nei medi-
simi mancamenti nelle figure da lui operate, che nella per-
sona sua si trova. E sapi, che con questo vitio ti bisogna
sommamente pugnare, con cio sia ch' egli è mancamento,
ch'è nato insieme col giuditio" (McM 87).

Matteo Bandello's report on Leonardo's Last Supper:
"Soleva anco spesso, ed io più volte l'ho veduto e consid-
erato, andar la matina a buon'ora e montar sul ponte,
perché il cenacolo è alquanto da terra alto; soleva dico,
dal nascente sole sino a l'imbrunita sera non levarsi mai
il pennello di mano, ma scordatosi il mangiare e il bere, di
continovo dipingere. Se ne sarebbe poi stato dui, tre e quat-
tro dì che non v'averebbe messa mano, e tuttavia dimorava
talora una e due ore del giorno e solamente contemplava,
considerava ed essaminando tra sé, le sue figure giudicava.
L'ho anco veduto secondo che il capriccio o ghiribizzo lo
toccava, partirsi da mezzo giorno, quando il sole è in lione,
da Corte vecchia ove quel stupendo cavallo di terra com-
poneva, e venirsene dritto a le Grazie ed asceso sul ponte
pigliar il pennello ed una o due pennellate dar ad una di
quelle figure, e di subito partirsi e andar altrove" (Villata,
1999, no. 346).
Malaguzzi-Valeri, 1915; Giordano, 1993, 1995,
and Welch, 1995 (Sforza cultural policy and self-

promotion through art in Milan). – Burckhardt, 1997, p. 49 (Ludovico's mistrust of Ascanio Sforza). – Kemp, 1981, pp. 182–187 (interpretation of Leonardo's Sala delle Asse).

VII From Mantua to Venice and back to Florence 1500–1503

Vasari, 1958, V, p. 92; *Leonardo & Venezia*, 1992, and Vecce, 1998, pp. 187–196 (Leonardo in Venice); Villata, 1999, nos. 143–144 (Leonardo's bank account in Florence and Lorenzo Gusnasco's letter to Isabella d'Este). – Viatte, 1999, pp. 16, 28–38 (cartoon of Isabella d'Este and genealogical court portraiture). – Wasserman, 1971 (*Burlington House Cartoon*). – Vasari, 1965, pp. 265–266. Pietro da Novellara's description of the *Virgin and Child with St Anne* of 3 April 1501:

"*Illustrissima et excellentissima domina, domina nostra singular. Hora ho havuta di vostra excellencia, et farò cum omni celerità et diligentia quanto quella me scrive. Ma per quanto me occorrre, la vita di Leonardo è varia et indeterminata forte, sì che pare vivere a giornata. À facto solo, dopoi che è ad Firenci, uno schizo in uno cartone: finge uno Christo bambino de età cerca uno anno che uscendo quasi de bracci ad la mamma, piglia uno agnello et pare che lo stringa. La mamma quasi levandose de grembo ad Santa Anna, piglia el bambino per spiccarlo da lo agnellino (animale immolatile) che significa la Passione. Santa Anna alquanto levandose da sedere, pare che voglia ritenere la figliola che non spicca el bambino da lo agnellino, che forsi vole figurare la Chiesa che non vorrebbe fussi impedita la passione di Christo. Et sono queste figure grande al naturale, ma stano in picolo cartone, perchè tutte o sedeno o stano curve et una stae alquanto dinanti ad l'altra verso la man sinistra. Et questo schizo ancora non è finito. altro non ha facto, se non dui suoi garzoni fano retrati, et lui a le volte in alcuno mette mano. Dà opera forte ad la geometria, impacientissimo al pennello. Questo scrivo solo perchè vostra excellencia sapia che io ho havuta la sua. Farò l'opra et presto darò adviso ad vostra excellencia, ad la quale mi racomando et prego Dio la conservi in la sua gratia*" (Beltrami, 1919, no. 107; Villata, 1999, no. 150; English translation by Kemp/Walker, 1989, pp. 271–273).

Nathan, 1992 (genesis of the *Virgin and Child with St Anne*, Pietro da Novellara).

Novellara's letter describing the *Madonna of the Yarnwinder* of 14 April 1501:

"*Illustrissima et excellentissima Domina domina nostra singular. Questa septimana santa ho inteso la intentione di Leonardo pictore per mezzo de Salai suo discipolo e di alcuni altri suoi affectionati, li quali per farmila più nota me lo menorno el merchordì santo. Insumma li suoi experimenti mathematici l'hano distracto tanto dal dipingere, che non può patire el pennello. Pur me asegurai di farli intendere cum destreza il parere di vostra excellentia, prima como da me, poi, vedendolo molto disposto al voler gratificare vostra excellentia per la humanità gli monstroe a Mantua, gli disse el tutto liberamente. Rimase in questa conclusione: se si potea spiccare da la maestà del Re de Franza senza sua disgratia, como sperava, ala più longa fra meso uno, che servirebbe più presto vostra excellentia che persona del mondo. Ma che ad ogni modo, fornito ch'egli avesse un quadretino che fa a uno Roberteto favorito del Re de Franza, farebbe subito el retrato, e lo mandarebbe a vostra excellentia. Gli lasso dui buoni sollicitadori. El quadretino che fa è una Madona che siede como se volesse inaspare fusi, el Bambino posto el piede nel canestrino dei fusi, e ha preso l'aspo e mira atentamente que' quattro raggi che sono in forma di Croce. E como desideroso d'essa Croce ride e tienla salda, non la volendo cedere a la Mama che pare gela volia torre. Questo è quanto ho potuto fare cum lui. Heri fornì la predica mia, Dio voglia che fazia tanto fructo, quanto è stata copiosamente udita*" (Beltrami, 1919, no. 108; Villata, 1999, no. 151; English translation by Kemp/Walker, 1989, pp. 271–273).

Kemp, 1994, and Starnazzi, 2000 (*Madonna of the Yarnwinder*). – Zöllner, 1994 (Francesco del Giocondo). – Heydenreich, 1952/1988 (bridge proposal for Sultan Bajezid II). – Villata, nos. 192, 149 (Tovaglia on the pace at which Leonardo worked, 25 May 1504; Isabella d'Este's request for a picture by Leonardo, 29 March 1501). – Vecce, 1998, pp. 207–215 (Cesare Borgia). – Villata, 1999, no. 143 (Leonardo's bank account). – Lightbown, 1986, pp. 440–441

(Isabella d'Este's commissions for Giovanni Bellini and Pietro Perugino).

Isabella d'Este inquires after Leonardo's lifestyle on 29 March 1501 in a letter to Pietro da Novellara and asks him to persuade Leonardo to paint her a picture:

"Reverendissime, se Leonardo fiorentino pictore se ritrova lì in Fiorenza, pregamo la Reverenda paternità vostra voglia informarse che vita è la sua, cioè se l'à dato principio ad alcuna opera, como n'è stato referto haver facto, et che opera è quella, et se la crede che'el debba fermarse qualche tempo lì, tastandolo poi vostra Reverenda como da lei se'l pigliaria impresa de farne uno quadro nel nostro studio, che quando se ne contentasse remetteresimo la inventione et il tempo in arbitrio suo. Ma quando la lo ritrovasse renitente, vedi almancho de indurlo a farne uno quadretto de la Madonna, devoto e dolce como è il suo naturale. Apresso lo pregarà ad volerne mandare uno altro schizo del retratto nostro, perochè lo Illustrissimo Signore nostro Consorte ha donato via quello che 'l ce lassò qua: che 'el tutto haveremo non mancho grato da la Reverenda vostra che da esso Leonardo" (Beltrami, 1919, no. 106; Villata, 1999, no. 149).

Shell/Sironi, 1991 (*Mona Lisa*). – de Tolnay, 1952; Zöllner, 1993, 1994, and Kress, 1995, 1999 (portrait typology and background to the commission for the *Mona Lisa*). – *Decor puellarum*, 1461, fol. 52 (on how chaste women should fold their hands). – Herzner, 1995, pp. 118–119 (Jan van Eyck's portrait of Isabella of Portugal).

Leonardo on the atmospheric illumination of a face:

"Sempre la gola od'altra perpendiculare deritttura, che sopra di se abbia alcuno sporto, sara piu oscura ch'ella perpendiculare faccia d'esso sporto. [...] Vedi in a che non v'alumina parte alcuna del cielo f k. et in b v'alumina il cielo i k; et in c v'alumina il cielo h k; et in d il cielo g k; et in e il cielo f k integralmente. adunque il petto sara di pari chiarezza della fronte, naso e mento" (TPL 466).

"Allora qui fia veduto li lati de' volti partecipare dell' oscurita delle parieti di muri à quello oposti, e cosi li lati

del naso. E tutta la faccia volta alla bocca della strada sara aluminata. [...] Et à questa s' aggiongiera la grattia d'ombre con grato perdimento, private integralmente d'ogni termine spedito. E questo nascera per causa della lunghezza del lume. [...] E la lunghezza del gia detto lume del cielo stampato dalli termini di tetti, cola sua fronte, che sta sopra la bocca della strada, alumina quasi insino vicino al nascimento delle ombre, che stano sotto gli oggietti del volto, e cosi di mano in mano si vanno mutando in chiarezza, in sino che terminano sopra del mento con iscurità insensibile" (TPL 422).

VIII Leonardo in Florence 1504–1506: Battle paintings and "muscular rhetoric"

Hager, 1992, and Meyer zur Capellen, 1996 (Leonardo, Michelangelo and Raphael in Florence). – Vasari, 1568, IV, p. 47; Frey, 1892, p. 115, and Chastel, 1983, pp. 142–169 (enmity between Leonardo and Michelangelo).

Additional contract for the *Battle of Anghiari* of 4 May 1504:

"Atteso e magnifici et excelsi Signori Priori di Libertà et Gonfaloniere di Giustizia del popolo fiorentino, come havendo più mesi fa Lionardo di Ser Piero da Vinci, cittadino fiorentino, tolto a dipignere uno quadro della Sala del Consiglio grande, et sendoci de già per detto Lionardo cominciata tal pictura in sur un cartone, et havendo etiam per tal cagione presi fiorini 35 larghi d'oro in oro, et desiderando e prefati magnifici Signori, che tale opera si conducha quanto più presto si può al suo desiderato fine, et che a detto Leonardo si paghi per tal conto di tempo in tempo qualche somma di denari. Però e prefati magnifici Signori in senatis deliberorono etc. che il detto Lionardo da Vinci debba havere interamente finito di dipingere el detto cartone et rechatolo alla sua intera perfetione per insino a tutto el mese di febbraio proxime futuro de 1504 [1505], ogni exceptione et gavillatione rimossa, et che al detto Lionardo si dia et paghi fiorini 15 larghi d'oro in oro per ciascuno mese a buon conto, intendendosi cominciato il primo mese addì 20 del mese d'aprile proximo passato. Et in caso che el detto Lionardo non habbia fra detto tempo finito detto cartone, allora e prefati magnifici Signori lo possino constringere per qualunche modo opportuno alle intera restitutione

di tutti quelli danari havessi havuti per conto di tale opera insino a detto dì. Et debba detto Lionardo quel tanto di cartone fusse facto rilasciarlo a detti magnifici Signori libero, et che fra detto tempo, che detto Lionardo si obbligha havere fornito il disegno di detto cartone. Et potrebbe essere, che a detto Lionardo venissi bene cominciare a dipignere et colorire nel muro della Sala detta quella parte che lui havessi disegnata et fornita in detto cartone, però sono contenti, quando questo achaggia, e prefati magnifici Signori darli quel salario ciascun mese che sarà conveniente per fare tale dipintura, et quello di che allora saranno d'accordo con detto Lionardo. Et così spendendo detto Lionardo tempo in dipignere in sul muro detto, sono contenti detti magnifici Signori prorogarli et allungharli el tempo soprascripto, fra il quale detto Leonardo si obbligha a fornire il cartone in quel modo et infine a quel termine, che allora saranno d'accordo detti magnifici Signori et detto Lionardo. [Et perchè e potrebbe ancora essere, che Lionardo] fra quello tempo, che lui ha preso a fornire el cartone, non havessi occasione di dipignere in detto muro, ma seguitassi di finire tal cartone, secondo l'obligo soprascripto, allora son contenti detti magnifici Signori non potere tal cartone così disegnato et fornito alloghare a dipignere a uno altro, non alienarlo in alcuno modo da detto Lionardo, senza expresso consenso suo, ma lasciare fornire tal dipintura a Lionardo detto, quando sia in termine da poterlo fare et dargliene a dipignere in sul muro per quella subventione ciascun mese, che allora seranno d'achordo et che sara conveniente: questo nondimeno sempre dichiarato, che detti fiorini 35 larghi d'oro in oro ricevuti per detto Lionardo et tutto quello che per lo advenire risceverà, come di sopra si dice, debba per contratto confessato havere presi et promettere pigliarli per lo advenire per conto et prezo della dicta pictura, a buon conto di quello che sarà dichiarato altra volta pe' detti magnifici Signori, pe' tempi existenti il detto Lionardo dovere riscevere per prezo di detta pictura etc" (Villata, 1999, no. 189, supplemented after Beltrami, 1919, no. 140; English translation by Kemp/Walker, 1989, pp. 270–271).

Isermeyer, 1964; Pedretti, 1968, pp. 53–86, and Kemp/Walker, 1989, pp. 270–271 (on the documentation relating to the *Battle of Anghiari*).

– Wackernagel, 1938/1981, pp. 336–337, 361, and Wittkower, 1989, pp. 56–58 (artists' compliance with contracts, exceeding of deadlines). – Liebeschütz, 1926, p. 124 (interpretation of centaurs in Fulgentius Metaphoralis), and Laurenza, 2001, p. 181 (interpretation of centaurs in St Isidore of Seville, *Etymologiae*, 11.3.37). – Spirito, 1489; Cartari, 1647, pp. 92, 330, and Meller, 1985 (Mars iconography of the Piccinino family and in general). – Hartt, 1986; Rubinstein, 1991, and Zöllner, 1998 (political iconography of the Grand Council Chamber in Florence and the *Battle of Anghiari*). – Ost, 1975; Bober/Rubinstein, 1986, no. 27; Cristoforo Landino, *Commedia di Danthe*, Venice 1529, fol. 79, after Panofsky, 1962, p. 219 (form and interpretation of the Fall of Phaeton). – Butters, 1985, pp. 45, 54–55 (problematical nature of Florentine military policy at the start of the 16th century). – Koehler, 1907; de Tolnay, 1969, pp. 105–109, 209, 219; Rubinstein, 1991, and dalli Regoli, 1994 (Michelangelo's *Cascina* cartoon).

IX Between Florence and Milan 1506–1510

Frey, 1892, p. 142 (the Anonimo Gaddiano on Leonardo's painting technique and the *Battle of Anghiari*). – Vecce, 1998, pp. 249, 258–259 (Leonardo's relations with his family in 1506). – Villata, 1999, nos. 227–228 (Isabella d'Este requests a work by Leonardo); nos. 233–237, 240–243 (correspondence concerning Leonardo's continuing stay in Milan); no. 229 (agreement granting Leonardo leave of absence in May 1506).
Letter by Charles d'Amboise to the Florentine Signoria of 16 December 1506:
"Magnifici et Excelsi viri tamquam fratres honorandi. Le opere egregie, quale ha lassato in Italia et maxime in questa città magistro Leonardo de Vinci, vostro concittadino, hanno portato inclinatione a tutti che le hanno veduto de amarlo singularmente, ancora che non l'havessino mai veduto. Et noi volemo confessare essere nel numero de quelli che l'amavemo prima che mai per presentia lo cognoscessemo. Ma doppoi che qua l'havemo manegiato et cum experientia provato le virtute sue,

*vedemo veramente che el nome suo, celebrato per pictura, è
obscuro, à quello che meritaria essere laudato in le più altre
parte, che sono in lui de grandissime virtute. Et volemo
confessare che in le prove facte de lui de qualche cosa che li
havemo domandato, de disegni et architectura et altre cose
pertinente alla conditione nostra, ha satisfacto cum tale
modo, che non solo siamo restati satisfacti de lui, ma ne
havemo preheso admiratione"* (Beltrami, 1919, no. 181;
Villata, 1999, no. 237).

Letter from Francesco Pandolfini to the Florentine
Signoria (whom Pandolfini addresses as the
"Council of Ten") of 12 January 1507:

*"[...] stamattina alle presentia del Christianissimo,
Sua Maestà mi chiamò, dicendo: 'E bisogna che e vostri
Signori mi scrivino. Scrivete loro che io desidero servirmi
di maestro Lionardo, loro pictore, quale si trova a Milano,
desiderando che mi facci alcune cose: et vedete che quelli
Signori lo gravino et li comandino che mi serva subito, et
che non si parta de Milano fino al mio venire. Lui è bon
maestro, et io desidero havere alchune cose di mano sua.
Et scrivete in modo a Firenze che sortisca questo effecto, et
lo fate subito, mandandomi la lettera, quale sarà la pre-
sente che comparirà, per via di Milano.' Io resposi a Sua
Maestà che trovandosi Lionardo ad Milano, le Signorie
Vostre li comanderebbono che ubidissi a sua Maestà,
benchè, essendo in casa sua, lei medesima non li potrebbe
mancho comandare di quelle, et che essendo el ritornato
costà, le Signorie Vostre lielo manderebbono a Milano ad
omni sua richiesta. Sua Maestà non potrebbe più desid-
erarlo. Et tutto questo è nato da un piccol quadro suto
condocto ultimamente di qua di sua mano: quale è suto
tenuto cosa molto excellente. Io nel parlare domandai Sua
Maestà che opere desiderava da lui, et mi respose: 'Certe
tavolette di Nostra Donna, et altro, secondo che mi verrà
alla fantasia: et forse anche li farò ritrarre me medesimo.'
Io nel parlare cum Sua Maestà per più scharicho di Vostre
Signorie in omni evento, discorrendo seco la perfectione di
Lionardo insiemi cum le altre qualità sue, Sua Maestà,
subiungendomi che ne haveva notitia, mi domandò se lo
conoscevo. Et respondendoli io che mi era amicissimo, mi
subiunse: 'Scriveteli voi subito un verso che non parta da
Milano intanto che Vostre Signorie li scrivino de Firenze.'
Et per questa causa io ho facto un verso al sopradicto*

*Lionardo, faccendoli intendere il buono animo di questa
Maestà [...]"* (Beltrami, 1919, no. 183; Villata, 1999,
no. 240).

Leonardo's draft of a letter to Charles d'Amboise
(spring 1508?):

*"Hora io mando costì Salai per fare intendere a vostra
Signoria come io sono quasi al fine del mio letigio che io ho
co'mia fratelli, come io credo trovarmi costì in questa pas-
qua e portare con meco due quadri di due nostre donne di
varie grandezze. Le quali son fatte pel cristianissimo nostro
rè, o per chi a vostra Signoria piacerà, io avrei ben caro di
sapere alla mia tornata di costà, dove io avessi a stare per
stanza, perchè non vorrei dare più noia a vostra Signoria,
e ancora, avendo io lavorato pel cristianissimo rè, se la mia
provisione è per correre o no"* (RLW § 1349).

Meyer Schapiro, 1956, p. 162 (typology and age of
St Anne). – Battisti, 1991, and Arasse, 1998, pp. 448–
461 (composition, iconography, tradition and religious
symbolism of the *Virgin and Child with St Anne*). –
Heydenreich, 1953, I, pp. 155–158 and Perrig, 1980,
pp. 10–12, 20–22, 28 (on Leonardo's views on the pri-
meval ocean and the creation of the world).

Leonardo's thoughts on how mountains were
created:

*"L'acqua che scolassi della terra scoperta dal mare, quando
essa terra s'innalzassi assai sopra del mare, ancora ch'ella
fussi quasi piana, comincerebbe a fare diversi rivi per le
parte più basse d'esso piano [...]. E cosi si andrebbon con-
sumando i lati di tali fiumi insino a tanto che li tramezzi
d'essi fiumi si farebbono acuti monti, e così scolati tali colli,
comincerebbono a seccarsi e creare le pietre a falde mag-
giori o minori, secondo le grossezze de' fanghi che li fiumi
portorono in tal mare per li loro diluvi"* (Ms. F, fol. 11v).

Leonardo's observations on the blue colour of the
air:

*"Ancora per esenplo del colore dell'aria allegheremo il fumo
nato di legne secche e vecchie, il quale uscendo de' camini
pare forte azzureggiare, quando si trova infra l'ochio e'l loco
oscuro [...]. Vedesi ancora nell'ombre oscure delle montagne
remote dall'ochio, l'aria, che si trova infra l'ochio e tale
ombra parere molto azzurra [...]"* (RLW § 300).

Allison, 1974; Kemp/Smart, 1980; dalli Regoli, 1991, and *Leonardo e il mito di Leda*, 2001 (*Leda* tradition). – Kemp, 1994 (workshop production based on cartoons of Leonardo's *Madonna of the Yarnwinder*). – Hiller von Gaertringen, 1999 (production of paintings based on cartoons and drawings in Perugino's workshop).

X The last years
Heydenreich, 1965/1988, and PRC, II, pp. 15–17 (Leonardo's designs for the Trivulzio monument). – Kemp, 1972, and Keele/Pedretti, 1978–1980 (Leonardo's late anatomical studies).
Leonardo's draft of a letter to Giuliano de' Medici of *c.* 1515:
"Tanto mi sono rallegrato, illustrissimo mio Signore, del desiderato acquisto di vostra sanità, che quasi il male mio da me s' è fugito. Ma assai mi rincrescie il non avere io potuto integralmente satisfare alli desideri di vostra Eccellenza mediante la malignità di cotesto ingannatore tedesco, per il quale non ò lasciato indirieto cosa alcuna, colla quale io abbia creduto farli piacere. […] La seconda cosa fu, che si fecie un' altra bottega e morse e strumenti, dove dormiva, e quivi lavorava per altri, dipoi andava a desinare coi Svizzeri della guardia, dove sta giente sfacciendata, della qual cosa lui tutti li vincieva di li se ne uscivu; e'l piu delle volte se n'andavano due tre di loro, colli scoppietti; ammazzando uccielli per le anticaglie, e questo durava insino a sera" (RLW § 1351).

Vasari, 1965, p. 269; Kaftal, 1952, 1965; Wohl, 1980, Pl. 130, 180, cat. 21, and Ruda, 1993, cat. 67c (St John with raised index finger as a pictorial type in Florence). – Aronberg Lavin, 1955, and Barolsky, 1989 (iconography of *John the Baptist*). – Pliny, 1977, 35.41–43, 67–68, 97 and 131 (shading and *atramentum*); Nagel, 1993, and Cennini, 1998, Ch. 31 (*sfumato*). – Stoichita, 1999, pp. 67–88 (religious symbolism of shadow). – Rzepinska, 1962, and Shearman, 1962 (light and shade). – Weil Garris Posner, 1974 (Leonardo's influence in Rome, Leonardo's chiaroscuro painting). – *Raffaello a Firenze*, 1984, pp. 189–198, 222–228 (St John iconography in the Vatican);

Davidson, 1985, pp. 7–26 (Raphael's *Portrait of Pope Leo X*). – Fritz, 1960 (iconography of the *John-Bacchus*). – Villata, 1999, nos. 7–8; Lomazzo, I, 1973, p. 104; Wittkower, 1989, pp. 187–188, and Eissler, 1992 (homosexuality of Leonardo and other artists). – Poggi, 1919, p. XXVI (description of the *John-Bacchus* by Cassiano dal Pozzo). – Pedretti, 1972 (Leonardo's work as an architect in France). – Vecce, 1998, pp. 330–343 (Leonardo in France).
Antonio de Beatis's description of the aged Leonardo:
"In uno de li borghi el signore con noi altri andò a videre messer Lunardo Vinci firentino, vecchio de più di LXX anni, pictore in la età nostra excellentissimo, quale mostrò ad sua Signoria Illustrissima tre quatri, uno di certa donna firentina, facto di naturale ad instantia del quondam Magnifico Iuliano de Medici, l'altro di san Iohanne Baptista giovane, et uno de la Madonna et del figliolo che stan posti in gremmo de sancta Anna, tucti perfectissimi. Ben vero che la lui per esserli venuta certa paralesi ne la dextra non se ne può expectare più cosa bona. Ha ben facto un creato milanese, chi lavora assai bene. Et benché il prefato messer Lunardo non possa colorire con quella dulceza che solea, pur serve ad fare disegni et insignare ad altri" (Villata, 1999, no. 314; English translation based on Kemp/Roberts, 1989, p. 41).

Bibliography

The Bibliography is organized into the sections "Abbreviations" (of anthologies, journals and editions of Leonardo's manscripts), "Sources", "Secondary Literature" and "Bibliographies", and details all the titles referred to in the main text and the catalogue of paintings.

I. ABBREVIATIONS

1.1. Anthologies of Leonardo's writings (see also 1.3.):

McC: MacCurdy, 1977 (with page number)
McM: McMahon, 1956 (with paragraph number)
MK: Kemp/Walker, 1989 (with paragraph number)
PRC: Pedretti, 1977 (with page number)
RLW: Richter, 1970 (with paragraph number)
TPL: *Trattato di pittura/Das Buch von der Malerei*, ed. Ludwig, 1882, and ed. Pedretti/Vecce, 1995 (with number)

1.2. Journals:

AB: *The Art Bulletin*
AeH: *Artibus et Historiae*
AH: *Art History*
ALV: *Achademia Leonardi Vinci. Journal of Leonardo Studies*
AL: *Arte Lombarda*
BM: *The Burlington Magazine*
GBA: *Gazette des Beaux-Arts*
JWCI: *Journal of the Warburg and Courtauld Institutes*
MKIF: *Mitteilungen des Kunsthistorischen Institutes in Florence*
RV: *Raccolta Vinciana*
ZfKG: *Zeitschrift für Kunstgeschichte*

1.3. Leonardo's writings (manuscripts):

CA: Codex Atlanticus, Milan, Biblioteca Ambrosiana: *Leonardo da Vinci, Il codice atlantico della Biblioteca Ambrosiana a Milano*, ed. A. Marinoni, 24 vols, Florence 1974–1980

CL: Codex Leicester, Collection Bill Gates, Seattle: *The Codex Hammer* [i. e. the Codex Leicester], ed. C. Pedretti, Florence 1987 (see also Leonardo, 1999)

CM I–II: Codices Madrid I and II, Madrid, Biblioteca Nacional: *The Manuscripts of Leonardo da Vinci at the Biblioteca Nacional of Madrid*, ed. L. Reti, 5 vols, New York 1974

Codex Arundel, London, British Museum: *I manoscritti e i disegni di Leonardo da Vinci, il Codice Arundel 263*, 4 vols, Rome 1923–1930

Codex Forster, London, Victoria and Albert Museum: *Leonardo da Vinci, Il Codice Forster del Victoria and Albert Museum di Londra*, ed. A. Marinoni, 3 vols, Florence 1992

K/P: K. D. Keele/C. Pedretti, *Leonardo da Vinci. Corpus of the Anatomical Studies in the Collection of her Majesty the Queen at Windsor Castle*, 3 vols, London/New York 1978–1980

MSS A–I: Manuscripts A–I, Paris, Institut de France: Leonardo da Vinci, *I manoscritti del Institut de France*, ed. A. Marinoni, 12 vols, Florence 1986–1990

PDM: C. Pedretti (Hg.), *The Drawings and Miscellaneous Papers of Leonardo da Vinci in the Collection of her Majesty the Queen at Windsor Castle*, vol. 1: *Landscape, Plants and Water Studies*, London 1982, vol. 2: *Horses and Other Animals*, London 1987 (vol. 4: *Figure Studies*, and vol. 5: *Miscellaneous Papers*)

RL: Royal Library, Windsor Castle: *The Drawings of Leonardo da Vinci in the Collection of Her Majesty the Queen at Windsor Castle*, ed. K. Clark/C. Pedretti, 3 vols, London 1968–1969 (first published 1935) [new edition: K. Keele/C. Pedretti, 1978–1980, Bibliography 2.1. – See also Pedretti/Roberts, 1984 Bibliography 3]

2. SOURCES

2.1. Leonardo

A. Chastel (ed.), *Leonardo da Vinci, Sämtliche Gemälde und die Schriften zur Malerei*, Munich 1990

K. Keele/C. Pedretti, *Leonardo da Vinci. Corpus of the Anatomical Studies in the Collection of Her Majesty the Queen at Windsor Castle*, 3 vols, London/New York 1978–1980

M. Kemp/M. Walker, *Leonardo on Painting*, New Haven/London 1989

Leonardo da Vinci, Das Buch von der Malerei, ed. H. Ludwig, 3 vols, Vienna 1882

Leonardo da Vinci. *Der Codex Leicester*, exh. cat., Munich/Berlin 1999/2000 [facsimile and German translation by M. Schneider]

Leonardo da Vinci, Libro di pittura, ed. C. Pedretti and C. Vecce, 2 vols, Florence 1995.

Leonardo da Vinci, *Der Vögel Flug. Sul volo degli uccelli*, ed. and trans. M. Schneider, Munich/Paris/London 2000

T. Lücke (ed.), *Leonardo da Vinci. Tagebücher und Aufzeichnungen*, 2nd edn, Leipzig 1952

H. Lüdecke, *Leonardo da Vinci im Spiegel seiner Zeit*, 2nd edn, Berlin 1953

E. MacCurdy (ed.), *The Notebooks of Leonardo da Vinci*, 2 vols, London 1977 (first published 1938)

A. McMahon (ed.), *Leonardo da Vinci. Treatise on Painting* (Codex Urbinas latinus 1270), 2 vols, Princeton 1956

J. P. Richter (ed.), *The Literary Works of Leonardo da Vinci*, 2 vols, 3rd edn, Oxford 1970 (first published 1883)

2.2. Other sources (not Leonardo)

L. B. Alberti, *Das Standbild. Die Malkunst. Grundlagen der Malerei*, ed. Oskar Bätschmann, Darmstadt 2000

Francesco Albertini, *Memoriale di molte statue e picture sono nell'inclyta ciptà di Fiorentia […]*, Rome 1510 (reprint Letchworth 1909)

Anonimo Gaddiano, see Frey, 1892

Anonimo Morelliano, see Frimmel, 1888

de Beatis, see Pastor, 1905

L. Beltrami, *Documenti e memorie riguardanti la vita e le opere di Leonardo da Vinci*, Milan 1919

F. Benedettucci (ed.), *Il libro di Antonio Billi* [1506–1515/1527–1531], Anzio 1991

Billi, see Benedettucci, 1991

Giovanni Gaetano Bottari/Stefano Ticozzi, *Raccolta di lettere sulla pittura, scultura ed architettura*, 10 vols, Milan 1822–1825 (reprint Hildesheim 1976)

Neri di Gino Capponi, "Commentarii", in: Ludovico A. Muratori, *Rerum italicarum scriptores*, Milan 1731 (reprint 1981), XVIII, col. 1155–1220

Vincenzo Cartari, *Immagini delli Dei de gl'antichi*, Venice 1647

F. Casolini (ed.), *I Fioretti di San Francesco*, Milan 1926

Cennino Cennini, *Il libro dell'arte*, ed. F. Brunello, Vicenza 1998

Cesare Cesariano, *Di Lucio Vitruvio Pollione de Architectura […]*, Como 1521

Père Dan, *Le Trésor des merveilles de Fontainebleau*, Paris 1642

Decor puellarum, Venice 1461

Fioretti di San Francesco, see Casolini, 1926

K. Frey (ed.), *Il Codice Magliabechiano* [c. 1537 to 1547], Berlin 1892 (reprint Farnborough 1969)

T. Frimmel (ed.), *Der Anonimo Morelliano (Marcantonio Michiel's Notizia d'opere del disegno)*, Vienna 1888

Fulgentius Metaphoralis, see Liebeschütz, 1926

Giovanni Battista Gelli, "Vite d'artisti", in: *Archivio storico*, 17, 1896, pp. 33–62

C. E. Gilbert, *Italian Art 1400–1500. Sources and Documents*, Evanston 1980

Paolo Giovio, "Leonardi Vincii vita", in: P. Barocchi (ed.), *Scritti d'arte del Cinquecento* (La letteratura italiana. Storia e testi, XXXII), 3 vols, Milan/Naples 1971–1877, I, pp. 7–9 [also in Vecce, 1998, pp. 355–357, and Villata, 1999, no. 337]

Hieronymus, *Ausgewählte Briefe*, translated from the Latin by L. Schade, Munich 1936 (Bibliothek der Kirchenväter, 2nd series, XVI)

Serviliano Latuada, *Descrizione di Milano*, Milan
1738 (reprint Milan 1997)

H. Liebeschütz, *Fulgentius Metaphoralis*,
Leipzig/Berlin 1926 (Studien der Bibliothek
Warburg, IV)

Gian Paolo Lomazzo, *Scritti sulle arti*,
ed. R. P. Ciardi, 2 vols, Florence 1973–1974

V. Lorini/A. Nova/S. Feser, *Giorgio Vasari, Das
Leben des Leonardo da Vinci*, Berlin 2006

Luca Pacioli, *Summa de arithmetica, geometria,
proportioni et proportionalita*, Venice 1494

Luca Pacioli, *Divina proportione. Die Lehre vom
Goldenen Schnitt [1509]*, ed. and trans. C.
Winterberg, Vienna 1889

L. v. Pastor, *Die Reise des Kardinals Luigi d'Aragona
durch Deutschland, die Niederlande, Frankreich und
Oberitalien, 1517–1518, beschrieben von Antonio de
Beatis*, Freiburg 1905

Francesco Petrarca, *Opere*, Florence 1975

Pliny the Elder, *Naturkunde/Naturalis historiae*,
ed. and trans. R. König, Munich 1977

G. Poggi (ed.), *Leonardo da Vinci. La vita di Giorgio
Vasari nuovamente commentata*, Florence 1919

Giuseppe Richa, *Notizie istoriche delle chiese
fiorentine*, 10 vols, Florence 1754–1762 (reprint
Rome 1972)

Michelangelo Salvi, *Historie di Pistoia e fazioni
d'Italia*, 3 vols, Rome 1656–1662

Giovanni Simonetta, *De gestis Francisci Sphortiae*,
Milan 1483 (also in: *Rerum italicarum scriptores*,
vol. 21, 1732)

G. Sironi, *Nuovi documenti riguardanti la Vergine
delle Rocce di Leonardo da Vinci*, Florence 1981

Lorenzo Spirito, *L'altro Marte*, Venice 1489

Carlo Torre, *Il ritratto di Milano*, Milan 1674

Giorgio Vasari, *Le vite de' più eccellenti architetti,
pittori, et scultori italiani [1550]*, ed. L. Bellosi
and A. Rossi, Turin 1986

Giorgio Vasari, *Le vite de' più eccellenti pittori
scultori ed architettori [1568]*, ed. G. Milanesi,
9 vols, Florence 1906

Giorgio Vasari, *Lives of the Artists*, trans. G. Bull,
Harmondsworth 1965

Vasari, see also Poggi, 1919; Lorini/Nova/Feser,
2006

E. Villata, *Leonardo da Vinci. I documenti e le testimo-
nianze contemporanee*, Milan 1999

Gasparo Visconti, *I canzonieri per Beatrice d' Este e
per Bianca Maria Sforza*, ed. P. Bongrani, Milan
1979

Jacobus da Voragine, *The Golden Legend*, trans.
W. G. Ryan, 2 vols, Princeton 1993

3. SECONDARY LITERATURE

A. A. Allison, "Antique Sources of Leonardo's
Leda", in: AB, 56, 1974, pp. 375–384

F. Ames-Lewis, "Drapery 'Pattern' Drawings in
Ghirlandaio's Workshop and Ghirlandaio's Early
Apprenticeship", in: AB, 63, 1981, pp. 49–62
(Ames-Lewis, 1981a)

F. Ames-Lewis, *Drawing in Early Renaissance Italy*,
New Haven/London 1981

F. Ames-Lewis/J. Wright, *Drawing in the Italian
Renaissance Workshop*, London 1983

F. Ames-Lewis, "Leonardo's Techniques", in:
Ames-Lewis (ed.), *Nine Lectures on Leonardo da
Vinci*, London 1990, pp. 32–44

C. Amoretti, *Memorie storiche su la vita, gli studi
e le opere di Leonardo da Vinci*, Milan 1804

D. Arasse, *Leonardo da Vinci. The Rhythm of the
World*, New York 1998 (first published Paris 1997)

M. Aronberg Lavin, "Giovannino Battista: A Study
in Renaissance Religious Symbolism", in: AB, 37,
1955, pp. 85–101

C. C. Bambach, "Leonardo, Tagliente, and Dürer:
'La scienza del far di groppi'", in: ALV, 4, 1991,
pp. 72–98

C. C. Bambach, *Drawing and Painting in the Italian
Renaissance Workshop. Theory and Practice, 1300–
1600*, Cambridge (Mass.) 1999

C. C. Bambach, "The Purchases of Cartoon
Paper for Leonardo's Battle of Anghiari and
Michelangelo's Battle of Cascina", in: *I Tatti
Studies*, 8, 1999, pp. 105–133

C. C. Bambach (ed.), *Leonardo da Vinci, Master Draftsman*, New York 2003

C. C. Bambach, "Leonardo and drapery studies on 'tela sottilissima de lino'", in: *Apollo*, 159 (503), 2004, pp. 44–55

C. C. Bambach, *Un' eredità difficile: I Disegni ed I manoscritti di Leonardo tra mito e documento* (Lettura Vinciana 47), Florence 2009

C. C. Bambach, "Seeking the Universal Painter", in: *Apollo*, 175 (595), 2012, pp. 82–85

M. Baratta, "Contributi alla storia della cartografia d'Italia III. La carta della Toscana di Leonardo da Vinci", in: *Memorie geografiche*, 5, 1911, pp. 5–76

M. Baratta, *I disegni geografici di Leonardo da Vinci conservati nel Castello di Windsor*, Rome 1941

P. Barolsky, "The Mysterious Meaning of Leonardo's Saint John the Baptist", in: *Source*, 8, 1989, pp. 11–15

S. Battaglia, *Grande dizionario della lingua italiana*, Turin 1961ff.

E. Battisti, "Le origini religiose del paesaggio veneto", in: *Venezia Cinquecento*, 1, 1991, vol. 2, pp. 9–25

M. Baxandall, *Giotto and the Orators. Humanist Observers of Painting in Italy and the Discovery of Pictorial Composition 1350–1450*, Oxford 1986 (first published 1971)

M. Baxandall, *Painting and Experience in Fifteenth-Century Italy. A Primer in the Social History of Pictorial Style*, 2nd edn, Oxford 1988 (first published 1972)

H. T. Beenken, "Zur Entstehungsgeschichte der Felsgrottenmadonna in der Londoner National Gallery", in: *Festschrift für Hans Jantzen*, ed. K. Bauch, Berlin 1951, pp. 132–140

S. Béguin, *Léonard de Vinci au Louvre*, Paris 1983

L. Behling: "Leonardo da Vincis Botanische Studien", in: *Die Pflanze in der mittelalterlichen Tafelmalerei*. pp. 101–110. Weimar 1957

W. Behringer et al., *Der Traum vom Fliegen. Zwischen Mythos und Technik*, Frankfurt/Main 1991

L. Beltrami, "La Sala delle Asse nel Castello di Milano decorata da Leonardo da Vinci nel 1498", in: *Rassegna d'arte*, 2, 1902, pp. 65–68, 90–93

L. Beltrami, "Il Musicista di Leonardo da Vinci", in: *RV*, 2, 1906, pp. 74–80

B. Berenson, *The Drawings of the Florentine Painters*, Chicago 1938

G. Berra, "La storia dei canoni proporzionali del corpo umano e gli sviluppi in area lombarda alla fine del Cinquecento", in: *RV*, 25, 1993, pp. 159–310

C. Bertelli, "Leonardo e l'Ultima Cena (ca. 1495–1497)", in: *Tecnica e stile: esempi di pittura murale del Rinascimento italiano*, ed. E. Borsook and F. Superbi Gioffredi, 2 vols, Florence 1986, pp. 31–42

L. Berti (ed.), *La Madonna Benois di Leonardo da Vinci a Firenze. Il capolavoro dell'Ermitage in mostra agli Uffizi*, Florence 1984

L. Berti (ed.), *Gli Uffizi*. Catalogo generale, Florence 1979

A. Beyer/W. Prinz (eds.), *Die Kunst und das Studium der Natur vom 14. zum 16. Jahrhundert*, Weinheim 1987

A. Blunt, *Artistic Theory in Italy 1450–1600*, Oxford 1940

G. Boas, "The Mona Lisa in the History of Taste", in: *Journal of the History of Ideas*, 1, 1940, pp. 207–224

P. P. Bober/R. Rubinstein, *Renaissance Artists and Antique Sculpture. A Handbook of Sources*, London/Oxford 1986

G. Bologna, *Milano e il stemma*, Milan 1989

G. Bora, *Due tavole leonardesche*. Nuove indagini sul Musico e sul San Giovanni dell'Ambrosiana, Vicenza 1987

G. Bora, "Prospettiva lineare e prospettiva, De Perdimenti: un dibattito sullo scorcio del Quattrocento", in: *Paragone*, 50 (595), 1999, pp. 3–45

E. Börsch-Supan, *Garten-, Landschafts- und Paradiesmotive im Innenraum. Eine ikonographische Untersuchung*, Berlin 1967



T. Brachert, "Finger-Maltechnik Leonardo da Vincis", in: *Maltechnik Restauro*, [75], 1969, pp. 33–45

T. Brachert, "A Distinct Aspect in the Painting Technique of the Ginevra de' Benci and of Leonardo's Early Works", in: *National Gallery of Art. Report and Studies in the History of Art*, [3], 1969 [1970], pp. 85–104

T. Brachert, "A Musical Canon of Proportion in Leonardo da Vinci's Last Supper", in: AB, 53, 1971, pp. 461–466

T. Brachert, "Radiographische Untersuchungen am Verkündigungsbild von Monte Oliveto", in: *Maltechnik Restauro*, [80], 1974, pp. 177–186

T. Brachert, "Die beiden Felsgrottenmadonnen von Leonardo da Vinci", in: *Maltechnik Restauro*, [83], 1977, pp. 9–24

P. Brambilla Barcilon/P. C. Marani, *Le lunette di Leonardo nel refettorio delle Grazie*, Milan 1990

P. Brambilla Barcilon/P. C. Marani, *Leonardo. L'ultima cena*, Milan 1999

H. Brammer, "Die Unterzeichnung eines Gemäldes aus dem Umkreis Leonardos", in: *Die Kunst und ihre Erhaltung. Rolf E. Straub zum 70. Geburtstag*, Worms 1990, pp. 169–176

S. Braunfels-Esche, *Leonardo da Vinci. Das anatomische Werk*, Stuttgart 1961

C. del Bravo, Rocce. "Sul significato d'un motivo in Leonardo e nei leonardeschi", in: AeH, 21, 2000, pp. 31–39

H. Bredekamp, "Die Erde als Lebewesen", in: *kritische berichte*, 9, 1981 (vol. 4/5), pp. 5–37

C. Brewis, "Leonardo? Convince Me", in: *The Sunday Times Magazine,* 9 October 2011, pp. 24–29

A. Brejon de Lavergnée, *L'inventaire Le Brun de 1683. La collection des tableaux de Louis XIV*, Paris 1987

D. A. Brown, "The London Madonna of the Rocks in the Light of two Milanese Adaptions", in: *Collaboration in Italian Renaissance Art*, ed. W. Stedman Sheard and J. T. Paoletti, New Haven/London 1978, pp. 167–177

D. A. Brown/K. Oberhuber, "Monna Vanna and Fornarina: Leonardo and Raphael in Rome", in: *Essays Presented to Myron P. Gilmore*, ed. S. Bertelli and G. Ramakus, 2 vols, Florence 1978, II, pp. 25–86

D. A. Brown, "Leonardo and the Idealized Portrait in Milan", in: AL, 67, 1983/1984, pp. 102–116

D. A. Brown, "Leonardo and the Ladies with the Ermine and the Book", in: AeH, 11, 1990, pp. 47–61

D. A. Brown, *Madonna Litta* (XXIX Lettura Vinciana), Florence 1990

D. A. Brown, *Leonardo da Vinci. Origins of a Genius*, New Haven/London 1998

D. A. Brown et al. (eds.), *Virtue and Beauty,* exh. cat., Washington, DC, 2001

A. Buck, *Humanismus. Seine europäische Entwicklung in Dokumenten und Darstellungen*, Munich 1987

D. Bull, "Two Portraits by Leonardo: Ginevra de' Benci and the Lady with an Ermine, in: AeH, 13, 1992, pp. 67–83

J. Burckhardt, *Die Kultur der Renaissance in Italien*, ed. H. Günther, Frankfurt 1997 (first published 1860)

M. Bury, "Leonardo, Non-Leonardo. The Madonna of the Yarnwinder", in: *Apollo*, 136, 1992, pp. 187–189

V. L. Bush, "Leonardo's Sforza Monument and Cinquecento Sculpture", in: AL, 50, 1978, pp. 47–68

H. C. Butters, *Governors and Government in Early Sixteenth-Century Florence 1502–1519*, Oxford 1985

J.K. Cadogan, "Linen drapery studies by Verrocchio, Leonardo and Ghirlandaio", in: ZfKG, 46, 1983, pp. 27-62

M. Calvesi, "Leda", in: *Leonardo. La pittura*, 1985, pp. 137–153

G. Calvi, "L'adorazione dei Magi di Leonardo da Vinci", in: RV, 10, 1919, pp. 1–44

G. Calvi, *I Manoscritti di Leonardo da Vinci dal punto di vista cronologico, storico e biografico*, Bologna 1925 (reprint Busto Arsizio 1982)

W. S. Cannell, "Leonardo da Vinci. The Virgin of the Rocks. A Reconsideration of the Documents

and a New Interpretation", in: GBA, 104, 1984, pp. 99–108

P. J. Cardile, "Oberservations on the Iconography of Leonardo da Vinci's Uffizi Annunciation", in: *Studies in Iconography*, 7–8, 1981/1982, pp. 189–208

F. Caroli, *Leonardo. Studi di fisiognomica*, Milan 1991

E. Casalini, *Una icona di famiglia. Nuovi contributi di storia e d'arte sulla SS. Annunziata di Firenze*, Florence 1998

R. Casciaro, *La scultura lignea lombarda del Rinascimento*, Milan 2000

G. Castelfranco, *Studi vinciani*, Rome 1966

A Catalogue of the Paintings at Doughty House Richmond & Elsewhere in the Collection of Sir Frederick Cook, Bt., Visconde de Monserrate, ed. by H. Cook. Volume I, *Italian Schools*, ed. by T. Borenius, London 1913

A Catalogue of Paintings and Drawings in the Collection at Wilton House, Salisbury. Compiled by Sidney Herbert Sixteenth Earl of Pembroke, London 1968

A. Cecchi, "Una predella e altri contributi per L'Adorazione dei Magi di Filippino", in: *Gli Uffizi. Studi e ricerche*, 5, 1988, pp. 59–72

A. Cecchi, "Niccolò Machiavelli o Marcello Virgilio Adriani? Sul programma e l'assetto compositivo delle Battaglie di Leonardo e Michelangelo per la Sala del Maggior Consiglio in Palazzo Vecchio", in: *Prospettiva*, 83–84, 1997, pp. 102–115

O. Cederlöf, "Leonardos Kampen om standaret", in: *Konsthistorisk Tidskrift*, 28 (9), 1959, pp. 73–98, and 30 (10), 1961, pp. 61–94

A. Chastel, *Le Madonne di Leonardo*, Florence 1979 (XVIII Lettura Vinciana)

A. Chastel, *Chronique de la peinture italienne à la Renaissance, 1280–1580*, Paris/Fribourg 1983

A. Chastel, *La Gioconda. L'illustre incompresa*, Milan 1989 (first published in French in 1988)

M. Cianchi, *Die Maschinen Leonardo da Vincis*, Florence 1988

R. P. Ciardi/C. Sisi, *L'Immagine di Leonardo. Testimonianze figurative dal XVI al XIX secolo*, Florence 1997

K. Clark/C. Pedretti, *The Drawings of Leonardo da Vinci in the Collection of Her Majesty the Queen at Windsor Castle*, 3 vols, London 1968–1969 (first published 1935)

M. Clayton, *Leonardo da Vinci. A Curious Vision*, London 1996

S. Clercx-Lejeune, "Fortuna Josquini. A proposito di un ritratto di Josquin des Prez", in: *Nuova Rivista Musicale Italiana*, 6, 1972, pp. 1–25

G. Colalucci, "Leonardo's St. Jerome: Notes on Technique, State of Conversation and its Restoration", in: *High Renaissance in the Vatican: The Age of Julius II and Leo X*, ed. M. Koshikawa, Tokyo 1993, pp. 109–110

J. Cox-Rearick, *La Collection de Francois Ier*, Paris 1962

E. Cropper, "The Beauty of Woman: Problems in the Rhetoric of Renaissance Portraiture", in: *Rewriting the Renaissance. The Discourses of Sexual Difference in Early Modern Europe*, ed. M. W. Ferguson et al., Chicago/London 1986, pp. 175–190, 355–359

J. Cunnally, "Numismatic Sources for Leonardo's Equestrian Monuments", in: ALV, 6, 1993, pp. 67–78

M. Dalivalle/M. Kemp/R. Simon, *Leonardo's Salvator Mundi and the Collecting of Leonardo da Vinci at the Stuart Courts* (in print)

B. F. Davidson, *Raphael's Bible. A Study of the Vatican Logge*, University Park/London 1985

M. Davies, *National Gallery Catalogues. The Earlier Italian Schools*, London 1951

B. Degenhart, "Eine Gruppe von Gewandstudien des jungen Fra Bartolomeo", in: *Münchner Jahrbuch der bildenden Kunst*, 11, 1934, pp. 222–231

V. Delieuvin (ed.), *La Sainte Anne, l'ultime chef-d'œuvre de Léonard de Vinci*, Paris 2012

Dessins italiens du Musée Condé à Chantilly. I. Autour de Pérugin, Filippino Lippi et Michel-Ange [C. Lanfranc de Panthou/B. Peronnet], Paris 1995

B. Dibner, "Maschinen und Waffen", in: Reti (ed.), 1996, pp. 166–189

L. Dimier, *Le Primatice*, Paris 1900

C. Dionisotti, "Leonardo uomo di lettere", in: *Italia medioevale e umanistica*, 5, 1962, pp. 183–216

A. Dülberg, *Privatporträts. Geschichte und Ikonologie einer Gattung im 15. und 16. Jahrhundert*, Berlin 1990

C. Echinger-Maurach, "'Gli occhi fissi nella somma bellezza del Figliuolo'. Michelangelo im Wett-streit mit Leonardos Madonnenconcepti der zweiten Florentiner Periode", in: *Michelangelo. Neue Beiträge*, ed. M. Rohlmann and A. Thielemann, Munich/Berlin 2000, pp. 113–150

S. Y. Edgerton, Jr., *The Renaissance Rediscovery of Linear Perspective*, New York etc. 1975

S. Y. Edgerton, Jr., "The Renaissance Development of the Scientific Illustration", in: *Science and the Arts in the Renaissance*, ed. J. W. Shirley and F. D. Hoeniger, Washington, DC, etc. 1985, pp. 168–197

K. R. Eissler, *Leonardo da Vinci. Psychoanalytic Notes on the Enigma*, New York 1961

J. Elkins, "The Case Against Surface Geometry", in: AH, 14, 1991, pp. 143–174

W. A. Emboden, *Leonardo da Vinci on Plants and Gardens*, Portland 1987

P. Emison, "Leonardo's Landscape in the Virgin of the Rocks", in: ZfKG, 56, 1993, pp. 116–118

B. Fabjan/P. C. Marani (eds.), *Leonardo. La dama con l'ermellino*, exh. cat., Rome 1998

E. Fahy, "The earliest works of Fra Bartolommeo", in: AB, 51, 1969, pp. 142-154

A. Falchetti, *La Pinacoteca Ambrosiana*, Vicenza 1969 (2nd edn. 1986)

C. J. Farago, *Leonardo da Vinci's "Paragone": A Critical Interpretation With a New Edition of the Text in the Codex Urbinas*, Leiden etc. 1992

C. J. Farago, "Leonardo's Battle of Anghiari: A Study in the Exchange Between Theory and Practice", in: AB, 76, 1994, pp. 301–330

F. Fehrenbach, *Licht und Wasser. Zur Dynamik naturphilosophischer Leitbilder im Werk Leonardo da Vincis*, Tübingen 1997

F. M. Feldhaus, *Leonardo der Techniker und Erfinder*, Jena 1922

S. Ferino-Pagden, "From Cult Images to the Cult of Images. The Case of Raphael's Altarpieces", in: P. Humfrey/M.Kemp (eds.), *The Altarpiece in the Renaissance*, Cambridge 1990, pp. 165–189

S. Ferino-Pagden (ed.), *"La prima donna del mondo". Isabella d' Este. Fürstin und Mäzenatin der Renaissance*, exh. cat., Vienna 1994

G. Ferri Piccaluga, "Sofia", in: ALV, 7, 1994, pp. 13–42

G. Ferri Piccaluga, "La prima versione della Vergine delle Rocce", in: ALV, 7, 1994, pp. 43–50

M. T. Fiorio, *Giovanni Antonio Boltraffio. Un pittore milanese nel lume di Leonardo*, Milan/Rome 2000

J. Fletcher, "Bernardo Bembo and Leonardo's Portrait of Ginevra de' Benci", in: BM, 131, 1989, pp. 811–816

B. B. Fredericksen, "Leonardo and Mantegna in the Buccleuch Collection", in: BM, 133, 1991, pp. 116–118

R. Fritz, "Zur Ikonographie von Leonardos Bacchus-Johannes", in: *Museion. Studien aus Kunst und Geschichte für Otto H. Förster*, Cologne 1960, pp. 98–101

G. Fumagalli, *Leonardo. "Omo sanza lettere"*, Florence 1952

L. Fusco/G. Corti, "Lorenzo de' Medici on the Sforza Monument", in: ALV, 5, 1992, pp. 11–32

P. Galluzzi, "The Career of a Technologist", in: *Leonardo. Engineer and Architect*, 1987, pp. 41–109

A. Gamberini/F. Somaini, *L'Età dei Visconti e degli Sforza: 1277–1535*, Milan 2001

C. Gandelmann, "Der Gestus des Zeigers", in: Kemp, 1992, pp. 71–93

J. Gantner, *Leonardos Visionen von der Sintflut und vom Untergang der Welt*, Berne 1958

M. D. Garrard, "Who Was Ginevra de' Benci? Leonardo's Portrait and Its Sitter Recontextualized", in: AeH, 27 (53) 2006, pp. 23–56

C. Gibbs-Smith, *The Inventions of Leonardo da Vinci*, Oxford 1978

E. Gibson, "Leonardo's Ginevra de' Benci. The Restauration of a Renaissance Masterpiece", in: *Apollo*, 133, 1991, pp. 161–165

C. Gilbert, "Last Suppers and their Refectories", in: *The Pursuit of Holiness in Late Medieval and Renaissance Religion*, ed. Charles Trinkaus and Heiko A. Obermann, Leyden 1974, pp. 371–407

Gilbert, see also 2.2. Sources

L. Giordano, "L'autolegittimazione di una dinastia: gli Sforza e la politica dell'immagine", in: *Artes*, 1, 1993, pp. 7–33

L. Giordano, *Ludovicus Dux: L'immagine del potere*, Vigevano 1995

H. Glasser, *Artists' Contracts of the Early Renaissance*, PhD thesis 1965, New York 1977

R. Goffen, *Icon and Vision: The Half-Length Madonna of Giovanni Bellini*, PhD thesis, New York 1974, Ann Arbor 1976

L. Goldscheider, *Leonardo da Vinci, Life and Work, Paintings and Drawings*, London 1959.

E. H. Gombrich, "Leonardo's Grotesque Heads. Prolegomena to Their Study", in: *Leonardo. Saggi e ricerche*, 1954, pp. 199–219

E. H. Gombrich, "Leonardo's Method of Working out Compositions", in: Gombrich, *Norm and Form*, Oxford 1966, pp. 58–63 (first published in French in 1954)

E. H. Gombrich, "The Form of Movement in Water and Air", in: Gombrich, 1976, pp. 39–56

E. H. Gombrich, *The Heritage of Apelles*, London 1976 (Gombrich 1976a)

E. H. Gombrich, "Ideal and Type in Italian Renaissance Painting", in: Gombrich, *New Light on Old Masters*, Oxford 1986, pp. 89–124

M. Goukowsky, "Du nouveau sur Léonard de Vinci. Léonard et Janus Lascaris", in: *Bibliothèque d'humanisme et renaissance*, 19, 1957, pp. 7–13

C. Gould, "The Newly-Discovered Documents Concerning Leonardo's Virgin of the Rocks and their Bearing on the Problem of the Two Versions", in: AeH, 2, 1981, pp. 73–76

C. Gould, "La Vergine delle Rocce", in: *Leonardo. La pittura*, 1985, pp. 56–63

C. Gould, "Leonardo's Madonna of the Yarnwinder. Revelations of Reflectogram Photography", in: *Apollo*, 136, 1992, 365, pp. 12–16

C. Gould, "The Early History of Leonardo's Vierge aux Rochers", in: GBA, 124, 1994, pp. 216–222

G. Gronau, "Ein Jugendwerk des Leonardo da Vinci", in: *Zeitschrift für Bildende Kunst*, 23, 1912, pp. 253–259

S. Grossman, "The Madonna and Child with a Pomegranate and Some Paintings from the Circle of Verrocchio", in: *National Gallery of Art. Report and Studies in the History of Art*, [2], 1968, pp. 47–69

J. Guiffrey, "La Collection de M. Gustave Dreyfus II", in: *Les artes*, [17], 1908, fasc. 71, p. 2015

J. Guillaume, "Leonardo and Architecture", in: *Leonardo. Engineer and Architect*, 1987, pp. 207–286

M. A. Gukovskij, *Madonna Litta* [in Russian], Moscow 1959

S. Hager (ed.), *Leonardo, Michelangelo, and Raphael in Renaissance Florence from 1500 to 1508*, Washington, DC, 1992

N. Hamilton, *Die Darstellung der Anbetung der heiligen drei Könige in der toskanischen Malerei von Giotto bis Lionardo*, Strasburg 1901

E. Harding/A. Braham et al., "The Restoration of the Leonardo Cartoon", in: *National Gallery Technical Bulletin*, 13, 1989, pp. 4–27

J. B. Harley/D. Woodward (eds.), *The History of Cartography I*, Chicago/London 1987

F. Hartt, "Leonardo and the Second Florentine Republic", in: *Journal of the Walters Art Gallery*, 44, 1983, pp. 95–116

R. Hatfield, "The Compagnia de' Magi", in: JWCI, 33, 1970, pp. 107–161

R. Hatfield, *Botticelli's Uffizi "Adoration". A Study in Pictorial Content*, Princeton 1976

R. Hatfield, *The Three Mona Lisas*, Milan 2014

G. W. F. Hegel, *Vorlesungen über die Philosophie der Geschichte* (Werke, XII), 4th edn., Frankfurt 1995 (first published 1832–1845)

J. S. Held, Rubens. *Selected Drawings*, 2ⁿᵈ edn, Oxford 1986

[P. Hendy], *National Gallery Catalogues. Acquisitions 1953–1962*, London, undated [1963]

V. Herzner, *Jan van Eyck und der Genter Altar*, Worms 1995

L. H. Heydenreich, *Die Sakralbau-Studien Leonardo da Vinci's*, Leipzig 1929

L. H. Heydenreich, "La Sainte-Anne de Léonard de Vinci", in: GBA, 10, 1933, pp. 205–219 (also in Heydenreich, 1988, pp. 13–22)

L. H. Heydenreich, "Vier Bauvorschläge Lionardo da Vincis an Sultan Bajezid II.", in: Heydenreich, 1988, pp. 53–60 (first published in *Nachrichten der Akademie der Wissenschaften, Göttingen, Philosophisch-Historische Klasse*, no. 1, 1952)

L. H. Heydenreich, *Leonardo da Vinci*, 2 vols, Basle 1953

L. H. Heydenreich, "Leonardos Salvator Mundi", in: RV, 20, 1964, pp. 83–109

L. H. Heydenreich, "Bemerkungen zu den Entwürfen Leonardos für das Grabmal Gian Giacomo Trivulzios", in: Heydenreich, 1988, pp. 123–134 (first published in the Festschrift for T. Müller, 1965)

L. H. Heydenreich, *The Last Supper*, London 1974

L. H. Heydenreich, "La Madonna del Garofano", in: *Leonardo. La pittura*, 1985, pp. 29–45

L. H. Heydenreich, *Leonardo-Studien*, (ed.) G. Passavant, Munich 1988

L. H. Heydenreich, "Der Festungsbaumeister", in: Reti (ed.), 1996, pp. 136–165

R. Hiller von Gaertringen, *Raffaels Lernerfahrung in der Werkstatt Peruginos. Kartonverwendung und Motivübernahme im Wandel*, Munich 1999

R. Hiller von Gaertringen, "Drawing and Painting in the Italian Renaissance Workshop" [rev. by Bambach, 1999], in: *Apollo*, 153, 2001 (no. 3), pp. 53–54

P. Hills, "Leonardo and Flemish Painting", in: BM, 122, 1980, pp. 609–615

A. M. Hind, "A Chiaroscuro Woodcut after Leonardo da Vinci", in: BM, 91, 1949, pp. 164–165

Hochrenaissance im Vatikan. Kunst und Kultur im Rom der Päpste I, 1503–1534, exh. cat., Bonn 1998

B. Hochstetler Meyer, "Louis XII, Leonardo, and the Burlington House Cartoon", in: GBA, 86, 1975, pp. 105–109

B. Hochstetler Meyer, "Leonardo's Hypothetical Painting of Leda and the Swan", in: MKIF, 34, 1990, pp. 279–294

V. Hoffmann, "Leonardos Ausmalung der Sala delle Asse im Castello Sforzesco", in: MKIF, 16, 1972, pp. 51–62

W. Hood, *Fra Angelico at San Marco*, New Haven/London 1993

C. Hope, "The Wrong Leonardo", in: *The New York Review of Books*, 9 February 2012

H. Horne, *The Life of Leonardo da Vinci by Giorgio Vasari*, London 1903

M. Hours, "Étude analytique des tableaux de Léonard de Vinci au Laboratoire du Musée du Louvre", in: *Leonardo. Saggi e ricerche*, 1954, pp. 13–25

M. Hours, "A propos de l'examen au laboratoire de la Vierge aux Rochers et du Saint Jean-Baptiste de Léonard", in: RV, 19, 1962, pp. 123–128

Il disegno fiorentino del tempo di Lorenzo il Magnifico, exh. cat., Florence 1992

C. A. Isermeyer, "Die Arbeiten Leonardos und Michelangelos für den grossen Ratssaal in Florence", in: *Studien zur Toskanischen Kunst. Festschrift for L. H. Heydenreich*, Munich 1964, pp. 83–130

B. Jestaz, "François Ier, Salaì et les tableaux de Léonard", in: *Revue de l'art*, 126, 1999, pp. 68–72

G. Kaftal, *Iconography of the Saints in Tuscan Painting*, Florence 1952

G. Kaftal, *Iconography of the Saints in Central and South Italian Schools of Painting*, Florence 1965

T. da Costa Kaufmann, "The Perspective of Shadows: The History of the Theory of Shadow Projection", in: JWCI, 38, 1975, pp. 258–287

K. D. Keele, *Leonardo da Vinci's Elements of the Science of Man*, New York/London etc. 1983

H. Kehrer, *Die heiligen drei Könige in Literatur und Kunst*, 2 vols, Leipzig 1908–1909

L. Keith/A. Roy, "Giampietrino, Boltraffio, and the Influence of Leonardo", in: *National Gallery Technical Bulletin*, 17, 1996, pp. 4–19

M. Kemp, "'Il concetto dell'anima' in Leonardo's Early Skull Studies", in: JWCI, 34, 1971, pp. 115–134

M. Kemp, "Dissection and Divinity in Leonardo's Late Anatomies", in: JWCI, 35, 1972, pp. 200–225

M. Kemp, "'Ogni dipintore dipinge sé': A Neoplatonic Echo in Leonardo's Art Theory?", in: *Cultural Aspects of the Italian Renaissance. Essays in Honour of Paul Oskar Kristeller*, ed. C. H. Clough, New York 1976, pp. 311–323

M. Kemp/A. Smart, "Leonardo's Leda and the Belvedere River-Gods", in: AH, 3, 1980, pp. 182–193

M. Kemp, "Leonardo da Vinci. Science and the Poetic Impulse", in: *The Royal Society of the Encouragement of Arts, Manufactures and Commerce Journal*, 133, 1983, fasc. 5343, pp. 196–214

M. Kemp, *Leonardo e lo spazio dello scultore*, Florence 1988

M. Kemp/J. Roberts (eds.), *Leonardo da Vinci*, exh. cat., London 1989

M. Kemp, *The Science of Art. Optical Themes in Western Art from Brunelleschi to Seurat*, New Haven/London 1990

M. Kemp (ed.), *Leonardo da Vinci. The Mystery of the "Madonna of the Yarnwinder"*, Edinburgh 1992

M. Kemp, "From Scientific Examination to the Renaissance Art Market: The Case of Leonardo da Vinci's Madonna of the Yarnwinder", in: *Journal of Medieval and Renaissance Studies*, 24, 1994, pp. 259–274

M. Kemp, *Der Blick hinter die Bilder. Text und Kunst in der italienischen Renaissance*, Cologne 1997

M. Kemp, *Leonardo da Vinci. The Marvellous Works of Nature and Man*, Oxford 2006 (first published 1981)

Kemp, see also 2.1. Leonardo

W. Kemp (ed.), *Der Betrachter ist im Bild. Kunstwissenschaft und Rezeptionsästhetik*, 2nd edn, Berlin 1992

M. Keynes, "The Iconography of Leonardo's London Cartoon", in: GBA, 117, 1991, pp. 147–158

D. Kiang, "Gasparo Visconti's Pasitea and the Sala delle Asse", in: ALV, 2, 1989, pp. 101–109

W. Köhler, "Michelangelos Schlachtkarton", in: *Kunstgeschichtliches Jahrbuch der kaiserlich-königlichen Zentralkommission*, 1, 1907, pp. 115–172

S. Kress, *Das autonome Porträt in Florence*, PhD thesis, Gießen 1995

S. Kress, "Memlings Triptychon des Benedetto Portinari und Leonardos Mona Lisa – Zur Entwicklung des weiblichen Dreiviertelporträts im Florentiner Quattrocento", in: C. Kruse/F. Thürlemann (eds.), *Porträt – Landschaft – Interieur. Jan van Eycks Rolin-Madonna im ästhetischen Kontext*, Tübingen 1999, pp. 219–235

A. Kreul, *Leonardo da Vincis Hl. Johannes der Täufer. Sinnliche Gelehrsamkeit oder androgynes Ärgernis?* Osterholz-Scharmbeck 1992

E. Kris/O. Kurz, *Die Legende vom Künstler. Ein geschichtlicher Versuch*, Frankfurt/Main 1980 (first published 1934)

P. O. Kristeller, *Humanismus und Renaissance*, 2 vols, Munich 1976

H. Kühn, "Naturwissenschaftliche Untersuchung von Leonardos Abendmahl in Santa Maria delle Grazie in Milan", in: *Maltechnik Restauro*, 91 (4), 1985, pp. 24–51

R. Kultzen, *Alte Pinakothek München. Katalog V. Italienische Malerei*, Munich 1975

T. K. Kustodieva, *The Hermitage. Catalogue of Western European Painting. Italian Painting. Thirteenth to Sixteenth Centuries*, Florence 1994

M. W. Kwakkelstein, *Leonardo da Vinci as a Physiognomist. Theory and Drawing Practice*, Leiden 1994

K. Kwiatkowski, *"La Dame à l'Hermine" de Léonard de Vinci. Étude technologique*, Wroclaw 1955

L'Annunciazione di Leonardo. La montagna sul mare, ed. A. Natali, place of publication not given, 2000 [2001]

D. Laurenza, *"De figura umana"*. *Fisiognomica, anatomia e arte in Leonardo*, Florence 2001

J. M. Lehmann, *Staatliche Kunstsammlungen Kassel. Gemäldegalerie Alte Meister, Schloss Wilhelmshöhe. Italienische, französische und spanische Gemälde des 16. bis 18. Jahrhunderts*, Fridingen 1908

I Leonardeschi ai raggi "X", ed. M. P. Garberi, Milan 1972

Leonardo da Vinci, New York, undated [c. 1965] (first published Novara 1939)

Leonardo da Vinci. Die Gewandstudien, exh. cat., Munich/Paris/London 1989

Leonardo da Vinci. Engineer and Architect, exh. cat., Montreal 1987

Leonardo da Vinci. Natur und Landschaft. Naturstudien aus der Königlichen Bibliothek in Windsor Castle, exh. cat., Stuttgart/Zurich 1983

Leonardo da Vinci's Sforza Monument Horse. The Art and the Engineering, ed. D. Cole Ahl, London 1995

Leonardo e il mito di Leda, ed. G. dalli Regoli, R. Nanni and A. Natali, exh. cat., Vinci 2001

Leonardo e l'età della ragione, ed. E. Bellone and P. Rossi, Milan 1982

Leonardo e le vie d'aqua, exh. cat., Florence 1983

Leonardo e l'incisione. Stampe derivate da Leonardo e Bramante dal XV al XIX secolo, ed. C. Alberici, exh. cat., Milan 1984

Leonardo & Venezia, exh. cat., Milan 1992

Leonardo. La pittura, ed. M. Alpatov, D. Arasse et al., 2nd edn., Florence 1985 (first published 1977)

Leonardo. Saggi e ricerche, Rome 1954

M. Lessing, *Die Anghiari-Schlacht des Leonardo da Vinci. Vorschläge zur Rekonstruktion*, Quakenbrück 1935

F. Leverotti, "La crisi finanziaria del ducato di Milano alla fine del Quattrocento", in: *Milano nell'età di Lodovico il Moro. Atti del convegno internazionale 1983*, 2 vols, Milan 1983, II, pp. 585–632

M. Levi d'Ancona, "La Vergine delle Rocce di Leonardo: studio iconografico delle due versioni di Parigi e di Londra", in: AL, 1, 1955, pp. 98–104

M. Levi d'Ancona, *The Iconography of the Immaculate Conception in the Middle Ages and Early Renaissance*, place of publication not given, 1957

J. Liebrich, *Die Verkündigung an Maria. Die Ikonographie der italienischen Darstellungen von den Anfängen bis 1500*, Cologne 1997

R. Lightbown, *Mantegna*, Oxford 1986

D. C. Lindberg, *Theories of Vision from al-Kindi to Kepler*, Chicago & London 1976

K. Lippincott, "The Art of Cartography in Fifteenth-Century Florence", in: *Lorenzo the Magnificent. Culture and Politics*, ed. M. Mallet and N. Mann, London 1996, pp. 131–149.

M. Lisner, "Leonardos Anbetung der Könige. Zum Sinngehalt und zur Komposition", in: ZfKG, 44, 1981, pp. 201–242

P. O. Long, "Picturing the Machine: Francesco di Giorgio and Leonardo da Vinci in the 1490s", in: *Picturing Machines 1400–1700*, Wolfgang Lefèvre (ed.), Cambridge 2004, pp. 117–141

Maestri e botteghe. Pittura a Firenze alla fine del Quattrocento, ed. M. Gregori et al., exh. cat., Florence/Milan 1992

F. Malaguzzi-Valeri, *La corte di Lodovico il Moro*, 4 vols, Milan 1915–1923

É. Mâle, "Les Rois mages et le drame liturgique", in: GBA, 4, 1910, pp. 261–270

P. C. Marani, *L'architettura fortificata negli studi di Leonardo da Vinci*, Florence 1984

P. C. Marani, *Leonardo e i leonardeschi a Brera*, Florence 1987

P. C. Marani, *Leonardo. Catalogo completo dei dipinti*, Florence 1989

P. C. Marani, *Leonardo e i leonardeschi nei musei della Lombardia*, Milan 1990

P. C. Marani, "I dipinti di Leonardo, 1500–1507. Per una cronologia", in: Hager (ed.), 1992, pp. 1–28

P. C. Marani, "Giovan Pietro Rizzoli detto il Giampietrino", in: *I Leonardeschi. L'eredità di Leonardo in Lombardia*, Milan 1998, pp. 275–300

P. C. Marani, *Leonardo. Una carriera di pittore*, Milan 1999

A. Marinoni, *I rebus di Leonardo da Vinci raccolti e interpretati*, Florence 1954

J. R. Mariotti, *Mona Lisa. La 'Gioconda' del Magnifico Giuliano*, Florence 2009

G. Martelli, "Il refettorio di Santa Maria delle Grazie in Milano e il restauro di Luca Beltrami nell'ultimo decennio dell'Ottocento", in: *Bollettino d'arte*, 65, 1980, pp. 55–72

I. Marzik, "Die Gestik in der *Storia* Leon Battista Albertis", in: Beyer/Prinz (ed.), 1987, pp. 277–288

R. McMullen, *Mona Lisa. The Picture and the Myth*, London 1976

J. Meder, *Die Handzeichnung*, Vienna 1919

P. Meller, "La Battaglia d' Anghiari", in: *Leonardo. La pittura*, 1985, pp. 130–136

C. Merzenich, *Vom Schreinerwerk zum Gemälde. Florentiner Altarwerke der ersten Hälfte des Quattrocento*, Berlin 2001

J. Meyer/W. v. Bode, *Königliche Museen. Gemälde-Galerie. Beschreibendes Verzeichnis*, Berlin 1878

J. Meyer zur Capellen, *Raphael in Florence*, Munich/London 1996

J. Meyer zur Capellen, *Raphael. A Critical Catalogue of His Paintings*, I, Landshut 2001

P. Micheli, "Alla ricerca della prima sala", in: *Notiziario del Comune* [di Firenze], no. 3/4, 1971, pp. 20–22

K. Moczulska, "Najpiekniejsza Gallerani i najdoskolalsza Gallen w portrecie namalowanym przez Leonarda da Vinci (The Most Graceful and the Most Exquisite gallée in the Portrait of Leonardo da Vinci)", in: *Folia historiae artium*, 1, 1995, pp. 55–76 (in Polish), 77–86 (in English)

D. D. Modestini, "The Salvator Mundi by Leonardo da Vinci", in: *Leonardo da Vinci's Technical Practice*, ed. by M. Menu, Paris 2014, pp. 139–151

J.-P. Mohan (ed.), *"Mona Lisa". Inside the Painting*, New York 2006

E. Möller, "Leonardo's Madonna with the Yarnwinder", in: BM, 49, 1926, pp. 61–68

E. Möller, "Leonardos Madonna mit der Nelke in der Älteren Pinakothek", in: *Münchner Jahrbuch der bildenden Kunst*, 12, 1937, pp. 5–40

E. Möller, "Leonardos Bildnis der Ginevra dei Benci", in: *Münchener Jahrbuch der bildenden Kunst*, 12, 1937/1938, pp. 185–209

E. Möller, *Das Abendmahl des Lionardo da Vinci*, Baden-Baden 1952

B. Morley, "The Plant Illustrations of Leonardo da Vinci", in: BM, 121, 1979, pp. 553–560

P. L. Mulas, "'Cum aparatu ac triumpho quo pagina in hac licet aspicere'. L'investitura ducale di Ludovico Sforza, il messale Arcimboldi e alcuni problemi di miniatura Lombarda", in: *Artes*, 2, 1994, pp. 5–38

P. Müller-Walde, "Beiträge zur Kenntnis des Leonardo da Vinci", in: *Jahrbuch der Königlich Preussischen Kunstsammlungen*, 18, 1897, pp. 92–169 [I–II]; 19, 1898, pp. 225–266 [III–IV]; 20, 1899, pp. 54–116 [V–VII]

E. J. Mundy, "Porphyry and the Posthumous Fifteenth Century Portrait", in: *Pantheon*, 46, 1988, pp. 37–43

A. Nagel, "Leonardo and sfumato", in: *RES. anthropology and aesthetics*, 24, 1993, pp. 7–20

A. Natali, "Lo Sguardo degli angeli. Tragitto indiziario per il Battesimo di Cristo di Verrocchio e Leonardo", in: MKIF, 42, 1998, pp. 252–273

A. Natali, "Il tempio e la radice", in: E. Cropper (ed.), *Florentine Drawing at the Time of Lorenzo the Magnificent*, Bologna 1994, pp. 147–156

J. Nathan, "Some Drawing Practices of Leonardo da Vinci: New Light on the Saint Anne", in: MKIF, 36, 1992, pp. 85–102

J. Nathan, *The Working Methods of Leonardo da Vinci and Their Relation to Previous Artistic Practice*, PhD thesis, London (Courtauld Institute of Art) 1995

J. Nathan, "Kunst und Naturbetrachtung. Funktionale Bildformeln im Werk Leonardos", in: F. Fehrenbach (ed.), *Leonardo da Vinci*, Munich 2002

J. Nathan, "Grammatik der Erfindung. Zur künstlerischen Arbeitsmethode bei Leonardo da Vinci", in: *Leonardo da Vinci all'Europa. Einem Mythos auf den Spuren (Romanice* vol. 22), M. Huberty/R. Ubbidiente (eds.), Berlin 2005, pp. 35–57

J. Nathan/F. Zöllner, *Leonardo da Vinci.
The Graphic Work*, Cologne 2014

J. Nelson, "The High Altarpiece of SS. Annunziata
in Florence: History, Form, and Function", in:
BM, 139, 1997, pp. 84–94

G. Neufeld, "Leonardo da Vinci's Battle of
Anghiari: A Genetic Reconstruction", in: AB, 31,
1949, pp. 170–183

A. Nova, "Die Legende des Künstlers: Beuys
und Leonardo", in: *Der Codex Leicester*, exh. cat.
Munich/Berlin 1999, pp. 59–69

A. Nova, "'La dolce morte'. Die anatomischen
Zeichnungen Leonardo da Vincis als Erkenntnis-
mittel und reflektierte Kunstpraxis", in: *Zeit-
sprünge. Forschungen zur Frühen Neuzeit*, 9, 2005,
pp. 136–163

C. D. O'Malley/J. B. de C. M. Saunders, *Leonardo
da Vinci on the Human Body*, New York 1952

H. Ost, *Leonardo-Studien*, Berlin/New York 1975

H. Ost, *Das Leonardo-Porträt in der Kgl. Bibliothek
Turin und andere Fälschungen des Giuseppe Bossi*,
Berlin 1980

A. Ottino della Chiesa, *Bernardino Luini*,
Novara 1956

W. and E. Paatz, *Die Kirchen von Florence*, 6 vols,
Frankfurt/Main 1940–1954

E. Panofsky, "Die Entwicklung der
Proportionslehre als Abbild der Stilentwicklung",
in: *Monatshefte für Kunstwissenschaft*, 14, 1921,
pp. 188–219

E. Panofsky, *Studies in Iconology. Humanistic Themes
in the Art of the Renaissance*, New York 1962
(first published 1939)

G. Passavant, *Andrea del Verrocchio als Maler*,
Düsseldorf 1959

G. Passavant, *Verrocchio. Sculptures, Paintings and
Drawings*, London 1969.

C. Pedretti, *Studi vinciani*, Geneva 1957

C. Pedretti, *Leonardo da Vinci. Fragments at Windsor
Castle from the Codex Atlanticus*, London 1957
(Pedretti, 1957a)

C. Pedretti, "A Ghost Leda", in: RV, 20, 1964,
pp. 379–383

C. Pedretti, "A Sonnet by Giovan Paolo Lomazzo
on the Leda of Leonardo", in: RV, 20, 1964,
pp. 374–378

C. Pedretti, *Leonardo da Vinci on Painting. A Lost Book
(Libro A)*, London 1965 (first published 1964)

C. Pedretti, *Leonardo da Vinci inedito. Tre saggi*,
Florence 1968

C. Pedretti, "The Burlington House Cartoon",
in: BM, 110, 1968, pp. 22–28

C. Pedretti, *Leonardo da Vinci. The Royal Palace
at Romorantin*, Cambridge (Mass.) 1972

C. Pedretti, *Leonardo. A Study in Chronology and
Style*, New York/London 1973

C. Pedretti, *The Literary Works of Leonardo da Vinci.
Commentary*, 2 vols, Oxford 1977

C. Pedretti, *Leonardo da Vinci Architekt*, Stuttgart/
Zurich 1980 (first published in Italian in 1978)

C. Pedretti, "Leonardo dopo Milano", in: Vezzosi,
1983, pp. 43–59

C. Pedretti, *Studies for the Last Supper from the Royal
Library at Windsor Castle*, Washington, DC, 1983
(Pedretti, 1983a)

C. Pedretti, *Leonardo. Il Codice Hammer e la Mappa
di Imola*, Florence 1985

C. Pedretti, "Leonardo at the Städel Museum",
in: ALV, 2, 1989, pp. 166–167

C. Pedretti, "La dama dell'ermellino come alle-
goria politica", in: *Studi politici in onore di Luigi
Firpo*, ed. S. Rota Ghibaudi et al., I, Milan 1990,
pp. 161–181

C. Pedretti, "Mirator veterum", in: ALV, 4, 1991,
pp. 253–255

C. Pedretti, "The Mysteries of a Leonardo
Madonna, Mostly Unsolved", in: ALV, 5, 1992,
pp. 169–175

C. Pedretti, "Leonardo in Sweden", in: ALV, 6,
1993, pp. 200–211

C. Pedretti/J. Roberts (ed.), *Leonardo da Vinci.
Drawings of Horses and Other Animals from the
Royal Library at Windsor Castle*, New York 1984

A. Perrig, "Leonardo: Die Anatomie der Erde", in:
Jahrbuch der Hamburger Kunstsammlungen, 25, 1980,
pp. 51–80

A. Perrig, "Masaccios Trinità und der Sinn der Zentralperspektive", in: *Marburger Jahrbuch für Kunstwissenschaft*, 21, 1986, pp. 11–43

U. Pfisterer, "Künstlerische 'potestas audendi' und 'licentia' im Quattrocento", in: *Römisches Jahrbuch der Bibliotheca Hertziana*, 31, 1996, pp. 107–148

F. Piel, *Tavola Doria: Leonardo da Vincis modello zu seinem Wandgemälde der "Anghiarischlacht"*, Munich 1995

A. Pizzorusso, "Leonardo's Geology: A Key to Identifying the Works of Boltraffio, D'Oggiono and Other Artists", in: RV, 27, 1997, pp. 357–371

Poggi, See 2.2. Other Sources

F. Polcri (ed.), *Una Battaglia nel Mito*, Florence 2002 (forthcoming)

J. Polzer, "The Perspective of Leonardo Considered as a Painter", in: M. Dalai Emiliani (ed.), *La prospettiva rinascimentale. Codificazioni e trasgressioni*, Florence 1980, pp. 233–247

J. Pope-Hennessy, *The Portrait in the Renaissance*, Princeton 1966

A. E. Popham, *The Drawings of Leonardo da Vinci With a New Introductory Essay by M. Kemp*, London 1994 (first published 1946)

A. E. Popham/P. Pouncey, *Italian Drawings in the Department of Prints and Drawings in the British Museum, The Fourteenth and Fifteenth Centuries*, 2 vols, London 1950

A. E. Popp, *Leonardo da Vinci: Zeichnungen*, Munich 1928

H. Posse, *Königliche Museen zu Berlin. Die Gemäldegalerie des Kaiser-Friedrich-Museums. Vollständiger beschreibender Katalog. Erste Abteilung. Die Romanischen Länder*, Berlin 1909

A. Prater, "Sehnsucht nach dem Chaos. Versuch über das Sfumato der Mona Lisa", in: *Ikonologie und Didaktik. Begegnungen zwischen Kunstwissenschaft und Kunstpädagogik*, ed. J. Kirschenmann et al., Weimar 1999, pp. 89–105

Prima di Leonardo. Cultura delle macchine a Siena nel Rinascimento, ed. P. Galluzzi, Milan 1991

Raffaello a Firenze, exh. cat., Florence 1984

K. M. Reeds, "Leonardo da Vinci and Botanical Illustration. Nature Prints, Drawings, and Woodcuts circa 1500", in: *Visualizing Medieval Medicine and Natural History, 1200–1550*, Jean A. Givens (ed.), Aldershot etc. 2006, pp. 205–237

G. dalli Regoli, *Mito e scienza nella "Leda" di Leonardo* (XXX Lettura Vinciana), Florence 1991

G. dalli Regoli, "Leonardo e Michelangelo: il tema della Battaglia agli inizi del Cinquecento", in: ALV, 7, 1994, pp. 98–106

S. V. Reit, *The Day They Stole the Mona Lisa*, New York 1981

Renaissance Engineers from Brunelleschi to Leonardo da Vinci, exh. cat., ed. P. Galluzzi, Florence 1996

L. Reti (ed.), *Leonardo. Künstler, Forscher, Magier*, Cologne 1996

S. de Ricci, *Description raisonnée de peintures du Louvre*, Paris 1913

E. F. Rice, *Saint Jerome in the Renaissance*, Baltimore/London 1985

I. A. Richter, *Paragone. A Comparison of the Arts by Leonardo da Vinci*, London 1949

D. Rigaux, *A la table du Seigneur. L'Eucharistie chez les primitifs italiens (1250–1497)*, Paris 1989

Rinascimento da Brunelleschi a Michelangelo. La Rappresentazione dell'architettura, exh. cat., Milan 1994

C. Robertson, "Leonardo da Vinci", in: BM, 154, 2012, pp. 132–133

D. Robertson, "'In Foraminibus Petrae': A Note on Leonardo's Virgin of the Rocks", in: *Renaissance News*, 7, 1954, pp. 92–95

M. Rosheim, *Leonardo's Lost Robots*, Berlin etc. 2006

M. Rossi/A. Rovetta, *Il Cenacolo di Leonardo. Cultura domenicana, iconografia eucaristica e tradizione lombarda*, Milan 1988

M. Rossi/A. Rovetta, *La Pinacoteca Ambrosiana*, Milan 1997

P. Rubin, "Commission and Design in Central Italian Altarpieces c. 1450–1550", in: E. Borsook/F. Superbi Gioffredi (eds.), *Italian Altarpieces 1250–1550. Function and Design*, Oxford 1994, pp. 201–230

N. Rubinstein, "Machiavelli and the Mural Decoration of the Hall of the Great Council of Florence", in: *Musagetes. Festschrift for Wolfgang Prinz*, ed. R. Kecks, Berlin 1991, pp. 275–285

J. Ruda, *Fra Filippo Lippi. Life and Work with a Complete Catalogue*, London 1993

J. Rudel, "Bacco e San Giovanni Battista", in: *Leonardo. La pittura*, 1985, pp. 121–128

M. Rzepinska, "Light and Shadow in the Late Writings of Leonardo da Vinci", in: RV, 19, 1962, pp. 259–266

A. Salzer, *Die Beinamen Mariens in der deutschen Literatur und der lateinischen Hymnenpoesie des Mittelalters*, Linz 1893

D. Sassoon, *Leonardo and the Mona Lisa Story: The History of a Painting Told in Pictures*, London 2006

C. Scailliérez, "La Vierge à l'Enfant avec sainte Anne de Léonard de Vinci: questions et hypothèses", in: *Au Louvre avec Viviane Forester*, Paris 2000, pp. 31–55

C. Scailliérez, *Léonard de Vinci. La Joconde*, Paris 2003

M. Schapiro, "Leonardo and Freud: An Art-Historical Study", in: *Journal of the History of Ideas*, 17, 1956, pp. 147–178

A. Scharf, *Filippino Lippi*, Vienna 1935

M. Schneider, 2000, see 2.1. Leonardo da Vinci, *Der Vögel Flug*

R. Schofield, "Amadeo, Bramante and Leonardo and the 'tiburio' of Milan Cathedral", in: ALV, 2, 1989, pp. 68–100

R. Schofield, "Leonardo's Milanese Architecture: Career, Sources and Graphic Techniques", in: ALV, 4, 1991, pp. 111–157

K. Schreiner, "Marienverehrung, Lesekultur, Schriftlichkeit. Bildungs und frömmigkeits-geschichtliche Studien zur Auslegung und Darstellung von Mariä Verkündigung", in: H. Keller/J. Wollasch (eds.), *Frühmittelalterliche Studien* (24. Jahrbuch des Instituts für Frühmittel-alterforschung der Universität Münster), Berlin/New York 1990, pp. 314–368

A. Schug, "Zur Ikonographie von Leonardos Londoner Karton", in: *Pantheon*, 26, 1968, pp. 446–455, and ibid., 27, 1969, pp. 24–35

D. Sedini, *Marco d'Oggiono. Tradizione e rinnova-mento in Lombardia fra Quattrocento e Cinquecento*, Milan 1989

W. v. Seidlitz, *Leonardo da Vinci. Der Wendepunkt der Renaissance*, 2 vols, Berlin 1909

M. Sérullaz (ed.), *Le XVIᵉ Siècle Européen. Dessins du Louvre*, Paris 1965

Lo sguardo degli angeli. Verrocchio, Leonardo e il "Battesimo di Christo", ed. A. Natali, place of publication not given, 1998

F. R. Shapley, *Catalogue of the Italian Paintings*. National Gallery of Art, Washington, DC, 1979

J. Shearman, "Leonardo's Colour and Chiaroscuro", in: ZfKG, 25, 1962, pp. 13–47

J. Shearman, *Only Connect … Art and the Spectator in the Italian Renaissance*, Princeton 1992

J. Shell/G. Sironi, "Cecilia Gallerani: Leonardo's Lady with an Ermine", in: AeH, 13, 1992, pp. 47–66

J. Shell/G. Sironi, "Salaì and Leonardo's Legacy", in: BM, 133, 1991, pp. 95–108

J. Shell/G. Sironi, "Un nuovo documento di paga-mento per la Vergine delle Rocce di Leonardo", in: *"Hostinato rigore". Leonardiana in memoria di Augusto Marinoni*, ed. P. C. Marani, Milan 2000, pp. 27–31

R. Simon, Official Press Release "Salvator Mundi", 7.7.2011, http://www.robertsimon.com/pdfs/ Leonardo_PressRelease_Long.pdf, access 25 February 2017

G. Sironi, *Nuovi documenti riguardanti la Vergine delle Rocce di Leonardo da Vinci*, Florence 1981

W. Smith, "Observations on the Mona Lisa Landscape", in: AB, 67, 1985, pp. 183–199

C. H. Smyth, "Venice and the Emergence of the High Renaissance in Florence: Observations and Questions", in: C. Bertelli (ed.) et al., *Florence and Venice: Comparisons and Relations*, Florence 1979, pp. 209–249

J. Snow Smith, *The Salvator Mundi of Leonardo da Vinci*, Seattle 1982

J. Snow Smith, "An Iconographic Interpretation of Leonardo's Virgin of the Rocks (Louvre)", in: AL, 67, 1983, pp. 134–142

J. Snow Smith, "Leonardo's Virgin of the Rocks (Musée du Louvre): A Franciscan Interpretation", in: *Studies in Iconography*, 11, 1987, pp. 35–94

E. Solmi, *Scritti Vinciani* (Le fonti dei manoscritti di Leonardo da Vinci e altri studi), Florence 1976 (first published 1908–1911)

H. von Sonnenburg, *Raphael in der Alten Pinakothek*, Munich 1983

C. Starnazzi (ed.), *La "Madonna dei Fusi" di Leonardo da Vinci e il paesaggio del Valdarno Superiore*, exh. cat., Arezzo 2000

C. Starnazzi, *Leonardo cartografo*, Florence 2003

R. Stefaniak, "On Looking into the Abyss: Leonardo's Virgin of the Rocks", in: *Konsthistorisk tidskrift*, 66, 1997, pp. 1–36

L. Steinberg, "Leonardo's Last Supper", in: *Art Quarterly*, 36, 1973, pp. 297–410

K. T. Steinitz, *Leonardo architetto teatrale e organizzatore di feste* (IX Lettura Vinciana), Florence 1970

C. Sterling, "Fighting Animals in the Adoration of the Magi", in: *Bulletin of the Cleveland Museum of Art*, 61, 1974, pp. 350–359

C. Sterling, *The Master of Claude, Queen of France*, New York 1975

R. S. Stites, *The Sublimations of Leonardo da Vinci*, Washington, DC, 1970

V. I. Stoichita, *Eine kurze Geschichte des Schattens*, Munich 1999

D. Strong, "The Triumph of Mona Lisa: Science and Allegory of Time", in: *Leonardo e l'età della ragione*, 1982, pp. 255–278

W. Suida, "Leonardo's Activity as a Painter", in: *Leonardo. Saggi e ricerche*, pp. 315–329

W. Suida, *Leonardo und sein Kreis*, Munich 1929

D. Summers, "'Maniera' and Movement: The 'Figura Serpentinata'", in: *Art Quarterly*, 35, 1972, pp. 269–301

K. F. Suter, *Das Rätsel von Leonardos Schlachtenbild*, Strasbourg 1937

C. Syre (ed.), *Leonardo da Vinci. Die Madonna mit der Nelke*, Munich 2006

L. Syson/L. Keith (eds.), *Leonardo: Painter at the Court of Milan*, London 2011

L. Syson/R. Billinge, "Leonardo da Vinci's Use of Underdrawing in the 'Virgin of the Rocks' in the National Gallery and 'St Jerome' in the Vatican", in: BM, 147, 2005, pp. 450–463

H. Tanaka, "Leonardo's Isabella d' Este. A New Analysis of the Mona Lisa in the Louvre", in: *Istituto Giapponese di Cultura in Roma. Annuario*, 13, 1976–1977, pp. 23–35

H. Tanaka, *Leonardo da Vinci. La sua arte e la sua vita*, Suwa 1983

H. Thode, *Franz von Assisi und die Anfänge der Kunst der Renaissance in Italien*, Essen, undated (first published 1885)

P. Tinagli, *Women in Italian Renaissance Art. Gender, Representation, Identity*, Manchester 1997

C. de Tolnay, "Remarques sur La Joconde", in: *La Revue des Arts*, 2, 1952, pp. 18–26

C. de Tolnay, *Michelangelo I. The Youth of Michelangelo*, Princeton 1969

G.-B de Toni, *Le piante e gli animali in Leonardo da Vinci*, Bologna 1922

P. Tonini, *Il santuario della Santissima Annunziata di Firenze*, Florence 1876

H. Travers Newton/J. R. Spencer, "On the Location of Leonardo's Battle of Anghiari", in: AB, 64, 1982, pp. 45–52

R. C. Trexler, *The Journey of the Magi. Meanings in the History of a Christian Story*, Princeton 1997

C. A. Truesdell, "Fundamental Mechanics in the Madrid Codices", in: *Leonardo e l'età della ragione*, eds. E. Belloni and P. Rossi, Milan, 1982, S. 309–324

R. A. Turner, *Inventing Leonardo*, Berkeley/Los Angeles 1992

A. Uccelli, *I libri del volo di Leonardo da Vinci*, Milan 1952

C. Vecce, *Leonardo*, Rome 1998

P. L. de Vecchi, "Iconografia e devozione dell'Immacolata in Lombardia", in: *Zenale e Leonardo*, 1982, pp. 254–257

J. Vegh, "Mediatrix omnium gratiarum. A Proposal for the Interpretation of Leonardo's Virgin of the Rocks", in: *Arte cristiana*, 80, 1992, pp. 275–286

K. H. Veltman, *Studies on Leonardo da Vinci I. Linear Perspective and the Visual Dimensions of Science and Art*, Munich 1986

P. Venturoli, "L'ancona dell'immacolata concezione di San Francesco Grande a Milano", in: *Giovanni Antonio Amadeo*, ed. J. Shell and L. Castelfranchi, Milan 1993, pp. 421–437

E. Verga, *Bibliografia vinciana 1493–1930*, 2 vols, Bologna 1931 (reprint 1970)

A. Vezzosi (ed.), *Leonardo dopo Milano. La madonna dei fusi (1501)*, Florence 1982.

A. Vezzosi (ed.), *Leonardo e il leonardismo a Napoli e a Roma*, Florence 1983

F. Viatte, *Léonard de Vinci. Isabelle d' Este*, Paris 1999

F. Viatte/V. Forcione (eds.), *Léonard de Vinci. Dessins et manuscrits*, Paris 2003

E. Villata, "Il San Giovanni Battista di Leonardo: un'ipotesi per al cronologia e la committenza", in: RV, 27, 1997, pp. 187–236

E. Villata, "Ancora sul San Giovanni Battista di Leonardo", in: RV, 28, 1999, pp. 123–158

F. Villot, *Notice des tableaux exposés dans les galeries du Louvre*, 1st series, Paris 1849

M. Wackernagel, *The World of the Florentine Renaissance Artist. Projects and Patrons, Workshop and Art Market*, Princeton 1981 (first published in German in 1938)

J. Walker, "Ginevra de' Benci by Leonardo da Vinci", in: *National Gallery of Art. Report and Studies in the History of Art* 1967, [2], 1968, pp. 1–38

M. Warnke, *Hofkünstler. Zur Vorgeschichte des modernen Künstlers*, Cologne 1985

J. Wasserman, "Michelangelo's Virgin and Child with Saint Anne at Oxford", in: BM, 111, 1969, pp. 122–131

J. Wasserman, "A Re-discovered Cartoon by Leonardo da Vinci", in: BM, 112, 1970, pp. 194–204

J. Wasserman, "The Dating and Patronage of Leonardo's Burlington House Cartoon", in: AB, 53, 1971, pp. 312–325

J. Wasserman, "Reflections on the Last Supper of Leonardo da Vinci", in: AL, 66, 1983, pp. 15–34

J. Wasserman, *Leonardo da Vinci*, New York 1984 (first published 1975)

W. J. Wegener, *Mortuary Chapels of Renaissance Condottieri*, PhD thesis, Princeton 1989

K. Weil Garris Posner, *Leonardo and Central Italian Art: 1515–1550*, New York 1974

E. S. Welch, *Art and Authority in Renaissance Milan*, New Haven/London 1995

M. Wiemers, *Bildform und Werkgenese. Studien zur zeichnerischen Bildvorbereitung in der italienischen Malerei zwischen 1450 und 1490*, Munich/Berlin 1996

J. Wilde, "The Hall of the Great Council of Florence", in: *Journal of the Warburg and Courtauld Institutes*, 7, 1944, pp. 65–81

R. and M. Wittkower, *Künstler – Aussenseiter der Gesellschaft*, Stuttgart 1989

H. Wohl, *The Paintings of Domenico Veneziano c. 1410–1461*, Oxford 1980

C. Wolters, "Über den Erhaltungszustand der Leonardobilder des Louvre", in: *Kunstchronik*, 5, 1952, pp. 135–144

J. Woods-Marsden, "Portrait of a Lady, 1430–1520", in: Brown, 2001, pp. 63–87

C. Yriarte, "Les Relations d'Isabelle d' Este avec Léonard de Vinci", in: GBA, 37, 1888, pp. 118–131

Zenale e Leonardo. Tradizione e rinnovamento della pittura lombarda, exh. cat., Milan 1982

F. Zöllner, *Vitruvs Proportionsfigur*, Worms 1987

F. Zöllner, "Rubens Reworks Leonardo: The Fight for the Standard", in: ALV, 4, 1991, pp. 177–190

F. Zöllner, "'Ogni pittore dipinge sé'. Leonardo on 'automimesis'", in: *Der Künstler über sich in seinem Werk. International Symposium held by the*

Bibliotheca Hertziana, Rome 1989, ed. M. Winner, Weinheim 1992, pp. 137–160

F. Zöllner, "Leonardo's Portrait of Mona Lisa del Giocondo", in: GBA, 121, 1993, pp. 115–138

F. Zöllner, *Leonardo da Vinci. Mona Lisa. Das Porträt der Lisa del Giocondo. Legende und Geschichte*, Frankfurt/Main 1994

F. Zöllner, "Karrieremuster: Das malerische Werk Leonardo da Vincis im Kontext der Auftragsbedingungen", in: *Georges-Bloch-Jahrbuch*, 2, 1995, pp. 57–73

F. Zöllner, "John F. Kennedy and Leonardo's Mona Lisa: Art as the Continuation of Politics", in: W. Kersten (ed.), *Radical Art History. International anthology. Subject: O. K. Werckmeister*, Zurich 1997, pp. 466–479

F. Zöllner, *La "Battaglia di Anghiari" di Leonardo da Vinci fra mitologia e politica (XXXVII Lettura Vinciana)*, Florence 1998

F. Zöllner, "Leonardo da Vinci: Die Geburt der 'Wissenschaft' aus dem Geiste der Kunst", in: *Leonardo da Vinci. Der Codex Leicester*, exh. cat., Munich/Berlin 1999

F. Zöllner, "Leonardo da Vinci's Portraits: Ginevra de' Benci, Cecilia Gallerani, La Belle Ferronière and Mona Lisa", in: *Rafael i Jego Spadkobiercy. Portret Klasyczny w Sztuce Nowozytnej Europy*. Toruń 2003 (*Sztuka i kultura*, 4), pp. 157–183

F. Zöllner, "Il paesaggio di Leonardo fra scienza e simbolismo religioso", in: *Raccolta Vinciana*, 31, 2005 [2006], pp. 231–256

F. Zöllner, "Leonardo und Michelangelo: vom Auftragskünstler zum Ausdruckskünstler", in: *Leonardo da Vinci all'Europa. Einem Mythos auf den Spuren* (*Romanice*, vol. 22), Maren Huberty/Roberto Ubbidiente (eds.), Berlin 2005, pp. 131–167

F. Zöllner, *From the Face to the Aura. Leonardo da Vinci's Sfumato and the History of Female Portraiture, Inventing Faces. Rhetorics of Portraiture between Renaissance and Modernism*, ed. by M. Körte et al, Munich 2013, pp. 67–83

V. P. Zubov, *Leonardo da Vinci*, Cambridge (Mass.) 1968 (first published in Russian in 1962)

4. BIBLIOGRAPHIES

E. Verga, *Bibliografia vinciana 1493–1930*, 2 vols, Bologna 1931 (reprint 1970)

L. H. Heydenreich, "Leonardo-Bibliographie, 1939–1952", in: ZfKG, 15, 1952, pp. 195–200

Leonardo da Vinci, New York undated [c. 1965] (first published Novara 1939), pp. 527–534

A. M. Brizio, "Rassegna degli studi Vinciani dal 1952 al 1968", in: *L'arte*, 1, 1968, pp. 107–120

A. Lorenzi/P. C. Marani, *Bibliografia Vinciana 1964–1979*, Florence 1982

M. Guerrini, "Bibliografia leonardiana", in: RV, 22, 1987, pp. 389–573; 23, 1989, pp. 307–376; 24, 1992, pp. 335–384; 25, 1993, pp. S. 473–522; 26, 1995, pp. 369–401; 27, 1997, pp. 471–569

M. Guerrini, *Bibliotheca leonardiana 1493–1989*, 3 vols, Milan 1990

Biblioteca Leonardiana di Vinci: http://www.bibliotecaleonardiana.it/bbl/home.shtml

Oxford Bibliographies in Art History (OUP): http://www.oxfordbibliographies.com/obo/page/art-history

Index

The index contains names of persons and works of art. Drawings by Leonardo are grouped according to subject under the artist's name. Numerals in *italics* refer to pages with illustrations.

Credits

Imprint

EACH AND EVERY TASCHEN BOOK PLANTS A SEED!
TASCHEN is a carbon neutral publisher.
Each year, we offset our annual carbon emissions with carbon credits at the Instituto Terra, a reforestation program in Minas Gerais, Brazil, founded by Lélia and Sebastião Salgado. To find out more about this ecological partnership, please check: www.taschen.com/zerocarbon.
Inspiration: unlimited.
Carbon footprint: zero.

To stay informed about TASCHEN and our upcoming titles, please subscribe to our free magazine at www.taschen.com/magazine, follow us on Instagram and Facebook, or e-mail your questions to contact@taschen.com.

Page 2
**Head of a Bearded Man
(so-called Self-portrait)**, c. 1510–1515 (?)
Red chalk, 333 x 215 mm
Turin, Biblioteca Reale, Inv. 15571

© 2024 TASCHEN GmbH
Hohenzollernring 53, D–50672 Köln
www.taschen.com

Original edition:
© 2003 TASCHEN GmbH

Translation: Karen Williams, Dartmouth

Printed in Bosnia-Herzegovina
ISBN 978–3–8365–9990–0